Art
of
the
Garden

Art of the Garden

The Garden in British Art, 1800 to the Present Day

Edited by Nicholas Alfrey,
Stephen Daniels and Martin Postle

With contributions by Stephen Bann,
Brent Elliott, Mary Horlock and Ben Tufnell

Exhibition sponsored by

≣Ⅱ ERNST & YOUNG

First published 2004 by order
of the TATE TRUSTEES
by TATE PUBLISHING, a division
of TATE ENTERPRISES LTD,
Millbank, London SW1P 4RG

www.tate.org.uk

on the occasion of the exhibition
at TATE BRITAIN, LONDON
3 JUNE – 30 AUGUST 2004

ULSTER MUSEUM, BELFAST
1 OCTOBER 2004 – 6 FEBRUARY 2005

MANCHESTER ART GALLERY
5 MARCH – 15 MAY 2005

British Library Cataloguing in
Publication Data. A catalogue record
for this publication is available from
the British Library

ISBN 1 85437 544 X (hardback)
ISBN 1 85437 502 4 (paperback)

Distributed in the United States and
Canada by Harry N. Abrams, Inc.,
New York

Library of Congress Cataloguing
in Publication Data
Library of Congress
Control Number 2004102501

Designed by
MELANIE MUES

Printed and bound in Belgium by
DIE KEURE

Cover:
HOWARD SOOLEY *Derek Jarman's Garden
at Dungeness c.*1990 (cat.71a, detail)

Authorship of the catalogues entries
is indicated by the following initials:
NA NICHOLAS ALFREY
SD STEPHEN DANIELS
MH MARY HORLOCK
MP MARTIN POSTLE
BT BEN TUFNELL

6 Sponsor's Foreword

7 Foreword

8 Acknowledgements

9 Introduction

ESSAYS

12 Country Gardens
 Martin Postle

22 Suburban Prospects
 Stephen Daniels

31 On Garden Colour
 Nicholas Alfrey

40 Gardens Illustrated
 Brent Elliott

48 The Garden of England:
 Theme and Variations
 Stephen Bann

CATALOGUE

58 Thresholds and Prospects

92 The Secret Garden

130 Fragments and Inscriptions

156 Coloured Grounds

186 Representing and Intervening
 with an essay by Mary Horlock

216 ARTISTS' GARDENS

 James Tissot
 Alfred Parsons
 Edward Atkinson Hornel
 Charles Mahoney
 Cedric Morris
 Ivon Hitchens
 Barbara Hepworth
 Patrick Heron
 Ian Hamilton Finlay
 Derek Jarman

238 Catalogue Notes

242 Bibliography

244 List of Works

248 Photographic Credits

249 List of Lenders

250 Index

Ernst & Young is delighted to sponsor such an outstanding exhibition as *Art of the Garden* and hopes this catalogue provides you with an insight into what is the first major exhibition to examine the relationship between the garden and British art.

This is the tenth exhibition that we have been associated with and our fifth with Tate. We are pleased to continue this relationship and are proud to be able to support Tate's commitment to the arts and the high quality exhibitions, such as this, that it presents.

Our sponsorship of *Art of the Garden* is part of our continuing partnership with the arts in the UK, including galleries, museums and other community art initiatives. We recognise the need for long-term and sustained investment in the arts and are pleased that our support makes it possible for such world class exhibitions to be staged and for the public to have access to them.

Nick Land
Chairman, Ernst & Young

Gardening is the most popular and widespread leisure activity in contemporary Britain. For some time it has also occupied a place of prime importance both in the poetics and politics of English national identity and in the dynamics of social hierarchy and expression. In the eighteenth century, the elevation of landscape gardening to a polite art, with contributions from painting, architecture, sculpture and literature, was part of its conversion to a patriotic art. And in more recent times, the garden as a signal of aesthetic sensibility and intellectual sophistication has led to fierce style wars, played out in the pages of glossy gardening magazines, through television programmes, or at the annual festival organized by the Royal Horticultural Society at the Chelsea Flower Show. But a proper analysis of garden culture will encompass dimensions far beyond nation, style and class, helping to define the difference between rural and urban traditions, for example, or the characters of the various regions of the country, and revealing how gardens work as imaginative spaces – on the ground as well as in words and pictures – and relate to the world beyond their walls or fences. These are among the purposes of *Art of the Garden* – a presentation, analysis and celebration of one vibrant strand of British visual culture stretching across two hundred years.

This exhibition began life in 1999 as an unusual and highly original proposal from Stephen Daniels and Nicholas Alfrey of the University of Nottingham, together with Martin Postle of Tate. The project that emerged from these beginnings has been superbly led by Martin, with a significant contribution from Mary Horlock in shaping and selecting the 'Representing and Intervening' section, and valuable support from Ben Tufnell and many others. Amongst our several outside contributors I would like especially to thank muf for their bold and sure-footed exhibition design, another elegant transformation of Tate Britain's Linbury Galleries. The show has been timed to coincide with the Bicentenary of the Royal Horticultural Society and we have been very pleased to contribute thereby to its 2004 *Year of Gardening*. Our further partnership with the BBC, whose series *Art of the Garden* is broadcast in parallel with the exhibition, has also been most fruitful and is part of a growing collaboration between our two institutions.

In the light of this multifaceted national celebration of gardens we have been keen to extend the showing of our exhibition beyond London – not, as is more usual with Tate Britain exhibitions, to overseas venues, but to other UK centres. Our proposals to the Ulster Museum, Belfast, and Manchester Art Gallery were immediately and enthusiastically accepted and I am delighted to be extending our existing relationships with these two fine museums. We look forward to further collaborations with them as part of Tate's expanding network of national initiatives. Most of all I would like to thank every one of the many lenders from public and private collections who have temporarily parted with important works of art to allow this exhibition to be realised. We are indebted to them for their public-spirited generosity. And for giving us the means to stage this exhibition in the first place I would like to record Tate's gratitude to Ernst & Young, whose substantial commitment to arts sponsorship is admirable and remarkable.

Stephen Deuchar
Director, Tate Britain

ACKNOWLEDGEMENTS

Tate Britain would like to thank the following individuals for their valuable contributions:

Ivor Abrahams, James Allen, Primrose Arnander, Gerry Badger, Sir Jack Baer, Stephen Bann, Janet Barnes, Wendy Baron, John Bedford, Roger Billcliffe, Peter Black, Tyrel Broadbent, Elizabeth Bulkeley, Richard Calvocoressi, Mat Collishaw, Camilla Costello, Dr Gill Clarke, Stuart Comer, David Crouch, Jill De Navarro, Flavia Dietrich, Anne Dulau, Sally Dummer, Brent Elliott, Cerith Wyn Evans, Florrie Evans, Dr Mark Evans, Patrick Eyres, Graham Fagen, Dee Ferris, Ian Hamilton Finlay, Cathy Frank, Anya Gallaccio, Cristy Gilbert, David Gilbert, Maggi Hambling, Kay Haslam, Harriet Hawkins, Mark Haworth-Booth, Anne Helmreich, Katherine and Susanna Heron, Susan Hiller, John Hitchens, Gary Hume, Andrew Hunt, David Inshaw, Sarah Jones, Janice Kerbel, Elaine Kuwahara, Francis Kyle, Darian Leader, Philip Long, Jonathan Makepeace, Sarah Mills, Ivan and Heather Morison, Paul Morrison, David Naylor, Jacques Nimki, Nils Norman, Tom Normand, Martin Parr, Dave Paterson, Andrew McIntosh Patrick, Alison Pattison, Marc Quinn, Kate Paul, John Pearce, Ellie Potbury, Rebecca Preston, David Rayson, Liz Reintjes, Alexander Robertson, Michael Rufus, Michelle Salter, Alice Sedgwick, George Shaw, Jessie Sheeler, John Shelley, Isobel Siddons, Pia Simig, Terry Slater, Bill Smith, Howard Sooley, David Spero, Phanis Vrettos, Angela Weight, Catherine Webster, Richard Wentworth and Christopher Wood; along with Liza Fior and Cathy Hawley of muf architects, Sculpture at Goodwood and Jay Jopling/White Cube for the generous loan of Marc Quinn's *The Overwhelming World of Desire (Paphiopedilum Winston Churchill Hybrid)*, and Nick Bell and Tyrone Lou of UNA Graphic Design. Indemnity has been kindly provided by the Department for Culture, Media and Sport.
In addition, the following colleagues at Tate have been of great assistance: Gillian Buttimer, Rebecca Fortey, Ken Graham, Tim Holton, David Fraser Jenkins, John Jervis, Andy Shiel and Ian Warrell.

ART OF THE GARDEN

What is the place of the garden in British art? Gardens certainly play a significant role within British culture as a whole, and a rich repertoire of visual imagery has developed around their design and improvement. Gardens are also an important motif in literature, especially poetry, and draw on a long tradition of garden symbolism from many cultures. As a theme in art, however, the garden is surprisingly elusive. Compared with other sites, such as hills and woods, towns and villages, rivers and coasts, gardens are not securely bounded by particular artistic traditions and movements.

In *The Artist and the Garden* (2000) Roy Strong identifies a tradition of garden painting that flourished in the portraiture of aristocratic families and their property, withered with the rise of eighteenth-century landscape art, and revived in the half-century before the First World War.[1] In her chapter on the art of the garden in *The Pursuit of Paradise* (1999) Jane Brown likewise acknowledges the significance of late Victorian and Edwardian garden painting, which she regards as enchanting, nostalgic and lightweight. The French Impressionists, by contrast, she sees as having the artistic force 'to raise gardens from the merely pretty'. Brown maintains that significant British garden art begins with self-consciously modern painters such as those associated with the Bloomsbury Group. The art of the garden in Britain, however, does not vanish from the aesthetic record in the way either of these accounts suggests. Rather, the art of the garden migrates across genres, including various modes of landscape and portraiture, as well as moving between various pictorial media.

There have been a number of notable exhibitions over the past thirty years on the culture of gardens in which artistic representations have figured prominently. *The Garden*, a pioneering exhibition held at the Victoria and Albert Museum in 1979 to celebrate a thousand years of British gardening, showed works of art alongside plans, maps and photographs. This established a framework for subsequent surveys, such as *The Glory of the Garden*, at Sotheby's in 1987, and *London's Pride*, at the Museum of London in 1990.[2]

By contrast, *Art of the Garden* emphasises works of art primarily as imaginative constructs in their own right, not as illustrations of gardens beyond the exhibition space, or as images representative of certain periods or places in British garden history. This exhibition focuses on art made throughout Britain since the early nineteenth century, when domestic life became an increasingly central subject of British art, and gardens and gardening spread widely among the population, including among a group of professional artists who were also keen gardeners. The paintings, drawings, photographs and installations draw on the expanding and differentiating culture of gardens in other domains: in design and literature, commerce and leisure.

During the period covered by this exhibition garden ownership in Britain has expanded to the point where there are now over twenty million private gardens – by far the highest number per capita of any nation in Europe – and gardening is the nation's most popular and widespread leisure activity. Private gardening has assumed a public, at times patriotic virtue, through, for example, the growing of vegetables during the Second World War, and flowers after it. Within Britain, England is conventionally esteemed as a quintessential nation of gardeners, and the Garden of England, although the sobriquet originally referred to Kent, is conventionally identified with the south-east as a whole. In the early nineteenth century Humphry Repton saw his domestic art of landscape gardening as both patriotic and polite, but his practice was concentrated in the counties close to London and he met resistance when he tried to extend it into Wales and Scotland.[3] A century later the ideas of William Robinson and Gertrude Jekyll had their power base firmly in the Home Counties, shaped by a nostalgia for the cottages and manor houses of 'Olde England'.[4] Today membership of the Royal Horticultural Society is concentrated in the south-east, with one third of its members living in London and Surrey.[5]

This exhibition both addresses the allure of this regional variety of Englishness and acknowledges other geographical traditions of garden culture in Britain. Cabbages are a focus of late nineteenth-century Scottish paintings by Arthur Melville and Edward Atkinson Hornel. Two of the most compelling artist-gardeners of recent times, Derek Jarman and Ian Hamilton Finlay, have worked respectively on the bleak coast of Dungeness and high on the Pentland Hills. Among the younger artists, George Shaw and David Rayson paint domestic gardens on West Midlands housing estates, portraying patio furniture as well as lawns and flower beds.

Art of the Garden comprises five interrelated sections, each containing to a varying degree historic, modern and contemporary works. The first section, 'Thresholds and Prospects', considers the perception and visualisation of the garden in the context of the wider landscape; as a space on the fringe or the margin, between town and country, city and suburb, between the status quo and the avant-garde. It is also concerned with the garden as an extension of the artist's studio, the threshold across which the external world is viewed and contemplated. Next, 'The Secret Garden' addresses the topos of the garden as an idyllic retreat, a place apart from the modern, workaday world. This section focuses on the garden as a metaphor for exploring the imaginative recesses of artistic sensibility, looking at lost, secret and derelict domains, spaces invested with erotic and spiritual potential. It considers gardens, an area rich in literary associations, as retreats into childhood, nostalgia or make-believe.

'Fragments and Inscriptions' foregrounds the non-horticultural, intellectual garden, which exists primarily to inspire thought and contemplation. It is a garden of reason, which partakes of an emblematic, associative and inscriptive tradition. 'Coloured Grounds' is concerned with the idea that both gardens and paintings are sites which are dedicated to the exploration of colour. It looks at the ways in which colour theory has been applied to both painting and gardening; and at how the changing terms of nature and artifice, informality and geometry, observation and abstraction, have been brought into play across the two practices.

The final section, 'Representing and Intervening', reveals how contemporary artists are still drawn to the conceptual and visual framework of the garden. With Britain's population becoming concentrated in towns and cities, many people feel increasingly distanced from nature, and a private garden space is an ever more precious asset. The idea of the garden remains strong in the popular mind, but for many it is precisely this – an idea. The garden's metaphorical associations grow more ambiguous and more extreme; for many artists it is still a site of reverie and imaginative potential, but it also stands for a lost world, a place that is neglected, interfered with and under threat.

Nicholas Alfrey
Stephen Daniels
Martin Postle

1 Roy Strong, *The Artist and the Garden*, New Haven and London 2000. **2** John Harris (ed.), *The Garden: A Celebration of One Thousand Years of British Gardening*, exh. guide, Victoria and Albert Museum, London 1979; *The Glory of the Garden*, exh. cat., Sotheby's, London 1987; Mireille Galinou (ed.), *London's Pride: The Glorious History of the Capital's Gardens*, exh. cat., Museum of London 1990. Two recent exhibitions give works of art a more central place. *Home and Garden*, held at the Geffrye Museum, London, in 2003–4, focused on paintings and drawings of London middle-class gardens in the eighteenth and nineteenth centuries as domestic spaces; *Enclosed and Enchanted*, held at the Museum of Modern Art, Oxford, in 2000, took a broader view of the garden, exploring ideas of nature and environment from an international perspective. **3** Stephen Daniels, *Humphry Repton: Landscape Gardening and the Geography of Georgian England*, New Haven and London 1999. **4** Anne Helmreich, *The English Garden and National Identity: The Competing Styles of Garden Design, 1870–1914*, Cambridge 2002. **5** Roger Lee, 'Shelter from the storm? Geographies of regard in the worlds of horticultural consumption and production', *Geoforum*, vol.31, no.2, May 2000, pp.137–57.

Country Gardens
Martin Postle

fig.1
Patrick Nasmyth (1787–1831)
*Landscape c.*1807
Oil on oak, 29.8 x 39.1
Tate

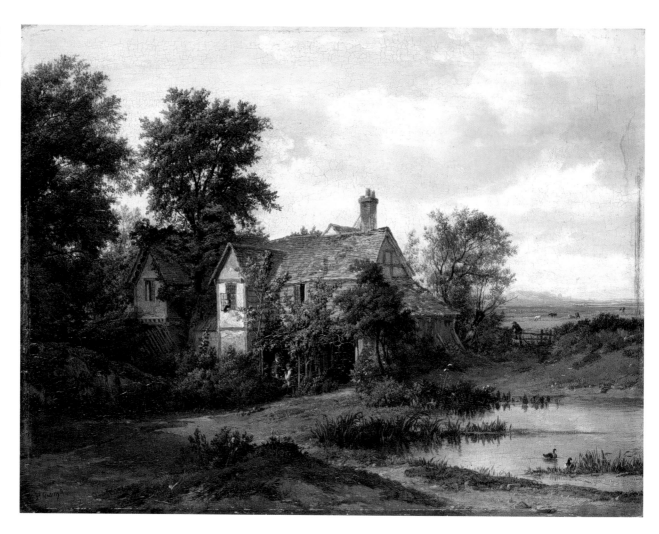

In a radio broadcast of 1937 the composer Percy Grainger introduced a performance of 'Country Gardens', the evocative English folk tune which he had made his own some twenty years earlier. 'The Country Garden in the English sense,' he stated, 'is not a flower garden. It is a small vegetable garden. So you can think of turnips if you like as I play it.'[1] 'Country Gardens' had proved a massive hit, although Grainger felt that it threatened to eclipse his status as a serious composer. In attempting to debunk the rose-tinted image conjured up by the tune, Grainger acknowledged that while the archetypal English rural plot was attractive to the eye, it was first and foremost a source of sustenance: the poor man's 'country garden' was an economic necessity, which in harsh times made the difference between subsistence and starvation. The turnip, then, was a more fitting emblem than the flower.

The country garden, by which is meant here the unpretentious plot of land attached to the cottage of the rural labourer, had been a stock feature of the British landscape since the mid-fourteenth century: it was then, in the wake of the Black Death, that the vastly reduced rural population began to acquire accommodation and land which could be regarded as private property.[2] It was not, however, until the nineteenth century that the labourer's garden *per se*

entered the consciousness of the artist or garden historian. In the later eighteenth century the rural labourer had attracted considerable attention, not least through the genre of the 'Cottage Door' pioneered by Thomas Gainsborough; but at this time artists and aesthetes assessed the pictorial potential of the rural poor in terms of the relative squalidness of their surroundings. The Reverend William Gilpin, for example, graded country people, animals and objects according to their degree of dilapidation: thus, a ragged peasant was more pleasing to the eye than a well-kempt specimen, and the hovel preferable to a neatly maintained cottage.[3] The vogue for images of rural indigence continued well into the nineteenth century. Among those artists who produced such works was Patrick Nasmyth (*fig.1*), who revelled in the aesthetic of the ramshackle: 'decayed pollard trees, old moss-grown orchards, combined with cottages and farm-houses in the most *paintable* state of decay, with tangled hedges and neglected fences, overrun with vegetation clinging to them with "all the careless grace of nature"'.[4] Over the course of the next sixty years or so this image of disorder, although it did not disappear, was modified by an apparently more sympathetic outlook; one which recognised the virtues of the domestic cottage economy, where the well-tended garden took pride of place. How, then, did this come about? One major factor was an increasing recognition of the economic viability and respect for the moral integrity of the rural plot; a phenomenon which was in turn underpinned by the inception of the allotment movement.[5]

The earliest attempts by government to provide the labouring poor with their own land went back to the sixteenth century, when an act of 1589 was passed requiring all cottages to have at least four acres of land attached. Needless to say, this legislation was not adequately enforced, and by the 1780s Arthur Young's appeals for the provision of land for the poor continued to go unheeded. It was not until the disastrous harvest of 1795 that the allotment (a legal term meaning a portion) was considered seriously as a means of alleviating widespread rural poverty. Alongside the provision of potato fields and cow pastures, there was a move to ameliorate the immediate domestic environment of the cottager through the allotment garden, attached to or close to the labourer's home. The cottage garden was promoted not just to provide sustenance and encourage self-help but as a means of strengthening the moral fabric of the family. As John Claudius Loudon observed in the first edition of his

Encyclopaedia of Gardening in 1822: 'In a moral and political point of view, cottage-gardens are of obvious importance; by attaching the cottager to his home and to his country, by inducing sober, industrious, and domestic habits; and by creating that feeling of independence which is the best security against pauperism.' He cautioned, however, that 'the garden of the labourer ought never to be so large as to interfere with his employment as a labourer'.[6] With the emphasis on moral improvement, it is not surprising to find among the early pioneers of the allotment movement, alongside enlightened clerics and landowners, the evangelical Society of Bettering the Conditions and Increasing the Comforts of the Poor, which addressed the issue with missionary zeal.[7]

By the mid-1840s there were tens of thousands of allotments in England, most of them in the south and west, the areas which had borne the brunt of recent agricultural crises. Spearheading the interests of the allotment holder was the Labourer's Friend Society (LFS), an organisation with considerable influence in government circles and among the landed classes. Although humanitarian in outlook, the LFS promoted the allotment not as a conduit for charity but as a vehicle for self-help and self-respect. Already by the early 1840s the LFS magazine recognised the way in which the allotment system had improved the visual appearance of the rural landscape: 'It has converted some of the most rough and uncomely villages in the kingdom into so many rural Auburns – into scenes of comfort, cleanliness, and picturesque beauty – into cottage gardens, breathing the scent of flowers around, and the bees humming in the summer sun.'[8] Even the Prime Minister, Sir Robert Peel, spoke out on behalf of the labourer's right to tend his own plot, declaring in 1843: 'I favour giving small allotments for leisure hours. I do not know of a better leisure occupation for him.'[9] Acknowledgement that the garden plot could be a source of leisure, as well as physical and moral support, helped pave the way for its acceptance as a legitimate source of aesthetic and visual pleasure for the middle classes.

In his recent account of the allotment movement in nineteenth-century Britain, Jeremy Burchardt argues for the vital impact of the garden plot (previously dismissed as marginal in every sense) on the rural economy. In doing so he resists arguments that have characterised it as regressive and paternalistic, not least because its proponents did not set out to use it as a means of reinforcing a social and cultural

hierarchy. Rather, Burchardt regards the allotment as 'a vector of the modernisation of rural society', a forward-looking, liberal movement that 'brought the values of the rural labouring poor more closely into line with characteristic elements of urban working-class culture, notably respectability, independence, self-help and mutuality'. With the advent of the allotment movement villages became less 'rough' and more 'respectable'.[10] In this context it is possible to understand why the cottage and its garden increasingly gained the respect of artists and aesthetes. Yet, while the rural population appeared to be moving forward (although many were actually moving out), the image purveyed by the paintings of Victorian artists such as Birket Foster and Helen Allingham served to uphold a fundamentally conservative viewpoint wherein the cottage garden was an emblem of tradition, continuity, and ultimately a source of national pride.

The impetus for painting the cottage garden, as is suggested here, may well have derived in part from the 'gentrification' of the English village by the later nineteenth century. It also related to a discourse among aesthetes, essayists, poets and gardeners which sought to link the garden to a sense of English – as opposed to British – national identity. Anne Helmreich, who explores this phenomenon in her recent book *The English Garden and National Identity*, highlights, among others, the role of William Robinson, who legitimised his 'wild garden' aesthetic through cottage gardens; these 'little Elysiums', as he called them.[11] In the visual arts, among the pioneers in the transformation of the country garden from humble plot to English Eden was Myles Birket Foster. Born on the north-east coast near Newcastle upon Tyne, Birket Foster made a highly successful living in London as a wood engraver and illustrator before turning to watercolour at the age of thirty-five. Shortly after this, in 1863, he settled in Witley, near Godalming, Surrey, where he built an imposing mock-Tudor mansion, together with 'at least three rosy-brick, diamond paned cottages for members of the outdoor staff and their families'.[12] It was from this vantage point that Birket Foster set out to capture the essence of the surrounding countryside, its villages and gardens. Birket Foster was capable of depicting the less salubrious aspects of the cottage garden (fig.2), such as the image of an old woman crouching in her cabbage patch, her jumbled washing draped unceremoniously across a ramshackle outhouse. On the whole, however, Birket Foster's vision was unclouded by the grim realities of rural poverty

and focused instead on the more attractive aspects of domestic cottage life in and around the country garden; garlanding flowers, picking hedgerow fruit or simply reading. His portrayal of the country garden proved extremely popular and influenced a younger generation of garden painters, not least Helen Allingham, who took up residence near Birket Foster in Surrey in the 1880s.

Allingham's formative role in promoting the ideal of the country garden is crucial to understanding how it became an emblem of English national identity by the early twentieth century. A doctor's daughter from Birmingham, Allingham made her career as a magazine illustrator. Following her marriage in 1874 to the Irish poet and editor William Allingham, she began to associate with some of the most influential literary and artistic figures of the age, including Thomas Carlyle, Alfred Lord Tennyson, Robert Browning, Dante Gabriel Rossetti and John Ruskin, who, according to *The Times*, 'used sometimes to speak of her with exaggerated admiration'.[13] Allingham's most popular works were depictions of the cottages and gardens of Surrey, although these were by no means confined to the dwellings of the poor. While she painted with painstaking detail, Allingham still felt free to improve on what she saw, here substituting rows of vegetables with colourful flower beds, there restoring original features obliterated by the recent 'home improvements'. Allingham regarded her paintings as visual records of traditional cottage culture, threatened by the incursions of urban middle-class entrepreneurs, who were provided with easy access to rural Surrey via newly established road and rail networks. Ironically, the sheer popularity of Allingham's watercolours did much to promote the vogue for country living and 'cottage tourism', which in turn despoiled traditional rural communities.[14] In 1903 a selection of her watercolours was published in a book entitled *Happy England*, although she herself disliked the title since her 'England' was located only in the south-east.

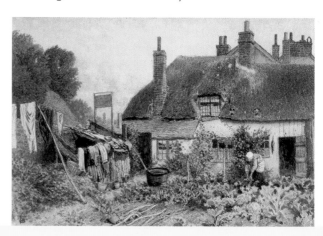

In 1909 Allingham provided illustrations for Stewart Dick's book *The Cottage Homes of England*. As Helmreich notes, Dick promoted the country cottage as a symbol of national pride, 'claiming that its homeliness reflects the English devotion to family, and its simple organic plan, like that of its garden, reveals the national character'.[15] As early as 1888 the *Art Journal* had remarked on the sanitised nature of Allingham's rural world, where 'there is not trace of sympathy with the stern realism to which we have grown accustomed'. It continued: 'For her there would be little attraction of a pictorial kind in the marks of grime and toil on rugged hands and bronzed faces, or in the loose blouses, the dowdy brown and blue skirts, and the close fitting caps that make the tiny Dutch toddler look nearly as old and careworn as its grandmother.'[16]

Even so, Allingham had attempted occasionally to present a more gritty image of 'stern realism' – as in the depiction of a young peasant woman standing in a field of cabbages, painted around 1884 (fig.4). The inspiration for this work may have derived in part from Allingham's personal experience. However, its uncanny resemblance to a celebrated painting of 1883 by the young Scottish artist James Guthrie suggests that she may have been paying more attention than is supposed to the rising generation of British 'Realist' painters.

A Hind's Daughter (fig.3) was painted by Guthrie in the village of Cockburnspath, on the east coast of Scotland. Here a young girl stands alone in

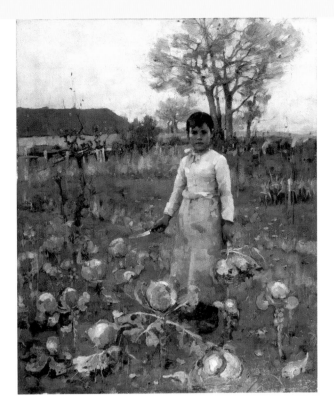

fig.3
James Guthrie (1859–1930)
A Hind's Daughter 1883
Oil on canvas, 91.5 x 76.2
National Gallery of Scotland

a vegetable plot tenanted by her father, a 'hind' or skilled labourer, whose cottage is glimpsed in the background. The scene, in contrast to the cottage garden pictures of Allingham, is bleak and uncompromising, the message centred on the harsh realities of rural life, where children, as well as adults, labour for their keep.[17] While the painting relates to a specific Scottish village, the image is ultimately generic, derived from a representation of rural life which Guthrie had absorbed through the example of contemporary French painters, notably Jules Bastien-Lepage. Although Guthrie did not train in Paris, many of his closest associates, collectively known as the 'Glasgow Boys', had studied there. In common with other British artists of the period influenced by the French Realist school, Guthrie habitually spent the summer months observing the routine activities of village life, centred on farms and working gardens. As one artist recalled of Cockburnspath in the early 1880s, 'nearly every cottage had an artist lodger and easels were to be seen pitched in the gardens or the square, in the fields close by, or near the little harbour'.[18] Guthrie preferred his native Scotland. Others, however, ventured to the Home Counties and to Lincolnshire, Suffolk and Worcestershire . In contrast to the accessible 'picturesque' scenery of the south-east favoured by English watercolourists, the locations chosen by Realist painters were well away from familiar tourist trails. While the former artists were busy evolving an aesthetic that was resolutely Anglocentric, the Realists placed the garden within a European cultural context. Here the portrayal of

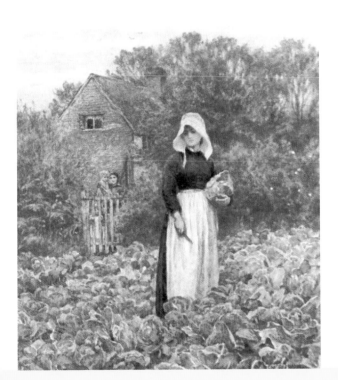

fig.4
Helen Allingham (1848–1926)
Cutting Cabbages c.1884
Watercolour
Location unknown

rural peasant life was designed not to satisfy a middle-class desire to appropriate the domestic circumstances of the cottager, but to signify its otherness.

In the late 1870s and 1880s artists of the Glasgow School painted a number of pictures featuring cottage gardens, including Arthur Melville's *A Cabbage Garden* (cat.5) and William MacGregor's *A Cottage Garden, Crail* (cat.6). These works are typical in the way that they foreground vegetable produce: cabbages in particular, it has been observed, 'were almost to become a leitmotif of Glasgow School painting during the 1880s'.[19] While such paintings present a corrective to the idyll purveyed by Allingham and her associates, the Glasgow Boys, and their British compatriots, were not revolutionaries.[20] Their art, derived largely from an accepted contemporary European model, was not tied to any radical political or social agenda. To be sure, the way in which they portrayed the country garden was far more earthy than the 'ornamental' garden school of Birket Foster and company, and certainly appeared modern to contemporaries. Even so, the bold technique of the Realists masked their essential conservatism. As they strove to present the image of a stoic rural community, unaffected by the vicissitudes of contemporary urban values, that very community was undergoing fundamental change.

By the mid-nineteenth century, as the movement gained momentum, the demand for allotment gardens far outstripped supply, not least because the demand came not only from rural labourers but from artisans, handloom weavers and framework knitters, who needed plots to supplement their uncertain wages. By the 1870s the allotment movement had become politicised, as tenants formed committees and societies and lobbied for their rights. Allotments, too, fostered agricultural trade unionism, engendering a spirit of self-respect and independence. At the same time, as the rural labouring population shifted increasingly towards the towns and cities, so the allotment was integrated into the urban landscape. As the plot was assimilated into urban working-class life, so the responsibility for the provision of allotment land shifted from the private landowner to public authorities, and to those employers of mass labour, the railways and mining companies. Consequently, the allotment became associated increasingly with the industrialised north rather than the rural south. In 1908 the government passed the Small Holdings and Allotments Act, by which it became incumbent on local councils to provide plots of land, while 1918

saw the establishment of the National Union of Allotment Holders. In the Allotment Acts of 1922 and 1925 the words 'for the labouring poor' were removed from the legislation in an attempt to nullify the stigma of charity. At the same time the 1922 Act mandated plot holders to grow vegetables and fruit, and not flowers.[21] The allotment garden, which had been in the nineteenth century the product of private enterprise, was in the twentieth century an object of municipal control. In such a guise its aesthetic appeal to middle-class consciousness was severely constrained.

Despite occasional excursions into the urban plot by Camden Town painters such as Charles Ginner, artistic interest in the 'common' garden remained firmly rooted in the countryside. This interest was allied to a rediscovery of indigenous folk culture, which, with the demographic shifts of the late 1800s and the transformation of Britain from a rural to an urban economy, was fast disappearing. Investigations into folk culture took many forms. In the 1890s the indefatigable Cecil Sharp began to collect and document Morris dances, including the 'Handkerchief Dance', which Percy Grainger transformed into 'Country Gardens'. Gertrude Jekyll, in addition to her horticultural pursuits, photographed rural artefacts such as tools, clothing and household items, which she published in her book *Old West Surrey, Some Notes and Memories* in 1904.[22] As the mania for preserving folk culture grew in the early decades of the twentieth century, the country garden, which in previous generations had been the object of an anodyne middle-class fantasy, provoked serious interest. The popularisation of the cottage garden by William Robinson and Jekyll focused attention on its format, its flowers and vegetables, and the nature of its economy. A spate of books and magazine articles provided hands-on advice on sowing, planting and husbandry. It was in this context that, during the 1920s and 1930s, a new generation of young British artists turned for inspiration to the country garden. Excited by the collective rediscovery of the English landscape, they grounded their enterprise not only in their visual response, but also in the attainment of horticultural expertise and the cultivation of their own country gardens.

John Nash was a leading figure in this new generation of artist-gardeners. In an auto-biographical note entitled *The Artist Plantsman* he recalled his idyllic childhood in rural Buckinghamshire at the end of the nineteenth century: 'Down the road there were five maiden ladies,

whose garden was a delight and where again we came in for instruction of a gentle nature. Each old lady still preserved her own childhood plot apart from the main garden, and the somewhat unkempt box-edged borders were full of "treasures".'[23]

Nash had enjoyed a privileged Edwardian upbringing, experiencing a way of life subsequently shattered by the First World War — as he knew only too well from his first-hand experience of the trenches. Before the war Nash and his elder brother, Paul, were closely associated with the urban-oriented Camden Town Group. Increasingly, however, John's preference was for landscape, his growing passion the garden. 'Where Paul would write a manifesto or form a group,' recalled John Rothenstein, 'John transplanted some roses; where Paul would cherish the words of Thomas Browne or Blake, John consulted a seed catalogue.'[24] During the 1920s John Nash formed friendships with the noted horticulturalists Clarence Elliott and Anthony Hampton, and illustrated several of the latter's gardening books (written under the pseudonym Jason Hill), including *The Curious Gardener*, a classic work of 1932. He also contributed articles to horticultural magazines and was in time recognised as an expert botanist in his own right.[25] The trajectory of Nash's career is in some ways paralleled by another noted 'artist plantsman' of the period, Cedric Morris, who was four years Nash's senior and in later years became a close friend. Morris, who, like Nash, came from a prosperous background, enjoyed a considerable reputation as a member of the avant-garde before turning his attention to horticulture. In time, according to the eminent gardener Beth Chatto, Morris's Suffolk garden came to contain 'the most fascinating and comprehensive collection of worthwhile and unusual bulbs' in the entire country.[26] Even so, his horticultural reputation was gained at a price, for as his fame as a breeder of rare irises grew, his status as an artist diminished.

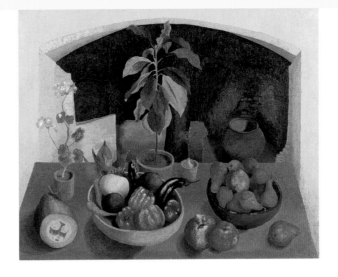

fig.5
Cedric Morris (1889–1982)
*Still Life of Garden Produce
against an Old Chimney* 1958
Oil on canvas, 96.5 x 121.9
Private Collection

What ultimately united Nash and Morris was the inspiration they derived from their country gardens, which in turn provided the mainstay of their work. At Lane End House, near Aylesbury, Buckingham-shire, and at Bottengoms Farmhouse, Essex (*fig.6*), to which he moved in 1944, Nash's passion for gardening and his artistic endeavours went hand in hand. Similarly, by the early 1930s Morris had turned his back on the metropolitan art scene, settling first at Pound Farm, Suffolk, and from 1939 at Benton End, an imposing sixteenth-century farmhouse, near Hadleigh, on the Suffolk-Essex border. Benton End is known today as the location of the East Anglian School of Painting and Drawing, which Morris and his partner, Lett Haines, established shortly after their arrival.[27] The garden, as it has been noted, was the focal point of Morris's career as a plantsman. It was also an object of study, as well as a source of sustenance – Haines using the produce grown there as the foundation for his considerable culinary skills (*fig.5*). Benton End was the vindication of the cottage garden tradition; a place for work, aesthetic enjoyment and a source of food for the table.

The rural idyll pursued by Nash and Morris from the 1930s was mirrored by other artists. In 1930 Edward Bawden, then embarking on a career in London as an artist and illustrator, wrote to a number of his friends suggesting that they start up an artists' colony in north-west Essex, noting the attractiveness of several villages there, including Finchingfield, Thaxted and Wethersfield.[28] In the event, Bawden took up residence at Brick House in the village of Great Bardfield. Although Bawden was in search initially of a weekend rural retreat, the house he settled on was not a country cottage but an imposing, three-storey, Georgian townhouse, which his father purchased for him as a wedding present in 1932. As well as Bawden and his wife, Brick House

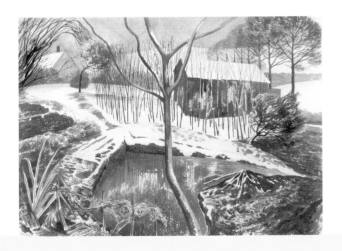

fig.6
John Nash (1893–1977)
Wild Garden, Winter 1959
Watercolour on paper, 40.6 x 57.1
Tate

accommodated his close friend Eric Ravilious, his wife and various artist friends who occasionally lodged there. Over the years Great Bardfield became the hub of an artistic community, including the painters Michael Rothenstein and John Aldridge and the textile designer Marian Straub, collectively dedicated to upholding traditional arts and crafts. Bawden, who remained at Great Bardfield until the 1970s, combined his highly successful commercial ventures with a keen interest in gardening.

Among Bawden's friends during the 1930s was the artist Charles Mahoney, with whom he exchanged plants and seeds, and to whom he wrote excitedly in 1934: 'What is your gardening news? Are you in the same feverish enthusiasm – I feel worn & thin & enervated by constant excessive study of plant lists.'[29] Mahoney, who stayed from time to time at Great Bardfield, was among the most passionate artist-gardeners of the period. An exact contemporary of Bawden and Ravilious, Mahoney developed a devotion to the garden, and more particularly plants, during the 1930s in the context of his close relationship with Evelyn Dunbar. Dunbar's letters to Mahoney from this time provide a compelling testament to the significance of horticulture among this loosely associated group of artists. Peppered with detailed descriptions of plants and often lovingly illustrated (fig. 7), they also chart the growth of their personal relationship: in one memorable letter she addresses Mahoney as 'Chas, my dear old potting shed...'[30] Dunbar's letters form the background to one of the most ambitious artists' garden books of the period, *Gardeners' Choice*, which she and Mahoney wrote and illustrated jointly in 1937. Although they were still only in their thirties, the botanical expertise demonstrated by Dunbar and Mahoney, as well as their passion for the garden, is all the more striking since it appears that Mahoney did not yet have a garden of his own. Indeed it was in 1937 that Mahoney, who had endured several years as an impoverished art teacher in London and Margate, purchased a modest sixteenth-century half-timbered house, Oak Cottage, in the village of Wrotham, Kent, where he lived with his widowed mother. The house, and more especially the garden, became Mahoney's artistic and spiritual home (see pp.224–5).

The inter-war years, during which these artists honed their horticultural expertise, marked a period of economic depression. During this time the prevailing cultural model set store by the husbanding of resources, and the garden plot, whether in the town or country, was identified positively with a progressive work ethic. The plot, despite the trammels of the municipal allotment, remained a signifier of integrity, self-reliance and self-respect. With the outbreak of the Second World War it also became an emblem of national pride, notably through the 'Dig for Victory' campaign inaugurated in October 1939. The propaganda generated by the campaign prompted the wholesale transformation of existing gardens, as well as municipal parks and city squares, into vegetable plots.

The end of the war inevitably marked a downturn, and by the 1950s the allotment was decried as an outmoded institution, the refuge of old men in cloth caps, thoroughly out of step with contemporary consumer culture. It was in this modernising post-war climate that Stanley Spencer produced *Goose Run, Cookham Rise* (fig. 8), a work which stood in defiance of current trends, and which was in marked contrast to Spencer's bourgeois 'potboiler' garden images.[31] Representative of the artist's penchant for disorder and detritus, *Goose Run* evoked the ethos of the rural plot, where the husbandry of livestock had traditionally played an important role alongside production of vegetables.

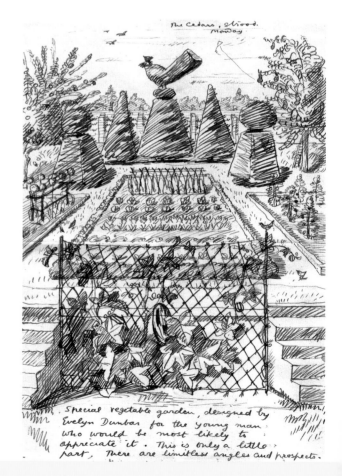

fig. 7
Evelyn Dunbar (1906–1960)
Illustration from letter
to Charles Mahoney,
September 1935
Ink on paper, 23.7 x 17
Private Collection

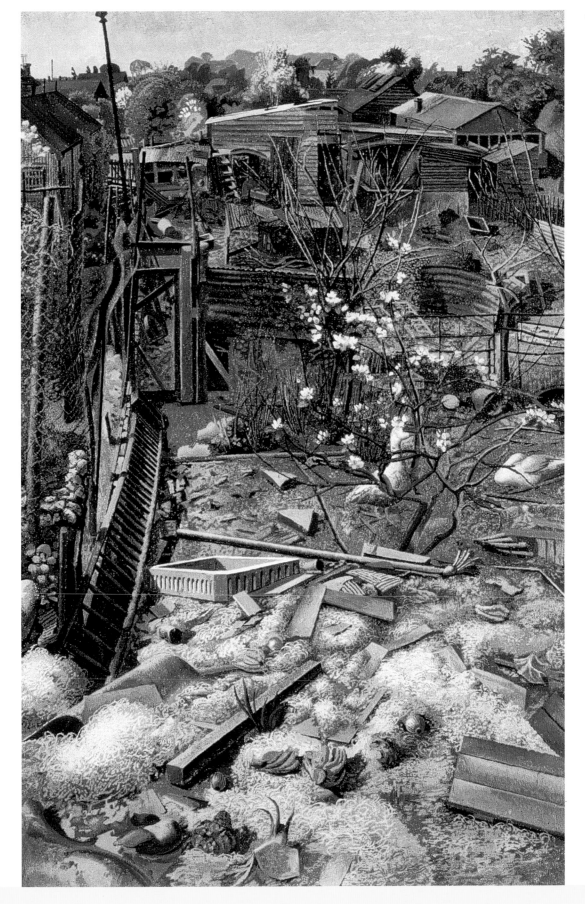

fig.8
Stanley Spencer (1891–1959)
Goose Run, Cookham Rise 1949
Oil on canvas, 76.2 x 50.8
Private Collection

As the allotment movement reached its nadir in the 1960s, the government commissioned a report to assess its future rule. The 'Thorpe Report', as it was known, was published in 1969: it laid renewed emphasis on leisure, promoting the plot as a hobby garden, a sanitised space for family recreation. In doing so, it was highly critical of existing plots, many of which were characterised as eyesores. In future, the report warned, the plot holder 'will no longer be able to cover his rhubarb with rusty old enamel buckets or protect his cucumbers with an old window frame propped up upon a heap of bricks'.[32] Paradoxically, it is the unstructured nature of the allotment, with its lack of rigid design principles and its philosophy of make and mend, that has guaranteed its survival as a locus of horticultural interest and provided stimulation for a new generation of artist-gardeners.

The commercial image of the country garden continues to be shaped by a collective nostalgia for the Victorian cottage tradition promoted by Helen Allingham and her followers. This model remains tied to an urban escapist mentality that promotes a desire to pursue a 'simple' life in the heart of the countryside. In recent years there has also been a resurgence of interest in the working garden, driven by ecological arguments in favour of organic produce and the reassertion of the rights of the plot holder against the depredations of planners and developers in quest of brownfield sites. The allotment, particularly in towns and inner cities, has become a site of regeneration and creativity, a focal point for artistic events and even an opera.[33] In the winter of 2001 the artists Heather and Ivan Morison acquired an overgrown allotment in Edgbaston, Birmingham (fig.10). Once they had restored some semblance of order they became fascinated by the garden, which, after years of

neglect, revealed the original Victorian beds and layout, as well as old apple trees and rose bushes.[34] Thus emerged the character of Ivan Morison 'the gardener', who periodically reports, through printed cards, on the various horticultural activities that take place on his plot (see cat.74). As the Morisons recall, their intention when they acquired their plot was to use it as the site of a scale model of Derek Jarman's house, Prospect Cottage, where they could make works of art. Like the original Prospect Cottage, however, the house and garden have been transformed into a work of art in their own right.

The location for Derek Jarman's pioneering garden, created between 1987 and his death in 1994, was a bank of shingle in the shadow of a nuclear reactor near Dungeness, Kent (see pp.236–7). The garden (fig.9), situated on the margins and created through adversity, was bound up with Jarman's personal situation as he campaigned vociferously for gay rights while simultaneously fighting his own battle with AIDS. Here Jarman combined his innate gifts as a plantsman with a respect for polite English garden traditions, and the result was a garden which both drew from the surrounding environment and provided an elegant commentary on its desolate beauty:

I waited a lifetime to build my garden,
I built my garden with the colours of healing,
On the sepia shingle at Dungeness.
I planted a rose and then an elder,
Lavender, sage, and Crambe maritima,
Lovage, parsley and santolina,
Hore hound, fennel, mint and rue.
Here was a garden to soothe the mind,
A garden of circles and wooden henges,
Circles of stone, and sea defences.[35]

Jarman was acutely aware that the county where he had made his home was the so-called 'Garden of England'. He knew also that his garden, on its bleak promontory, was literally the 'Last of England'.[36]

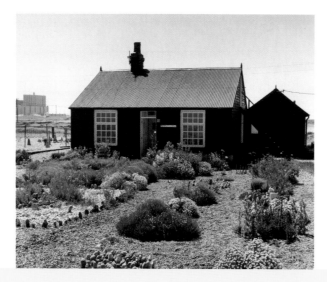

fig.9
Howard Sooley (born 1963)
View of Derek Jarman's Garden, Prospect Cottage, Dungeness c.1994
Photograph

1 John Bird, *Percy Grainger*, revised ed., Oxford 1999, p.187. 2 For an overview of the emergence of the English cottage garden in the Middle Ages, see Edward Hyams, *English Cottage Gardens*, London 1970, pp.1–11. 3 See Christopher Hussey, *The Picturesque. Studies in a Point of View*, London 1983, pp.117–18. 4 James Nasmyth, *An Autobiography*, ed. Sam Smiles, London 1883, p.60. 5 See Jeremy Burchardt, *The Allotment Movement in England, 1793–1873*, Woodbridge 2002. 6 J.C. Loudon, *An Encyclopaedia of Gardening, Comprising the Theory and Practice of Horticulture, Floriculture, Arboriculture, and Landscape-gardening*, London 1822, p.1203. 7 See Burchardt 2002, pp.31–2. 8 Ibid., p.84. The reference to 'rural Auburns' is to 'sweet Auburn', the subject of Oliver Goldsmith's celebrated poem of 1770 *The Deserted Village*. 9 Burchardt 2002, p.96. 10 Ibid., p.236. 11 Anne Helmreich, *The English Garden and National Identity: The Competing Styles of Garden Design, 1870–1914*, Cambridge 2002, p.47. See also Karen Sayer, *Country Cottages: A Cultural History*, Manchester 2000, especially pp.113–41. 12 Jan Reynolds, *Birket Foster*, London 1984, p.106. 13 Helen Allingham's obituary, *The Times*, 26 September 1926. 14 See Helmreich 2002, pp.78–9. 15 Ibid., p.86. 16 Laura Dyer, 'Mrs Allingham', *The Art Journal*, 1888, p.199. 17 See Tom Normand, 'A realist view of a Victorian childhood: re-reading James Guthrie's *A Hind's Daughter*', *Scotlands*, vol.4, no.2, 1997, pp.41–53. 18 Roger Billcliffe, *The Glasgow Boys. The Glasgow School of Painting 1875–1895*, London 1985, p.108. 19 Ibid., p.46. 20 Ibid., p.300. 21 See David Crouch and Colin Ward, *The Allotment. Its Landscape and Culture*, London 1988, pp.113, 191. 22 See Helmreich 2002, pp.156–7. 23 John Nash, *The Artist Plantsman*, London 1976, p.2 (unpaginated). 24 John Rothenstein, *Modern English Painters*, 3 vols., London 1984, vol.2, p.167. 25 See John Rothenstein, *John Nash*, London 1983, pp.97–106. 26 See Beth Chatto, 'Sir Cedric Morris, Artist-Gardener', *Hortus*, no.1, 1987, pp.14–20, and Ursula Buchan, 'Iris and Art', *The Garden*, July 1997, pp.472–5. 27 See Ben Tufnell, *Cedric Morris and Lett Haines. Teaching Art and Life*, exh. cat., Castle Museum, Norwich 2002; Gwynneth Reynolds and Diana Grace, *Benton End Remembered*, London 2002. 28 Edward Bawden to Charles Mahoney, Percy Horton and Geoffrey Rhodes, August 1930, ms. correspondence, private collection. 29 Edward Bawden to Charles Mahoney, August 1934, ms. correspondence, private collection. 30 Evelyn Dunbar to Charles Mahoney, September 1935, ms. correspondence, private collection. 31 Timothy Hyman and Patrick Wright (eds.), *Stanley Spencer*, exh. cat., Tate Britain 2001, no.107. 32 Crouch and Ward 1988, p.197, quoting from the Departmental Committee of Inquiry into Allotments of 1969, known as the 'Thorpe Report'. 33 See David Crouch, *The Art of Allotments. Culture and Cultivation*, Nottingham 2003, passim. 34 Email from Ivan Morison to Ben Tufnell, Tate, 22 October 2003. 35 Derek Jarman, *Chroma. A Book of Colour – June '93*, London 1994, p.68. 36 See Stephen Daniels, 'Britain in Bloom', *Tate* magazine, Spring 2000, p.33.

fig.10
Heather and Ivan Morison
(born 1973 and 1974)
*Colours and Sounds
in Ivan Morison's Garden,
Spring 2002* 2002
Installation, DVD and projection
on suspended two-sided screen,
dimensions variable
Danielle Arnaud Contemporary
Art, London

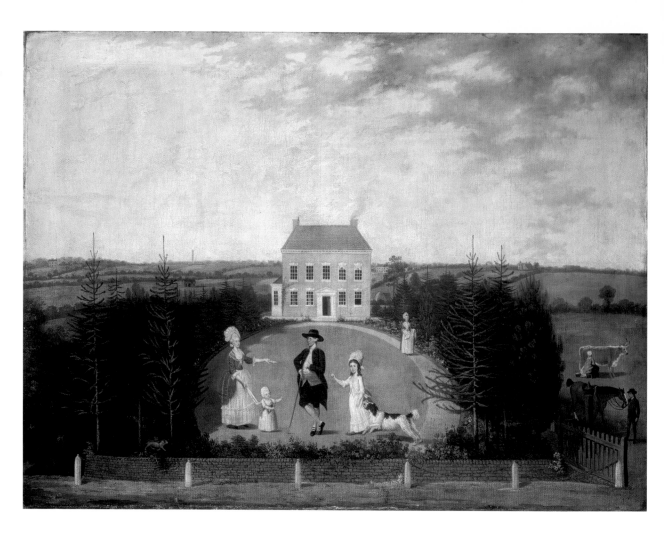

fig.11
William Williams
(active 1758–1797)
Conversation Piece before a
*House in Monument Lane c.*1780
Oil on canvas, 101.7 x 137
Birmingham Museums and Art
Gallery

Suburban Prospects
Stephen Daniels

Oh! it really is a werry pretty garden
And Chingford to the eastward could be seen;
Wiv a ladder and some glasses,
You could see to 'Ackney Marshes
If it wasn't for the 'ouses in between.[1]

From the eighteenth century the surroundings of
major towns and cities in Britain came into focus
as a suburban landscape that was becoming central
to modern development.[2] Homes and gardens
in various sizes and styles, from villas in pleasure
grounds to terraced houses fronting narrow
gardens, lined major routes, initially rivers and
turnpikes, later railways and motor-roads. Around
London a metropolitan region extended far into
the countryside, even to the coast, for those who
could afford long weekends in gentrified cottages.
The garden-like image of south-east England owed
much of its appearance to major roads and railway
lines passing through a succession of ornamental
gardens and finely cultivated fields, orchards and
hop-grounds.[3] A highly mobile land market in
the urban periphery created a shifting scene for
the occupants of individual homes and gardens,
with a varied succession of views, from apparently
untouched nature to other homes and gardens.

Suburban locations were convenient for established rural and urban interests, but also opened a space for expanding social groups, such as commercial and professional families from dissenting and evangelical circles, to live the good life and shape polite culture through the making of gardens and appreciation of nature (fig.11).[4] First published in 1785, William Cowper's influential poem *The Task* claimed the moral and patriotic virtues of gardens and gardening for a newly confident ecumenical middle class. 'Domestic happiness' was the 'only bliss|Of Paradise that has survived the fall' and paradise might be regained by cultivating the space between a city and a countryside corrupted by financial and aristocratic interests, signified on the one hand by congested streets and on the other by bleak landscape parks. While he does not undertake heavy work, the poem's dutiful husband carefully oversees garden cultivation and performs the more delicate skills of sowing, weeding and pruning. His elegant garden displays a wide variety of flowering and fruiting plants, the green-house a global range of exotics. Surrounded by finely cultivated fields, the garden offers glimpses of the places with which it is contrasted, including 'yonder heath' where uncouth citizens resort, and the city from where they come. This goodly garden offers extensive prospects, a knowledge of divine handiwork in the terrestrial and celestial world and a vantage point on the world from which it is protected:

'Tis pleasant through the loopholes of retreat
To peep at such a world; to see the stir
Of the great Babel, and not feel the crowd.
Thus sitting, and surveying thus at ease
The globe and its concerns, I seem advanced
To some secure and more than mortal height.[5]

If suburban landscape, as a material and metaphorical middle ground, helped shape a new social consensus, it was also an arena for accentuating and refining social distinctions, through the condition and appearance of gardens and the views they offered. If the wealthiest could secure the finest prospects across their pleasure grounds, focused on traditional landmarks such as cathedrals and palaces, the rest jockeyed for position in more complex surroundings, among recreation grounds, reservoirs and brick-fields, as well as other houses, confident that polite opinion saw more pleasure in enjoying prospects than in owning them.[6] Upmarket developments were carved out from former landscape parks, downmarket developments lined dusty roads. More established interests looked down on the new middle England, using the term 'suburban' derogatively to describe

a territory of mean and narrow views. In its domestic model of manliness, which included gardening along with reading improving books, taking walks and conversing with women and children, the pious suburb seemed ridiculously effeminate.[7]

Precocious residents of lower-rent suburbs (most housing was rented) were accused of various crimes against connoisseurship in their tawdry attempts to keep up appearances. This proved to be an enduring theme of caricature prints and satirical literature, whose showy suburban scenes are populated by a range of outcasts from traditionally civic and rustic society: cockneys, nabobs, Quakers, Jews, Frenchmen, mistresses.[8] An early satire, Robert Lloyd's *The Cit's Country Box* (1762), focuses on a 'choice retreat' of a London tradesman, a shrine to the popular cult of 'taste'. 'Some three or four mile out of town', close by a stage coach road, the cultured traveller is amazed to see a gaudy villa built in a mixture of Gothic and Chinese styles, replacing a former classical temple in an old yew wood, the new garden laid out according to a popular pattern book, 'with angles, curves and zig-zag lines' and sunken fence 'By whose miraculous assistance,|You gain a prospect two fields' distance.'[9]

Garden design on a suburban scale, around villas and ornamental cottages, produced a rich body of visual imagery. Humphry Repton's vision of landscape gardening as a polite art was expressed in watercolour designs and published aquatints, contrasting presently dull with prospectively delightful scenes. Repton was commissioned to improve a variety of views in the neighbourhood of cities, from the vista of London, focused on St Paul's, from Kenwood and Wanstead, done in the Claudean style of villa views of Rome, to views of cathedrals in Norwich and Hereford, factories in Leeds and shipping in Bristol, done in a variety of picturesque and panoramic formats. If Repton was seen by his country critics as figure of consumer culture, selling scenic illusions rather than substantial improve-ments, later in his career he himself complained that his clients came increasingly from commercial interests, 'worthy cockneys' made suddenly wealthy from trade and speculation, who employed him for a day merely to stake out a field or two for their new villa. The contrast with albums of views prepared for prestigious commissions, and the fact that even favoured clients failed to implement designs, increased Repton's regard for landscape gardening as an art realised more properly on paper than on the ground. Above all he commended the

refashioning of his own roadside villa and flower garden in Essex, as shown in his final publication, as an example of improving scenery and society (*fig.12*). This involved enclosing grazing land to extend the garden, shutting out a butcher's shop and passing coaches and beggars, to frame a view focused on the village inn, where Repton organised assemblies for established local families who were indifferent or hostile to one another, creating a politely convivial landscape pivoting on the vantage point of a professional man.[10]

John Claudius Loudon, Repton's self-appointed successor as the national authority on landscape gardening, repositioned the suburban garden as a progressive region of taste and citizenship. In the process he reformed Repton's vision, reducing its artistry and illusionism, abandoning aquatints as illustrations for cheaper woodcuts in more practically minded publications aimed at a wider audience (*fig.13*). An expatriate Scot living in London, Loudon looked beyond established English garden culture, including its institutions such as the Horticultural Society of London and the Royal Botanic Gardens at Kew, to re-envision the suburban garden from an international, liberal perspective. Loudon's writings assimilate lessons from Germany and the United States, especially in the educational function of gardens, and were intended to circulate 'in the temperate climates of both hemispheres'. Suburban gardens provided a range of work for all the family, from spells of digging to grafting to watering plants on summer evenings and working in winter by candlelight in the greenhouse. Such practical knowledge rendered a householder a 'man of taste' appreciating 'suburban scenery'. Publishing in partnership with his wife Jane, Loudon maintained that the ornamental side of gardening opened up a domain for women: 'we venture to assert that there is not a mantuamaker or milliner who understands her business, that might

not, in a few hours, be taught to design flower gardens with as rich a skill and taste as a professional landscape gardener'.

Loudon's *The Suburban Gardener and Villa Companion* (1838) identifies a broad suburban region beyond the congested streets on the one hand and remote farms on the other, one which took in public libraries, museums and factories as well as plots of improved agriculture and even pleasure grounds on progressive aristocratic estates. This region was characterised by a free and efficient circulation of goods, services and information, including good roads, cheap publications, piped water and sewage, which promised equal access to the civic virtues of health, knowledge, enjoyment and respect. Loudon's suburban landscape was based on a grid of four rateable values, from 'fourth rate' roadside plots of less than an acre, like his own, intensively cultivated, garden in Bayswater, to 'first rate' properties of ten acres of more, the largest, like Kenwood House, with kitchen gardens, pleasure grounds and profitable fields. In forming and managing their gardens, suburban residents would take account of the site and situation of their property, avoiding noxious features like gasworks, tanneries and market gardens (reeking of decaying vegetables), instead seeking out neighbouring suburban residences, nurseries, heathland and advanced industrial landmarks:

A railroad is a new feature in the suburbs of larger towns; and though a residence close to the line may not be agreeable to many persons, yet, at a moderate distance, we should think it would form one of the finest artificial features ... We have been much struck with the object of the carriages passing along the line of the Manchester railway, as seen from the beautiful villas.[11]

With their varied and rapidly changing landscape, suburbs offered painters a rich source of subjects, styles and narratives, and the opportunity to explore

fig.12
Humphry Repton (1752–1818)
View from My Own Cottage in Essex, with and without overlay, from *Fragments on the Theory and Practice of Landscape Gardening*, published 1816
British Library

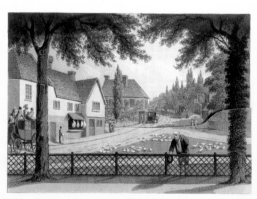

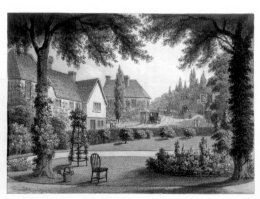

VIEW FROM MY OWN COTTAGE, IN ESSEX.

VIEW FROM MY OWN COTTAGE, IN ESSEX.

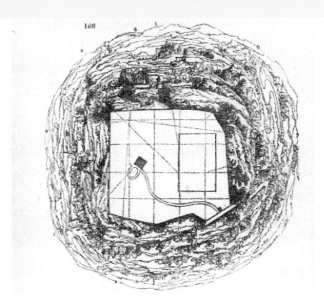

the place of gardens in a broad cultural field of vision. Old-fashioned gardens around cottages and manor houses threatened with demolition came into view as pictorial motifs as modern gardens were laid out on former farmland, parks and heathland. The framed view through a modern glass window became a standard device for picturing gardens as landscapes.

Paul Sandby's drawing of his garden from the back window of his house in St George's Row, off Bayswater Road, made around 1772 (fig.14), focuses on social distinctions in suburban prospects. It is one of a series Sandby drew of sites in this area which was then on the western edge of London, including tea gardens, taverns and the turnpike terminus. The drawing commemorates the recent purchase and improvement of the property, a display of the artist's professional and cultural advance. It shows Sandby's garden laid out in neo-classical fashion, in the image of Italian villa courtyards, with a flagged floor, busts, urns, bas-reliefs, a few pots of flowers and a flight of steps leading to a gazebo-like structure, the artist's studio, glazed with full-length panels, revealing views of St George's Fields beyond. One servant deals with laundry, while another returns from serving refreshments in the studio. Sandby's house was also a cultural meeting place, for summer evening *conversazione*, and both professional and social functions evidently override more private, family ones.

The aloof sophistication of Sandby's garden contrasts with that next door. Here is a horticultural scene in which a whole family, husband, wife and daughters, set about their garden, energetically hoeing and watering, an image of domestic virtue looked down upon from Sandby's side, even by the cat prowling his fence.[12]

John Linnell's drawings of suburban gardens are part of a series showing scenes at the literal cutting edge of modern life, shaped by axe, spade and shovel, and including gravel pits, brickfields and building sites. They depict such scenes in intensely observed detail, expressing Linnell's dissenting views of the natural world and its transformation. Linnell documented in one view (fig.15) the making of the house and garden of his fellow Baptist the architect Charles Heathcote Tatham, a spade leaning against the newly whitewashed wall, next to the sapling to be planted when work resumes; the view looks across into Marylebone Fields, on the verge of being transformed from rough pasture and old plantations into the villa landscape of Regent's Park. Linnell was himself an enthusiastic, self-sufficient gardener, raising fowl and bees, growing fruit trees, flowering plants and a fine lawn at his house in Bayswater (next door to Loudon, whose portrait he painted) and instructing his children in digging and sowing, grinding corn and brewing, as well as studying and drawing the natural world. When Linnell was considering joining the Society of Friends in 1830, and concerned about their views on painting, the Quaker poet Bernard Bartram was delighted to discover he was 'a practitioner in my favourite department of thy art — landscape painting ... I know no reasons why it should be more unquakerly to draw or paint a beautiful landscape than to build a fine house or lay out and embellish its grounds'.[13]

As the built-up area of streets and houses advanced, so artists moved further into the countryside, aided by suburban railway travel, discovering the gates of Eden just beyond the station, projecting paradise on impoverished rural areas. Landscape paintings of a variety of subjects seemed highly horticultural. Thus John Ruskin criticised the planted setting of Millais's *Ophelia* 1851–2, 'that rascally wirefenced garden-rolled-nursery-maid's paradise' when he should

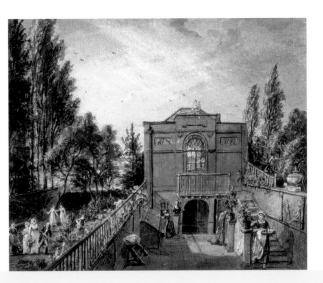

have painted 'pure nature', not just nature found in remote regions but in places accessible to Ruskin's home in the wealthy suburb of Herne Hill, the woods and heaths of Surrey.[14] By the 1840s, when he was making a better living with more pastoral subjects, Linnell found Bayswater increasingly built up, and moved to the stockbroker belt of Surrey, where he purchased a hilltop property near the railway station of Redhill Junction, with extensive views of the countryside, and, as a local farmer remarked, enjoyed more revenue from painting the landscape than he could from cultivating it.[15]

Ford Madox Brown's *An English Autumn Afternoon* 1852–5 (*fig.16*) is one of a series of views he painted of the environs of north London. Looking out from an upper-storey window of the artist's lodgings in the high street, the picture shows a panorama and is a study of leisure which complements Brown's other Hampstead street scene, *Work* 1852–65, depicting the laying of a new sewer. With an oval format which recalls global projections, the view is structured according to Loudon's grid of suburban scenery. Immediately below is a richly planted series of 'fourth rate' gardens, including such useful spaces as a poultry yard and a small orchard where fruit picking is in progress. In the distance, to the left, is the classic 'first rate' Kenwood House, a key scenic feature for lower-rated (in terms of Loudon's four rates) landscapes in the area.

At the time of the painting the owner of the land in the middle distance, the sixty-acre East Heath Park, proposed to crop it with houses instead of hay, issuing a prospectus showing it developed with villas and 'third rate' two-acre gardens either side of an avenue marked by the course of the sand track. Local residents, including the artistic community and Kenwood's owner, Lord Mansfield, supported an alternative scheme of a public park for the recreation of all north Londoners, but of course conveniently located for themselves. The site the couple occupy in the foreground, complete with steps, handrail and bench, appears to be transposed from the parkland in the distance, as if they gaze upon a vantage point which may be denied them, and with it the full prospect of London signified in the painting by the haze to the right. The figures recall the couple in Tennyson's poem on a suburban garden, sitting 'upon a garden mound ... cours[ing] about|The subject most at heart ... Like doves about a dovecote'. As such, they may allude to the artist's secret marriage to a servant girl from Highgate, signified by its church spire on the horizon. The artist later rejected this narrative, calling the couple 'hardly lovers, more boy and girl, neighbours and friends', 'peculiarly English', for 'in no other country would they be so allowed out together, save in America'. Indeed the picture has parallels with contemporary panoramic American painting, showing, for better or worse, nature being progressively civilised.[16]

Nineteenth-century novels explored the shifting condition and style of suburban houses and gardens in narratives of progress and decline. Decayed gardens in future slums and pioneering plots in peripheral developments contrast with enclaves of greenery in exclusive older suburbs and old-fashioned gardens just beyond the frontier of bricks and mortar. Such was the pace of residential expansion, the promotional rhetoric of speculative builders and the sometimes precarious position of suburban residents, that disjunctions of idyll and reality conventionally frame descriptions of home and garden. Dickens's *Dombey and Son* (1848) describes the doomed defence of Staggs's Gardens, Camden Town, whose residents lose the plot in every sense as the place is to be cleared to make way for the railway:

It was a little row of houses, with little squalid patches of ground before them, fenced off with old doors, barrel staves, scraps of tarpaulin, and dead bushes; with bottomless tin kettles and exhausted iron fenders thrust into the gaps. Here the Staggs's Gardeners trained scarlet beans, kept fowls and rabbits, erected rotten summer-houses (one was an old boat), dried clothes, and smoked pipes. Some were of the opinion that Staggs's Gardens derived its name from a deceased capitalist, one Mr. Staggs, who had built it for his delectation. Others, who had a natural taste for the country, held that it dated from those rural times when the antlered herd, under the familiar denomination of Staggses, had resorted to its shady precincts. Be this as it may, Staggs's Gardens was regarded by its population as a sacred grove not to be withered by railroads.[17]

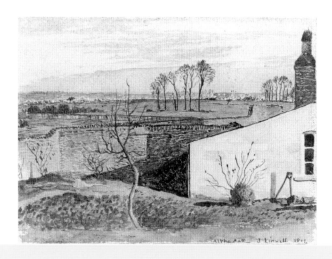

fig.15
John Linnell (1792–1882)
Alpha Cottage 1814
Watercolour on paper,
10.7 x 14.6
Fitzwilliam Museum, Cambridge

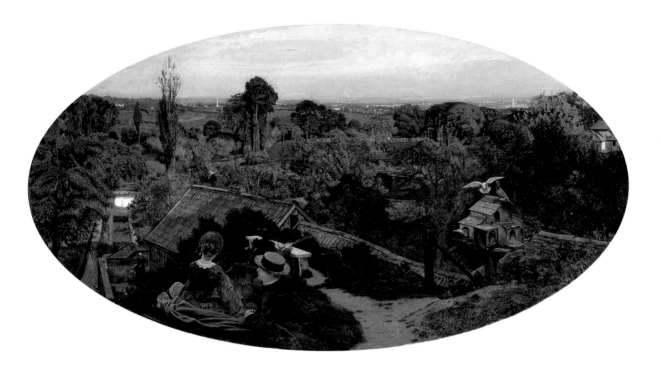

fig.16
Ford Madox Brown (1821–1893)
An English Autumn Afternoon
1852–5
Oil on canvas, 71.2 x 134.8
Birmingham Museums
and Art Gallery

Just outside what was then the western edge of London is North Villa, home of the eponymous hero of Wilkie Collins's *Basil* (1852). His bedroom window 'looked at a strip of garden – London garden – a close-shut dungeon for nature, where stunted trees and drooping flowers seemed visibly pining for the free air and sunlight of the country, in their sooty atmosphere, amid their prison of high walls'.[18]

By the 1870s the term 'suburbia' designated an extensive region, whose fine social and moral distinctions were charted in a range of publications, including the periodical press.[19] Satirical writing and illustration focused on two new spaces of status-seeking opened up by the railway: the 'aesthetic' suburb, represented by the artistic colony of Bedford Park to the west of London, and what might be termed the anti-aesthetic suburb, represented by Holloway in north London, home to the figure of the office clerk, *Punch*'s Mr Pooter.

The new District line station at Turnham Green prompted the development of Bedford Park by an artistically inclined property developer, close to the high-cultural Thameside region around Chiswick. Built on land formerly owned by the horticulturalist John Lindley, it was developed as a highly staged landscape with 'Queen Anne' Arts and Crafts-style houses and fashionably old-world gardens. With an art school and a club for theatrical performances, as well as a conspicuous colony of artists and writers,

Bedford Park became a byword for cultural posing. The painter Edward Abbey said the place made him feel as though he were walking through a watercolour, and the poet W.B. Yeats, son of an unsuccessful artist, who lived there as a young man and planted aesthetically correct sunflowers, recalled how 'we went to live in a house we had seen in pictures, and even met people dressed like people in story books'.[20] *Punch* published the spoof diary of the culturally challenged, if safely domesticated, Mr Pooter, his very address, The Laurels, Brickfield Terrace, designating his uneasy location on the slope between the middle and lower classes.[21] The Laurels has 'a nice little garden which runs down to the railway … beyond the cracking of the garden wall at the bottom, we have suffered no inconvenience'. Mr Pooter sows his gardens with radishes and mustard-and-cress after a hard day at work before retiring early to bed. Upon purchasing a second-hand book, *Gardening*, he spends a Saturday afternoon adding some borders of 'half-hardy annuals' and after hearing of the wonders of 'the new Pinkford's enamel paint' buys two tins of red to colour the flower-pots.[22]

The Pooter figure was transposed to a more promising-looking landscape in promotional suburban imagery. The 1908 underground railway poster for Golders Green (*fig.17*) offered 'a place of delightful prospects', for it was not only the station for Hampstead Garden Suburb, planned

as a scenic and socially inclusive Arts and Crafts-style development, but also for more speculative commercial housing in a vaguely vernacular style, marketed for commuters. The poster shows commuters walking from the train in the distance along what appears to be one of the Garden Suburb's carefully planned and planted pedestrian routes. The householder has returned to his picture-book wife and child, removed his jacket and rolled up his sleeves to water his brilliant sunflowers. The inset text is a passage from Cowper's *The Task*, on the pleasures of peeping at the city 'through the loopholes of retreat'. C.B. Purdom's *The Garden City* (1913) made the Pooter figure the pioneer hero of the new development at Letchworth:

To come home from the train at night or from one's office or workshop in the town ... to enter one's quiet garden ... not many men are so happy ... though a garden may hold in it what belongs to the past, it is made for the future ... a garden makes you think of the future; for you cannot be in it without wondering how this and that will turn out, and what wonders time will perform.[23]

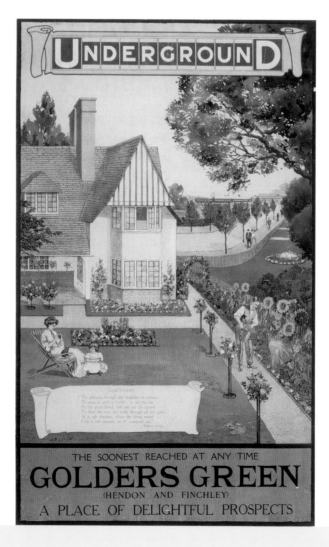

After the First World War the shortage of 'homes fit for heroes', equipped with a private garden as well as toilet and living room, prompted a house and road building boom in which the garden suburb became the dominant form of residential development. Four million new houses with gardens were built before the Second World War, a quarter publicly funded. The road system expanded rapidly around cities, more for cheap rapid public transport, in the form of motor buses and electric trams, than for private cars. Planning and design guidelines for local authorities set out spacious layouts, with broad avenues and crescents, front and back gardens, playgrounds and allotments, to provide light and air and create pleasing vistas to and from houses. The retention of some old trees and patches of common, the planting of grass verges with roadside trees and the fashion for low-walled front gardens, with shrubs and flowers, enhanced scenic character. Higher-fenced back gardens were for more private pursuits, hanging out washing, children playing and growing vegetables, but from any bedroom window there came into view a more public, patchwork landscape across which the outdoor pursuits of others might be surveyed.

Tenancy regulations for council residents demanded minimum standards of garden maintenance, which included preserving existing trees and cutting back hedges. Time as well as space was provided for gardening, along with other outdoor hobbies, by a reduction in working hours and the introduction of daylight-saving time. A popular culture of gardening flourished, locally and nationally, through clubs, classes, competitions, magazines, exhibitions and radio programmes and some neighbourly sharing of tools, seeds and cuttings. Inter-war suburbia was promoted as an idyllic domestic scene in commercial advertising and municipal publicity. Suburban landscapes took on an appealing image in popular fiction from Agatha Christie's modern villadom to the magical metroland of Rupert Bear.[24]

The expansion of suburbia, especially in 'ribbon development' along arterial roads, reactivated the tradition of anti-suburban invective.[25] Conservative literary opinion contrasted new developments with the maturity of older, leafier suburbs, an arcadian landscape filtered through memories of childhood and a university world of college gardens and fellow students' country houses. Progressive expertise aligned with the modern movement in architecture and planning, redrawing distinctions between city and country, saw in suburbia an invasive

rash of muddle and mess, a view reinforced by the vogue for aerial photography, which showed new developments advancing through an orderly pattern of fields and parkland. Slough, developed around new light industries on the main road from London to Bath, became the classic ground of suburban indeterminacy. In 1937 John Betjeman infamously called on 'friendly bombs' to fall on Slough.[26] The following year cartoonist Osbert Lancaster targeted residences in 'the infernal amalgam' of 'By-Pass Variegated', which would 'inevitably become the slums of the future ... an eventuality that does much to reconcile one to the prospect of aerial bombardment' (fig.19).[27] At the outbreak of war in 1939 an officially published 'graphic narrative' on 'Air Raid Precautions' showed the very spaciousness of recent suburban development reducing bomb damage and gardens offering spaces to dig for shelter as 'The Jones family sees it through'.[28]

The Castles on the Ground (1946), written by J.M. Richards (editor of the modernist Architectural Review) during a year's absence from England on active service in the eastern Mediterranean, and illustrated by John Piper, reappraised suburbia patriotically in terms of the 'English picturesque tradition' (fig.18). The book was cast in the genre of exploratory surveys in search of England, discovering a country unknown to snobbish experts on English culture and landscape, and attempting to describe from within as well as without. The 'suburban scene' included a wide variety of homes and gardens, from ornate Victorian villas in densely planted grounds to recently built semi-detached residences with modest lawns, encompassing prosperous places such as Cheam and Rickmansworth and cheaper developments near 'some arterial road in Osterley or the outskirts of Birmingham', ranging from

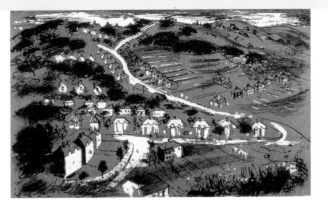

fig.18
John Piper (1903–1992)
Lithograph from The Castles
on the Ground: The Anatomy
of Suburbia by J.M. Richards,
published 1946

'Becontree to Wythenshawe, from Port Sunlight to Angmering-on-Sea', a scene unfolding in 'a panoramic whole'.

The structure to this scenery was the 'winding road system'. Indeed, in summer, the peppery smell of asphalt was as distinctive a suburban scent as the sweet smell of mown grass, and part of 'the essence of the modern suburban scene' was 'the quiet between the passing car lights'. Along with the grid of electricity and telephone wires, water and sewage pipes, the road system linked individual houses and their occupants' various pursuits with team-spirited places, clubs, libraries and playing fields, as well as commercial sites, shopping parades and Odeons, as it recycled survivals from the past: the gatepost of an estate lodge in a recreation ground, an Arts and Crafts villa converted to council offices. Suburbs were increasingly home to people who made their living 'from distributive trade and transport'.

If this seemed part of the Americanisation of English life, Richards pointed out that many old market and Georgian towns seen as exemplars of civic culture were in fact built as landscapes for trade and transport, spacious suburbs beyond congested town centres. If there was an element of fantasy to The Castles on the Ground, it was, as the title implied, a functional fantasy, mobilising the dreams of all suburban residents: 'as the amateur gardener admires the picture on the seedpacket, aware that the luxuriant growth depicted is a little larger than life, yet half persuaded that something like it may indeed come true'. Despite speculative builders and bureaucratic planners, 'suburban style' was founded, like English watercolour, on the 'unpretending enthusiasm of the talented amateur', working in the garden shed, growing purple sprouting broccoli and winter lettuce.

Scorned by Richards's contemporaries 'as either an irrelevant eccentricity or a betrayal of the forward-looking ideals of the Modern Movement',

fig.19
Osbert Lancaster (1908–1986)
By-Pass Variegated
from Pillar to Post: The Pocket
Lamp of Architecture,
published 1938
Tate

the book was reissued in 1973, with a new introduction which claimed that it was in fact ahead of its time in championing the virtues of 'public participation'. A broader cultural movement reappraising suburbia as a complex and creative landscape gathered momentum from this period, perhaps in retrospect, seeing more clearly a century in which civil society was dominated by suburban life. Suburban gardens are now valued as sites of natural and social history, while memoirs, novels and paintings look back on suburbs as landscapes of childhood less in anger than affection and British pop music is esteemed as an art form for its suburban sensibility.[29]

Restored to their appearance in the 1950s, the teenage homes and gardens of John Lennon and Paul McCartney in the suburbs of south Liverpool are among the most notable recent acquisitions of the National Trust. Lennon's home, Mendips, one of a spacious inter-war row of semis built in the grounds of an earlier villa, faces a wide arterial avenue; 'a nice semi-detached place with a small garden and doctors and lawyers and that ilk living around', Lennon recalled in 1980. Across the municipal golf course, a former landscape park,

is McCartney's home, 20 Forthlin Road, a newly built 1950s terrace council house, in front, facing the street, 'a lavender hedge bordering a pocket-handkerchief lawn and a small mountain ash growing outside the glass-panelled door', the back looking on to the grounds of a police college. The wider reaches of this historically layered and socially mixed suburban world were hymned by the Beatles as a surreal childhood pastoral, as songs on two sides of a 1967 single, 'Strawberry Fields Forever' and 'Penny Lane'. Lennon's secret garden was not his own, a neat plot of lawn, flowers and fruiting trees, where he was posed in family photos, but the overgrown grounds of Strawberry Fields, a neighbouring Victorian former villa used as an orphanage. As the boy dropped over its walls, so the music of 'Strawberry Fields' takes you down, as in *Alice in Wonderland*, into a dream world where 'nothing is real'. In contrast 'Penny Lane' takes a brighter, more public survey of the local roundabout and shopping parade, a kaleidoscopic scene recalling the view 'through the frame of the bus window from the god like height of the upper deck'. As a place of memory, Penny Lane 'is in my ears and in my eyes|There beneath the blue suburban skies'.[30]

1 Chorus from *The Cockney's Garden*; lyrics Edgar Bateman, music George Le Brunn, first performed 1894. **2** Elizabeth McKellar, 'Peripheral visions: alternative aspects and rural presences in mid-eighteenth-century London', *Art History*, vol.22, no.4, November 1999, pp.495–513. **3** Peter Brandon, 'The diffusion of designed landscapes in south-east England', in H.S.A. Fox and R.A. Butlin (eds.), *Change in the Countryside*, London 1973, pp.165–87. **4** Leonore Davidoff and Catherine Hall, *Family Fortunes: Men and Women of the English Middle Class 1780–1850*, London 1987, pp.149–92, 357–96. **5** William Cowper, *The Task*, ed. Henry Thomas Griffith, Oxford 1936, pp.48–145. **6** Todd Longstaffe-Gowan, *The London Town Garden 1740–1840*, New Haven and London 2001. **7** Davidoff and Hall 1987, pp.162–7. **8** Diana Donald, '"Mr Deputy Dumpling and family": satirical images of the city merchant in eighteenth-century England', *Burlington Magazine*, vol.131, 1989, pp.755–63; Rebecca Preston, 'Home landscapes: amateur landscapes and popular culture in the making of personal, national and imperial identities 1815–1914', unpublished PhD dissertation, 1999, pp.132–6. **9** Quoted in John Dixon Hunt (ed.), *The Oxford Book of Garden Verse*, Oxford 1994, p.138. **10** Stephen Daniels, *Humphry Repton: Landscape Gardening and the Geography of Georgian England*, New Haven and London 1999. **11** J.C. Loudon, *The Suburban Gardener and Villa Companion*, London 1838, pp.1–11, 31, 327, 411, 455. **12** Longstaffe-Gowan 2001, pp.53–8. **13** A.T. Story, *The Life of John Linnell*, London 1892. **14** Jason M. Rosenfeld, 'New Languages of Nature in Victorian England: the Pre-Raphaelite Landscape, Natural History and Modern Architecture in the 1850s', unpublished PhD dissertation, New York University 1999, pp.97–9, 131–7, 145–55. **15** *John Linnell: A Centennial Exhibition*, ed. Katharine Crouan, exh. cat., Fitzwilliam Museum, Cambridge 1982. **16** Julius Bryant, *Finest Prospects: Three Historic Houses: A Study in London Topography*, exh. cat., The Iveagh Bequest, Kenwood, London 1986, pp.129–31; Alastair Ian Wright, 'Suburban prospects: vision and possession in Ford Madox Brown's *An English Autumn Afternoon*', in Margaretta Frederick Watson (ed.), *Collecting the Pre-Raphaelites: the Anglo-American Enchantment*, London 1997, pp.185–97; Alfred Lord Tennyson, *Selected Poems*, ed. Aidan Day, London 1991, p.85. **17** Charles Dickens, *Dombey and Son*, ed. G.K. Chesterton, London 1907, pp.60–1. **18** Quoted in Rosenfeld 1999, p.117. **19** Lynne Hapgood, '"The New Suburbanites" and contested class identities in the London suburbs, 1880–1900' and Gail Cunningham, 'The riddle of suburbia: suburban fictions at the *fin de siècle*', in Roger Webster (ed.), *Expanding Suburbia: Reviewing Suburban Narratives*, New York 2000, pp.31–50, 51–70. **20** Walter L. Creese, 'Imagination in the suburb', in U.C. Knoepflmacher and G.B. Tennyson (eds.), *Nature and Victorian Imagination*, Berkeley 1977, pp.49–67; Mark Girouard, *Sweetness and Light: the 'Queen Anne' Movement 1860–1900*, Oxford 1977; quotations from Margaret Jones Bolsterli, *The Early Community of Bedford Park*, London 1977, pp.66, 128. **21** Hapgood 2000, pp.38–9. **22** George Grossmith and Weedon Grossmith, *The Diary of a Nobody* [1892], London 1940, pp.27, 38, 57. **23** C.B. Purdom, *The Garden City: A Study in the Development of a Modern Town*, London 1913, pp.106–7. **24** Alan A. Jackson, *Semi-Detached London: Suburban Development, Life and Transport, 1900–1939*, London 1973; Paul Oliver, Ian David and Ian Bentley, *Dunroamin: The Suburban Semi and its Enemies*, London 1994; J.W.R. Whitehand and C.M.H. Carr, *Twentieth Century Suburbs: A Morphological Approach*, London 2001; Alison Light, *Forever England: Femininity, Literature and Conservatism Between the Wars*, London 1991. **25** Whitehand and Carr 2001, pp.10–19. **26** David Matless, *Landscape and Englishness*, London 1998, pp.34–6. **27** Osbert Lancaster, *Pillar to Post: The Pocket Lamp of Architecture*, London 1938. **28** Oliver et al. 1994, pp.45–6. **29** Roger Silverstone (ed.), *Visions of Suburbia*, London and New York 1997; Michael Bracewell, *England is Mine: Pop Life in Albion from Wilde to Goldie*, London and New York 1997; David Gilbert and Rebecca Preston, '"Stop being so English": suburban modernity and national identity in the twentieth century', in David Gilbert, David Matless and Brian Short (eds.), *Geographies of British Modernity*, Oxford 2003, pp.187–203. **30** National Trust, *Mendips*, London 2002; Barry Miles, *Paul McCartney: Many Years from Now*, London 1998, pp.15–17, 306–8; Ian MacDonald, *Revolution in the Head: the Beatles' Records and the Sixties*, London 1994, pp.170–9.

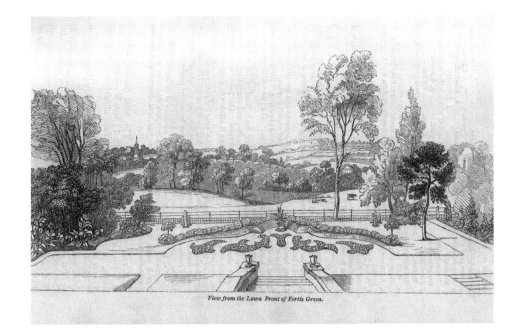

View from the Lawn Front of Fortis Green.

fig. 20
John Claudius Loudon
(1783–1843)
*View from the Lawn Front
of Fortis Green* 1840
Woodcut of the garden of
W.A. Nesfield's villa from
Gardener's Magazine,
published February 1840
Royal Horticultural Society,
Lindley Library

On Garden Colour
Nicholas Alfrey

*Surely one of the objects of a good garden is that it shall be
pictorially beautiful — that it shall be a series
of enjoyable pictures painted with the living flowers* [1]

The idea that the principles of gardening should
be informed by those of painting was being strongly
advocated by Gertrude Jekyll and her mentor,
William Robinson, well before the end of the
nineteenth century. This view presupposed a series
of affinities between the two practices: both required
skills of composition and the proper management
of foregrounds in relation to backgrounds and
distances, both had their massing and shading, their
concern for form and proportion, and, above all,
both required an understanding of colour as their
most significant resource. The argument for pictorial
values in gardening was advanced to counter an
earlier belief that garden design should be more
closely affiliated to architecture, and that colour
in the garden should follow the principles of
architectural decoration. There was clearly no
equivalent in contemporary painting for the
formality, geometry and polychromatics of the high-
Victorian garden, but it was nevertheless a former
painter, W.A. Nesfield, who had emerged as the
leading exponent of the formal style and who
referred to his practice as 'the art of painting with
nature's materials'.[2]

How deeply does the analogy between painting and
gardening run, or was art invoked in the gardening
literature only as a rhetorical strategy, intended
to secure gardening's claims to a higher standing?
The case of the artist-turned-gardener is an obvious
place to start, though such careers were hardly
typical. The idea of conceding precedence to the
artist was widely resisted in certain quarters,
particularly among the emerging professions of
landscape architect and garden designer, and it
cannot be automatically assumed that a painter's
practice will provide the key to his or her enterprise
as a gardener.

The subjects of this essay, William Andrews Nesfield
(1794–1881), Gertrude Jekyll (1843–1932) and
Alfred Parsons (1847–1920), all moved from painting
to garden-making, but at least in the first two cases,
the discontinuities are as striking as the progression.
Nesfield and Jekyll made colour a central aspect of
their work, even though their attitudes towards it
differed radically. Both made reference to painting
as a model, though there is nothing painterly about
the gardens Nesfield created, while Jekyll's colourism

fig. 21
William Andrews Nesfield
(1794–1881)
*Design for Circular Compartment
for the Royal Horticultural
Society's Garden at
South Kensington* 1862
Chromolithograph published as
supplement to *The Gardener's
Chronicle & Agricultural Gazette*,
September 1862
Royal Horticultural Society,
Lindley Library

was arguably more advanced than that of any British painter of her day. For Parsons, gardens were a fit subject for painting, and the gardens he made may well have resembled his pictures. There is a more straightforward exchange between the two fields here, but Parsons's example was lent resonance through the writing of Henry James, who saw in it the very essence of England's garden art.

Polychromatics

In his career as a watercolour painter, Nesfield never came near to achieving the kind of influence he would command later as a designer of gardens. After an initial career in the army, he was elected to the Old Watercolour Society in 1823 and exhibited there every year for almost thirty years.[3] In the first volume of *Modern Painters*, Ruskin singled him out as an exemplary painter of falling water, and praised his torrents as 'unequalled in colour, except by Turner'.[4] But it was in the field of gardening that Nesfield achieved such prominence that his style came to be identified with the period as a whole and he could be referred to as 'the master-spirit of the age'.[5]

It is difficult at first to see any continuity of vision in his move from one career to the other. His pictures were typically of wild or picturesque scenery, the conventions similar to those followed by Copley Fielding or a dozen others. As a garden designer, however, he deployed a bolder, more emphatic palette. He became best known for his parterres and coloured walks, making use of blue slate, white and yellow Derbyshire spar, adamantine clinker, pounded brick, ground glass and shells in his elaborate geometrical compositions. His artistic signature could hardly have changed more radically.

Nesfield's change of direction came about through opportunity and family connections. His cousin, and after 1826 his brother-in-law, was the architect Anthony Salvin, whose rapidly expanding practice created the need for a partner to handle the garden design aspect of his commissions. Nesfield's own marriage and family commitments after 1833 made him more disposed to take up the dependable source of income offered to him through Salvin. By 1844 he admitted that 'painting is now almost a dead letter', so hard pressed was he with land and garden engagements, and he ceased exhibiting altogether after 1851.[6]

Nesfield was first noted in his new profession when the garden he designed for his own villa at Fortis Green (fig.20), then just north of London, was published by J.C. Loudon in 1840.[7] Here he laid out his first parterre, shown in both plan and outline view in illustrations to Loudon's article. Viewed from the lawn, the shaped beds make up the foreground to a vista that extends across the Earl of Mansfield's grounds to Highgate church in the middle distance. The effect is of a picturesque landscape framed by an ornamental border, or fragment of a border, a stylised margin to a wider prospect. This garden was essentially suburban in character; Nesfield's subsequent projects would amplify this basic idea for aristocratic clients, extending formal parterres deeper into the space beyond the house, and setting colour and order in the foreground against mysterious, indefinite distances. He was as much concerned with shaping the larger landscape as with the parterre, and it is this aspect of his work that continued to draw on his sensibilities as a landscape painter. However, his most prestigious, accessible and widely discussed project was for an urban context and thus necessarily enclosed. This was the new garden for the Royal Horticultural Society in South Kensington (fig.21), opened by Prince Albert in 1861. Here Nesfield's style was at its most concentrated and emphatic, with colonnades, coloured walks and floral beds laid out in the form of scrolls, chains and national emblems. Much admired at first, it was, by the 1870s, widely criticised as over-designed and inadequate for the display of horticulture.[8]

Nesfield justified his use of a variety of tinted gravels and other materials on the grounds that his gardens would retain their colourful aspect throughout the year and thus defy the English winter. He was critical of the 'bald, unmeaning' look even formal gardens were apt to have out of season. Clarity of form was critical: edges should preferably be of box, to create a clear distinction between the coloured compartments. George Eyles, the gardener responsible for realising the South Kensington parterres, described the preparatory stages: 'the ground should now present a surface as flat as a drawing board, and you may proceed to trace out upon it the figure of the embroidery'.[9] Nesfield derived his formal sources from 'olden times', disparaging the 'vile manner' of the past hundred years, and in correspondence with clients frequently invoked 'the old masters' as his inspiration. By this he meant the old masters of gardening, though he rarely named them. He believed these masters always

respected the tenets of a higher art, namely painting, and once claimed that the design of a parterre was formerly regarded 'as conformable to the rules of Art as the composition of a Picture on a canvas'.[10]

Nesfield insisted that it was his experience as a painter that gave him the advantage as a designer. The 'garden artist' was a very different thing from the 'executive gardener', and artistic vision is what set him above the nurseryman and engineer, though their skills needed to be understood and utilised. Early in his garden career, he wrote to the Duke of Newcastle with reference to the defective design of a cascade at Clumber Park, Nottinghamshire: 'Your Grace's remark that "there are few who have sufficient of the artist in them to execute a work of this kind" is perfectly correct. As a painter, I have studied from nature for the past 18 years and have drawn the character of torrents and cascades, perhaps with as much assiduity as any Artist in England.'[11] Nesfield had painted Niagara Falls in his early years as an artist, and several decades later would go on to create the extraordinary fantasias of falling waters for Lord Ward at Witley Court, Worcestershire (that 'monster work' which, when

restored, may yet ensure the revival of his reputation). There is a literal connection here between his work as artist and garden maker, but in general his appeal to the authority of painting was intended to operate on an altogether more elevated plane. Certainly the geometries of his own art are strikingly out of step with the naturalistic conventions that were so prevalent in the painting of his time.

'The rage for making every thing assume a supposed appearance of nature was almost universal in England until lately,' observed J. Gardner Wilkinson in his book *On Colour* (1858).[12] He was primarily concerned with architectural decoration, but the last section was devoted to 'laying out dressed or geometrical gardens' (*fig.22*). His principles are broadly in accord with those of Nesfield, namely that there should be an absolute distinction between art and nature, and that the beauty of geometrical form in a garden is preferable to transient or seasonal beauty. Wilkinson did provide tables of suitable plants for the gardener, but this was so that a succession of flowers of the right colour could be identified to ensure that the design, fixed in advance, could be continued through the year. In this version of gardening, colour is predetermined and everything is made subservient to the designer's vision. A writer in the *Journal of Horticulture* in March 1863 thought that Wilkinson's was 'the last and best book' on the subject of colour available to the gardener, and concluded that 'we may soon expect to see the whimsical combinations and the indiscriminate and incongruous mixtures of colours, as at present very generally adopted in flower gardens, superseded by arrangements more in accordance to the true principles of taste'.[13]

Gardening as a Fine Art
Inevitably there was a reaction against the ideal of the formal garden as exemplified by Nesfield, and against decorative flower gardening in general. William Robinson was the most prominent critic of the formal style and his *The Wild Garden* (1870) was influential in promoting an alternative ideal. His protégée Gertrude Jekyll referred to the 1860s as a time when 'the general taste in horticulture was in deepest degradation' and was especially disparaging about the kind of gardening 'in which the spaces of the design are filled in with pounded brick, slate, shells or some colouring substance other than flowers'.[14]

In a new chapter added to the fourth edition of his *The English Flower Garden* in 1895, 'Art in Relation to Flower Gardening and Garden Design', Robinson declared that 'unhappily our gardeners have suffered for years at the hands of the decorative artist' and that, as a consequence, horticultural values had been diminished. Rather than look to the decorative arts, he wanted gardeners to take their lead from painters and to learn how to compose pictorially. In the same year he noted in his *Tree and Garden Book*, a record of horticultural (and some cultural) activities at his own house in Sussex, Gravetye Manor, that 'there is no reason why the garden, which in our country is so often the foreground to a beautiful landscape, should not itself be a picture always'.[15] But Robinson left open the question of what kinds of composition a gardener might seek to emulate deliberately: Crome, Corot and Turner were the masters he specified by name, but for very general reasons, and it is not self-evident from this list that he even thought of painting as a source of ideas for garden colour.

Jekyll, though, had direct experience of painting and had begun her career as a painter. References to pictorial effect are frequent in her writings, and her thinking about colour is developed in a sustained way. She first articulated her ideas on the subject in her contribution to the first edition of Robinson's *The English Flower Garden* (1883), and her most extended account came in her book *Colour in the Flower Garden* (1908), introduced with characteristic modesty: 'I may perhaps have taken more trouble in working out certain problems ... especially in ways of colour-combinations, than amateurs in general.'[16] Not surprisingly, a number of accounts of Jekyll's career have suggested that her eventual success as a gardener was due in part to her early training as a painter.

The painter George Leslie concluded his often-quoted opinion of the young Jekyll's accomplishments by saying that 'her artistic taste is very great, and if it

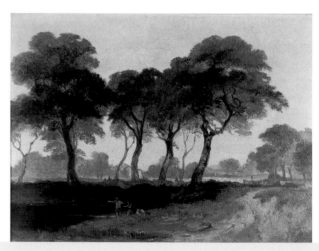

fig.23
Gertrude Jekyll (1843–1932)
*Copy of Clapham Common by J.M.W. Turner c.*1870
Oil on canvas, 32 x 43
Collection of Sir Andrew Duff Gordon

had not been for the extreme near-sightedness of her vision, I have little doubt that painting would have predominated over all her other talents'.[17] Jekyll's own account echoes this: 'when I was young I was hoping to be a painter, but, to my lifelong regret, I was obliged to abandon all hope of this, after a certain amount of art school work, on account of extreme and always progressive myopia'.[18] The pictures she exhibited, however, hardly support the idea of a great painter *manquée*. There were nine in total, the first shown at the Royal Academy in 1865 and the others at the Society of Female Artists in 1867, 1868 and 1870. All are of animal subjects, and most seem to have been in a light and humorous vein (the only one to survive, *Thomas, Portrait of a Favourite Cat in the Character of Puss in Boots*, is in the collection of Godalming Museum). A number of more informal watercolour sketches have come to light, including several dating from her visit to Algeria in the winter of 1873–4; these are strongly influenced by Hercules Brabazon Brabazon, an artist whose example meant a great deal to her, though not until after she had ceased to exhibit her own pictures.[19]

Throughout the second half of the 1860s and into the early 1870s Jekyll made a regular practice of copying older masters, particularly Turner (see cat.76), and a direct connection has sometimes been made between these copies and the planting schemes she would later devise.[20] The almost exact-scale copy (*fig.23*) of Turner's *View on Clapham Common c.*1800–5, however, suggests that her interest in the artist was not necessarily focused on his handling of colour, and her choice of this sober-toned early work seems to anticipate her own later photographic images of heath, trees and woodland rather than her experiments in chromatic progression.

It is in the field of colour theory that the influence of her early training at the Schools of Art in South Kensington can be seen most clearly, and the ideas of Chevreul in particular left a lasting impression. Some of the writers she is presumed to have studied, such as Owen Jones, J. Gardner Wilkinson and George Field, had their main influence in the fields of architecture and the decorative arts, in other words precisely the areas she would come to reject, but the attempt to formulate principles to guide the application of colour continued to interest her.[21] Admittedly, she would later sound a sceptical note about the relevance of theory in remarks added to the fourth edition of *The English Flower Garden*: 'to consider the "laws" of colour laid out by writers on decoration is a waste of time'.[22] However, there

are frequent references to the natural laws of colour in her writing, but her approach was also distinguished by her pragmatic acknowledgement of the variables involved in setting out a garden. Brent Elliott has pointed out that the kind of colour theory she was reading as an art student was also being widely discussed in the gardening literature of the day, though it underpinned a very different system of gardening from the one she would advocate.[23] The practical applications of Chevreul's theories in particular had been debated for years, going back even earlier than the publication in English in 1854 of *The Principles of Harmony and Contrast of Colours and their Application to the Arts*.[24] How far could science improve the standards of gardening? The principle that complementary colours should form the basis of a planting scheme had been tried, resisted and discredited, a crucial issue being the place of foliage or ground colour and the extent to which this interfered with the working out of an abstract prescription. The advance of scientific knowledge in the field of the transmission and reception of colour would soon challenge earlier assumptions, though, as John Gage has shown, the growing complexity of theory would also make it increasingly inaccessible to artists.[25]

The proper use of colour in gardening continued to be an issue, however, and the need to find a working principle that could be justified by natural law remained a pressing concern. Wilkinson and others had voiced the suspicion that the English were afraid of colour and prone to either avoiding it or using it ineptly. The preference for bold colour could be dismissed as the sign of an unsophisticated society, but there was also the potent counter-argument that the highest values could be expressed through colour, and that its correct and confident use would be indicative of a progressive and polished culture. The problem, therefore, was to find a way of using strong colour without falling into the trap of garishness or vulgarity.

The basis of the system that Jekyll proposed was that an appearance of brilliancy could be achieved through an understanding of complementaries. Closely related colours, either cool or warm, should be grouped so as to saturate the eye and prepare it for the complementary colour, the next stage in the progression, thus creating an intensity of effect. Harmony is ensured through a relationship between colours adjacent in the spectrum, while contrast (the juxtaposition of widely spaced colours) should be used more sparingly. Blues, for example, required

fig. 24
*A September Grey Garden c.*1908
Photograph from
Colour in the Flower Garden
by Gertrude Jekyll,
published 1908
Royal Horticultural Society,
Lindley Library

A SEPTEMBER GREY GARDEN.

in marked contrast to Nesfield's laying out of his predetermined figures on a surface of prepared earth. The bedding-out system had made the nurseryman the equivalent of the artists' colourman, supplying flowers of the right hue to fill in the outlined design. Jekyll's colour harmonies, on the other hand, were to be realised only through a detailed knowledge of plants, and *Colour in the Flower Garden* achieves a subtle balance between the discussion of chromatic schemes and specific advice on what to grow.[28]

contrast to bring out the full effect: 'any experienced colourist knows that the blues will be more telling – more purely blue – by the juxtaposition of a rightly placed complementary colour'.[26] She was interested in schemes for gardens of special or restricted colour, but her blue garden could not achieve its desired effect without the introduction of notes of pale yellow and white.

Jekyll's ideas on colour were worked out in practice from the second half of the 1880s in the great herbaceous border of her own garden at Munstead Wood, Surrey (*figs.24–5*). Two hundred feet long and fourteen feet wide, and backed by a high sandstone wall, it was designed to be at its best in the late summer, and exemplified her ideas on colour progression. Beginning with cool colours (blue, white, pale yellow, pale pink), it moved to strong yellows, oranges and reds in the central section, and then receded in inverse sequence through cooler colours again to purple and lilac. This was her masterpiece, the realisation of an ideal: 'in setting a garden we are painting a picture, only it is a picture of hundreds of feet or yards instead of so many inches, painted with living flowers and seen by open daylight'.[27]

The whole border could be viewed as a single composition, with each section a picture in itself. The soil was Jekyll's canvas, but her approach was

The flower garden might be envisaged as a picture, but it is an essentially transient one. The gardener must work with time as well as with space, light and living matter. A border cannot be established in a single season and requires the orchestration of complex resources to bring it to its full effect. Considered as a work of art, a garden is always vulnerable to changing circumstances, and the conditions of display are utterly unlike those pertaining to painting. The great border at Munstead Wood was never in the public eye and was shown only to friends and select professionals, but the word-pictures Jeykll created served to disseminate her ideas. Her books often included a plea, increasingly plaintively expressed, for readers to respect her privacy and not to try to see beyond her garden wall. Her colour compositions were made visible only in the form of her own monochrome photographs with which her books were illustrated, but she also included plans of planting schemes which served to both map what had been done and to model borders still to be created. The plans show in outline her characteristic irregular drifts contained within elongated rectangular frames, their amorphous shapes in marked contrast to the hard edges of the high-Victorian geometric parterre. From such schematic outlines her colour schemes could, in theory, be emulated: they provide the key to future garden pictures. Given her own account of her fading eyesight, however, it is not clear how much Jekyll herself could see of the pictures she had created, and her garden, for all its appeal to the senses, is also a place of the mind's eye.

Garden Pictures

'I have long worked to prove that the garden, instead of being a horror to the artist, may be the very heart of his work.'[29] William Robinson felt that it was a vindication of his approach that artists should at last be able to find a garden 'full of pictures'. His remark came after four painters, Alfred Parsons, Mark Fisher, H.A. Olivier and H.G. Moon, visited

fig. 25
Plan of the Grey Garden from
Colour in the Flower Garden
by Gertrude Jekyll,
published 1908
Royal Horticultural Society,
Lindley Library

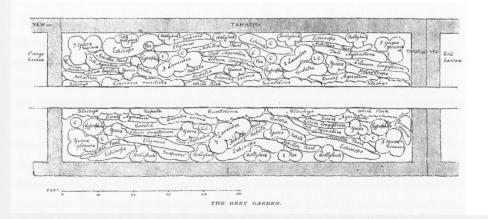

THE GREY GARDEN.

Gravetye Manor in the summer of 1895. Four years earlier he had invited Moon and the American painter W.E. Norton to work from spring through to winter at Gravetye, and the paintings they produced were exhibited at Stephen Gooden's gallery in Pall Mall in November 1892. Robinson himself wrote the introduction to the catalogue, arguing that a natural approach to gardening had created sympathetic conditions for the artist, who until recently 'has been driven from what should be the heart of the landscape'.[30]

The idea that the modern flower garden might lead to the emergence of a school of painting had been made explicit for the first time the previous year at an exhibition of watercolours by George Elgood at the Fine Art Society. The author of the introduction to the catalogue claimed that the flower garden was a relatively new subject for art in England and attributed this to the decline of the fashion for artifice in garden design and the development of a culture of flowers. The schematic colours and insistent contrasts of the formal garden had not been incentives to artistic creation, but fortunately now 'the scarlet geranium, the blue lobelia, the yellow calceolaria, no longer hold undisputed sway on every hand'.[31] The author credited Frederick Walker with the invention and popularisation of the flower garden as a subject and cited Helen Allingham and Alfred Parsons among contemporary practitioners. They might form the kernel of the new school.

Parsons had his own exhibition at the Fine Art Society later that year, 1891, and the introductory essay, 'Gardens and Orchards', was written by Henry James. James had already characterised Parsons as an artist who knew exactly how Americans would like England to appear,[32] and he now made the idea of the garden carry the very essence of Englishness: 'It would perhaps be extravagant to pretend, in this embarrassed age, that Merrie England is still intact; but it would be strange if the words "happy England" should not rise to the lips of the observer of Alfred Parsons' numerous and delightful studies of the gardens, great and small, of his country.'[33]

Other commentators were pointing to the garden as a new subject for art, made possible only by advances in gardening itself, but James emphasised the idea of duration: the slow growth of character in a place, the sense that 'such fortunate corners have had a history'. He commented on garden making as a national obsession: 'one must have lived in other lands to observe fully how large a proportion of this one is walled in for growing flowers'. Parsons, he felt, had captured 'that peculiarly English look of the open air room', that 'nook quality, the air of a land and a life so infinitely sub-divided that they produce a thousand pleasant privacies'. He made no direct comment on the artist as a colourist, but referred to the English love of flowers as 'the most unanimous protest against the greyness of some of the conditions'.

In making the English flower garden the symbolic heart of the nation, James had found the ideal artist in Parsons. His career combined the practices of painting, garden illustration and garden making. Unlike Nesfield and Jekyll, for whom painting was a prelude to their garden work, Parsons exhibited throughout his life, gradually diversifying until he had shown at almost the entire range of late-Victorian and Edwardian art institutions.[34] He was a prolific illustrator and became closely involved with Robinson's publications, particularly his journal *The Garden*. His work for the 1881 edition of *The Wild Garden* helped give the book a new lease of life, and his watercolour illustrations for Ellen Willmott's *The Genus Rosa* (1910) are still celebrated. Parsons had begun writing garden journalism for Robinson by 1878, and his own book *Notes in Japan* (1896) contributed to the craze for Japanese gardens

fig.26
Alfred Parsons (1847–1920)
China Roses, Broadway
Watercolour on paper
Christopher Wood Gallery,
London

out from his pictures. He began his garden making in the Cotswolds, but the reputation of Lawrence Johnston's later, and in some ways radically un-English, garden at Hidcote has proved more durable than Parsons's nooks. If he was overshadowed in his two main areas of competence, Parsons remains a key figure in the 'school' of garden painters in late-Victorian and Edwardian England. The standing of that school itself, however, has remained uncertain.[36] The garden must be understood as a modern subject, but this means that in the medium of watercolour it could not be accommodated to the native tradition, while oil painters could be accused of leaning too much towards the French (one critic complained that Moon and Norton 'were handicapped by looking at nature through Corot's eyes' in their paintings of Gravetye).[37] The modern flower garden could

in Britain. He began to design gardens from the mid-1890s (*fig.27*), initially for his American friends of the Broadway circle, then increasingly on a commercial basis. He also created the set ('an old Somersetshire garden a hundred years ago') for James's play *Guy Domville*, and later a real garden for the author at Rye.[35]

Parsons had perfect credentials as an artist-gardener and was certainly well connected, but his reputation has not endured in either field. Can we deduce anything more general about the changing relationship between painting and gardening from the transience of his achievement, or was he simply overshadowed by brilliant, and more specialised, contemporaries? It was his colleague John Singer Sargent who created the most memorable image of a garden at Broadway in *Carnation, Lily, Lily, Rose* (cat.75), though the artifice involved in staging the picture had not much to do with the Robinsonian ideal of the natural garden or the cult of the English vernacular, and its prestige is bound up with its success as an exercise in Impressionism and Sargent's association with Monet. As a painter, Parsons has slipped into relative obscurity, but his garden projects are not well documented either, and the character and appearance of his gardens can only really be worked

be envisaged as an experimental theatre of colour, but the pictures it gave rise to were increasingly dismissed as unadventurous, while the subject matter itself came to be seen as steeped in nostalgia, escapism and privilege, and not as a convincing theme from modern life.

With Jekyll, the border had become a picture, but those painters who were tempted to make pictures of a border found themselves in a restricted position. Labour-intensive, spectacular and ephemeral, the herbaceous border could qualify as a work of art in its own right. The management of complex colour effects could be realised only through a complete knowledge of materials and conditions (the right combinations of plants, proper preparation of the ground, consideration of soil, drainage, latitude, position, lighting and so on), all underpinned by an understanding of the laws of colour. Garden painters could not follow this rigorous process of working through the materials from first principles and were therefore confined to a passive, merely illustrative role. When Jekyll spoke of her main enterprise as 'working out certain problems' of colour, her terminology seems to anticipate the critical language of colour-field painting by more than half a century. It would certainly be many years before a painter, focused on the issue of colour and on the verge of a breakthrough, could make meaningful use of the analogy with gardening again (fig.28).

1 Gertrude Jekyll, *A Gardener's Testament*, London 1937, p.128. 2 The phrase is used by William Andrews Nesfield in a letter to William Hooker of 2 February 1846; cited by Christopher Ridgway in 'William Andrews Nesfield: Between Uvedale Price and Isambard Kingdom Brunel', *Journal of Garden History*, vol.13, 1993, p.78. 3 See M.J. Tooley (ed.), *William Andrews Nesfield, 1794–1881: Essays to Mark the Bicentenary of his Birth*, Durham 1994, for full lists of pictures exhibited by Nesfield in his lifetime and works by him in public collections. 4 John Ruskin, *Works*, III, London 1903, p.530. 5 John Robson cited by M.J. Tooley in the entry on Witley Court, in *William Andrews Nesfield, 1794–1881: Bicentenary Exhibition*, exh. guide, Durham University Library 1994. 6 Letter from Nesfield to Hooker quoted by Shirley Evans, 'Life and Times of William Andrews Nesfield', in Tooley 1994, pp.6–7. A comparison might be made here with the case of another painter and garden designer, Edward William Cooke (1811–1880). Cooke was drawn into garden design through his marriage into the Loddiges family, famous for their nursery business in Hackney. He is best known for his collaboration with James Bateman at Biddulph Grange, beginning in 1849; he also created gardens for two houses of his own in Kensington and, most notably, at Glen Aldred, Sussex, after 1866. Cooke's main career continued to be that of a landscape and marine painter, however, and it is clear that for him gardening was a diversion rather than a change of direction. See John Munday, *Edward William Cooke, 1811–1880, A Man of His Time*, Woodbridge 1996. 7 *Gardener's Magazine*, February 1840, pp.49–58. 8 Brent Elliott, *Victorian Gardens*, London 1986, pp.140–3. 9 *Gardener's Chronicle and Agricultural Gazette*, 26 April 1862, p.380. 10 Quoted by Ridgway 1993, p.77. This article, drawing extensively on papers in the Nesfield family archive, offers the fullest account of his aesthetic, sources and attitude to the modern world. 11 Quoted by Evans in 'William Andrews Nesfield: an Introduction to his Life and Work' in Christopher Ridgway (ed.), *William Andrews Nesfield, Victorian Landscape Architect*, York 1996, p.7. 12 J. Gardner Wilkinson, *On Colour*, London 1858, p.14. 13 W. Keane, 'The progress of flower gardening', *Journal of Horticulture and Cottage Gardener*, vol.4, March 1863, pp.199–200. 14 Gertrude Jekyll, 'Colour in the Flower Garden', in William Robinson, *The English Flower Garden*, London 1883, p.cxii. 15 William Robinson, *Gravetye Manor, or Twenty Years Work round an Old Manor House*, London 1911, p.95. Robinson's original manuscript, 'Gravetye Manor: Tree and Garden Book and Building Record, 1885–1911', is in the Lindley Library, RHS. 16 Gertrude Jekyll, *Colour in the Flower Garden*, London 1908, pp.vii–viii. 17 George Leslie, *Our River*, London 1888, p.37. 18 Gertrude Jekyll, 'About Myself', in Jekyll 1937, pp.6–7. 19 The most detailed account of Jekyll's early career as an artist is Joan Edwards, 'Gertrude Jekyll: "Prelude and Fugue"', in Michael Tooley and Primrose Arnander (eds.), *Gertrude Jekyll, Essays on the Life of a Working Amateur*, Witton-le-Wear 1995, pp.44–56. See also Judith Tankard, 'Where Flowers Bloom in the Sands', *Country Life*, 12 March 1998, pp.82–5. 20 See for example the preface to the 1982 edition of Gertrude Jekyll, *Colour Schemes for the Flower Garden*, Woodbridge 1982, pp.9–14. 21 Jekyll's copy of George Field, *Chromatics, or an Essay on the Analogy and Harmony of Colours*, London 1817, is in the Lindley Library. See John Gage, *George Field and his Circle: From Romanticism to the Pre-Raphaelite Brotherhood*, Cambridge 1989, particularly pp.59–64. 22 William Robinson, *The English Flower Garden*, fourth ed., London 1895, p.232. 23 Elliott 1986, pp.205–9. 24 The section on 'Colour Theory and the Bedding System', ibid., pp.123–8. 25 John Gage, *Colour and Culture: Practice and Meaning from Antiquity to Abstraction*, London 1993, particularly pp.173–6. 26 Jekyll 1908, p.90. For her own account of her herbaceous border, see ch.6, 'The Main Hardy Flower Border', pp.49–57. 27 Jekyll in Robinson 1883, p.cx. 28 On the great border see Jane Brown, *Gardens of a Golden Afternoon*, London 1982, pp.41–6; David Ottewill, *The Edwardian Garden*, New Haven and London 1989, pp.62–4; Martin Wood, 'Gertrude Jekyll's Munstead Wood', in Tooley and Arnander 1995, pp.100–4; Judith B. Tankard and Martin Wood, *Gertrude Jekyll at Munstead Wood: Writing, Horticulture, Photography, Homebuilding*, Stroud 1996. 29 Robinson 1911, p.95. The fullest account of Robinson in relation to art is in Anne Helmreich, *The English Garden and National Identity: The Competing Styles of Garden Design, 1870–1914*, Cambridge 2002, ch.2, pp.39–65. 30 The catalogue introduction was reprinted in Robinson 1911, pp.69–71. 31 George Elgood, 'A Summer among the Flowers', cat. intro., Fine Art Society, London 1891. 32 Henry James, 'Our Artists in Europe', *Harper's Magazine*, vol.79, June 1889, pp.55–65. 33 Henry James, 'Gardens and Orchards', prefatory note to *Catalogue of a Collection of Drawings by Alfred Parsons*, exh. cat., Fine Art Society, London 1891. 34 Nicole Milette, 'Landscape Painter as Landscape Gardener: the Case of Alfred Parsons, RA', unpublished PhD dissertation, University of York 1997, lists all the works exhibited by Parsons. This study attempts to identify all Parsons's work as a garden designer. 35 Leon Edel (ed.), *Henry James, Letters*, III, Cambridge, Massachusetts 1980, p.422. 36 On the formation of a garden school, see Anne Helmreich, 'Contested Grounds: Garden Painting and the Invention of National Identity in England, 1880–1914', PhD dissertation, Northwestern University 1994. See also Penelope Hobhouse and Christopher Wood, *Painted Gardens: English Watercolours, 1850–1914*, London 1988. 37 The review is pasted into the manuscript of Robinson's 'Gravetye Manor: Tree and Garden Book', p.267 (see note 15); the remark on Corot is underlined and Robinson has written 'rubbish' in the margin.

Gardens Illustrated
Brent Elliott

Until the nineteenth century there was effectively no tradition of garden illustration in British book publishing. The practical gardening manuals of the sixteenth and seventeenth centuries, like the herbals of the same period, were full of pictures of plants, but not of garden scenes showing how they were to be deployed. The few images of gardens that did appear in print have attained a possibly disproportionate reputation in the last hundred years simply because there is so little else in the period that can be used as a visual reference for the revivalist designer. A couple of woodcuts, in *The Gardeners Labyrinth* (1586) by 'Didymus Mountaine' (Thomas Hill) *(fig. 31)* and in William Lawson's *New Orchard and Garden* (1631), have been the basis for Elizabethan-style gardens from the Shakespeare garden at New Place, Stratford-upon-Avon, in the 1920s, to the Queen's Garden at Kew in the 1960s. Fortunately for the modern designer, the very crudity of these illustrations leaves considerable scope for the imagination in interpreting them.[1]

The early eighteenth century brought a brief flurry of garden images in books, in two forms. The first was a consequence of the English translation by John James of Dezallier d'Argenville's *Théorie et pratique du jardinage* (1712), the standard work on garden design of the school of Le Nôtre, which included plans of parterres, mazes and bosquets. In its wake, Stephen Switzer and Batty Langley published works that included similar plans, and supplemented them with folding engraved plates of fountains, ruins and other garden scenes. The scenes in Langley's *New Principles of Gardening* (1728) and Switzer's *Universal System of Water and Water-works* (1734) are based on the conventions of late seventeenth-century landscape painting, and are engraved with a heavy use of cross-hatching for greater chiaroscuro *(fig. 29)*. The treatment of

The Design of a Fountain & Cascade after ye grand manner at Versailes

Plate XVII.

Tho: Bowles Sculp.

fountains in both works reveals the limitations of the printed baroque: a fascination with the numinous and ephemeral, in the form of the spray of water in fountains, is defeated by printing technology, as the jets of water, rendered in line engraving, appear as massively solid objects. A few frontispieces – most notably in Lawrence's *Clergyman's Recreation* (1714), Switzer's *Nobleman, Gentleman, and Gardener's Recreation* (1715) and Fairchild's *City Gardener* (1722) – served as additional sources of garden scenes, most notably parterres.

The second form was that of the prospect, as used by Johannes Kip and Leonard Knyff in their delineations of British gardens in *Britannia Illustrata* (1719). There was already a flourishing tradition of naïve landscapes of country seats, but this was given new impetus by these bird's-eye views.[2] At the beginning of the twentieth century the work of Kip and Knyff was in turn drawn on by historical revivalists; the architect Mervyn Macartney edited a volume of their engravings, claiming in his preface that the gardens of the early eighteenth century met the requirements 'of some modern architects as to the necessary relation of the house to its surroundings' – that is, symmetry and the comparative independence of garden compartments from any overall stylistic demand.[3]

The development of the landscape garden effectively short-circuited these traditions of illustration. As the proponents of the landscape rejoiced in stripping away the formal accretions of previous generations, it could be said that the number of subjects for garden illustration declined. Sir William Chambers's book on his projects at Kew was devoted entirely to buildings and no English garden manual

The House and Gardens at Woburn in Surrey as laid out by Philip Southcote Esq.

illustrated specimen boulders for the landscape the way LeRouge's *Cahiers* did in France. From the early eighteenth century there was a flourishing trade in the production of topographical prints, some of which included views of landscape gardens, but it was not until the last quarter of the century, beginning with William Watts's *Seats of the Nobility and Gentry* (1779), that books on country houses began to appear in which landscape gardens were depicted in small engraved plates. But now the heavy line and cross-hatching that had characterised the plates in Langley and Switzer were replaced by a variety of textures using smaller incisions on the plate, creating finer representations of greensward in particular. This tradition carried on into the nineteenth century, in the work of J.P. Neale, first for his own *Views of Seats* in the 1820s, and then, after a publishers' reorganisation, by *Jones' Views of Seats* at the end of the decade.[4]

Almost the only work of the period on garden design (if we except Repton, to whom we are about to come) to have coloured plates was the 1801 edition of Whately's *Observations on Modern Gardening* (fig.30), a work first published, unillustrated, in 1770. This late edition used engravings after William Woollett, whose reputation was based on his deployment of chiaroscuro: heavily worked fore-grounds and delicate backgrounds.[5] The Whately engravings offered a corresponding colour scheme: earth colours at the base of the picture, giving a brown foreground, fading to air colours at the top, with various tones of green, blue and brown in the middle. This is a representative treatment of

fig.30
After William Woollett (1713–1785)
The House and Gardens at Woburn in Surrey as laid out by Philip Southcote Esq. 1798
Engraving from *Observations on Modern Gardening* by Thomas Whately, published 1801
Royal Horticultural Society, Lindley Library

fig.31
Anonymous woodcut from *The Gardeners Labyrinth* by Didymus Mountaine (Thomas Hill), published 1586
Royal Horticultural Society, Lindley Library

landscape colours in the eighteenth century, and while it may have been well adapted to the scenic intentions of the landscape garden, it helps to explain why there are so few paintings of flower gardens from the period. In the nineteenth century this tradition of painting was taken as a point of reaction by gardeners, who used it to stress the irrelevance to gardening of painting as traditionally carried out. The Leeds-based landscape gardener Joshua Major wrote: 'What has the painter to do with the gay parterre, the delightful flower garden, – the soul's delight of the majority of mankind?', while Henry Bailey, head gardener at Nuneham, Oxfordshire, added: 'I am at a loss to trace the analogy between a landscape painting and a flower garden.'[6] The consequence was that for much of the nineteenth century there was a rift between painting (which meant, in practice, landscape painting) and the printed illustration of gardens.

It is interesting therefore that the one writer on garden design who used coloured plates in his works at this period was to become associated with the revival of the flower garden. Humphry Repton began his career claiming to be the successor of Capability Brown, and his first works, *Sketches and Hints on Landscape Gardening* (1795) and *Observations on ... Landscape Gardening* (1803, reissued 1805), depicted landscape gardens in the eighteenth-century style, though with less emphasis on the brown foreground. But in his *Designs for the Pavilion at Brighton* (1808) and his *Fragments* (1816) (*fig.33*) he depicted scenes with flower beds in the principal views, and other formal garden features. The Brighton plans bore a decorative device with the words, 'Gardens are works of art, not of nature' – thus signalling a redirection of garden aesthetics that dominated the following century.[7]

Repton had devised the distinctive marketing tactic of preparing for each potential client a 'Red Book', a manuscript volume outlining his proposals and illustrating them with watercolour sketches, showing the same view before and after his intended works;

fig.32
E. Adveno Brooke (active 1850s)
The Alhambra Garden from
Elvaston Castle from *Gardens of England*,
published 1856–7
Royal Horticultural Society,
Lindley Library

the reader lifted one or more flaps on the illustration to see the outcome, or range of choices. In his published works Repton carried on this practice: most of his plates have inserted flaps showing the unamended version of a scene, which are lifted to reveal the Reptonian version. (Much of the text was also extracted from Red Books.) Few people would have seen the Red Books themselves, but a wider audience would have had access to the printed works; in the wake of Repton, the rising landscape designers J.C. Loudon and W.A. Nesfield both produced their own equivalents of Red Books for some of their early clients. In 1840 Loudon published an edition of Repton's collected works in one handy volume for the gardener's pocket; the coloured plates were replaced by small woodcuts, and the before-and-after views separated on the page.[8]

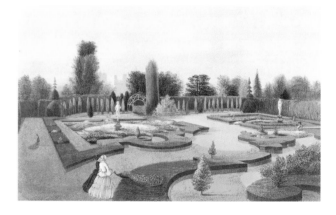

Loudon relied on woodcuts also in his *Gardener's Magazine*, the first practical magazine for gardeners in Britain, which he founded in 1826 and ran until his death in 1843. Many of the blocks were reused for his book *The Suburban Gardener and Villa Companion* (1838), posthumously reissued in an expanded edition as *The Villa Gardener* in 1850. Loudon did not specify his sources for the illustrations of gardens, but in one case, Nesfield's villa at Fortis Green, Muswell Hill (*fig.20*), he lamented that he had been unable to use the pictures in *The Suburban Gardener* because Nesfield had been slow in providing the drawings.[9] Nesfield was, admittedly, an artist himself; but it is possible that the other garden views in Loudon's magazine were also based on artwork provided by the owners of the individual gardens. After Loudon's death the woodcuts he had used continued to appear, not only in further editions of his own works; the *Gardener's Magazine of Botany* and the *Florist's Guide* reprinted articles from his magazine, and, whether from his widow or from Longmans, his publishers, borrowed the printing blocks in order to duplicate the illustrations.

fig.33
Humphry Repton (1752–1818)
Proposal for Wanstead House
from *Fragments on the Theory and Practice of Landscape Gardening*, published 1816
Royal Horticultural Society,
Lindley Library

Woodblocks normally deteriorated with use, lines broke or were rubbed flat, and once weekly newspapers began to use them for large issue runs the rate of erosion suffered by the blocks became more pronounced. The expedient was hit on of making a metal cast of the woodblock, creating from the cast a metal duplicate of the carved surface, and fastening it on to a block of wood for insertion into the printing forme. The result was indistinguishable from a genuine wood engraving, and the process went on being referred to as wood engraving throughout the century even though actually a metal surrogate was used. The change is associated primarily with the *Illustrated London News*; the first of the gardening magazines to follow its example was the *Gardeners' Chronicle*. By the late 1850s the technique had become standard. The *Illustrated London News* had become noted in the middle of the decade for using photographs as the basis for its wood engravings, especially with Roger Fenton's Crimean War images, and by the 1860s images clearly based on photographs were being used in the *Gardeners' Chronicle* and its rival magazines, providing much greater detail of texture.

It was through illustrations in these media that visual information about the early and high Victorian garden was disseminated. At a time when gardeners were becoming obsessed with colour schemes and the first rules for the arrangement of colour in the flower garden were being discussed in the press, it was almost entirely through monochrome line illustrations that the period's preferred planting and design were conveyed. A few magazines tried rendering flower garden plans in colour, using chromolithography, but these experiments were few and far between – the *Florist's Journal* in the 1840s, the *Journal of Horticulture* and the *Gardeners' Chronicle* at the beginning of the 1860s, the *Chronicle* again in the 1880s, using a chastened range of colours to portray carpet-bedding patterns. This absence of colour creates immense problems for the restorer of Victorian gardens, because so many of the preferred plants for parterre display have now vanished; some pelargonium cultivars can still be found, but none of the petunia, verbena or calceolaria cultivars that shared the spotlight with them from the 1840s to the 1870s. No one today can hope to replicate exactly a high-Victorian parterre; when the plant list includes several scarlet pelargoniums and purple verbenas, it is possible that the effect depended on small colour differences that, in the absence of surviving plants, can only be guessed at.

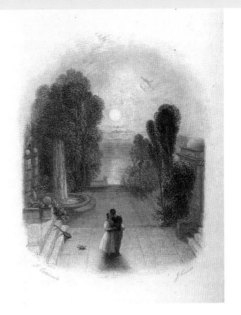

fig.34
John Cousen (1804–1880) after George Cattermole (1800–1868)
Engraving from *Evenings at Haddon Hall* by the Baroness de Calabrella (Mrs Thomas Jenkins), published 1846
Private Collection

The one significant book to depict the elaborate parterres of the 1850s in colour was E. Adveno Brooke's *Gardens of England* of 1856–7 (fig.32). It is difficult to know whether it exercised any influence at the time. The paintings on which the chromolithographs were based were exhibited at McLean's gallery in 1856, but it is not referred to in the gardening press in subsequent years. (One of Brooke's illustrations, of borders at Trentham, Staffordshire, was reproduced as a line engraving in the *Leisure Hour*, but that was not a gardening magazine.) The book probably has greater status as a record than as a role model.[10]

The finer detail obtained by steel engraving made virtually no inroads into gardening publishing, though garden scenes appear occasionally in the gift books and fine editions that flourished in the second quarter of the century. One example of particular importance was *Evenings at Haddon Hall* (fig.34) by the Baroness de Calabrella (Mrs Thomas Jenkins), published in 1846 with engravings after George Cattermole, an artist whose role in popularising historically revivalist imagery has been insufficiently studied.[11] These plates, accompanying stories set in the Renaissance or the Middle Ages, emphasised

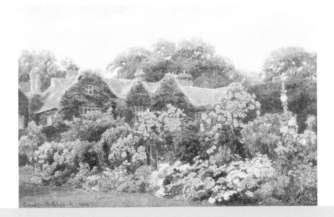

fig.35
George Elgood (1853–1943)
From *The Garden That I Love* by Alfred Austin, published 1906
Royal Horticultural Society, Lindley Library

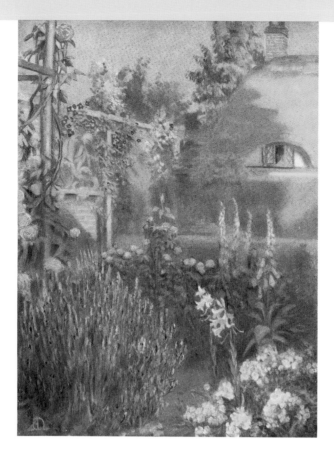

fig.36
Anna Lea Merritt (1844–1930)
From *An Artist's Garden,*
published 1908
Royal Horticultural Society,
Lindley Library

terraces, fountains and Italianate architectural details – in other words the attributes of the Italianate garden that was rapidly becoming the major domestic style in England.

The flower garden, by the 1860s, was being illustrated in books and periodicals directed at an audience consisting in part of interested amateurs but more largely of professionals – the head gardeners at the country houses who were the principal authors of the articles. Slowly, the art world began to adapt to this new focus of interest. The picturesque conventions of the late eighteenth century, which had led a generation of gardeners to dismiss the relevance of painting, had now passed away; Constable, Turner, Mulready, the Pre-Raphaelites and the watercolour schools had changed the tonal quality of British painting; bright colour was now acceptable; the flower garden need no longer be regarded as an unsuitable subject for art. So, during the 1860s, the first beginnings of a school of painting devoted to the flower garden emerged, in the work of Myles Birket Foster and Frederick Walker, which did not emerge on to the printed page until nearly the end of the century.

Birket Foster and his successor, Helen Allingham, both lived in the Surrey village of Witley and became well known for painting cottage gardens – a term of some imprecision. Several of Allingham's paintings were eventually published in the books

Happy England (1903) and *The Homes of Tennyson* (1905), and it is apparent that some of the gardens that in other contexts were described as cottage gardens were in fact the gardens of small manor houses, or even details of larger country house gardens. A scene in Tennyson's estate at Farringford, showing the dairy cottage near the kitchen garden, was depicted in *The Homes of Tennyson* as 'The dairy door, Farringford'; another painting of the same scene in *The Charm of Gardens* (1910) simply as 'The cottage'. This looseness of definition characterised most of the late nineteenth-century discussions about the aesthetics of cottage gardening; by the early twentieth century 'cottage garden' had become a stylistic term, as applicable to a country house like Hidcote as to a genuine rustic cottage. Indeed there is evidence that the popularity of cottage garden painting influenced the planting of genuine cottage gardens after the turn of the century; agricultural depopulation and the use of cottages for weekend accommodation were trends already becoming apparent during the Edwardian period, and the market was increasing for cottages with gardens planted for ornament rather than practical food production.[12]

Frederick Walker died young in 1874, leaving only a few paintings that were greatly influential on the garden artists of the next generation. His garden scenes fell into the category of the 'old-fashioned' or 'old-world' gardens that were becoming popular in the 1870s: based on medieval, Tudor and seventeenth-century precedents, turning away from prospects in favour of enclosures, from bedding in favour of herbaceous borders and from classical statuary in favour of topiary. Walker's paintings were not published at the time; the only one to be reproduced in a garden book was *The Lady in the Garden*, used as the frontispiece to Sieveking's 1889 anthology *In Praise of Gardens*. But during the 1890s a group of artists emerged who became particularly devoted to the portrayal of old formal gardens and of new gardens modelled on their precedent; associated with the Fine Art Society and a group of related galleries, Alfred Parsons, George Elgood, Beatrice Parsons, and Ernest Arthur Rowe in particular developed long-lasting careers.[13]

More than any other publisher, the Glasgow firm of Adam and Charles Black issued works that used the works of these and other garden artists in the Edwardian period.[14] Among the most prominent were a limited edition of Alfred Austin's *The Garden That I Love*, with plates by Elgood (*fig.35*), and E.T. Cook's *Gardens of England*, with plates by Beatrice

Parsons. These latter plates were also issued as postcards. The main rivals to Black in garden illustration were Longmans, who also used Elgood as the illustrator for Gertrude Jekyll's *Some English Gardens*, in the long run the most successful of all the illustrated works of the period (it was reissued as late as 1935). Another artist-writer working for Longmans was Cyril Ward, whose *Royal Gardens* was issued in two different formats in the same year, 1912.

While an artist like Beatrice Parsons could turn her hand to any type of garden, formal or wild, and went on to a long career of producing cover illustrations for Suttons seed catalogues, others were more limited in their stylistic choices. Elgood and Rowe in particular favoured old-fashioned gardens as their subjects, and the popularity of their works may have helped to disseminate the late nineteenth century's preferred modes of historical revivalism. At Arley Hall, Cheshire, there is a painting by Elgood of figures in eighteenth-century dress within the garden – presumably either a caprice or a depiction of a fancy-dress party, for the garden was designed in the 1830s. (There exists, in the Lindley Library, a similar picture of people in sixteenth-century dress at Elvaston Castle by George Maund; again, the garden dates from the 1830s.) This sort of fantasy, which could be regarded as a natural consequence of an interest in historical revivalism, has been characterised as a 'culture of deceit', though it is difficult in retrospect to determine whether deceit was the original intention.[15]

The work of Elgood, Parsons and especially Rowe is precise and detailed, but by the time their work began to appear in book form the English art scene had become accustomed to Impressionism, and other artists favouring garden themes adopted more impressionistic styles. The roots of this new convention in printed illustration lay in William Robinson's magazine *The Garden*, which he had founded in 1871; consistently throughout his editorship, Robinson experimented with page layout, typography, and illustration to increase the beauty of the magazine. From 1878 he used Alfred Parsons as an illustrator of garden scenes, not only in *The Garden* but in his own books, especially the later editions of *The Wild Garden*. In 1880 he hired Henry George Moon as an artist, and made great claims for him as the first artist to depict plants accurately as they were found in the garden rather than as dissected specimens. From the botanical point of view, Moon's illustrations are not excellent – they do not show the details the botanist needs for

identification – but as indications of the habit and expected appearance of the plant in a garden setting they still offer good predictive value. Moon had a great influence on turn-of-the-century botanical illustration, and his rather washy views of flowers in their settings may have provided a basis from which subsequent artists could explore impressionistic techniques.[16]

The first artist to illustrate a gardening book in this manner was Margaret Waterfield, whose books *Garden Colour* (1905) and *Flower Grouping in English, Scotch and Irish Gardens* (1907) (*fig.37*) were both published by Dent.[17] She was followed by Anna Lea Merritt, a well-established artist best known today for her painting *Love Locked Out*, whose book *An Artist's Garden* (*fig.36*) was published by Allen and Unwin in 1908. Merritt claimed in her preface that 'I have not acquired the latest impressionist style, which so ably represents things as seen from a motor-car at full speed. I have been obliged to sit out for many hours daily in freezing wind, and later in burning sun, looking long and carefully at flower and leaf.'[18] Nonetheless, her use of misty and imprecise effects, not only for distance but for near backgrounds, allies her more with Waterfield than with Elgood or Rowe.

Within this little flood of books we can distinguish a genre whose tentative beginnings lay in the third quarter of the century, but which was now coming into its own, and which has been retrospectively named the garden autobiography.[19] The pioneering work of this genre was Alfred Smee's *My Garden*, an account of his garden at The Grange, Wallington, Surrey (part of which survives today as a municipal

fig.37
Margaret Waterfield (1863–1953)
Image of Kew from *Flower Grouping in English, Scotch and Irish Gardens*, published 1907
Royal Horticultural Society,
Lindley Library

park). It was illustrated with some 1300 engravings, most of them of plants, but including dark and heavily worked views of his fernery and water garden.[20] The later development of this genre accompanied the spread of half-tone and other techniques used in works such as Merritt's *An Artist's Garden*. Shortly before the First World War, Marion Cran's *The Garden of Innocence* was published (1913); this and its post-war sequels led the genre into the world of photography as its mode of illustration, and E.A. Bowles's three celebrated books about his garden at Myddelton House in Enfield appearing in 1914–15, consolidated this shift.[21]

Photographs had been used as the basis for magazine illustrations since mid-century, but it was not until the 1880s that magazines — the *Gardeners' Magazine* to begin with, followed by the *Gardeners' Chronicle* — began to issue photographic illustrations as supplementary plates. In 1897 the first issue of *Country Life* appeared, printed on shiny paper so that photographic half-tones could appear on the same pages as text; in 1900 its publishers took over William Robinson's magazine *The Garden*, and forthwith began to print it similarly on shiny paper. *Country Life* was the first magazine associated with gardening to employ its own photographers instead of relying on images supplied by the owners of gardens; but in its earliest years it too relied heavily on outsourced images, with the amusing consequence that one of its photographs of Heckfield Place (1898) is demonstrably the basis of a *Gardeners' Chronicle* engraving published seventeen years earlier.[22]

The arrival of photography may also be seen as helping to create a sub-genre of the garden autobiography: the garden-construction narrative. The pioneer this time was George Hillyard Swinstead, who in 1910 issued *The Story of My Old-world Garden ... and How I Made It in a London Suburb*. The garden (*fig. 38*) was at

14 Kidderpore Avenue, Hampstead, and the book was published by the Swiss Cottage publisher Baines & Scarsbrook, best known for the *Cricklewood Directory* and other works of local interest. The text told the story of the making of the garden; there were plans, offered as models for other suburban gardeners; and there were twenty-six plates, mostly photographic, of views in the 55 x 45-foot garden. Never before had a garden been depicted so copiously in relation to its size. The illustration reproduced here pays homage to the previous technology for garden depiction.[23]

Colour photography as a form of garden illustration did not make inroads on publishing until the 1930s. *Country Life*'s first colour photographs of a garden (of the herbaceous borders at Port Lympne, Kent) appeared in 1936, and it was not until well after the Second World War that it became widely adopted. As late as the 1960s colour illustrations were printed on different paper from text, and confined to small gatherings; most books on gardens and garden design still relied primarily on monochrome. But during the 1970s offset photolithography triumphed in the publishing world and superseded printing with metal type even for unillustrated books. As a result the use of colour distributed through the entire book has become general.

From the point of view of accurate representation, especially in terms of colour, the present day may be regarded as the golden age of garden book illustration. As a medium for conveying information about gardens, however, the book is now being challenged by television; a presenter walking through a garden under the eye of a camera is able to bring the three-dimensional structure of the garden to life in a way that no book, not even a pop-up book, has yet rivalled. Whether book illustration will find ways of meeting this challenge remains to be seen.

PLATE II.

A SECLUDED SKETCHING-GROUND.

fig.38
George Hillyard Swinstead
(active 1910s)
A Secluded Sketching-Ground
c.1910
Photograph from
*The Story of My Old-world
Garden ... and How I Made
It in a London Suburb*,
published 1910
The Royal Horticultural Society,
Lindley Library

1 See Brent Elliott, 'Historical Revivalism in the Twentieth Century', *Garden History*, vol.28, 2000, pp.17–31.
2 John Harris, *The Artist and the Country House*, London 1979. 3 Mervyn Macartney, *English Houses and Gardens in the Seventeenth and Eighteenth Centuries*, London 1908, p.ii. 4 John Preston Neale, *Views of the Seats of Noblemen and Gentlemen in England, Wales, Scotland, and Ireland*, series 1–2, 2 vols., Sherwood, Jones & Co., London 1818–29. *Jones' Views of the Seats, Mansions, Castles, &c. of Noblemen and Gentlemen in England, Wales, Scotland and Ireland*, Jones & Co., London 1829–31. Sherwood, Jones & Co. ceased trading in 1829, leaving Jones & Co. apparently in possession of Neale's work. Francis Orpen Morris, *A Series of Picturesque Views of Seats of the Noblemen and Gentlemen of Great Britain and Ireland*, 6 vols., London 1866–80. 5 *Bryan's Dictionary of Painters and Engravers*, new ed., London 1919, V, p.394. 6 Joshua Major, *The Theory and Practice of Landscape Gardening*, London 1852, p.151; Henry Bailey, letter, *Gardeners' Chronicle*, 1849, p.373.
7 Repton's instruction that the Red Books were not to be printed survived until 1977, when the Basilisk Press issued facsimiles of three of them, on the grounds that as Repton could not have anticipated offset photolithography, it did not count as printing as he understood it. 8 Humphry Repton, *The Landscape Gardening and Landscape Architecture of the Late Humphry Repton ... a New Edition ... by J.C. Loudon*, London 1840. 9 J.C. Loudon, 'Descriptive Notices of Select Suburban Residences: Fortis Green', *Gardener's Magazine*, vol.16, 1840, pp.49–58. 10 See *Gardeners' Chronicle*, 1856, p.119 for the announcement of the prospectus. The date 1857 appears in the letterpress, so publication must have continued into that year. An engraving of the borders at Trentham was reproduced in *The Leisure Hour*, 1859, p.441.
11 Baroness de Calabrella, *Evenings at Haddon Hall*, London 1846. 12 Andrew Clayton-Payne and Brent Elliott, *Victorian Flower Gardens*, London 1988, particularly pp.13–17, 43–5. 13 Of these artists only Elgood has been the subject of a decent biographical study: Eve Eckstein, *George Samuel Elgood: His Life and Work 1851–1943*, London 1995.
14 A brief list of the more important A. & C. Black publications, with the featured artists: Helen Allingham, *Happy England* (1903 and later eds.); Arthur Paterson, *The Homes of Tennyson* (1905 – Helen Allingham); Alfred Austin, *The Garden That I Love* (1906 – George Elgood); Alfred Austin, *Lamia's Winter-quarters* (1907 – Elgood); E.T. Cook, *Gardens of England* (1908 – Beatrice Parsons); Mrs Alfred Sidgwick, *The Children's Book of Gardening* (1909); Una Silberrad, *Dutch Flowers and Gardens* (1909 – Mima Nixon); Dion Clayton Calthrop, *The Charm of Gardens* (1910 – anthology); Mima Nixon, *Royal Palaces and Gardens* (1916 – Mima Nixon). 15 John Glenn, 'Climate of Deceit', *The Garden (Journal of the Royal Horticultural Society)*, vol.125, 2000, pp.60–1. 16 For Parsons, see Nicole Milette, 'Landscape Painter as Landscape Gardener: the Case of Alfred Parsons, RA', unpublished PhD dissertation, University of York 1997. For Moon, see Brent Elliott, 'Habit and Habitat', *The Garden (Journal of the Royal Horticultural Society)*, vol.121, 1996, pp.332–4.
17 William Frederick, Jr, 'Margaret Helen Waterfield 1863–1953', *The Garden (Journal of the Royal Horticultural Society)*, vol.112, 1987, pp.351–6. 18 Anna Lea Merritt, *An Artist's Garden*, London 1908, pp.ix–x. 19 Beverley Seaton, 'The Garden Autobiography', *Garden History*, vol.7, no.1, 1979, pp.101–20. 20 Alfred Smee, *My Garden: Its Plan and Culture*, London 1872: there were two editions, both published by Bell & Daldy, in the same year. 21 Marion Cran, *The Garden of Ignorance* (1913 and later eds.); *The Garden of Experience* (1922); *The Story of My Ruin* (1924); *The Joy of the Ground* (1928); *The Squabbling Garden* (1934); *Hagar's Garden* (1941), all published by Herbert Jenkins, London. E.A. Bowles, *My Garden in Spring* (1914); *My Garden in Summer* (1914); *My Garden in Autumn and Winter* (1915), all published by T.C. and E.C. Jack, London. 22. Brent Elliott, *The Country House Garden*, London 1995, pp.7–10. 23. G. Hillyard Swinstead, *The Story of My Old-world Garden (dimensions 55 ft. x 45 ft.) and How I Made It in a London Suburb*, London 1910.

" THE QUEEN ELIZABETH " ROSE :
" I ADMIRED IT ENORMOUSLY THE
FIRST TIME I SAW IT . . . (A) GROUP OF
IT THIS YEAR MORE THAN CONFIRMED
THAT FIRST OPINION."

Photograph by J. E. Downward.

The Garden of England: Theme and Variations
Stephen Bann

'The Chelsea crowds show clearly that we are a nation of gardeners – and heroes'. So wrote the veteran nurseryman and plant collector Clarence Elliott on 9 June 1956 in the *Illustrated London News*.[1] Reviewing the annual Chelsea Flower Show, which had impelled him to relinquish his own garden and 'the lovely Cotswold country at the loveliest time of the year', this seasoned commentator attempted to put into words the euphoria that overcame him on his visit to 'the world's greatest flower show'. He expressed the wish that he might convey 'some slight idea of [its] magnificence and ... beauty' to those who are prevented from seeing it: 'readers in this country, and overseas readers in every corner of the Commonwealth and Empire, and in all the innumerable other countries reached by the *Illustrated London News*'.

It will be no surprise that the magazine itself – proud survivor of the great troupe of illustrated periodicals that revolutionised the European press in the nineteenth century – was powerfully underwriting this ecumenical message from an English garden festival. At the centre of the page, beneath the heading 'In an English Garden', was a photograph of '"The Queen Elizabeth" Rose', a new variety from Harry Wheatcroft which a caption endorsed enthusiastically (*fig.39*). On the opposite page, the new rose's royal dedicatee took centre stage: 'Her Majesty Taking the Salute at the Conclusion of the Birthday Parade'.

A better-known text published the same year and touching on the English garden struck a rather different note. It was in 1956 that Nikolaus Pevsner published his Reith Lectures on 'The Englishness of English Art', but this did not specifically address a 'nation of gardeners'. Pevsner had little space to devote to gardens in a study concerned predominantly with England's architectural heritage. But he did recognise their national significance, arguing that 'picturesque gardening' had a long and intimate connection with the English political tradition. Pevsner substantiated the point by quoting from George Mason's *Essay on Design in Gardening* (1768), which stated that landscape gardening in England derived from the nation's 'Independency ... in

matters of taste and in religion and government'. Most suggestive among his comments on the influence of gardening on the broader planning of town and countryside was his gloss on the statement: 'The picturesque entered the town not on urban terms.'[2] Faithful to his current project of distinguishing English architectural achievements from their Continental – primarily French – counterparts, Pevsner ascribed the emergence of landscaped London squares to 'the old and eminently English tradition of cathedral towns. The English cathedral stands in a close, that is a precinct, originally as a churchyard turfed and tree-planted, and later landscaped.'

Yet Pevsner's important study did not give further attention to this theme of the 'eminently English' *rus in urbe*. The sole garden that he illustrated was the country-house park of Claremont, Surrey, where Capability Brown's landscape had erased the earlier contributions of Vanbrugh, Kent and Bridgeman. As for 'the picturesque in the city', he could pursue his earlier theme only by saying that 'when it comes to the problems of today, it has little to contribute'.[3] Believing the main task of the present to be 'the planning of new towns, or parts of towns', he called for the development of 'an English national planning theory' based on the precept of Pope: 'Consult the genius of the place in all.' But in advocating such a philosophy of respecting 'the character of the site ... not only the geographical but also the historical, social and especially the aesthetic character', Pevsner made no further reference to the precedent of the English cathedral close.

Can we find any sort of mediation between these two views of the English garden expressed in 1956? Would the veteran horticulturalist reporting on the Chelsea Flower Show have had anything in common with the committed architectural modernist taking Capability Brown as his model as he urged discretion upon the builders of new towns? Probably not. But it is worth noting that Edward Hyams, in writing *The English Garden* (1964), recognised the need to encompass the English gardening and landscape tradition in terms of two antagonistic impulses that were, in his view, of equal importance. These he

equated with the 'Paradise-Garden' and the 'Picture-Garden'.4 Of the second, the most salient example that he could pick was Stourhead, and one of its grand Claudean vistas appeared on the cover of the book. But for the first he went to the other end of the scale, identifying the Paradise type with the generic 'cottage garden', which he illustrated with several images.

Hyams acknowledged a crucial tension in the English tradition between 'great gardens' and 'cottage gardens'. Moreover, he was convinced that it was not Stourhead but the cottage garden that offered the best hope for the future. He had taken the part not of Pevsner's town planners (whose star had perhaps waned a little by the 1960s), but of the innumerable 'gardeners – and heroes' celebrated by Clarence Elliott. Indeed Elliott himself attracted a compliment in Hyams's book for an innovation peculiar to the cottage garden: that of substituting 'our native and very prostrate thyme for grass' on sites where grass would not naturally remain short.5 Doubtless he had planted a thyme lawn at his own country home, Clematis Cottage, Broadwell, Moreton-in-Marsh.6 It would be wrong to conclude, however, that the Cotswold cottage idyll took all the prizes in the panorama that Hyams sketched in *The English Garden*. In exploring the variety of English garden forms, he took care to include an approving passage on the allotment.

In focusing initially on the period roughly half a century ago, I have tried to bring out from the start the different stakes – horticultural and architectural, traditionalist and modern – that have been invested in the concept of the English garden. To enlarge the debate in the context of the present exhibition, I need also to indicate the wider rim of concerns – poetic, aesthetic and historical – that have framed (and continue to frame) the discourse of the garden in British culture.7 This excursus through national symbolism and literary tradition will, however, eventually lead us back to specific issues implied in the contrast between Elliott, Pevsner and Hyams, and to a further mention of Pevsner's distinctive interpretation of *rus in urbe*.

In considering Elliott's reference to 'a nation of gardeners – and heroes', one can appreciate that the 1950s was a significant time for issues of national identity to rise the surface. This was a period when the breakdown of the old European order in the course of two world wars had resulted in an intense scrutiny of the collective symbols underscoring the identity of the major nation states. Symptomatic of this process was the English publication of Elias Canetti's *Crowds and Power* in 1962. Canetti's account of the crowd in modern history suggested that each of the main European countries could be identified with a particular symbol. This reflected not only the determining influence of history and geography, but also the entire cast of mind through which a particular population saw its place in the wider world. Having himself grown up in the shadow of the multinational Austro-Hungarian Empire while it was losing its Central European hegemony, Canetti understandably ascribed a purposeful national destiny to the new German nation state centred on Berlin. He attributed to Germany the 'crowd symbol' of the forest, expressed in anthropomorphic terms as a mass of marching men. For the Spanish, Canetti selected the figure of the Matador, and for France the collective symbol of the Revolution, which was both an event in history and a mythic source of unity. In Britain's case he chose the image of the Sea Captain on board ship.8 In his assessment it was Britain's status as a sea-girt island that symbolically predestined her eventual emergence as a worldwide imperial power.

Canetti's concept of the 'crowd symbol' was itself, as I have stressed, the product of a particular historical phase in the development of contemporary Europe. But it is worth pointing out that any such 'crowd symbols' have already been established in the national tradition by literary and poetic usage. Such a powerful symbol as that of the Sea Captain circulates not as an isolated concept but as an image already freighted with connotations. If we seek out the antecedents of the 'Ship of Empire' in the English tradition, we find that there is a close connection between the imagery of marine domination and Elliott's 'nation of gardeners – and heroes'.

One source among many is the legendary speech made by the dying John of Gaunt, in Shakespeare's *Richard II*, Act 2, scene 1. Here the signifiers linking war and the garden come thick and fast. England is described as 'this seat of Mars | This other Eden, demi-paradise'. Extending the audacious comparison, the connected images of the walled garden and the moated manor house are then introduced. A concrete reference is mobilised to reinforce the striking metaphor of the jewel in its silver setting:

This precious stone set in the silver sea,
Which serves it in the office of a wall,
Or as a moat defensive to a house.

It would, however, be facile to make too much of this comparison between two 'Elizabethan' ages, the 1590s and the 1950s. As the current exhibition deals with the role of the garden in the past two centuries, I want to look back at some of the transformations of the 'Eden' metaphor in British culture during this period. The question, however, is how far back we must go to recognise the existence of a mythic core that resists dilution – one to which a wide variety of garden, park and landscape expressions can be attached. The evidence shows, I believe, that these are often myths attached to Britain's earliest recorded history, and have passed into currency as that history has been written down and interpreted by generations of antiquarians and travel writers.

This is not a common pattern among western European nations. When Canetti identified France's 'crowd symbol' as the Revolution, he reasonably saw French national identity as being bound up with the events following 1789. Eugen Weber has constructed a comparable genealogy of the development of French national consciousness in his essay 'In Search of the Hexagon', which traces the stages preceding the acceptance of this geometrical figure as an image of the French state. Michelet is quoted for explaining in his *Tableau de la France* that 'national entity finds its imperfect origin in geography, but is fulfilled in history'.[9] For him, the upheaval of the Revolution succeeds precisely in fusing together the distinct medieval provinces that each contribute their special qualities to the overall blend. Yet the ultimate image of France in terms of the pure geometry of the Hexagon only supervenes when, in the cold light of post-war decolonisation, geography assumes a new, restricting significance. Weber concludes: 'Suggestively, the first use of "hexagon" in a title is found in an article of 1956, written to show the relative nature of the country's limits.'

In England, perhaps, the magic number of seven has not been so successfully demythologised. For it was not the geometrical definition of frontiers so much as the lure of ancient kingdoms that offered the starting point for history and topography. The notion of the Heptarchy – the seven original kingdoms established after the invasion of Angles, Saxons and Jutes – was a starting point for Bede, in his founding history of the English church and people; for Camden in his Tudor celebration of

Britannia; and also for such later, more selective descriptions of favoured parts of the country as in William Lambarde's *Perambulation of Kent* (1570).[10] Wessex, Sussex, Kent, Essex, East Anglia, Mercia and Northumbria were, however, at least in terms of any post-Conquest development, inappropriately matched entities – some being perpetuated in the names of English counties and others left hanging as mere names only to be recently revived in the titles of royal princes and new universities.

Clearly the connotations of the Heptarchy tend in an exactly opposite direction to those of the Hexagon, and this comparison also brings out, on the English side, the role played by the metaphor of the garden. For the garden conceived in Edenic terms is indeed more than a frontier, limit or enclosure. It is a replete space, a protected area, dense in its symbolism. The fact that one of the original constituent kingdoms of the Heptarchy – surviving now in the form of a county – is generally known as 'The Garden of England', is indeed no accident. For Kent to merit this title, it needed to possess already the historical identity of a place set apart.

I will not, however, speculate on the origins of this epithet 'The Garden of England'. I will take the term as read, like the following commentator from the 1960s, who goes on to make an important qualification:

Kent has often been called 'The Garden of England'.
In a sense the whole of Southern England is like a garden laid out on a vast scale ... Even so, this part of the chalk country where it slopes towards the Thames Valley justifies Kent's traditional character as a garden in a more precise sense than any other county.[11]

The rhetorical moves that underpin this judgement are interesting, since they show how geography is inflected by poetics as well as by history. It is a question of taking the part for the whole – a basic move in any form of poetic creation. 'Southern England', so described here, assures the identity of the whole of England as a garden, but only by excluding the Northern parts (metonymy). The key phrase 'The Garden of England' then focuses the garden-like character of the South into one particular part, Kent. Southern England is only 'like' a garden (simile). Kent, though itself part of the South, is termed 'The Garden of England', the part substituting for the whole (synecdoche). Nonetheless, it is primarily one part of Kent

(here described in geographical terms) that qualifies the county (kingdom) to be described in this way.

In noting such poetic usage in journalistic prose, we gain a limited insight into the ways in which the myth of the English garden has developed in the general context of English literary culture. For it is in the writings of major poets and novelists that Edenic themes and the poetics of garden description have become most significantly intertwined. Only a few writers can be considered here, as signposts to a much richer field of investigation. If I begin with Rudyard Kipling, this is because he chose to regard the entirety of English culture in terms of a well-tended garden when he wrote 'The Glory of the Garden' in 1911:

Our England is a garden, and such gardens are not made
By singing: — 'oh, how beautiful!' and sitting in the shade,
While better men than we go out and start their working lives
At grubbing weeds from gravel paths with broken dinner knives.

In this poem, though, any remote echo of Shakespeare's John of Gaunt is rapidly overhauled by a social message of some acerbity, with the garden being used as a token for the difference between honest labour and passive enjoyment. The Arts Council of Great Britain understandably warmed to this pragmatic intention when it chose the title 'The Glory of the Garden' for what was perhaps the most wide-ranging report to date on the full range of art and culture throughout contemporary Britain.[12]

Indeed Kipling was hardly a person to luxuriate long in Eden. But he was a man of the Heptarchy, choosing to settle in Sussex, a county (as he put it) that was both a bishopric (the See of Chichester) and a kingdom. His poem 'Sussex' cleverly contrasts the distinctive landscape of that county with a stereotyped notion of the enclosed garden, and also smuggles in the adjacent sea, only to reclaim a paradise of a kind at the end of it all:

No tender-hearted garden crowns,
No bosomed woods adorn
Our blunt, bow-headed, whale-backed Downs.
But gnarled and writhen thorn ...

We have no waters to delight
Our broad and brookless vales
Only our close-bit thyme that smells
Like dawn in Paradise.[13]

It is precisely as a counterweight to the myth of the Garden developed by the Pre-Raphaelites and the Aesthetic Movement that Kipling's stern Sussex landscape makes its impact. The orthodoxy of the previous generation might be represented, for example, by the garden imagery of a novel such as George Meredith's *Rhoda Fleming* (1865), whose heroine's descent from a Kentish farmhouse into the grim streets of London — 'from a home of flowers into regions where flowers are few' — duplicates the fate of the fallen woman in Dante Gabriel Rossetti's only sortie into contemporary life, the painting *Found* 1854.[14] Meredith underlines the Edenic reference by including two ancient, admonitory trees in the Kentish garden: 'The two stone-pines in the miller's grounds were likened by them to Adam and Eve turning away from the blaze of Paradise.'

Of course, the Paradise garden was not merely a symbol in the work of the Pre-Raphaelites and their associates. It was through the initiative of the young William Morris that The Red House was built among Kentish orchards, with a garden whose 'geometric, sub-divided' structure is even now being uncovered by the National Trust, after 140 years of private ownership and the inevitable encroachment of suburbia on the surrounding countryside.[15] Morris, however, in a late poem, chose to enshrine the message of Eden in reverse: that is to say, he raised the Utopian prospect of a love transcending the human condition of the Fall:

In the garden we wandered while day waned apace
And the thunder was dying aloof;
Till the moon o'er the minster-wall lifted his face,
And grey gleamed out the lead of the roof.

Then we turned from the blossoms, and cold were they grown:
In the trees the wind westering moved;
Till over the threshold back fluttered her gown,
And in the dark house was I loved.[16]

Both Kipling and Morris, then, subject the Eden myth to local transformations, drawing out its ambivalence, and employing the garden setting both to evoke and to contest the Christian message of the Fall. Kipling's most haunting description of a Sussex garden, in the short story 'They', could almost appear as an evocation of his own final home in the county, Bateman's just outside Burwash, though Kipling himself could hardly have installed such phantasmagoric topiary to welcome the unsuspecting visitor:

As the light beat across my face my fore-wheels took the turf of a great still lawn from which sprang horsemen ten feet high with levelled lances, monstrous peacocks, and sleek round-headed maids of honour ... all of clipped yew. Across the lawn — the marshalled woods besieged it on three sides — stood an ancient house of lichened and weather-worn stone, with mullioned windows and roofs of rose-red tile. It was flanked by semi-circular walls, also rose-red, that closed the lawn on the fourth side, and at their feet a box hedge grew man-high.[17]

With its horsemen of yew, and its enclosed garden 'besieged' by the surrounding world, this is certainly an image of the English manor house and garden that suggests the military metaphors of John of Gaunt's speech. Yet the embattled house in effect provides a setting for one of Kipling's most poignant ghost stories — the tale of a blind woman and her elusive, indeed non-existent as it turns out, children, the suggestive scenario of which T.S. Eliot was to echo when he compiled his own epitome of timeless Englishness in *Four Quartets*.[18]

A Sussex garden is also described at the outset of one of Walter Pater's memorable 'imaginary portraits', where it creates a moving contrast to the foreign place where the young soldier Emerald Uthwart dies a dishonourable death. The home garden in Sussex is, in Pater's words, 'a tree-less place ... in the midst of the old disafforested chase'. It fits into a historical context, and it also forms an aesthetic continuum with the surrounding countryside: 'beyond, the fields, one after another, through the white gates breaking the well-grown hedge-rows, were hardly less garden-like; little velvety fields, little with the true sweet English littleness of our little island, our land of vignettes'.[19] Pater is indeed extraordinarily attentive, in this story, to the enmeshed character of the English landscape, and it is with a similar feeling for the interconnections between the varieties of garden landscape that he describes Emerald's first arrival as a pupil at the King's School in the Precincts of Canterbury Cathedral:

The long, finely weathered, leaden roof, and the great square tower, gravely magnificent, emphatic from the first view of it over the grey down above the hop-gardens, the gently-watered meadows, dwarf now everything beside ... More and more persistently, as he proceeds, in the 'Green Court' at last, they occupy the outlook.[20]

One may bear in mind, in reading this passage, that Pater's own schooldays in Canterbury would have involved a daily journey from his mother's house in Harbledown, by way of hop-gardens and meadows, to the school buildings in the 'Green Court' of the North Precincts, which 'through the long summer ... is fragrant with lime-blossom'.[21] But it is not only the veiled autobiographical dimension that makes the passage so striking. In a critical essay on Mrs Humphry Ward's *Robert Elsmere* (1888), Pater had complimented the author on bringing out 'the so well-known grey and green of college and garden' of Oxford and showing how 'the landscape naturally counted for a good deal in the development' of her characters. His own semi-fictional work also provides a sense of how Englishness might be construed in terms of a symbiotic fusion between gardens and those who perceive and use them.

Pater's brief descriptions of Canterbury and Oxford recall Pevsner's point about the English cathedral close as a precedent for the London square. It is indeed surprising, from a gardenist point of view, that so little attention has been devoted to these distinctive urban enclaves. As is testified by William Gostling's *Walk about Canterbury* — a work whose 1825 edition was in Pater's library — the conversion of the pre-Reformation monastery of Christ Church into a foundation with a Dean and Chapter had involved a reallocation of the land that was previously 'the garden of the convent'. A wall 'with a very ancient arch in it' marked the division between the south side of the close proper and the area known to Gostling's time as 'The Oaks', where each of the new prebendal houses 'had a spot of ground for a garden allotted'.[22] The designation of 'The Oaks' thus perpetuated the memory of an area set apart for gardening on the south side of the Precincts, even though (as Gostling remarks) oaks had long since vanished from the site. On the north side of the Close was the 'Green Court', turfed with a diagonal 'gravelled walk' and planted with the 'high and spreading lime-trees' whose fragrance Pater would later recall (*figs.40–1*).[23]

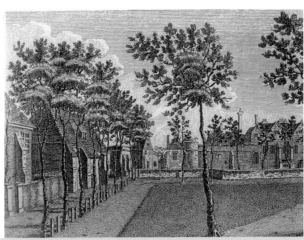

fig.40
View through the Green Court to the Deanery in the North Precincts of Canterbury Cathedral from *A Walk in and about the City of Canterbury* by William Gostling, published 1825, Private Collection

John Dixon Hunt has written of the importance of gardens and parks providing for the visitor 'a strong sense of entering a special zone'.[24] A close such as Canterbury's must always have preserved the character of a 'special zone', or indeed of several such zones, since the compartmentalisation that Pevsner identified as a feature of English Gothic architecture extended to parcels of land in just the same way as it applied to sub-divisions of space within a great ecclesiastical building. Although the occupants of the prebendal houses lost their shares in 'The Oaks', their eighteenth-century and Victorian successors created gardens around their substantial residences, incorporating the ruins and architectural fragments that lay ready to hand. Inevitably, the common focus of all these gardens would be the 'leaden roof' and 'great square tower' of the Cathedral itself. A watercolour by William De la Motte from July 1844 shows them rearing up beyond the Deanery Garden (fig.42). In the foreground the Dean's wife has arranged for some architectural fragments to be assembled into a garden seat.[25]

The gardens of the Canterbury Precincts are never likely to acquire the astounding popularity of Sissinghurst, in the Kentish Weald, of which Morris's The Red House is already being acclaimed as a precursor.[26] Yet the very degree to which these garden compartments are embedded within such a historical and architectural context gives them an exemplary significance.[27] The fact that the regulation of the Precincts still embodies a series of careful gradations between private, semi-private and public space ensures that some gardens will remain secret. However, there is an annual opening of what is possibly the most remarkable of them all, situated between the Cloisters and Chillenden Chambers. Gostling had already noted of this residence, allotted to an archdeacon, that 'the common kitchen' of the pre-Reformation monastery was 'now a garden'. One of the mid-fourteenth-century fireplaces is visible, still blackened from smoke. An archway containing perhaps the oldest surviving sculptural representation of St Thomas Becket leads to a large sunken garden, whose extent and depth derive from the fact that this was the original site of the Cellarer's Hall. '[F]or the most part ruins or gardens,' writes Gostling of the adjoining areas, neatly expressing in that artless formula the inextricably interwoven texture of the site.[28]

What we can observe in the gardens of a close like Canterbury's is a kind of overdetermined picturesque, where the historic architecture enriches all the vistas. Here the horizon, the 'eye-catcher', is inevitably the Bell Harry Tower. Nevertheless, the various types of planting, from the traditional

fig.41
Map of Canterbury from A Walk in and about the City of Canterbury by William Gostling, published 1825. The Precincts of the cathedral can be seen in the right-hand section of the map, bounded by the city walls. The Green Court is labelled N; the area known as 'The Oaks', previously the garden of the monastic community, is in the South Precincts, labelled M. Private Collection

rows of trees to more recently installed herbaceous borders, create their own localised effects of *rus in urbe* within each enclosure.

That the picturesque in the city has, in Pevsner's words, 'little to contribute' would be a dispiriting conclusion to this essay. Ian Hamilton Finlay's recent and ongoing work at St George's Brandon Hill, Bristol, has shown indeed that a modest town churchyard can also be revivified as a contemporary garden (*fig.43*). St George's lies close beside the public park of Brandon Hill and not far from College Green, which is a turfed enclosure relating to the precincts of a pre-Reformation religious foundation (now the Cathedral). The churchyard descends the hill in a series of walled terraces, and the church, in the form of a classical temple, has recently become a renowned concert hall. Here Finlay's inscribed plaques and stone benches enact through their citations a double process of metamorphosis. The text of Virgil's *Eclogues*, celebrating Circe's magical use of song, appears in Latin and English. The Czech composer Janáček's reminiscence of being transported in dreams provides a musician's analogy for the poetic authorship of the garden. Through minimal means, the imaginative space is expanded, and in becoming also a garden, the churchyard takes on a new historical and poetic identity.

1 Clarence Elliott, 'Chelsea 1956', *Illustrated London News*, 9 June 1956, p.688. **2** Nikolaus Pevsner, *The Englishness of English Art*, London 1956, pp.166–7. **3** Ibid., pp.168–9. **4** See Edward Hyams, *The English Garden*, London 1964, passim. **5** Ibid., p.125. **6** See the entry on Clarence Elliott (1881–1969) in *Who Was Who*, where he is credited with introducing and reintroducing to cultivation a number of plants, including a variety of thyme. **7** For an extended treatment of this issue in relation to the period following the Second World War, see David Matless, *Landscape and Englishness*, London 1998, particularly chapter 7, 'Citizens in Reconstruction', and chapter 8, 'Landscape and Englishness in an Altered State'. **8** Elias Canetti, *Crowds and Power*, trans. Carol Stewart, London 1962, pp.75–90. **9** Eugen Weber, 'In Search of the Hexagon', in *My France: Politics, Culture, Myth*, Cambridge, Massachusetts, and London 1991, pp.67, 70–1. **10** See William Lambarde, *Perambulation of Kent*, Bath 1970, pp.xii–xvi. **11** E.F. Lincoln, *The Heritage of Kent*, London 1966, p.11. **12** See Arts Council, *The Glory of the Garden: The Development of the Arts in England: A Strategy for a Decade*, London 1984. **13** Rudyard Kipling, *The Five Nations*, London 1903, pp.72–3. **14** Quoted in Stephen Bann, 'Meredith's Plain Story', *Literatur in Wissenschaft und Unterricht*, vol.XI, no.2, 1978, p.76. It is likely that the painting was still in Rossetti's studio in Cheyne Walk, London, when Meredith took up intermittent residence there in 1862. **15** See report by John Lee in *Toronto Globe and Mail*, 19 July 2003, T8. **16** William Morris, *Poems Written by the Way*, London 1892, p.77. The complexity of the poem with regard to Christian myth can be gauged by the fact that the early stanzas clearly indicate the dating of the scene to be on Good Friday. **17** Rudyard Kipling, *Traffics and Discoveries*, London 1904, pp.304–5. **18** T.S. Eliot, *Four Quartets*, tenth impression, London 1955, 'Burnt Norton', p.13: 'There rises the hidden laughter|of children in the foliage …' **19** Walter Pater, *Miscellaneous Studies*, Oxford 1895, pp.200–1. **20** Ibid., p.208. **21** Ibid., p.226. **22** William Gostling, *A Walk in and about the City of Canterbury*, Canterbury 1825, p.135. **23** Ibid., p.151. **24** John Dixon Hunt, 'The Garden as Virtual Reality', *Die Gartenkunst*, 1997, no.1, p.7. **25** See Patrick Collinson et al. (eds.), *A History of Canterbury Cathedral*, Oxford 1995, pl.51. **26** Lee 2003, T8. **27** For further discussion, see Stephen Bann, 'Shrines, Gardens, Utopias', *New Literary History*, vol.25, no.4, Autumn 1994, pp.825–38. **28** Gostling 1825, p.197.

fig.42
William De la Motte (1775–1863), *Canterbury Cathedral: View from the Bishop's Garden* 1844
Watercolour, 35.5 × 26
Canterbury Cathedral Archives

fig.43
Ian Hamilton Finlay (born 1925)
Inscribed plaque in the garden of St George's, Brandon Hill, Bristol.
Photograph: Sarah Mowl

Catalogue

Thresholds and Prospects

*P*rospects, elevated views of landscape, are a resilient genre of garden portraiture. Established in British art in the early eighteenth century as so-called bird's-eye views, showing new or newly fashioned gardens from aerial vantage points, prospects developed into a complex and comprehensive genre of landscape art. Vantage points for prospect views multiplied, often as part of the apparatus of garden design, including gazebos, groves, balustrades and bay windows, park entrances, roadside beauty spots and carriage windows. These devices acted as screens, framing some features, concealing others, creating a variety of views, from narrow vistas to wide-ranging panoramas. If the garden prospects of country houses looked over extensive private estates, the views usually included a social world of fields, forests, roads and rivers, sometimes towns and cities. Garden prospects were valued for portraying public virtues of good taste, social order and commercial productivity.

Prospects charted time as well as space. The term 'prospect' usually meant a view into the future as well as the distance, often of an improving world, but views in the style of paintings of the Italian *campagna* also looked back to past garden glories, sometimes over ruined gardens. Reflecting the literature on gardens as well as the look of the land, prospects blended topographical view with poetic vision. In drawings and designs, commissioned paintings and published prints, prospects contributed to the impression of Britain as a garden-like landscape, a nation in which the garden diffused throughout its society and territory as a defining form of cultural identity.[1]

As this section of the exhibition shows, the prospect tradition of garden portraiture has been continually reworked and revitalised since the nineteenth century, during which period garden access and ownership has extended to the majority of the British population. The focus in these works is on the gardens of professionals, notably professional artists. They show gardens of various sizes and styles, front and back, flower and vegetable, horticultural and architectural, in various situations, village, city, suburb and seaside. The pictures deploy a number of viewpoints, including gates, balconies, terraces, paths, patios and bedroom windows. In many works the artist has a personal stake in the scene, in views of their own gardens or those of their family, close friends and neighbours. As well as addressing some private concerns, these pictures also document public issues such as wartime mobilisation or suburban planning. They deploy a rich range of cultural allusions, drawing on the Bible, topographical poetry and novels, and on canonical works in the tradition of prospective art.

For the artists represented, garden paintings are integral to a wider body of landscape exploration. For many, including John Constable (cats.1–2) and George Shaw (cat.26), they are part of a series of landscape depictions, from many viewpoints, of a childhood home locality. It is scarcely surprising that these pictures express a strong strain of personal memory, even nostalgia. Atkinson Grimshaw's view of an old, neglected manor house garden (cat.4) is one of a series in his home city of Leeds, but for the former railway clerk

it represented a move upward and outward, in a picture commemorating his move to the mansion, setting the seal on his professional success. Spencer Gore (cats.10–12) expressed a more mobile, metropolitan vision of domestic modernity through garden views from the many houses he stayed at within easy reach of a London railway station, from Letchworth through Camden Town to Brighton. Taking in a less striking, but not less significant, range of scenery, Stanley Spencer (cat.16) focused on gardens of all classes within his cherished Thameside village of Cookham, including the newly made gardens of rural council houses. For some artists in this section, such as Turner (cat.3) and Melville (cat.5), their works here are part of a touring profession of landscape art, if they also express a domestic familiarity that gardens as a subject invite.

Two thresholds distinguish these prospective views, almost as motifs in themselves: fences and windows. Each was central to formulating landscape gardening in the nineteenth century as a polite art for those with smaller gardens, and has been thoroughly assimilated into the popular aesthetics of gardens since. Fencing in these pictures is a major feature and structuring device. It takes a variety of forms, brick walls, wooden palings, iron railings, shrub hedges. Indeed most of the gardens shown are surrounded by fencing high enough to shut out the view of the landscape from ground level, and from those figures shown, such as McIntosh Patrick's wife and daughter (cat.18), Pissarro's granddaughter and her nursemaid (cat.9) and the gardeners in the works by Constable (cat.2), Gore (cat.12) and Mahoney (cat.17), all focused, heads down, on tasks at hand. Only from a vantage point which transcends it is the very enclosure which defines a garden fully evident. From the elevated view of the artist, fencing both divides private gardens from the world beyond and establishes connections, for example through repeated patterns in neighbouring gardens, in field boundaries and the layout of streets and buildings, or by creating vistas on distant landmarks.

Fenestration was a focus of landscape gardening. Larger windows, with lowered sills, let in more light for reading and writing, viewing and drawing pictures, and increased the exterior field of vision. Wooden frames structured views and glass panes intensified focus and distributed it more evenly. Blinds, curtains, bows, coloured glass and transparencies, and plants on sills and balconies, made windows key scenic devices.[2] Windows came to define modern landscape sensibilities more broadly, as a threshold between an inner personal and an outer public domain, between the self and society.[3] Two highly, almost anxiously, detailed pictures painted in wartime exemplify this. Constable's window views over his family's gardens frame a threshold between a public, patriotic domain of agrarian improvement and a private world of family mourning. On the eve of his call-up for the Second World War, McIntosh Patrick looked from his bedroom window to his wife and child in their garden and beyond them to the strategic industrial landscape of Dundee. In many of these pictures the windows of neighbouring buildings also feature in the view, as if a self-conscious form of spectatorship is as much a subject as the landscape in view.
—*Stephen Daniels*

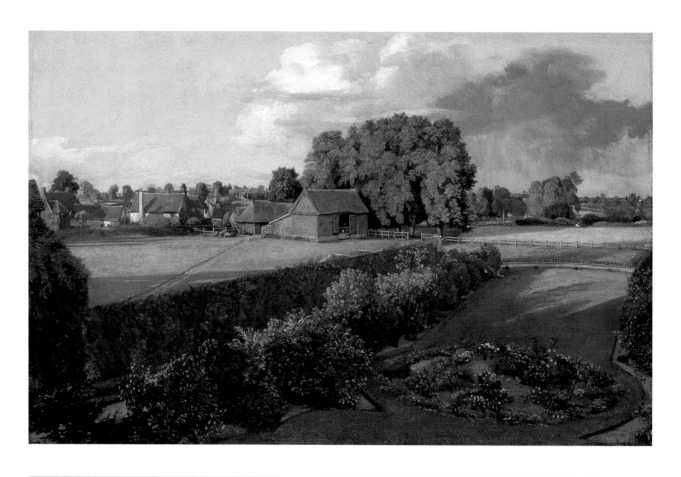

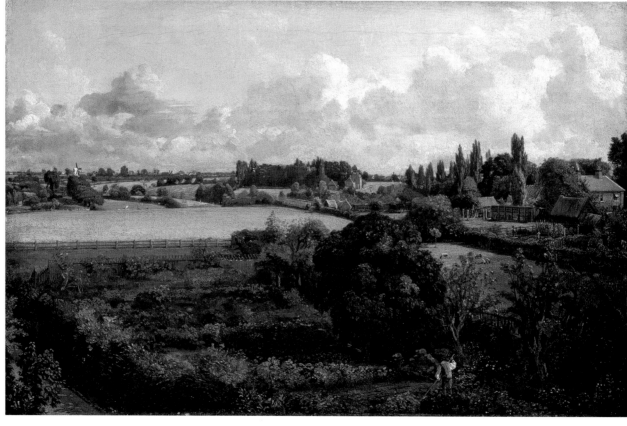

1

John Constable (1776–1837)
Golding Constable's Flower Garden 1815
Oil on canvas, 33 x 50.8
Ipswich Borough Council, Museums and Galleries
LONDON ONLY

2

Golding Constable's Vegetable Garden 1815
Oil on canvas, 33 x 50.8
Ipswich Borough Council, Museums and Galleries
LONDON ONLY

This pair of paintings shows two aspects of the back view from the upper storeys of Constable's family home in East Bergholt, Suffolk. Together they present a comprehensive prospect of an intricate landscape belonging to Constable's father, Golding: the two gardens and, beyond them, corn-fields and pastures reaching to the family windmill on the horizon. It is late summer and the landscape is in a state of high cultivation. Flanking the prospect, creating a landscape panoramic in scope, are other properties in the village. Features are delineated evenly across the picture surface, those in the distance in the same sharp focus as those in the foreground. The lens-like intensity recalls the windows which define the threshold of the view. The even focus is also cartographic; this area was being intensively mapped at the time, including the map for the enclosure award which codified the pattern of properties in view.[1]

The *Flower Garden* and *Vegetable Garden* are just two of a sequence of paintings that Constable produced between 1814 and 1816, surveying with great precision various sites in his home village, including those around the family's water mill at Flatford. The pair was never exhibited by Constable, perhaps because they portrayed some personal, intimate concerns of the artist. The image is one of orderly landscape management. As good Protestants, the Constable family took seriously the moral and religious duty to cultivate the land carefully. Moreover, in a period of war, such a productive landscape carried patriotic associations.

The kitchen garden, worked by the family gardener, hoeing or raking, displays rows of vegetables, conspicuously cabbages, and also some fruit trees, including plums. The flower garden is a recent and more fashionable addition, a so-called 'mingled flower garden' or 'English garden' carefully sown to produce flowers from spring until late autumn designed to be seen from windows. It was a style which earned a seal of approval from the leading evangelical poem on the virtues of gardening and farming, William Cowper's *The Task*, a particular favourite of Constable:

A flowr'y island, from the dark green lawn
Emerging, must be deem'd a labour due
To no mean hand, and asks the touch of taste.

This touch of taste was provided by Constable's mother, Ann. She undertook the more delicate tasks, sowing, hoeing and pruning in her own garden, as well as casting a critical eye on the horticultural efforts of her neighbours, in a period when the supervision and practice of ornamental gardening were recommended as a polite pursuit for women. As with some biblical gardens, and the new role of flowers and garden-like graveyards in Christian remembrance, the Constables' garden carried more melancholy associations. For it was while working in the garden the previous spring that Ann Constable fell into a fever, brought on, Constable's brother informed him, 'by the cold, which was very severe, & stooping to weed'; she died within a week. The garden blooming on this late summer evening, a long shadow cast across it, echoed by the dark cloud on the horizon, proves a poignant memory of his mother and her passing.[2] SD

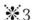 3

Joseph Mallord William Turner (1775–1851)
View from the Terrace of a Villa at Niton,
Isle of Wight, from Sketches by a Lady exh.1826
Oil on canvas, 45.5 x 61
Museum of Fine Arts, Boston

This painting shows the garden of The Orchard, a villa overlooking the English Channel situated just east of St Catherine's Point, the most southerly point of the Isle of Wight. The Orchard was the home of Sir Willoughby Gordon and his wife Julia, née Bennet; they had acquired the property in 1813 and undertaken extensive modifications to the house and grounds. (In 1818 Lady Gordon inherited a second property on the island, the Jacobean Manor of Northcourt, at Shorwell, the environs of which were also painted by Turner.) While the island as a whole had a reputation as the 'Garden of England' in the Georgian period, it was the picturesque scenery of the undercliff along the south-west coast between Niton and Ventnor that was particularly favoured as a location for fashionable villas. Contemporary depictions of The Orchard tend to show it from the seaward side, surrounded by trees and with the cliffs looming behind, but the viewpoint in this painting emphasises the improvements to the grounds and the cultivated aspect of the site. The terraced gardens were celebrated enough to warrant a visit from Queen Victoria in 1867.

Julia Bennet had been a pupil of Turner in 1797, and was afterwards taught by Thomas Girtin and David Cox.[3] She had evidently remained in contact with Turner, and it has been suggested that this painting was commissioned from him as a gift to her husband. Turner had travelled around the Isle of Wight in 1795, but as he had never visited The Orchard, he developed his composition from sketches provided for him by Lady Gordon. A comparison of her original watercolour (Private Collection) with Turner's painting suggests that he might have added some improvements of his own, for example in the detail of the fountain playing on the garden's lowest level.[4] The character of the picture is very much aligned to his vignette style of the 1820s, with fanciful emblems of the civilised life (palette, shawl and lute) set against the geological chaos of the undercliff and a wide prospect of the channel beyond. NA

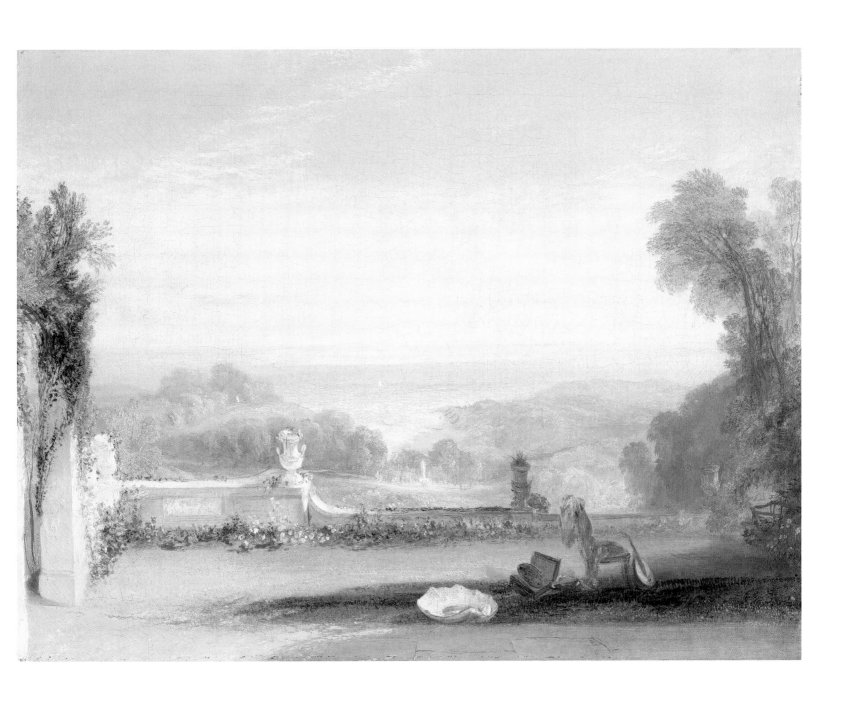

4

Atkinson Grimshaw (1836–1893)
Knostrop Hall, Early Morning 1870
Oil on canvas, 59.7 x 90.2
Private Collection

To seal his success as a professional artist in Leeds, in 1870 Grimshaw took on the tenancy of Knostrop Old Hall, a seventeenth-century manor house two miles east of the city centre, and commemorated the event with this painting. As a thriving centre for contemporary art, with an enthusiastic circle of patrons among the commercial and industrial elite, Leeds proved a promising environment for the former railway clerk and apparently self-taught painter. The city's expansion brought Knostrop Hall within a short carriage ride of the city centre, part of a suburbanised zone of old estate lands. In taking up his new residence Grimshaw also moved into a landscape resonant with literary associations.[5]

This view across the entrance gardens to the house blends fact and fantasy. The detail is meticulously observed and Grimshaw may have based it on photographs (still, silhouetted leafless trees are a signature of early landscape photography using slow exposures). There is a good deal of fabrication. The artist has added an ornate wing to the house to make it appear more 'Jacobean'. If the gardens had in fact been neglected, they now conform more fully to the topos of 'the deserted garden', a staple of Victorian literature and art.[6] Broken bows of overgrown trees and shards of clay pots litter the left foreground, while on the right an ivy-covered roller lies half-buried in the soil.

Grimshaw's garden echoes the garden imagery in the poems of Tennyson, with their lonely halls, chill dawns, dying leaves, decaying flowers and bare and blackened trees. (The painter's devotion to the poet extended to naming his children after characters in *Idylls of the King*.) The painting is also Tennysonian in sustaining a dual image of the garden as both escapist paradise and social actuality, notably the old aristocratic gardens coming into the possession of an industrially based middle-class family like Grimshaw's.[7] The stately architecture of walls, fountains and entrance gate appears in good condition and there are signs of renovation, including new palings and saplings.

Grimshaw continued to depict garden themes in views based at Knostrop, notably some scenes of women in walled gardens and conservatories in the style of Tissot, if more respectably so. He also made a series of views of suburban lanes running outside high-walled villas, usually walked by lone female figures, a contrast with the women secured within. SD

Arthur Melville (1855–1904)
A Cabbage Garden 1877
Oil on canvas, 45.1 x 30.5
Andrew McIntosh Patrick

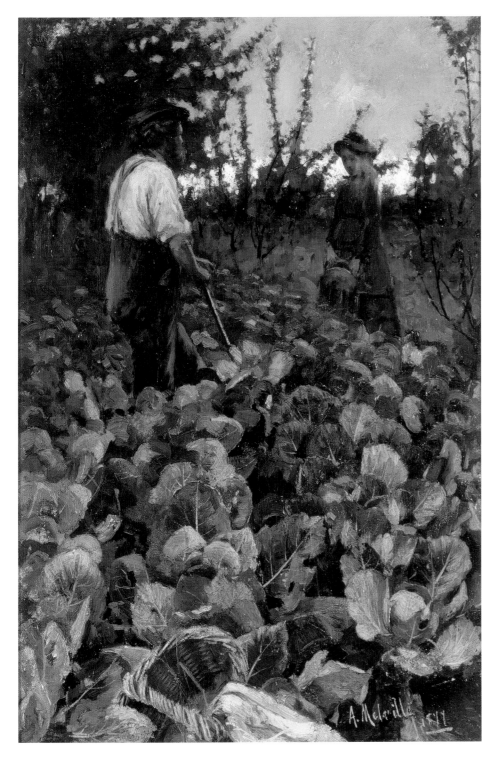

A Cabbage Garden launched Melville's international career when it was exhibited at the Royal Academy in 1878. Aged twenty-two, Melville was then a full-time student at the Royal Scottish Academy, Edinburgh. He had secured his place after successfully submitting a painting titled *The Scottish Lassie* to the Academy's annual exhibition. It was painted while he worked as a clerk in Dalkeith, taking art classes in the evening, and was sold to his father's employer. *A Cabbage Garden* shows the influence of Melville's tutor at the RSA, James Campbell Noble, who also lived in Melville's home village of East Linton. Noble was the luminary of a group of painters based in East Lothian who specialised in scenes of field working, focused on local subjects, and were influenced by modern Dutch rural paintings, already popular with British collectors. In the mid-nineteenth century East Lothian was renowned for the prosperity of its farming and well-paid, well-fed farm workers, probably unrivalled in Europe; despite, or perhaps because of, the fact that conditions were now visibly worsening, there is little sign of social hardship in these pictures.[8]

Cabbages, a staple of north European agriculture, featured frequently in art focused on rural, especially peasant, life. Indeed they had a particular Scottish resonance, both within the country and throughout a British empire in which Scots were a dominant force, for their associations with the 'kailyard', a cottage kitchen garden dominated by purple kale (a key ingredient of many broths) and the name for a highly popular, deeply sentimental genre of fiction dealing with common, country life.

Melville's painting portrays a cornucopia of cabbages, plump and richly coloured; the garden looking less like a kailyard than an intensively farmed plot. This impression is strengthened by the upper part of the picture, in which the garden is bordered by an orchard, suggesting it is on the grounds of an estate. There is a parallel with Frederick Walker's watercolour of 1870 *An Amateur* (cat.33) showing a man working in a cabbage patch as part of an estate's kitchen gardens. The line between cabbage garden and orchard marks a social boundary too, for, in what appears to be an episode from a narrative, a well-to-do girl has stopped to talk to the sturdy gardener leaning on his spade.

The success of *A Cabbage Garden* prompted Melville to study in Paris, following a number of British painters to the Académie Julian, and to settle in the village of Grez, near Fontainebleau, an established painting ground, where he drew scenes of rural life. On his return to Scotland he became a highly influential figure in the prominent art circle based in Glasgow. SD

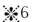 6

William York MacGregor
(1855–1923)
A Cottage Garden, Crail 1883
Oil on canvas, 40.5 x 63.5
Private Collection

Scion of a wealthy family of Glasgow shipbuilders, William MacGregor was the central figure of the school of painters known as 'The Glasgow Boys'. While the Boys gravitated to MacGregor's Glasgow studio, and took advantage of the flourishing market and public for art in the British Empire's second city, scenes of the city are conspicuously absent from their work. In retreat from the problems of city life, its squalor and social divisions, most focus on an apparently purer, more wholesome and homely life in the countryside, country villages and small towns, largely in Scotland. Most of the Boys undertook summer sojourns in such places, some settling permanently. MacGregor stayed in Crail, a small fishing and farming town on the coast of Fife, during most summers between 1878 and 1885, for up to five months at a time. *A Cottage Garden, Crail* was one of a number of his pictures of subjects and scenes drawn from the town.

The garden in MacGregor's painting is largely sheltered by buildings in Crail's main street, Marketgate. The vernacular character of the house, a Fife harling, named after the distinctive pale-coloured exterior rubble stone, is picked out by the sun shining on its freshly rendered surface. The garden features a patch of splendid cabbages, the leitmotif of Scottish garden painting, and is also stocked with flowers and fruit trees; evidently a comfortably-off household. It is a luminous scene with a recreational, holiday atmosphere.

It is instructive to look at *A Cottage Garden, Crail* alongside another of MacGregor's Crail subjects, *The Vegetable Stall* 1884 (fig.44). Painted at a time when the diet of industrial cities like Glasgow was increasingly processed, notably with tinned food, the picture offers an alluring, highly colourful array of vegetables (potatoes, onions, turnips, carrots, cabbages, leeks and rhubarb) not grown privately in local gardens, nor for subsistence, but produced commercially for sale in the market street of Crail and compact towns like it. Contemporary scenes set in a long-established, well-planned town, these pictures present an orderly vision of modern life.[9] SD

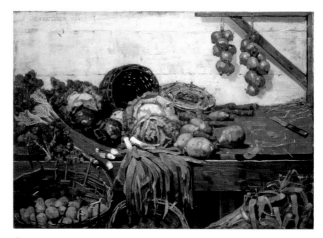

fig.44
William York MacGregor
(1855–1923)
The Vegetable Stall 1884
Oil on canvas, 106.5 x 153
National Gallery of Scotland

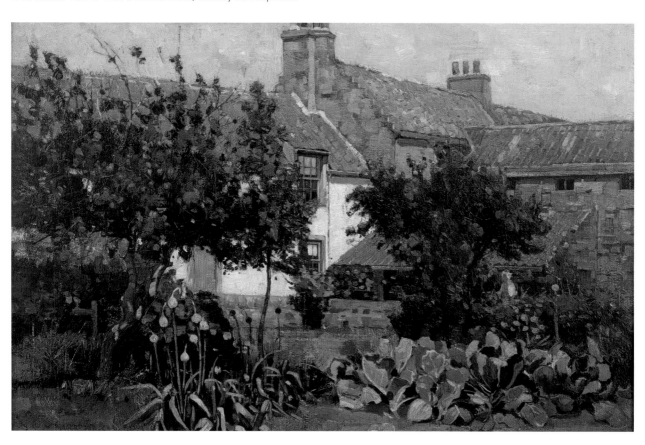

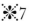**7**

Edward Atkinson Hornel
(1864–1933)
In the Crofts, Kirkcudbright 1885
Oil on canvas, 40.6 x 61
Private Collection

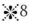**8**

Edward Atkinson Hornel
(1864–1933)
In Mine Own Back Garden 1887
Oil on canvas, 40.6 x 30.5
Hunterian Art Gallery,
University of Glasgow

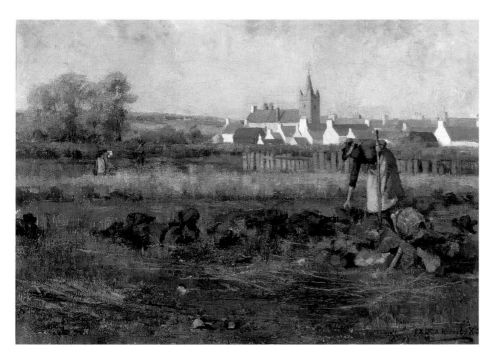

One of the Glasgow Boys, who made their artistic reputation in the booming city, Edward Hornel lived and worked for most of his life in his home town of Kirkcudbright, Galloway. While he frequently visited Glasgow, and occasionally worked in the studio of his close friend George Henry, Hornel preferred to paint in the comparative peace and quiet of Kirkcudbright. The distinctive skyline of the town, with its towered Tollbooth and whitewashed, gable-ended houses, features in these paintings.

In the Crofts, Kirkcudbright 1885 recalls garden scenes set in painting grounds popular with Scottish artists, such as James Guthrie's *A Hind's Daughter* 1883 (fig.3), Henry's *A Cottar's Garden* 1885 (Hornel Trust, Broughton House, Kirkcudbright), painted at Cockburnspath, Berwickshire, and given to Hornel or one of his family, and Frank O'Meara's *Towards Night and Winter* 1885 (Hugh Lane Municipal Gallery of Modern Art, Dublin), set in the French village of Grez-sur-Loing, which Hornel could have seen exhibited in the Glasgow Institute earlier in 1885.[10] *In the Crofts* looks across the main allotments to the south of Kirkcudbright, and shows a woman working a plot with a large patch of kale, with two more working figures beyond. The afternoon sun highlights the autumnal colours of nature and the brilliant townscape beyond.

The viewpoint of *In Mine Own Back Garden* 1887 is slightly to the east of *In the Crofts*. The title may not be Hornel's, and the archaic 'mine own' makes it sound like a quotation, but Hornel reputedly lived for a short period in a house in

this location around 1886–7.[11] The title confirms this site as a private enclosure, in contrast to the public space of the town crofts. Sunlight plays upon roses, but the conspicuous kale plant draws on the earthier kailyard image of Scottish garden art. Hornel appears to have followed the exhortation of the Glasgow Boys' father-figure, William MacGregor, to 'hack the subject out'. Pigment is laid on thickly in square brushstrokes, giving the bare earth the appearance of being freshly dug. It is as if the artist has just put down his spade, thrust in the centre of the garden, and picked up his brush to paint in the same robust manner as he gardens, hacking out the subject before returning to hack out more kale.

Hornel arranged accommodation for Henry and other Glasgow Boys in the town and the area became a favourite painting ground. In 1886 local artists formed a Fine Art Association, exhibiting there each year. In September 1887 the Glasgow weekly *Quiz* reported:

Kirkcudbright is rapidly coming to be recognized as an art centre … Rumour hath it that the sunny south of Scotland — that garden of our land — is made sunnier to artists' eyes by the smile of beauty. It may be questioned whether the artist is more fascinated by the scenery or society of that favoured spot.[12] SD

9

Camille Pissarro (1830–1903)
Bath Road, London 1897
Oil on canvas, 54 x 65
Ashmolean Museum, Oxford, Pissarro Family Gift, 1951

In four visits to London Pissarro painted a series of suburban scenes, to the south and west of the capital. In May 1897, aged sixty-seven, he made his last visit to see his artist son Lucien, who was recovering from a stroke at his home in Bedford Park, an aesthetically planned west London suburb with a conspicuous artistic colony.

Staying two months and largely tending to his son, Pissarro was able to paint little apart from a series of views from the house. This picture, evidently unfinished, was painted from the front window. It shows his four-year-old granddaughter Orovida, accompanied by a nursemaid, crouching on the lawn apparently examining some plants. Orovida Pissarro was already skilled in drawing and Pissarro saw her as a potential artist, which she in fact became. Over the hedge is Bath Road, one of the newer streets on the edge of Bedford Park, planted, in the suburb's fashion, with young flowering trees; over the road is a group of houses in the characteristic red-brick Arts and Crafts style, the nearest shown with its conservatory and garden.

Pissarro's other paintings from the house, some from its balcony at the back, offer a panorama of the local suburban landscape. They include a fête on the cricket ground, a steam train approaching the Bath Road signals (*The Train, Bedford Park* 1897, Private Collection) and a view over allotments and railway line to a common faced by a church and a block of new flats (fig.45).[13] SD

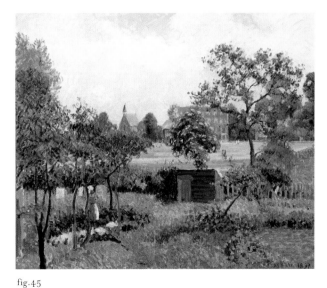

fig.45
Camille Pissarro (1830–1903)
Stamford Brook, London 1897
Oil on canvas, 54 x 65.1
Private Collection

IO

Spencer Gore (1878–1914)
The Fig Tree 1912
Oil on canvas, 63.5 x 76.2
Tate. Bequeathed by J.W. Freshfields 1955

Gore portrayed gardens in and around the various houses he lived in, worked in and visited; gardens of many shapes, sizes and styles, in different urban and rural settings, shown in various seasons and weather conditions.[14] Along with parks, sports grounds, theatres and railway stations, they were key sites in his scenes of modern life. It is a repertoire which reflects Gore's engagement with French modern art. It also underscores his grounding in English culture, an Old Harrovian's love of cricket and tennis, and the eye for residential property typical, perhaps, of the son of a successful estate agent. (Wyndham Lewis thought Gore unrivalled in discriminating 'exquisite, respectable and stodgy houses'.)[15]

The Fig Tree is one of a series of views from the upstairs flat Gore rented, after his marriage, at 2 Houghton Place, off Mornington Crescent in Camden Town, painted from a vertiginous vantage point which recalls his views from theatre balconies. A number are views in winter of bleak, leafless back gardens, but this is more lush. It shows the garden belonging to his house, with a lone figure, perhaps his new wife, and, giving the picture its title, a spectacular fig tree spreading rampantly up the wall from the neighbouring garden. Fig trees have powerful religious connotations, primarily as the tree in the Garden of Eden, and carry a sinister charge. In the high-walled gardens of Edwardian London, heated by coal fires, and other pollutants, fig trees thrived, sucking up moisture from other plants, their roots crushing underground pipes and foundations. It is as if the gardens in view are a container for this omnivorous plant, eclipsing others within its shade. SD

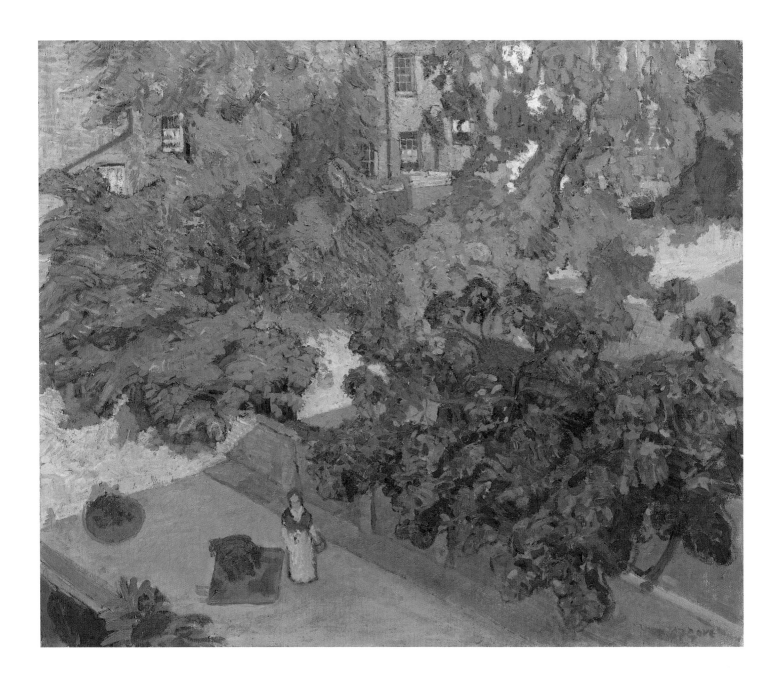

Spencer Gore (1878–1914)
From a Window in Cambrian Road, Richmond 1913
Oil on canvas, 56 x 68.5
Tate. Presented by subscribers 1920

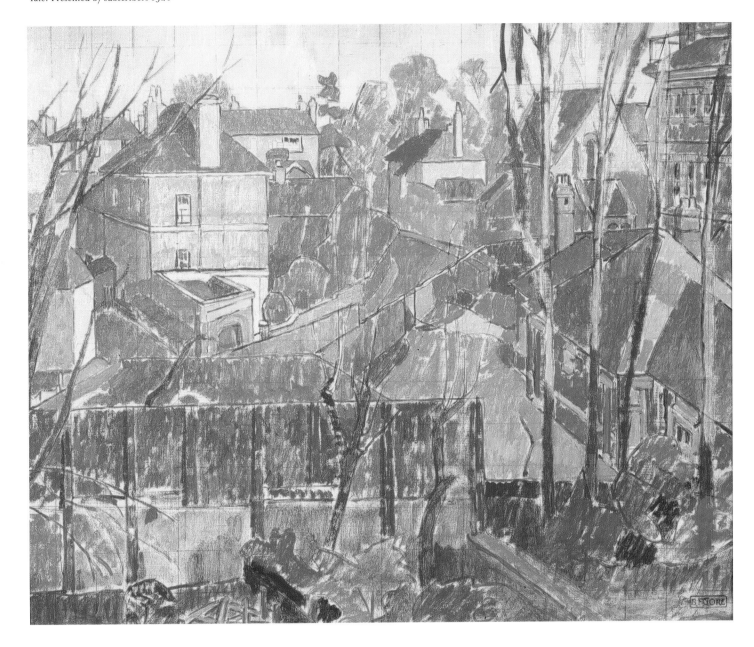

Gore and his wife and baby daughter moved from Camden Town to Richmond upon Thames in the early summer of 1913; from a smoky inner suburb to a salubrious outer suburb, to 6 Cambrian Road on the edge of Richmond Park. It was an area with family associations (his grandfather lived nearby when holding the government post of Commissioner of Woods and Forests) as well as a traditional resort of well-to-do artists and writers. Gore painted some forty pictures of the area, especially in autumn and winter, mainly scenes in the park and Cambrian Road itself. He died in March 1914 after catching pneumonia while painting in Richmond Park.[16]

As in the paintings from his rooms and flats in Camden Town, this unfinished picture is a view from an upper-storey window, looking over the garden and those of neighbours to the surrounding streets. The wintry sunshine highlights the structure of the scene, the bare trees and newly built wooden fence, the pattern of walls and roofs. With its faceted forms and areas of flat, somewhat summary, colour, the painting takes forward some of the schematic innovations Gore had undertaken the previous year when staying with Harold Gilman in Letchworth, Hertfordshire.[17]

Wyndham Lewis reproduced this picture to illustrate his obituary of Gore in the first issue of his avant-garde journal *Blast*. Lewis noted: 'His latest work, with an accentuation of structural qualities, of new and suave simplicity, might, in the course of several examples I know, be placed beside that of any of the definitely gracious artists in Europe.'[18] SD

12

Spencer Gore (1878–1914)
The West Pier, Brighton 1913
Oil on canvas, 63.5 x 76.2
Collection of the Mellon Financial Corporation, Pittsburgh

Gore stayed for a week in Brighton in the summer of 1913, before moving from Camden Town to Richmond upon Thames. This is one of two paintings he made after drawings from his host Walter Taylor's house in Brunswick Square.[19] It combines the garden with another favourite motif of modern painters and writers, the seaside.

Taylor collected work by Gore and others who painted in the style of the Camden Town School, and was also a great friend of Arnold Bennett, who wrote much of *Clayhanger* (1910) and *Hilda Lessways* (1911) in Brighton, best-selling novels with brilliant descriptions of the town and its promenade at the peak of its Edwardian fame.

The novels describe a spectacular scene, of new building thrusting upward and outward:

Brighton was evidently a city apart … the incredible frontage of hotels, pensions and apartments … bow windows and flowered balconies, giving glory to human pride … the broad and boundless promenade alive with all its processions of pleasure … nearly every bow window, out of tens of thousands of bow windows bulging forward in an effort to miss no least glimpse of the full prospect … There were two piers that strode and sprawled into the sea … and, between the two, men were walking miraculously on the sea to build a third, that should stride farther and deeper than the others.[20]

Gore's two paintings from Taylor's house similarly portray the dynamism of the Brighton sea front. The foreground of one, *Brighton Pier* 1913 (Southampton City Art Gallery), is defined by a balustrade of the balcony and the hedge of the garden below. The view of this painting appears measurably lower, being from a lower-floor bow window. The corner of the garden fills nearly half the picture. It is both a sheltered scene of calm, paced by the gardener, and an entrée into the busy scene beyond. Its triangular hedge thrusts into the picture, echoed in the bathing machines and the piles of the new pier. A thoroughly modern crowd of promenaders, with straw-hatted couples, children and babies in prams, enjoys the sunshine and sea air while pleasure craft ply the shore. SD

13

William Ratcliffe (1870–1955)
Hampstead Garden Suburb from Willifield Way c.1914
Oil on canvas, 51 x 76.3
Tate. Lent by Hampstead Garden Suburb

Exhibited at the first exhibition of the London Group in March 1914, this painting portrays Hampstead Garden Suburb from its initial social centre, the Club House, in a view from the top of its tower. From the outset, the sponsors and architects envisioned the Suburb as a pictorial as well as a green space, founded in a place associated with a group of landscape painters, Constable, Linnell and Samuel Palmer. The planning and architectural press publicised designs, illustrations and maps as the Suburb took shape.

Sited on the east side of Willifield Green, the Suburb's Club included a bowling green, tennis courts and tree-lined walks. Open to all residents over eighteen, the Club was formed to bring together the socially mixed population, and offered a range of activities, from whist drives to geography lectures. It was also the base of the Suburb's popular Horticultural Club. The view is down Willifield Way to the new development around Central Square. Designed by Edwin Lutyens in collaboration with Raymond Unwin, this represented a formal, highly professional, realignment of the Suburb. Lutyens confessed he found the taste of the Suburb's founding social visionary, Henrietta Barnett, aesthetically short-sighted: 'A nice woman but proud of being a philistine,' he told Unwin, 'has no idea much beyond a window box full of geraniums, calceolarias and lobelias, over which you can see a goose on a green.'[21]

William Ratcliffe made his early reputation painting scenes with bright progressive associations. He took up painting as a profession in 1908, aged thirty-eight, when living in the new Garden City of Letchworth, Hertfordshire. After working from home as a graphic designer and illustrator, producing drawings for postcards, calendar images and billheads for the Garden City Press, he painted views of Letchworth and its surroundings. Ratcliffe spent some months in 1913 painting scenes around a farm in Sweden occupied by advanced thinkers, before moving to Hampstead Garden Suburb the following year, lodging with his brother the journalist S.K. Ratcliffe in Willifield Way.[22] SD

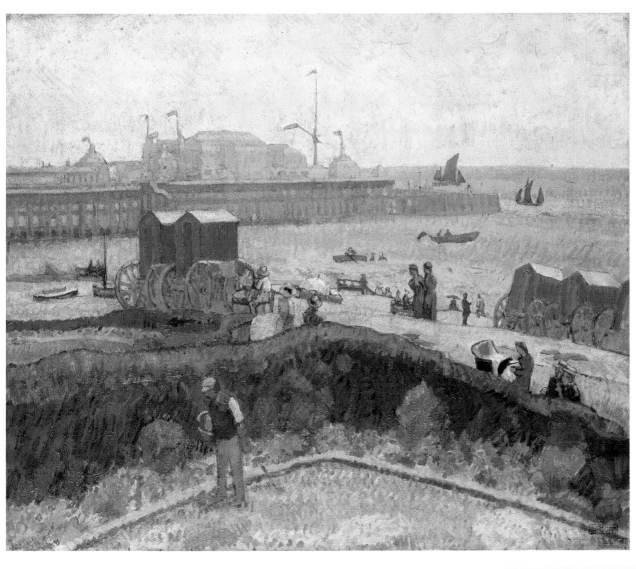

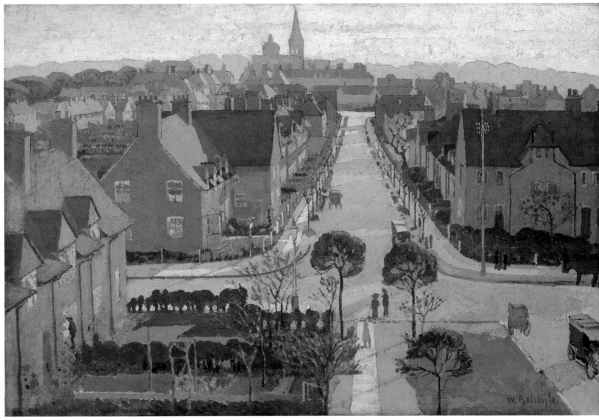

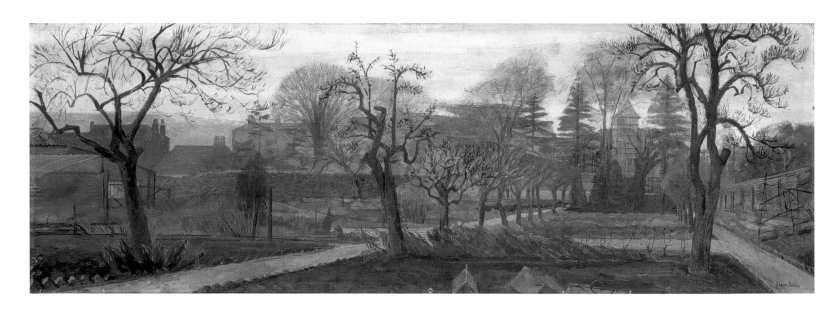

✳14

Evelyn Dunbar (1906–1960)
Winter Garden c.1929–37
Oil on canvas, 30.5 x 91.4
Tate. Purchased 1940

As Dunbar recalled, *Winter Garden* was a view of her parents' garden at Strood, near Rochester, Kent. The painting was begun before she came to London as a student in the late 1920s, and completed some ten years later, around 1937.[23] Dunbar's family, who supported her artistic aspirations, added an extension to their house, the so-called 'Tower', which functioned as her studio. The garden was equally important to Dunbar. Here she would take cuttings, prepare seedbeds and make full notes on the growth and habits of various plant species. As Dunbar's painting shows, it was a grand, spacious garden with rows of fruit trees, large flower beds and long avenues. The Dunbars, a well-to-do family, employed two gardeners, their efforts being reflected in the neatly edged paths and the glass cloches in the foreground of the painting.[24]

Having studied at Rochester School of Art and at Chelsea, Dunbar enrolled at the Royal College of Art in 1929. There she was encouraged by the Principal, William Rothenstein,

who in turn introduced her to Charles Mahoney, then a tutor at the college. As Rothenstein's son, John, noted: 'Between these two artists there is a clear affinity of vision, and Mr. Mahoney's influence upon her, has, I should judge, had an inspiring rather than a repressive effect, inasmuch as it has revealed to her certain elements latent in herself which, without it, she might have taken long to discover.'[25]

During the 1930s Dunbar also formed a close personal bond with Mahoney, centred on their shared love of gardens and garden painting. They honed their horticultural expertise through visits to Kew Gardens, the Royal Horticultural Society shows at Vincent Square, the constant exchange of plants and cuttings, and regular correspondence. The fruit of their labour was the book *Gardeners' Choice*, which they wrote and illustrated in 1937. The following year Dunbar designed and illustrated *A Gardener's Diary* for *Country Life* magazine. MP

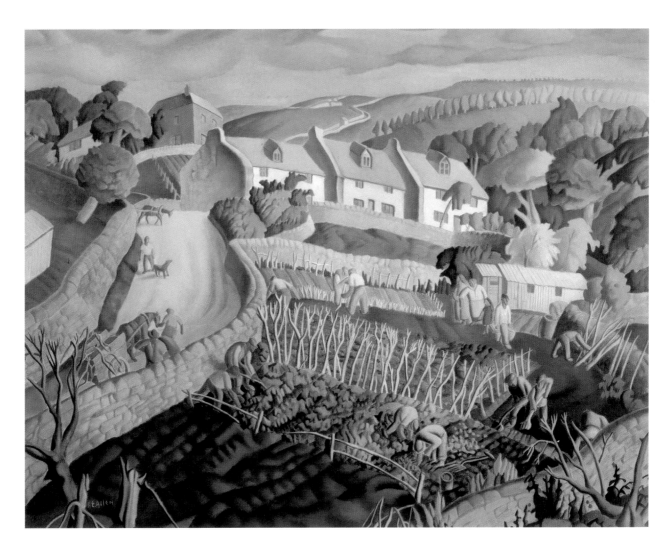

❋15

Harry Epworth Allen (1894–1958)
Village Allotments 1937
Tempera on canvas board, 45.5 x 59.5
Private Collection

The gardens that feature in Harry Allen's paintings are not private domestic spaces but allotments and smallholdings, components of a working landscape which are woven into the texture of the surrounding countryside. This picture depicts allotment life in the hamlet of Two Dales, near Matlock, Derbyshire, where men, women and children energetically tend narrow strips of land in a communal plot on the edge of the village.

Allen, who was born and grew up in Sheffield, began to paint professionally after he was made redundant from the steel industry in 1931. He was particularly attracted to the landscape of Derbyshire, where he observed that 'the thousands of miles of limestone walls undulating over valleys and hills have a pictorial significance which while being essentially typical is to a great extent unique. Many people find this type of landscape uninteresting, but to

the artist in search of rhythm of line and colour it is most interesting'.[26] Allen, as this comment suggests, was motivated not only by the considerations of local topography but also by the formal issues related to pictorial composition. 'We are concerned primarily with rhythm and design, and our colour must be employed for the purpose of reinforcing these fundamentals and strengthening form.'[27] This 'Modernist' aesthetic won Allen admirers in the 1930s and 1940s, and his work sold well. However, it also distanced him from more conservative critics and was a contributing factor in his decision to resign from the Sheffield Society of Artists in 1937. MP

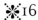16

Stanley Spencer (1891–1955)
Cookham Rise 1938
Oil on canvas, 45.7 x 61
Art Gallery and Museum, Royal Pump Rooms,
Leamington Spa (Warwick District Council)

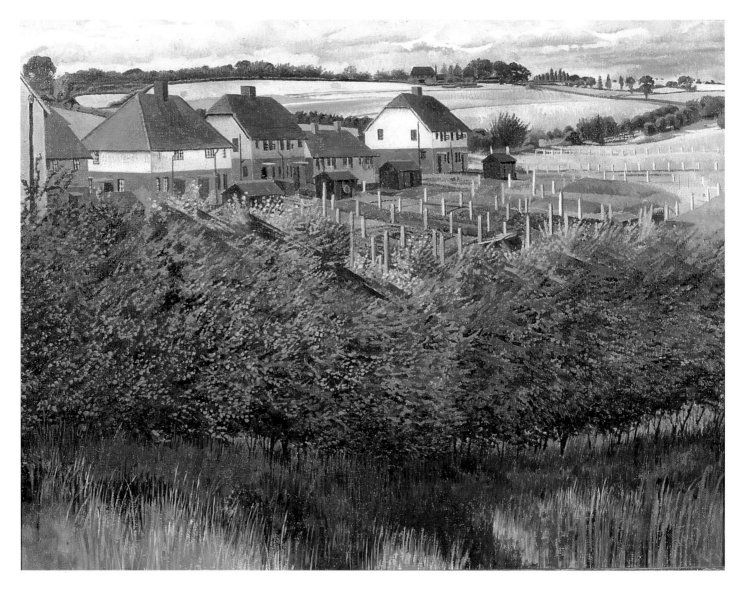

This is one a sequence of paintings Spencer produced in the 1930s of his home village of Cookham, Berkshire, focused on gardens as the key ground for larger landscape views. With detailed precision, they show a variety of sizes and styles of garden: rockeries, shrubberies, lawns, flowers in beds and pots, variously enclosed by hedges, brick walls, iron railings, concrete posts and wooden fences. The gardens border a series of sites: the River Thames, the main street, farms and fields. The sequence plots a topographical and social map of Cookham and its surroundings.

This painting shows a row of new, publicly funded houses and gardens built for working men and families in an outlying area, Cookham Rise. It was the kind of roadside development which offended some rural preservationists, but Spencer has made the row appear a fitting addition to the landscape and its cultivation.[28] Freshly creosoted garden sheds stand in a row behind each house facing the

long plots bordered by concrete posts strung with wire. The nearer plots have been dug over, while those beyond await the spade. With its panoramic form, documentary observation and workaday subject, *Cookham Rise* shares the survey style of British landscape painting in the inter-war years, deployed for a number of regions, for example by James Bateman in the Cotswolds and James McIntosh Patrick in Angus, Scotland.[29]

Spencer himself was deprecating of many of his garden paintings, produced, he said, as 'potboilers', a secure selling line to reduce the mounting debts of a chaotic personal life, and to fund his preferred mode of figurative painting. But in a home place which Spencer regarded as an earthly paradise, some may have a personal register; Duncan Robinson suggests they offer a vision of 'domestic order absent from Spencer's own turbulent life'.[30] SD

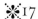17

Charles Mahoney (1903–1968)
Wrotham Place from the Garden c.1938–9
Oil on canvas, 40.7 x 61
Tate. Presented by the Trustees of the Chantrey Bequest 1993

Charles Mahoney painted this view from the back garden of his house, Oak Cottage, in Wrotham, which he purchased with his brother in 1937 as a home for himself and his widowed mother. The house, a pretty, late sixteenth-century half-timbered building, was to become Mahoney's home until his death some thirty years later. The garden, which he planted with great innovation, became the wellspring of his horticultural expertise and the principal source of his artistic inspiration.

Wrotham (pronounced 'Rootam') is situated in the vale of Kent, the 'Garden of England', abounding in orchards, oast houses and picturesque villages. As Mahoney was aware, it lay in Samuel Palmer's 'Valley of Vision', only a few miles away from Shoreham. The present picture, among the earliest that Mahoney painted at Wrotham, was probably made in the winter of 1938–9, before Mahoney had erected the garden shed which was to become his studio or had planted the various fruit trees and climbing plants which later festooned the garden wall. As Sir John Rothenstein noted, Mahoney's vision (unlike Palmer's) concentrated on the commonplace and the familiar. 'Rusted roofs of corrugated iron, brick walls, wheelbarrows and allotments figure frequently in his landscapes. His friends recall that he even referred with a shade of disapproval to "beauty".'[31] And yet, like Stanley Spencer's, Mahoney's commonplace art had a distinct beauty of its own.

The view in the present picture is to the north-east, towards Oak Cottage, just out of sight to the right of the composition. In the foreground, beyond the wall, is the spacious garden belonging to the adjoining Georgian almshouses, contained within the low-roofed building with white chimneys. The residents of the almshouses are portrayed at work on their vegetable plots, then still a vital source of sustenance. Beyond the almshouses can be glimpsed the roofline and red-brick chimneys of the Elizabethan mansion Wrotham Place. The prospect from Mahoney's garden has changed little since the late 1930s, although nowadays the peace and tranquillity are threatened by the hum of adjacent motorway traffic. MP

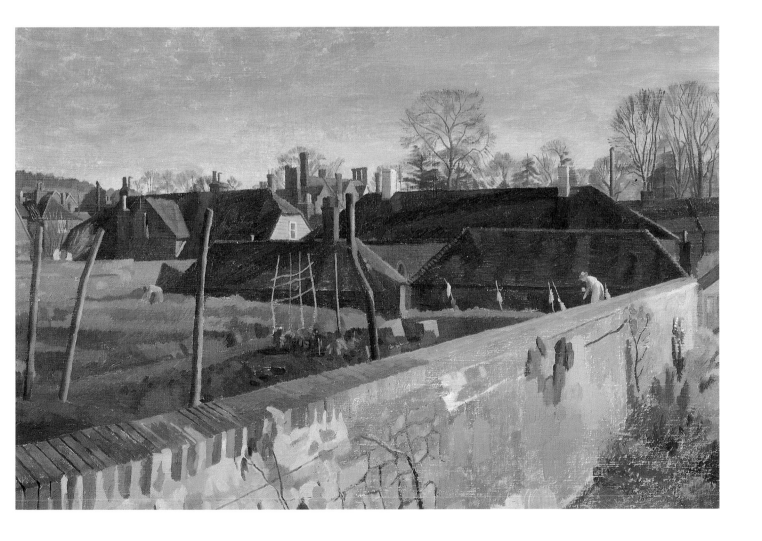

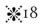18

James McIntosh Patrick (1907–1998)
A City Garden 1940
Oil on canvas, 71 x 91.4
McManus Galleries, Dundee City Council, Leisure and Arts

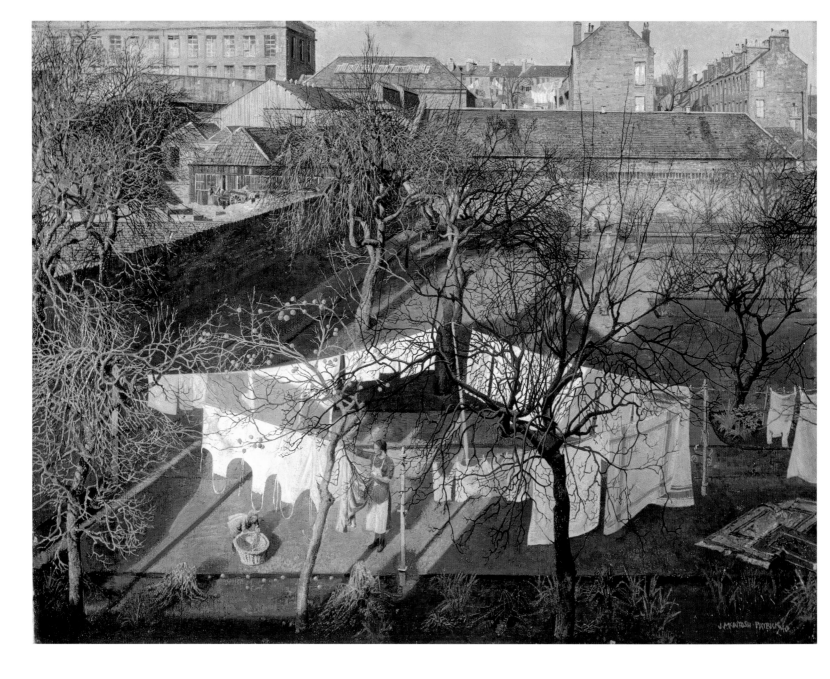

James McIntosh Patrick (1907–1998)
A City Garden 1940

Painted while Patrick was waiting to be called up for active service, and first exhibited at the Royal Academy in the winter of 1940, *A City Garden* expresses wartime concerns. The view is of the artist's own garden from the bedroom window of the house in his native Dundee, a former jute merchant's villa, he had lately purchased at a reduced price because it was close to likely bombing targets near the port, notably the Tay Railway Bridge. In the garden is the young family Patrick is soon to leave; his wife hanging the week's washing, his daughter picking out items from the laundry basket. A long shadow is cast on the lawn on this late-autumn morning, a few apples still clinging to a tree.

The picture is composed in the documentary 'survey' style with which Patrick established his reputation as a land-scapist, with highly detailed, rigorously structured, panoramic views of the Scottish countryside, especially his native Angus.[32] The first of Patrick's works to be painted directly from the motif, *A City Garden* continues to project a sense of good, productive order, in which the domestic enclosure of the private garden is viewed within a wider, more public landscape. Beyond the walled garden are the streets of industrial Dundee. At the top left is a jute mill; one of its products, carpets, is shown on Patrick's lawn on the bottom right. The rows of houses to the right include the end-of-terrace house where the Patricks first lived. Over the wall to the left an Anderson shelter is being built.

When Patrick returned from wartime service abroad with the camouflage corps he painted a companion picture to *A City Garden*, a view over the front garden of his house, *Tay Bridge from My Studio Window* (fig.46), completed in 1948. This prospect looks past the front railings (which in fact had been taken down for the war effort), his wife on the path, his son cycling by, over the public pleasure ground of Magdalen Green, showing the remains of 'Dig for Victory' vegetable plots, to the Tay estuary and its railway bridge, where trains steam in each direction.

Patrick returned to painting views of his garden in later life, when the look of the garden, lushly overgrown, had changed along with his style, which now used softer brushwork and thicker paint. In an interview with BBC Scotland in 1978 he explained: 'Many folk do too much gardening … Gardening should go along with nature … Nature wants to be lush … you should destroy as little as possible of what's alive.'[33] SD

fig.46
James McIntosh Patrick (1907–1998)
Tay Bridge from My Studio Window 1948
Oil on canvas, 71.1 x 101.6
McManus Galleries, Dundee City Council,
Leisure and Arts

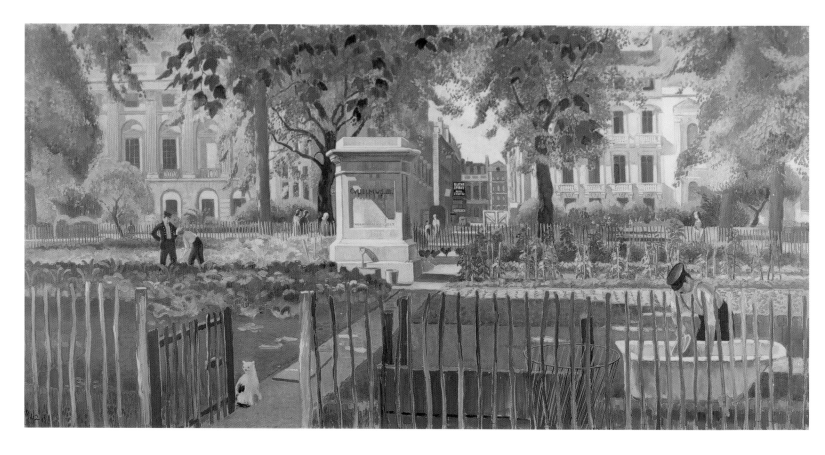

※19

Adrian Allinson (1890–1959)
The A.F.S. (Auxiliary Fire Service)
*Dig for Victory in St James's Square c.*1942
Oil on canvas, 55.5 x 120
City of Westminster Archives Centre

The image of allotment gardens in the war effort, as a material symbol of public spirit, is all the stronger in this picture for showing the opening up of an enclave of established social privilege in London's West End. The laying-out of allotments in the private gardens of St James's Square, designed by John Nash, was part of a wider public transformation of the place. Its railings were scrapped, a patriotic measure (resisted in some aristocratic squares) further championed as an aesthetic one by the Modernist *Architectural Review* because it opened up space and unfolded vistas. Bomb shelters were built. The surrounding mansions and clubs were requisitioned for military and civilian government departments. The 1807 statue of William III in Roman style was removed for safekeeping.[34] A spade is shown leaning on its plinth.

Commissioned by the War Artists Advisory Committee, the painting shows the Auxiliary Fire Service, heroes of the Blitz, continue its war effort, digging for victory, although as much work is going into watering the rows of cabbages and runner beans from an old bath. The atmosphere is light and relaxed. A vista opens through a wicker gate guarded by a cat, across the allotments and down Charles II Street to London's theatreland. A sign advertises Noël Coward's play *Blithe Spirit*, rapidly written in 1941, after the author's London flat and office took a direct hit in a bombing raid. The play's humour, based on a medium (played by Margaret Rutherford) who brings back the wrong people from the dead, irritated the critics but was enormously popular with the public. The theatrical note may have particularly appealed to the artist. Allinson made his early reputation as a painter of London theatre scenes; he also designed scenery for the Beecham Opera and illustrated a theatre column in the *Daily Express*. This painting exploits the scenographic landscape of the West End to stage a piece of patriotic theatre. sp

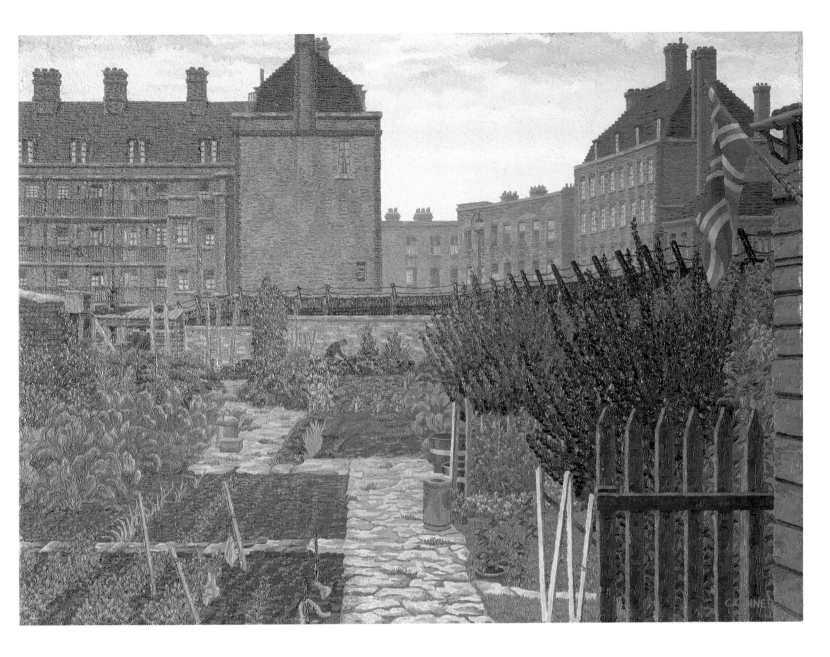

20

Charles Ginner (1878–1952)
Bethnal Green Allotment 1943
Oil on canvas, 55.9 x 76
Manchester Art Gallery

When he undertook this commission from the War Artists Advisory Committee, Charles Ginner had long been renowned for his urban landscapes, notably modern London scenes, including parks and gardens, in a style which barely altered, showing a wealth of detail within rigorous, tightly framed designs. This painting depicts a wartime allotment garden in London's East End, an image of stability for an area which had recently endured intense destruction and damage.[35]

Hanging on the shed, framing the view, is a Union Jack, commemorating the Queen's recent visit in June 1943 to allotments laid out on bombed sites. It recalls the flags in another patriotic painting by Ginner, the view of 1937 from his flat window *Flask Walk, Hampstead, on Coronation Day* (Tate). The Bethnal Green allotments are neatly tended, but also, like an encampment, fortified by a barbed-wire-topped wall. This impression is strengthened by the looming, barrack-like buildings beyond. These are a monument to an earlier public-spirited transformation, the model blocks of flats built at the end of the nineteenth century by the London County Council on the site of a slum district. Built to be aesthetically scenic as well as healthy, they now appeared, in contrast to more recent garden suburb municipal estates, to be somewhat forbidding.[36] SD

21

Cedric Morris (1889–1982)
*Wartime Garden c.*1944
Oil on canvas, 61 x 76.5
Estate of Cedric Morris

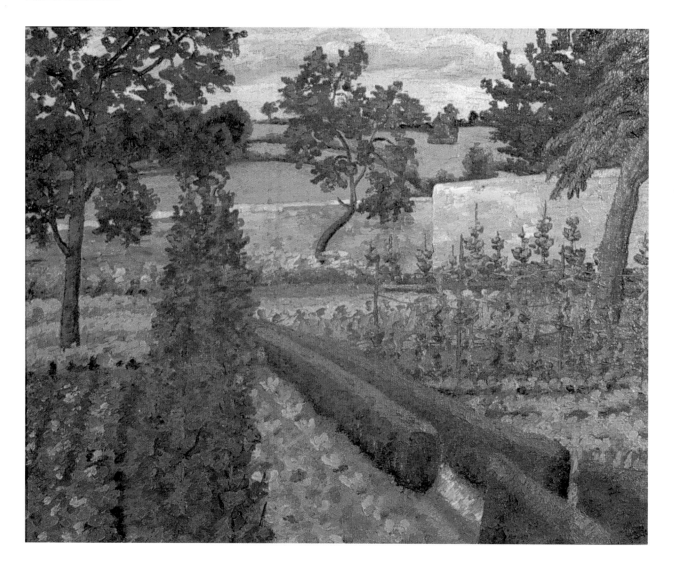

This painting depicts the vegetable beds at Benton End in Hadleigh, Suffolk, Morris's home from 1940 until his death in 1982. During the war much of the garden at Benton End was given over to the production of fruit and vegetables. In the painting it is late summer: the garden is full of runner beans, cabbages, broad beans and other vegetables and the fields beyond are full of ripe golden corn. Given the context within which the work was painted, highlighted by the painting's title and date, the image might be read as a celebration of the continuing fecundity of rural England in a time of extended hardship.

Morris made at least two other paintings of the vegetable garden (both in private collections), showing it from different angles and tracing the patterns of growth from bare soil spotted with rows of seedlings through to ripeness and the anticipation of the harvest. It is a characteristic of many of Morris's flower and garden paintings that he includes a view into the distant countryside (see also cat.87).

This work can be linked to a group of paintings by Morris which might be described as 'produce' paintings (see fig.5). These depict fruits and vegetables harvested at Benton End: Morris was ahead of his time in growing vegetables, such as courgettes, peppers and aubergines, which were still considered extremely exotic. They are rich in colour and the produce is often arranged in sexually suggestive groups or as visual recipes (for example, *Ratatouille* 1954, Private Collection). During the war and in the period of rationing that followed, these works stand out as celebrations of good food and good living. BT

Harry Bush (1883–1957)
A Corner of Merton, 16 August, 1940 exh.1945
Oil on canvas, 94 x 127
Imperial War Museum, London

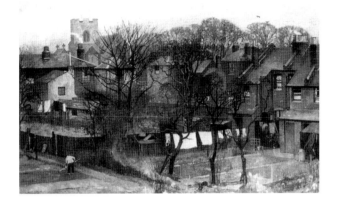

fig.47
Harry Bush (1883–1957)
Spring Morning, Merton 1932
Oil on canvas, 101.6 x 152.4
Private Collection

This painting shows the effect of an air raid on south London during the height of the Battle of Britain; a bomb crater in back gardens viewed from the studio of Harry Bush in the south London suburb of Merton. Bush lived in Queensland Avenue, a terrace of Arts and Crafts-style houses, in a custom-built artist's house with an extra studio storey. The house was purchased in 1911 for Bush's wife, Noel Nisbet, a noted watercolourist of mythical, medievalist scenes, by her father Hume Nisbet, who taught at the Watt Institute and School of Art in Edinburgh.

Harry Bush became known as the 'Painter of the Suburbs' owing to a series of views in and around his home in Merton which were exhibited at the Royal Academy from 1922. These are mostly prospects of houses and gardens, many from his own studio or bedroom window. They show the building of houses and fences, and everyday scenes in the garden at all seasons, digging, hoeing, feeding chickens, putting out washing (fig.47). There are also glimpses of institutional structures, churches and small factories. The series, which continued until 1954, amounts to an

affirmative survey of a suburban community being made and maintained. Bush saw the ancestry of his art in the quiet dignity of Dutch and Flemish domestic scenes, and, as his younger daughter recalled, mixed pigments and oils 'so that his work should mellow, glow and last, and, if possible, improve'.[37]

If this painting appears a dramatic contrast with what might be expected of a suburban scene, it is an image of wartime endurance. As the title suggests, this unassuming corner of a London suburb is as much an icon of the Blitz as the celebrated *Daily Mail* photograph of St Paul's Cathedral rising miraculously above the smoke and flames.[38] SD

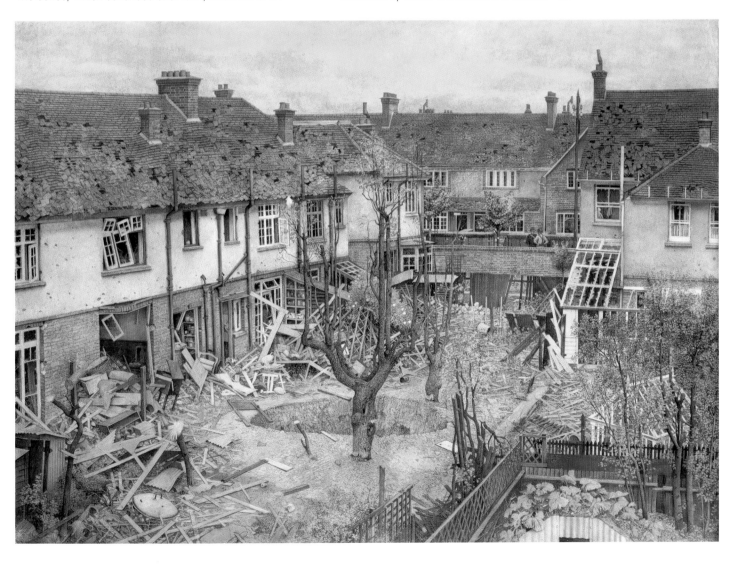

Douglas Percy Bliss (1900–1984)
Gunhills, Windley 1946–52
Oil on canvas, 76.2 x 101.6
Tate. Purchased 1981

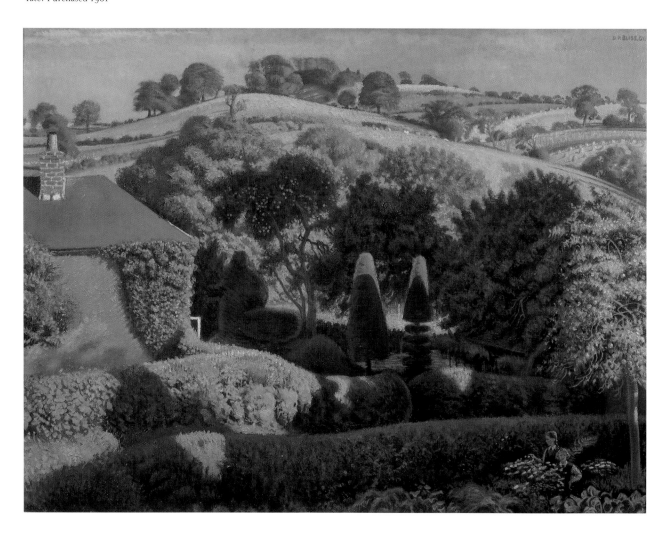

Throughout his career Bliss painted views of gardens, seen at various seasons and different times of day, from each of the houses where he lived: in London, Scotland and Derbyshire. In 1945, after a bomb damaged their home in Blackheath, London, Bliss and his wife, the painter Phyllis Dodd, moved to Derbyshire, and shortly after his discharge from the RAF, to Hillside Cottage at Gunhills, Windley, on the edge of the Peak District. The following year Bliss was appointed Director of the Glasgow School of Art, but retained Hillside Cottage as a holiday home and lived there permanently after retiring in 1964.

Gunhills, Windley is the earliest of a series of scenes viewed from the first-floor bedroom of Hillside Cottage. The painting combines a series of viewpoints, looking down to a small portion of Bliss's garden, with his two daughters, across a deeply hedged lane to the garden of Yew Cottage, belonging to his neighbour Mrs Bull, and up to Gunhills. The landscape heaves with the great trees in full foliage which first attracted Bliss to the area: oaks and elms in the far fields and topiary yews in Mrs Bull's garden.[39]

After the painting was exhibited at the Royal Academy in 1947 it was photographed as the colour frontispiece to a book in Batsford's popular series of topographical guides, J.H. Ingram's *North Midland Country*, published in the winter of 1947–8. Bliss then decided to strengthen the design, giving it more shape and contour. He painted out a white-washed hen house in Mrs Bull's garden and some cumulus clouds on the horizon. He repainted the whole landscape slightly earlier in the evening, when the tops of topiary trees still caught the light and contrasted with the fruit trees in shadow behind. The desired shadow pattern depended on a particularly brilliant light at a specific time, 7 to 8 pm in August to September, and owing to a sequence of bad summers the painting took years to complete to the artist's satisfaction.

In a conversation in 1982 Bliss's younger daughter, Prudence, then a lecturer in Fine Art at Newcastle University, saw in the picture the blend of 'form and fact' which reflected her father's affiliation with topographical printmaking and his admiration for eighteenth-century landscape design: '[he] would have liked to be a landscape gardener had he not been an artist'.[40] SD

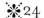24

Stanley Spencer (1891–1955)
The Hoe Garden Nursery 1955
Oil on canvas, 67.8 x 108.2
Plymouth City Museums and Art Gallery

This painting was commissioned by Plymouth City Council. Although they gave the artist freedom of subject matter they hoped that Spencer would paint a landscape commemorating the reconstruction of the city following extensive bomb damage in the Second World War. Not surprisingly, the patrons, and many of the public, were confused by the result. If they were seriously expecting Spencer to portray the newly planned, Modernist city centre, they were disappointed: what they got was a view of the older, more piecemeal-looking municipal nursery on Plymouth Hoe. However, as Robert Bartram has shown, the painting does offer a vision of post-war reconstruction with local and national associations, if that of a visitor rather than an inhabitant, as well as reflecting some of Spencer's own horticultural preoccupations.[41]

Overlooking Plymouth Sound, the Hoe has a prominent place in British naval history through associations with various expeditions, famously Sir Francis Drake's game of bowls on the eve of his victory over the Spanish Armada. The Drake monument is shown on the right edge of the

painting. Since the mid-nineteenth century the Hoe had been a public promenade and gardens, and the nursery raised flowering plants for gardens there and in others parts of the city. During the war the Hoe, like most other public gardens, had been given over to the growing of vegetables. When Spencer received the commission, flower gardening had made a resurgence, in the media as well as on the ground. In the new Elizabethan age, Britain was again in bloom.

The painting shows the nursery in early summer 'at its most productive moment in the gardening year … just before the bedding plants are taken out … the glass casing has been removed from the cold frames so that the flowers can absorb the sun'.[42] Various species are identified, including geraniums, fuchsias and begonias. The picture's attention to the function and structure of the scene extends to its portrayal of a range of materials: wood, variously shaped and finished, brick, glass, terracotta, bamboo, iron (cast and corrugated), tiles, gravel and barbed wire. The artefactual nature of gardening has seldom been so carefully portrayed. Compressed into the field of vision are sheds, a greenhouse, the nurseryman's cottage and an observational platform equipped with two Stevenson screens containing apparatus to measure the weather. SD

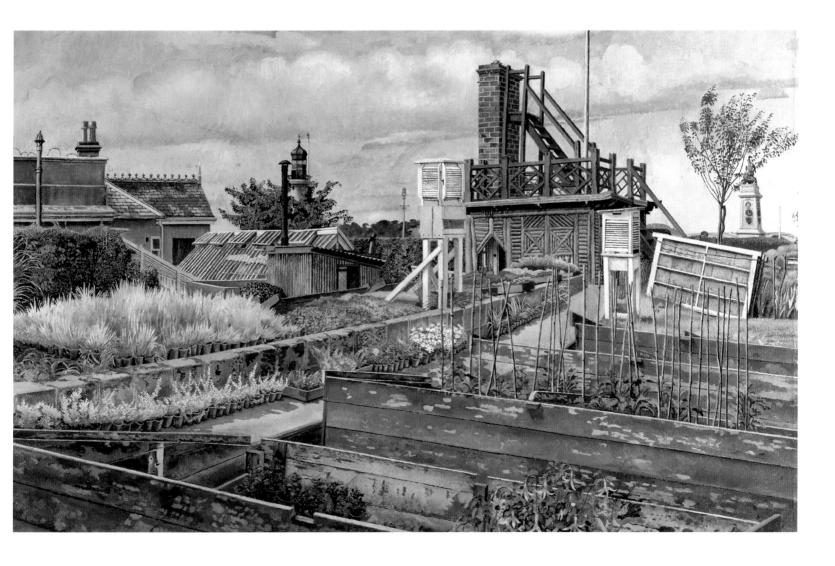

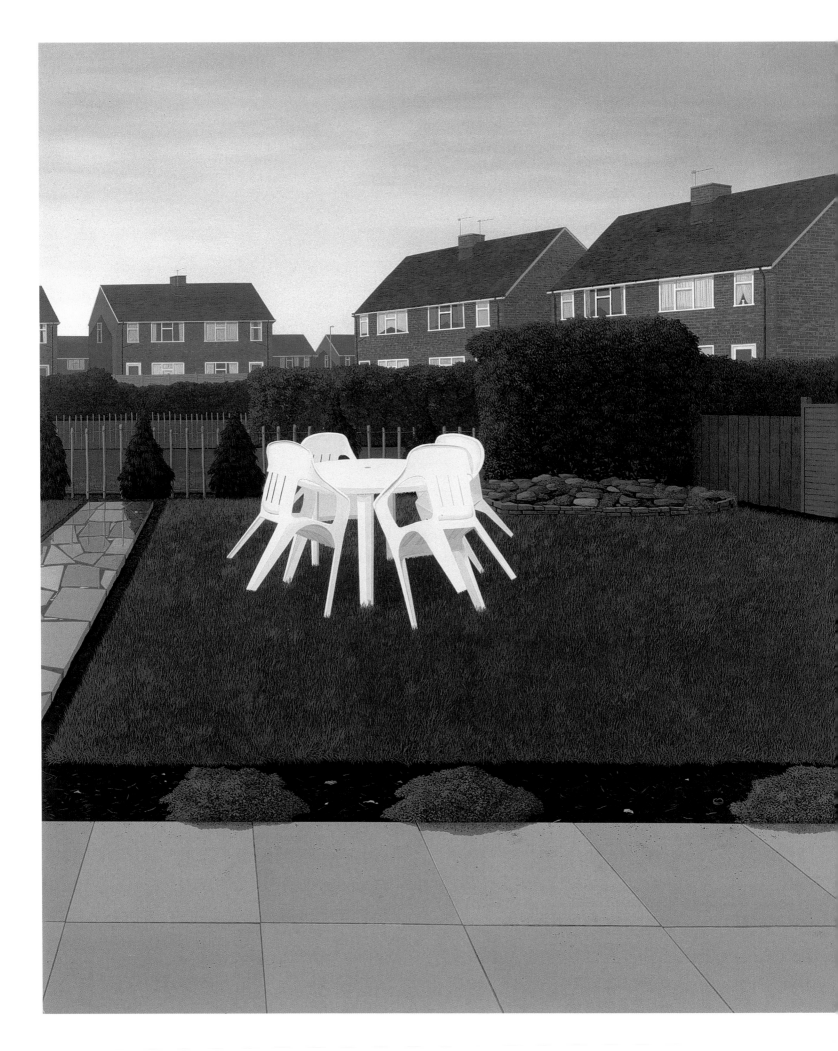

David Rayson (born 1966)
Patio 1998
Acrylic on board, 77.5 x 111.8
Private Collection, New York

This painting is one of a series of pictorial reconstructions of places on the Ashton Park estate, Wolverhampton, built in the 1950s, where Rayson grew up. The pictures include views from various boyhood vantage points: street corners, canal bridges, back alleys, landing windows, the back seat of a family car. They focus on mesmerising, sometimes monumental features: an electricity pylon, an industrial chimney, an abandoned fridge, a clump of pampas grass and, in this view from the patio of the artist's family house, an arrangement of brilliant-white plastic garden furniture. It is a recollection of the garden in late autumn, the lawn and hedges with their final cut, the beds cleared of dead flowers, when the regular structure of the scene, including the paths, walls and fencing, comes into view. Rayson remembers this as a garden in which he happily played but one which, under his mother's management, was kept neat and tidy and marked by clear boundaries.[43] If the chairs are sensibly tipped against the rain, they also suggest the inclination of a close family.

The prospect of neighbours' houses in *Patio* recalls a specific time when Rayson remembers Ashton Park as a very sociable place. In his more recent recreations of the estate, which envision changes since then, the boundaries between private and public space are drawn differently, in a more generic, oppressive landscape. Houses are fitted with satellite dishes and kitchen extensions, grass sprouts in patios and high fencing shuts out the neighbours; streets and playgrounds are strewn with litter and covered in graffiti. These developments signify, on the one hand, a more moneyed and interior world, and, on the other, an exterior world starved of public investment and a sense of citizenship. If Rayson's views offer, as he suggests, fragments of larger narratives, these later pictures appear to be episodes in a story of social decline.[44] It is an oddly timeless story, in which signs of neglect and obsolescence are portrayed with as much care and attention as features which are brand new, each part of the order of things. In the close-up view *Garden* 2000, empty fried chicken cartons, displaying the 'Keep Britain Tidy' logo, are strewn on paving slabs and lawn; the view could be a fragment of front garden, bordering the public pavement, but, more troublingly, it might be part of a dysfunctional back garden, showing the discarded containers of a pre-cooked, carry-out family meal.[45] SD

26

George Shaw (born 1966)
An English Autumn Afternoon 2003
Humbrol enamel on board, 77 x 101
Collection of Joel and Nancy Portnoy

The title of this painting refers to Ford Madox Brown's
An English Autumn Afternoon 1852–5 (fig.16), a prospect
from the artist's lodgings.[46] The suburban scenery in Shaw's
picture is that of Tile Hill, Coventry, the housing estate that
was his childhood home. It was an upbringing that also
nurtured Shaw's passion for art and literature, and which
included family trips to Birmingham Museum and Art
Gallery, in which Brown's painting is displayed.[47] Shaw's
An English Autumn Afternoon is one of a series of luminous
paintings of Tile Hill; it follows a winter morning view of
the same scene from the bedroom window, *Scenes from
the Passion: The First Day of the Year* 2003 (Collection of
Carolyn Alexander, New York). This series includes recreation
grounds, rows of garages and blocks of flats, some
looking run-down, and also much older features: fields,
parks and woods, churches, cottages and villas. Shaw
was intrigued that the suburb was developed among the
remnants of Shakespeare's Forest of Arden: as the shadow
falls across the front gardens of *An English Autumn
Afternoon*, so the late afternoon sun highlights the fields
and woods in the distance.

'For me, time has … become diagrammatic around certain
points in my childhood,' Shaw declares. Recalling the
'spots of time' in Wordsworth's great autobiographical
poem *The Prelude*, these places of childhood reverie are
collective as well as personal memory images. Shaw's
art re-visions the cultural inheritance of English landscape,
especially its meditative, melancholy register. As well
as allusions to Victorian painting and photography, there
are echoes of post-war poetry, especially Larkin, realist
cinema and television, and the songs of Joy Division and
the Smiths.

Shaw's method of picture making combines a series of
techniques which diffuse the autobiographical element of
the work. Following the tracks of his childhood wanderings,
he took hundreds of colour snaps, developed in an hour
at high-street chemists. He focused on typical sites to
be found on many post-war estates, with no topical clues
– no cars or people. Selecting a photograph which
triggered a memory, he made a drawing from it in a style
he describes as a 'How to Draw' textbook exercise. The
drawing was pinned to a piece of primed MDF board, its
image imprinted with a hard fine pencil. He then blocked in
colour with Humbrol enamel paint, the kind used by model
makers, building up detail layer by layer.[48] This painstaking,
time-consuming combination of popular techniques gives
the paintings a richness and depth appropriate to their
cultural resonance. SD

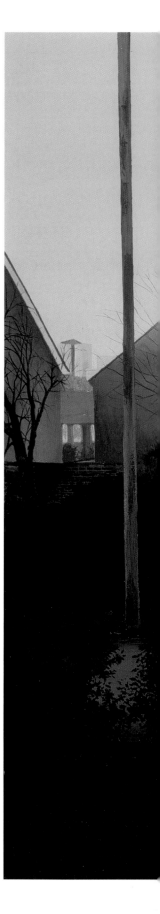

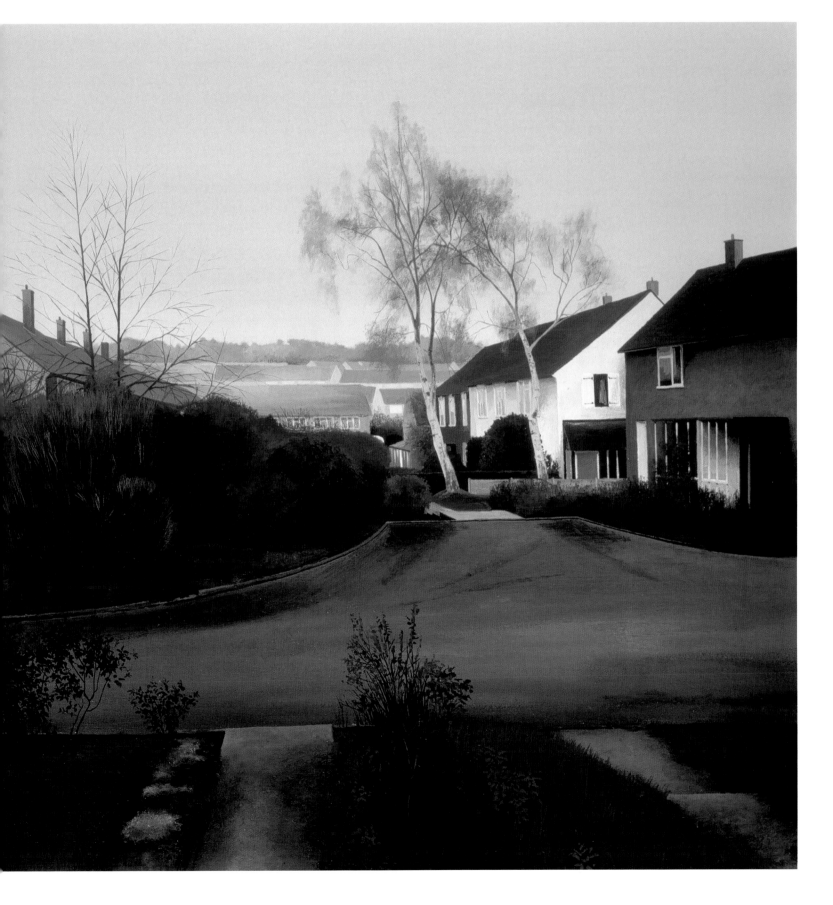

The Secret Garden

he sun shone down for nearly a week on the secret garden. The Secret Garden was what Mary called it when she was thinking of it. She liked the name, and she liked still more the feeling that when its beautiful old walls shut her in, no one knew where she was. It seemed almost like being shut out of the world in some fairy place.[1]

At a manor house on a bleak Yorkshire moor three children discover a neglected garden: as they tend the garden, so they themselves are led on a journey of physical and spiritual regeneration. Since its publication in 1911 Frances Hodgson Burnett's celebrated children's classic *The Secret Garden* has provided one of the most comforting images of the garden; as a refuge from the stresses of modern life and the workaday world, a realm of innocence and enchantment.

The first section of the exhibition, 'Thresholds and Prospects', looked outwards from the private space to the public domain, viewing the garden in the context of the physical landscape that surrounds it. As in that section, a number of works featured in 'The Secret Garden' also depict gardens owned by artists or gardens with which artists maintained a close personal relationship. Here, however, the accent is upon intimacy and introspection. Hence, the inclusion of two small garden scenes by John Constable (cat.27) and Thomas Churchyard (cat.29), both of which relate to the artist's domestic circumstances; as well as a recent study by Lucian Freud (cat.58) of the buddleia growing in his suburban London garden. The section also addresses the emotional attachment of the artist to the garden, engaging with the topos of the 'secret garden' through themes such as childhood, sexuality, spirituality and the supernatural.

During the nineteenth century the identification of the garden with childhood imagination was nurtured through a vibrant literary and illustrative tradition. Here the supernatural – in the form of fairies – played an important mediating role; their enduring appeal nowhere more apparent than in the 'Flower Fairy' books produced, from the 1920s, by Cicely Mary Barker (cats.39–40). By contrast, Beatrix Potter's anthropomorphic garden fantasy *The Tale of Peter Rabbit* (cats.37–8) is fraught with danger, as the seemingly innocuous vegetable plot becomes a site of mortal conflict. Even so, such narratives, produced by adults for children, are designed essentially to reassure. For adults themselves, childhood memories of the garden can evoke more painful thoughts and associations. Carel Weight's picture *The Silence* (cat.50), based on his own boyhood, alludes to the constraints and strictures of family life, through the ritual observance of Remembrance Day in a drab post-war suburban garden. In a similar vein, Sarah Jones's *The Garden (Mulberry Lodge) VI* (cat.57) portrays two teenage girls posing awkwardly in the parental garden, their expressions and body language indicative of a shared sense of anxiety and subjection. The darker side of the 'secret garden' is a subject which has interested another contemporary artist, Mat Collishaw, whose *Who Killed Cock Robin?* (cat.56) combines the enchantment of Victorian fairy culture with more disturbing undercurrents relating to childhood.

For several thousand years the garden has been associated with femininity. In antiquity the garden was personified by the goddess of the spring, Flora, bedecked with flowers; a point of reference which is taken up in Albert Moore's *A Garden* (cat.32). In Christianity, too, the garden has played an important visual role in the embodiment of womanhood, the enclosed garden, or *hortus conclusus*, being used as a symbol of the Immaculate Conception of the Virgin Mary. This iconography is consciously recalled in Charles Mahoney's *Autumn* (cat.48), with its Madonna-like central figure. Indeed female religious iconography features in several other works in this section, including Stanley Spencer's *Zacharias and Elizabeth* (cat.41), where the traditional temple setting is supplanted by a Cookham garden, and John Shelley's enigmatic *Annunciation* (cat.51), in which the Virgin Mary is confronted in a country lane by the angel Gabriel leaning on a bicycle. Elsewhere, although the specific religious connotation is bypassed, the image of the woman in an enclosed garden is tacitly acknowledged. The mysterious female in Samuel Palmer's *In a Shoreham Garden* (cat.28) is fleeting and spectral; Arthur Hughes's troubled young heroine weeps with the pangs of love in her ivy-clad bower (cat.31); while Hilda Carline's mother is portrayed in isolation, wrapped in private grief at the loss of her husband (cat.42).

The garden has long been used in European art to frame narratives relating to love and sexual desire. The biblical story of creation takes place in the Garden of Eden, the temptation of Adam and Eve confirming the seductive aspects of this earthly paradise. It is an iconography subtly employed by Tissot in *Holyday* (cat.34), where illicit sexual passions are stirred in the shadows of a north London garden. The classical 'Garden of Love' was presided over by Cupid, here alluded to directly in J.W. Waterhouse's erotic Edwardian fantasy *Psyche Opening the Door into Cupid's Garden* (cat.35), and more generally in David Inshaw's *The Badminton Game* (cat.52), a 1970s reverie on the 'game' of love. The less salubrious aspects of desire also emerge in this section, notably in David Jones's autobiographical *The Garden Enclosed* (cat.43), where the awkward embrace of a young couple mirrors the artist's own confused sexual state.

While the Secret Garden usually connotes the voluntary retreat by an artist into a private world, it can occasionally function as a signifier of enforced confinement. The later work of the Victorian artist Richard Dadd (cat.30) was produced under a cloud of mental illness, in an insane asylum. For Dadd, who had no access to any sort of garden, other than that which existed in his mind's eye, the garden was at once a means of escape and a constant reminder of his own predicament. —*Martin Postle*

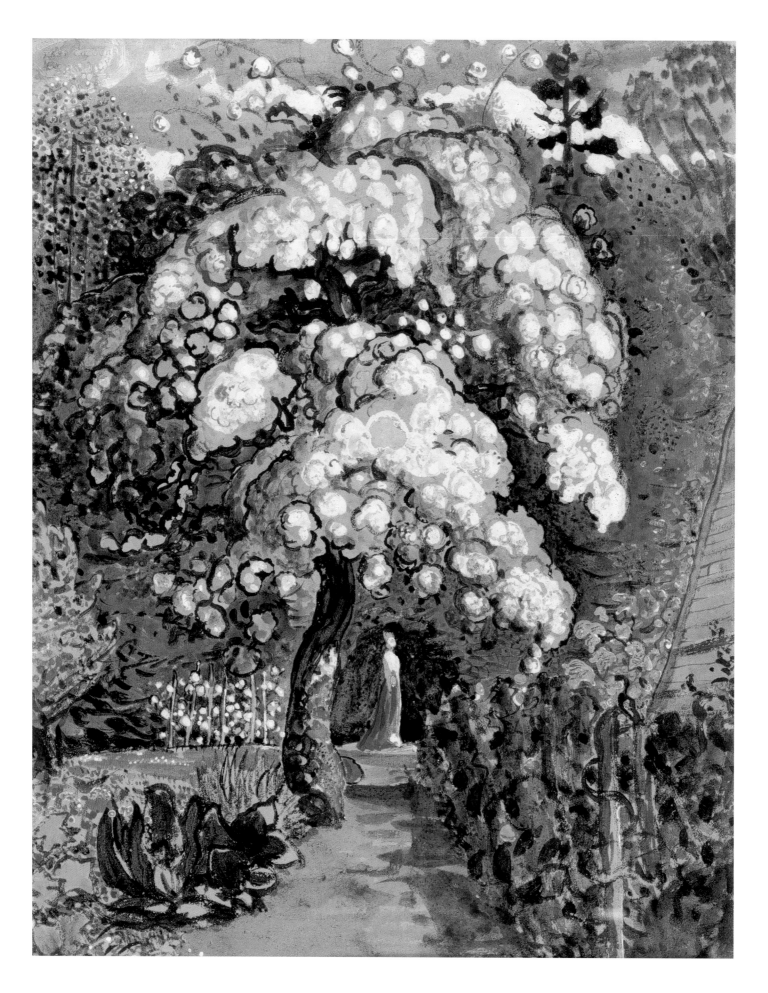

❧28

Samuel Palmer (1805–1881)
*In a Shoreham Garden c.*1829
Watercolour and bodycolour, 27.9 x 22.2
Victoria & Albert Museum, London
LONDON ONLY

This is one of several paintings of gardens made by Palmer in and around the village of Shoreham, Kent, during the late 1820s. It is also one of Palmer's most remarkable works, exemplifying the visionary nature of his art at this time. At the centre of the picture stands an apple tree loaded with blossom, its blooms bursting forth into the sky above. At the extreme right is the corner of a barn or shed, to the left a patch of lawn. Beyond the path is the mysterious figure of a woman in red. Although the wealth of horticultural detail indicates that Palmer's composition is based on a particular garden in the village, the stylised forms and the presence of the ghostly figure also proclaim it to be a garden of the mind.

In his late teens Palmer had befriended the artist John Linnell, who introduced him to the prints of Albrecht Dürer and Lucas van Leyden. In 1824, also through Linnell, Palmer met William Blake. Inspired by Blake's illustrations to *The Book of Job* and Virgil's *Pastorals*, and by the poetry of Milton, he set out to recreate the natural world according to his own imaginative impulses. It was at this time that he went to live in Shoreham.

Palmer, who had moved from London to the countryside initially because of his poor health, spent about seven years in Shoreham, where, thanks to a legacy from his grandfather, he was able to purchase five cottages and set himself up as a local landlord.[1] From time to time Palmer was joined by artist friends Linnell, George Richmond, Edward Calvert and others, who called themselves 'The Ancients'. They met in a cottage which they nicknamed 'Rat Abbey'. Palmer himself lived at a rather grander dwelling, Water House. It is possible that the present work is based on the garden there. MP

27

John Constable (1776–1837)

View in a Garden at Hampstead, with a Red House beyond 1821
Oil on canvas, 35.5 x 30.5
Victoria & Albert Museum, London
MANCHESTER ONLY

From 1819 to 1826 John Constable regularly rented a house
in the village of Hampstead, a few miles north-west of
London. He made this oil sketch when he was staying there,
at 2 Lower Terrace. The view of the garden is taken from an
upper window of the house, looking towards Upper Terrace.
The sheets of washing hanging out to dry in the garden lend
an unusually intimate touch to the work.[2]

Constable, who was then living in London, began to visit
Hampstead so that his wife and family could enjoy a breath
of fresh air in this so-called 'Vale of Health'. He also made oil
sketches of the nearby heath, the skies and the view from
his own back garden. It was a time of intense domestic
activity, not least because Constable's fourth child, Isabel,
was born there in August 1822. The previous summer,
already perhaps feeling the strain of fatherhood, Constable
had retreated to the archetypal male haven, the shed: 'At
this little place I have (sundry) small works going on – for
which purpose I have cleared a small shed in the garden …
and have made it a workshop, & a place of refuge – when
I am down from the house.'[3] This shed is the likely subject
of another oil sketch by Constable of around 1821.[4] MP

29

Thomas Churchyard (1798–1865)
The Garden Tent c.1850
Oil on oak, 18 x 16.4
Tate. Presented anonymously in memory
of Sir Terence Rattigan 1983

This intimate and informal oil study depicts two girls,
Thomas Churchyard's daughters, seated inside a makeshift
garden tent apparently erected in the artist's garden behind
his house in Cumberland Street, Woodbridge, Suffolk. The
picture, like so many of Churchyard's oil studies, remained
little known beyond his immediate family circle during his
lifetime and only came to light in the twentieth century,
after the death of the artist's youngest daughter in 1927.

Characteristically, Churchyard painted this little oil sketch
on a wooden board, possibly taken from a piece of wall
panelling or item of furniture – Churchyard also utilised
the lids of cigar boxes for his paintings. In his art he was
influenced by Constable and the Norwich landscape painter
John Crome, both of whose works he collected. Like
many of Churchyard's works, watercolours, oils and pencil
sketches alike, the picture has an air of spontaneity, and
was in all probability quite impromptu. Since he did not
routinely sign or date his work it is difficult to ascertain
when he made this sketch, although, if it does include
his daughter Bessie (1834–1913), it may have been made
some time around 1850.

Thomas Churchyard, lawyer, wit, amateur painter and
humanitarian, was a remarkable man. As a boy he boarded
at Dedham Grammar School, where John Constable had
studied some twenty years earlier. In 1822 he set up as a
solicitor in Woodbridge. Although he gave up his solicitor's
practice in 1832 to become a professional artist, he soon
returned to Suffolk, where he resumed his legal career.
He continued to sketch assiduously, however, dedicating
his life's work to his seven daughters, including Bessie
(or 'Bessy'), whose name, along with her father's initials,
is inscribed on the back of this picture. MP

30

Richard Dadd (1817–1886)
Portrait of a Young Man 1853
Oil on canvas, 60.9 x 50.7
Tate. Bequeathed by Ian L. Phillips 1984,
and accessioned 1992

Richard Dadd painted this portrait in 1853 in the insane asylum at Bethlem Hospital, St George's Fields, Southwark, where he had been detained ten years earlier for the murder of his father.

A well-dressed young gentleman sits formally on a garden bench partly constructed from an improvised latticework of tree branches. He is situated in an idyllic garden landscape, painted with painstaking precision. In the foreground strands of ivy intertwine with the branches, their leaves specked with tiny dewdrops. The foliage of a giant sunflower frames the sitter's head, while to the right a large garden roller lies on the lawn before a classical temple. On the bench are a handkerchief, flowers and a bright red fez, the last object presumably recalling the headgear worn by Dadd during his earlier journey to the Middle East. The dreamlike aura of the image is underlined by the knowledge that (aside from the sitter) Dadd painted most of the picture from memory and imagination.

Bethlem Hospital (the central part of which is now the Imperial War Museum) was a bleak environment, especially for those confined to the criminal wing. Dadd spent most of his time there in a tiny cell with little daylight, his only contact with 'nature' being the institution's exercise yard. Yet, as it has been observed, Dadd 'survived as a person throughout these terrible years because he survived as a painter'.[5]

Principal among those who took a sympathetic interest in Dadd's art was Dr William Hood, who came to work at Bethlem Hospital in 1852, at the age of twenty-eight. Hood was a man of compassion and insight: immediately on his arrival he made improvements, enlarging windows, introducing flowers, books and even an aviary. It has been convincingly suggested that the young man in Dadd's picture was Dr Hood.[6] Indeed, given the friendship that Hood shared with Dadd, and the renewed hope that he gave him, the present portrait would have been a fitting tribute. MP

31

Arthur Hughes (1832–1915)
April Love 1855–6
Oil on canvas, 88.9 x 49.5
Tate. Purchased 1909

Arthur Hughes apparently painted *April Love* in the open air in a garden in Maidstone, Kent, according to 'strict Pre-Raphaelite principles'.[7] The garden in question belonged to Thomas Cutbush, the brother of a business associate of Hughes's father-in-law, whose daughter probably modelled for the figure of the young girl in the picture. However, the composition was almost certainly worked up in Hughes's London studio at 6 Upper Belgrave Place. When Hughes exhibited the picture at the Royal Academy in 1856 it was accompanied by lines from Tennyson's 'The Miller's Daughter', although, as has been observed, this was an afterthought since the woman and her lover are not standing by a millstream but in an ivy-covered arbour or summer house.[8]

The subject of the painting is the transience of young love, indicated by the discarded rose petals at the woman's feet, while the ivy, a symbol of immortality, provides hope of salvation and deliverance. The woman's situation within the arbour consciously draws on the tradition of the *hortus conclusus*; the enclosed garden as a symbol of the Immaculate Conception, and, more generally, a reference to female virginity and the 'private' sphere of womankind. MP

ॐ32

Albert Moore (1841–1893)
A Garden 1869
Oil on canvas, 174.5 x 88
Tate. Purchased with assistance from
the Friends of the Tate Gallery 1980

Albert Moore exhibited this painting at the Royal Academy
in 1870. At the time the critic Sidney Colvin, in a frequently
quoted passage, observed Moore's 'habit, right or wrong,
of making the decorative aspect of his canvas, regarded as
an arrangement of beautiful lines and refreshing colours,
the one important matter in his work. The subject, whatever
subject is chosen, is merely a mechanism for getting
beautiful people into beautiful situations.'9 This is true,
but only up to a point.

Moore's art is invariably considered in relation to the
Aesthetic Movement, and the dictum of art for art's sake,
in which the beauty of colour, form and composition were
deemed to be the artist's only concern. At the same time
Moore's art is not devoid of subject matter, not least
because his series of classically draped figures celebrates
the sensuousness of the female form, allied, at times,
to the imagery of the garden. While Moore was apparently
unwilling to give his pictures titles, the words he used to
describe them – 'A garden', 'Azaleas', 'Apricots', 'Blossoms'
– highlight the significance of the horticultural metaphor
to his art.

The title of the picture alludes to the physical space in
which the figure stands, but also to the woman herself,
who recalls Flora, classical goddess of Spring. Moore would
have known that the 'enclosed' garden was an established
symbol of the Immaculate Conception of the Virgin Mary,
although Moore's own exotic 'garden flower', her back
turned provocatively from the viewer, has far more in
common with the sensuous pagan deity than with any
Christian icon. MP

33

Fred Walker (1840–1875)
An Amateur 1870
Watercolour and bodycolour, 17.7 x 25.4
The British Museum, London

The setting of Fred Walker's watercolour is the kitchen garden of a large mansion, indicated by the imposing gateway at the extreme right of the composition. Walker may have painted this picture in the summer and early autumn of 1870 while staying at Bisham, Berkshire, thus opening up the possibility that the nearby house is Bisham Abbey.[10] The man is presumably harvesting summer cabbage, and the presence of scarlet runner bean flowers in the left foreground confirms the time of year.

The composition, although it appears to have been painted over several weeks, or even months, seems to have been based on a specific incident observed by the artist. The profession of the 'amateur' gardener was confirmed in 1891,

when the painting was shown at Burlington House with the title *Coachman and Cabbage*.[11] The man, so it seems, has stolen into the garden to help himself to a cabbage from the kitchen garden. The coach house would appear to be the pedimented building, just through the gate, beyond the glimpsed coach wheel.

During his lifetime Walker was regarded as one of the greatest British watercolourists of the age. Among his admirers was Van Gogh, who in 1885 noted of Walker and his contemporary George Pinwell: 'They did in England exactly what Maris, Israëls, Mauve, have done in Holland, namely restored nature over convention; sentiment and impression over academic platitudes and dullness.'[12] MP

34

James Tissot (1836–1902)
*Holyday c.*1876
Oil on canvas 76.2 x 99.4
Tate. Purchased 1928

Holyday is set in the London garden of the French artist James Tissot at 17 Grove End Road, St John's Wood. As the picture's title indicates, the scene takes place on a public holiday, a day set aside for leisure and relaxation, and one which originally marked a day of special religious observance. However, the illicit pleasures hinted at in Tissot's painting suggest that the artist was intent on describing a Garden of Eden into which temptation had already trespassed.

In the foreground a young woman leans forward, flirtatiously pouring milk into the teacup proffered by the man sprawled languidly by the pool. The ring on her finger and the cameo of the soldier she wears indicate that she is married to someone else.[13] As the elderly chaperone dozes, couples

loiter furtively among the chestnut trees. The young sportsmen, in caps and flannels, wear the colours of I Zingari, an elite amateur cricket club. They are thus clearly denoted as 'gentlemen' at leisure.

In 1877 Tissot exhibited the painting at the inaugural show at London's Grosvenor Gallery, a venue which was quickly to become associated with avant-garde and somewhat risqué taste. There it was viewed by the young Oscar Wilde, at that time a student at Dublin University. While he conceded that it contained 'some good colour and drawing', not least in the 'withered chestnut tree, with the autumn sun glowing through the yellow leaves', Wilde was repulsed by Tissot's 'over-dressed, common-looking people, and ugly, painfully accurate representation of modern soda water bottles'.[14] MP

35

John William Waterhouse (1849–1917)
Psyche Opening the Door into Cupid's Garden 1904
Oil on canvas, 106.7 x 68.5
Harris Museum and Art Gallery, Preston

The subject of Waterhouse's painting is loosely based on
the celebrated classical tale of Cupid and Psyche told by
Lucius Apuleius in the *Metamorphoses*, or *The Golden
Ass* (second century AD). Here Cupid, incognito, woos the
beautiful maiden Psyche, before abandoning her when she
uncovers his identity. Determined to regain her lover, Psyche
wanders the earth in search of Cupid, until they are reunited
in heaven by the gods. The precise episode in the narrative
portrayed by Waterhouse is unclear, although it may relate
to the moment she first approaches Cupid's palace. While
the story was viewed in the Renaissance as an allegory
of the union of the Soul (Psyche) with Desire (Cupid),
Waterhouse's image uses the garden as the setting for an
erotic fantasy, as the door opens the way to sexual licence.

Waterhouse had turned to the classical subject of the
woman in the garden in the 1870s, under the influence
of Lawrence Alma-Tadema. Over the next few decades
his treatment of the subject became increasingly erotic,
in works such as *Flora and the Zephyrs* (1897, Private
Collection) and *The Awakening of Adonis* (1899, Private
Collection). In the early 1900s Waterhouse painted a series
of women with flowers, an indication, it has been observed,
that he 'valued flowers and women as vessels of the
seeds of new growth'. However, as the same writer notes,
such conservative sentiments were anathema to a new
generation of women reformers, giving rise, for instance,
to the uprooting of orchids at Kew Gardens in 1913
by suffragettes.[15] MP

❧36

Ernest Arthur Rowe (1862–1922)

Campsea Ashe, Suffolk c. 1904–5
Watercolour, 41.9 x 53.3
Private Collection

When Ernest Arthur Rowe visited Campsea Ashe, Suffolk, in the early years of the twentieth century it was among the most impressive 'stately' gardens in the country. Originally laid out in the 1680s in the grounds of Ashe High House, the garden now boasted long 'canals', radiating avenues of lime trees, enormous clipped yew hedges and colourful terrace gardens.[16] In Rowe's watercolour the garden, deserted save for two strutting peacocks, evokes an air of timeless privacy and privilege. Yet within a generation the house had been demolished and the gardens despoiled, the only evidence of its former glory being the watercolours of Rowe and Elgood and the written testimony of Gertrude Jekyll.[17] Indeed, by the 1970s garden historians were looking on the 'lost garden at Campsea Ashe' as something of a secret.[18]

Rowe, who had studied originally as a lithographer, was among the foremost garden painters of the late Victorian and Edwardian period. From the 1890s, when he began to specialise increasingly in garden art, he travelled extensively throughout the British Isles, painting many of the nation's grandest gardens, including Compton Wynyates, Hampton Court, Hever Castle and Penshurst. Although Rowe's watercolours were calculated to celebrate the opulence of the 'great' British garden tradition, he earned comparatively little from his art and his personal contact with the occupants of landed estates was invariably limited to the head gardener, with whom he liaised when making an appointment to paint there.[19] Although Rowe began to make a decent living from his art in the early 1900s (and built a house on the proceeds), the First World War effectively brought a premature end to his career. MP

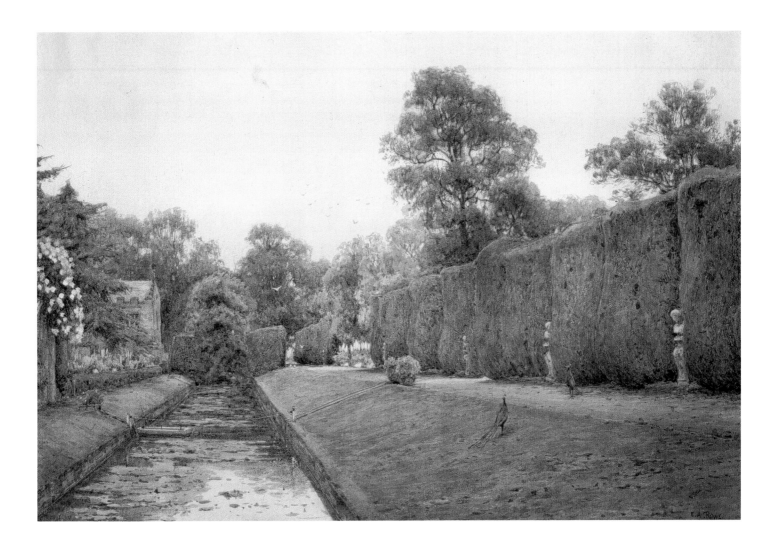

37

Helen Beatrix Potter (1866–1943)
'The Rabbits' Potting Shed': two rabbits busy potting geraniums 1891
Watercolour, 21 x 16.5
Victoria & Albert Museum, London

This is one of several grisaille drawings in which Potter combined real places with the imagined activities of small animals. Here, for example, the rabbits are busily potting geraniums in a shed based on one which Potter had sketched during a visit to Bedwell Lodge, Hertfordshire, in the summer of 1891. Two years later she began to formulate the story which was to become the basis of her first children's book, *The Tale of Peter Rabbit*.

Beatrix Potter came from a well-to-do family with a keen interest in the visual arts. From an early age she showed a gift for drawing, while her facility at recording animal and plant life developed rapidly during extended family holidays in Scotland and the Lake District. Later, in London, she regularly attended the annual summer exhibition at the Royal Academy, as well as making frequent visits to the National Gallery and Natural History Museum. Her own studies of flora, fauna, fossils and insects were made with scientific detachment, notably those of fungi, in which her expertise was widely acknowledged.

Potter's interest in book illustration was stimulated by the work of Randolph Caldecott and Walter Crane, whose coloured drawings she copied. In childhood Potter had produced her own fantasy drawings, although she did not return to the genre until her mid-twenties, when in 1890 she successfully sold designs for Christmas cards featuring her pet rabbit. MP

38a–b

Helen Beatrix Potter (1866–1943)
From *The Tale of Peter Rabbit* 1901
a *Peter Hiding in the Potting Shed*
b *Peter Sees the White Cat*
Watercolour, each 9.4 x 7.3
Frederick Warne Archive, London
LONDON ONLY

Beatrix Potter first published *The Tale of Peter Rabbit* in 1901. In the celebrated story 'naughty' Peter strays into the vegetable garden, where he gorges himself on lettuce, French beans and radishes. Chased by the old gardener, Mr McGregor, he hides in a watering can in the potting shed before making his escape – minus his shoes and jacket, which Mr McGregor fashions into a scarecrow. Peter finally returns home, where his mother puts him to bed with a dose of camomile tea. In Potter's narrative the garden is forbidden territory, fraught with danger. As his mother reminds him, Peter's own father had 'an accident' there, ending up in Mrs McGregor's rabbit pie.

Potter experienced a lonely childhood and focused much of her affection on her pet animals, especially her rabbits, which she frequently made the subject of her paintings and drawings. In September 1892, in a letter to her former governess's son, Potter first wrote the story of four rabbits – Flopsy, Mopsy, Cottontail and Peter – that was to become *The Tale of Peter Rabbit*. In 1901, unable to find a publisher for her book, she printed *Peter Rabbit* privately. However, in 1902 a second edition appeared, with new colour illustrations, published by Frederick Warne and Company. The two watercolours were reproduced in this edition.

As Potter recalled, the garden featured in *The Tale of Peter Rabbit* was an amalgam of various gardens, principally Lingholm, near Keswick, where she had spent her summer holidays. The fishpond which appears in the illustration showing Peter and the white cat derived from a garden in Tenby, while the infamous potting shed was based on Bedwell Lodge, Hertfordshire (see cat.37). To a friend Potter later recalled that 'Mr McGregor' was a gardener near Berwick, 'the only gardener I ever saw who weeded a gravel walk lying flat on his stomach!', although she also told an American enquirer that she had never known a gardener of that name.[20] MP

38a *Peter Hiding in the Potting Shed*

38b *Peter Sees the White Cat*

The ROSE Fairy

❧39

Cicely Mary Barker (1895–1973)
The Rose Fairy c.1925
Watercolour, 21 x 14.9
Frederick Warne Archive, London

First published in 1923, Cicely Mary Barker's 'Flower Fairy' books went on to become one of the most popular series of children's books produced in the twentieth century. Simple in format and design, the series captured the imagination of generations of children brought up between the wars. Altogether Barker painted more than 150 flower fairies, which featured in thirteen books in the series during her lifetime. *The Rose Fairy* first appeared in *Flower Fairies of the Summer* in 1925, while *The Geranium Fairy* was made for *Flower Fairies of the Garden*, published in 1944.

The vogue for fairies had gathered pace in the mid-nineteenth century through the work of writers such as John Ruskin, Charles Kingsley, Christina Rossetti and William Allingham, as well as numerous fairy painters and illustrators, notably Arthur Rackham and Kate Greenaway, both of whom Barker greatly admired. In the early twentieth century fairies remained in fashion, not least through the success of J.M. Barrie's play *Peter Pan* of 1904 and Rose Fyleman's poem (popularised as a song) 'The Fairies', with its opening lines:

There are fairies at the bottom of our garden!
It's not so very, very far away;
You pass the gardener's shed and you just keep straight ahead—
I do so hope they've really come to stay.

In 1922 the fairy phenomenon was given a new twist with the publication of Sir Arthur Conan Doyle's *The Coming of the Fairies*, which contained photographs of 'real' fairies (the so-called 'Cottingley Fairies') taken by two young girls. Although these images were revealed years later to be a hoax, many at the time accepted them as genuine. Barker's books, following hard on the heels of this sensational revelation, capitalised on the willingness of parents to suspend their disbelief and indulge their children's fantasies.

Barker's eye for detail and meticulous technique were influenced by her love of the Pre-Raphaelites. The various flowers in the Flower Fairy illustrations were painted either directly from real specimens or, if she was unable to access them, from botanical illustrations. Her 'fairies' were modelled on the children who attended her sister's kinder-garten, as well as young neighbours. Barker's studio was in the garden, and in it she also kept a chest that contained home-made costumes and props, including fairy wings made from twigs and gauze.[21] MP

The GERANIUM Fairy

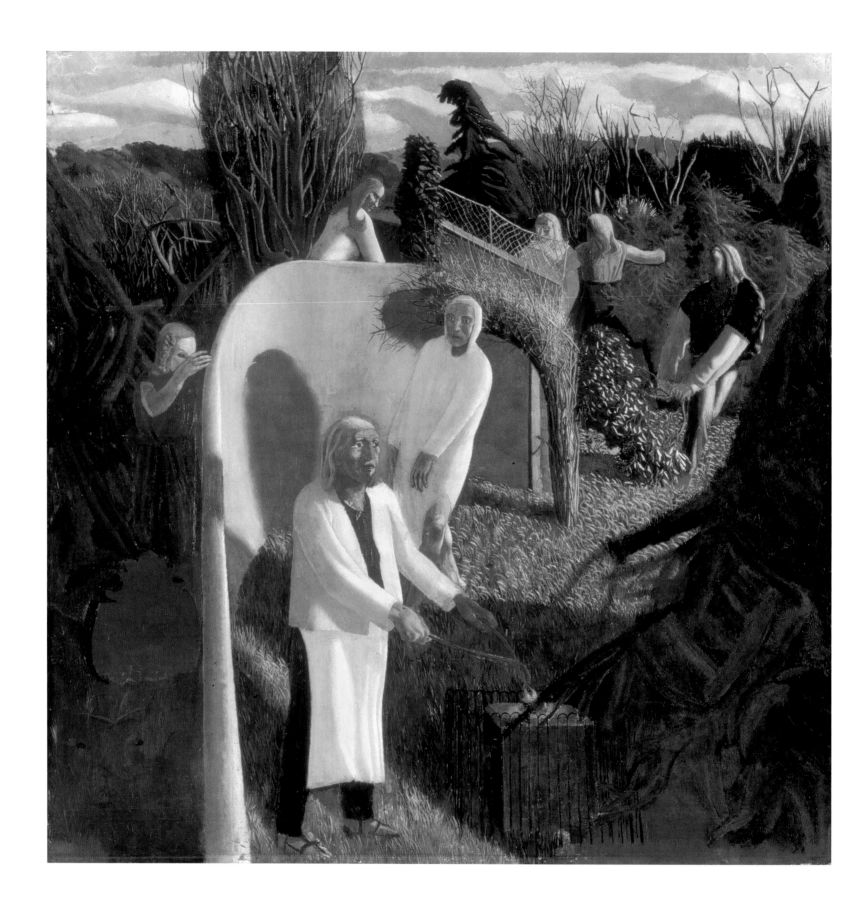

41

Stanley Spencer (1891–1959)
Zacharias and Elizabeth 1913–14
Oil on canvas, 142.6 x 142.8
Tate. Purchased jointly with Sheffield Galleries & Museums Trust
with assistance from the National Lottery through the Heritage
Lottery Fund, the National Art Collections Fund, the Friends
of the Tate Gallery, Howard and Roberta Ahmanson and private
benefactors 1999

Spencer began *Zacharias and Elizabeth* in December 1913.
At the time he was living at his parents' home in Cookham,
Berkshire. He had also acquired a studio there, in a dilapidat-
ed Georgian house, Wisteria Cottage. This he rented for one
shilling and sixpence a week from his cousin, Jack Hatch,
the village coalman. From the rear of the house Spencer
had a view of the gardens belonging to nearby St George's
Lodge, the setting for the present picture.

In the foreground Zacharias stands by an altar, an angel clad
in white behind him. On the edge of the garden Zacharias
reappears with Elizabeth, her head turned away, her arm
buried in the branches of a yew tree. To her right a gardener
drags a tree branch through the grass, a detail based on an
observation Spencer had made in the garden at Cookham.
'The high wall,' he noted, 'seen from the back window of
Wisteria, although Cookham and particularly a part that I
liked, was not quite personal enough for me.' He decided
therefore to leave it blank.[22]

For Spencer Cookham was a virtual Garden of Eden. There
he had spent a sheltered childhood, schooled by his sisters
in a shed in the next-door neighbours' garden. With his
imagination free to roam, Spencer transformed the village
and its inhabitants into a heaven on earth. At the Slade
School of Art, where he studied from 1908 to 1912, he
learned to love the art of the early Italian Renaissance,
and embraced religious iconography in his own art. When
he left the Slade he recalled that he had 'entered a kind of
earthly paradise. Everything seemed fresh and to belong
to the morning.'[23]

Of *Zacharias and Elizabeth* Spencer wrote in 1937: 'I wanted
to absorb and finally express the atmosphere and meaning
the place had for me … It was to be a painting characterising
and exactly expressing the life I was, at the time, living and
seeing about me. It was an attempt to raise that life round
me to what I felt was its true status, meaning and purpose.
A version of the St Luke passage, the gardener dragging
the branch of ivy, and Mrs Gooden giving me permission to
walk about the garden of the untenanted St George's Lodge,
resulted in this painting.'[24] MP

42

Hilda Carline (1889–1950)
Melancholy in a Country Garden 1921
Oil on canvas, 59.8 x 64.4
Private Collection

Hilda Carline painted this picture in the early summer of
1921 in the garden of Byways, home of the artist Muirhead
Bone, in the village of Steep, near Petersfield, Hampshire.
It was a difficult time for Carline, whose father had died
suddenly a few months earlier. She and her mother were
at Steep with her future husband, Stanley Spencer, who
had been invited there by Bone to work on the scheme
for a war memorial in the local village hall.

In the foreground stands Carline's grieving mother, her
isolated and forlorn figure turning towards the open gate
and the fields beyond the confines of the country garden.
In this sense the composition refers to the familiar trope
of the *hortus conclusus*, in which the 'private' condition of
womankind is defined by the enclosed space of the garden.
As it has been observed, this painting was as much an
expression of Carline's own sense of loss and bereavement
as it was of that of her mother.[25]

Hilda Carline grew up in leafy north Oxford, in a house
named The Shrubbery, which stood in a large garden filled
with trees and shrubs. Her early home environment appears
to have had a strong influence on the choice of subject
matter in her later paintings, which often feature trees and
gardens. At the time Carline painted the present picture she
was living with her mother in Hampstead, although she was
also part of a group of young artists who gathered around
the studios of her artist brothers, Sydney and Richard. They
included Henry Lamb, John and Paul Nash, Charles Ginner
and Spencer, to whom she became engaged in 1922. MP

43

David Jones (1895–1974)
The Garden Enclosed 1924
Oil on panel, 35.6 x 29.8
Tate. Presented by the Trustees of the
Chantrey Bequest 1975

In 1921 David Jones's conversion to Roman Catholicism prompted him to join the artistic and religious community at Hopkin's Crank, home of the sculptor Eric Gill, in Ditchling, Sussex. Here he learned the craft of wood engraving and was inducted into the Guild of St Joseph and St Dominic. It was here, too, that he painted *The Garden Enclosed*, which alludes to his engagement to Gill's eighteen-year-old daughter, Petra.

Jones probably painted the picture in a barn near to Gill's house, where he both worked and slept. The view in the painting is from the back door of Hopkin's Crank, looking through the garden towards the sheds and outhouses. A flock of geese scatter across the garden path, alarmed perhaps at the presence of the young lovers. In the centre foreground lies a small wooden doll, a toy that Gill had carved for his daughter as a child, now discarded.

The title of the picture is derived from the Song of Solomon, chapter 4, verse 12: 'A garden enclosed *is* my sister, *my* spouse; a spring shut up, a fountain sealed.' The enclosed garden, as Jones would have been aware, was a traditional symbol for the Virgin Mary. Here the 'virgin' takes the form of Jones's fiancée, caught in an uneasy embrace as she resists his amorous advances. The irony was that while Jones's mentor Gill was a devout Catholic he was also sexually deviant, having entered into incestuous relationships with two of his daughters, including Petra. Thus, while he encouraged Jones in his attentions towards his daughter, Gill retained a strong proprietorial interest. Although Jones was probably unaware of the extent of Gill's hold over his daughter, the title and format of the painting nonetheless reveal the garden as a site of sexual confusion and illicit desire, an Eden after the Fall.[26] MP

❧44

Eric Ravilious (1903–1942)
The Greenhouse: Cyclamen and Tomatoes 1935
Watercolour and pencil on paper, 47 x 59·7
Tate. Presented by Sir Geoffrey and the Hon. Lady
Fry in memory of the artist 1943

This is one of several paintings of greenhouses made by Ravilious during the 1930s. His choice of subject is typically offbeat; the serried ranks of cyclamen cloistered beneath a canopy of ripening tomatoes offering an insight into an otherwise enclosed world. Like many of the subjects chosen by Ravilious for his art at this time (wind pumps, steam engines and rusting machinery), *The Greenhouse* deliberately avoids the human presence while at the same time focusing on the impact of man-made objects on the environment.

Ravilious became attracted to the garden as a subject for his art during the early 1930s when he was living in the village of Great Bardfield, Essex, with his close friend Edward Bawden, who had studied alongside him at the Royal College of Art. Indeed, Ravilious was just one of a number of ex-RCA students, including Bawden, Douglas Percy Bliss, Evelyn Dunbar and Charles Mahoney, who were all attracted to gardens as well as rural landscape.

While Ravilious continued to live and work in Essex, he was by the mid-1930s also lodging near Firle, Sussex, with another ex-RCA student, Peggy Angus. As she recalled, the greenhouse in question was in a nursery garden at Firle Place, run by 'a charming old man', one Mr Humphrey, who had 'spent his youth in exotic biological exploration, including an orchid hunt up the Amazon', and who also had a collection of rare apple trees, including a Russian one from the Tsar's orchards.[27]

As Anna Pavord has observed, this well-ordered greenhouse exhibits all the expertise of the professional plantsman: 'Raised beds are contained within brick walls built on either side of the central gangway paved with terracotta tiles and perforated with iron grilles for underfloor heating. The raised beds have wooden covers, on top of which stand massed ranks of cyclamen in pots. But the beds themselves are not wasted. From the back of the covers, the thick stems of tomato plants, planted in the soil of the raised beds, are trained like vines up the side ribs of the greenhouse and along the struts of the roof. They bear a heavy crop of yellow tomatoes that make a tunnel all the way through the building, and provide useful shade for the cyclamen'.[28] MP

45

C. Eliot Hodgkin (1905–1987)
The Haberdashers' Hall, 8 May 1945 1945
Tempera on panel, 29.2 x 36.8
Imperial War Museum, London

From September 1940 to May 1941 the City of London was subjected to intense bombing by the Luftwaffe. Over the next few years the resulting waste ground became host to numerous wild flowers, creating impromptu gardens among the ruins and debris. As the botanist J. Edward Lousley remarked at the time: 'If the streets of London in 1944 and 1945 were not paved with gold it may at least be said that the bombed sites were clothed with the golden flowers of a Ragwort from Mount Etna and the silver of a Fleabane from Canada!'[29] Before the war Lousley estimated that no more than twenty flower species grew in the City of London. By 1944, as a result of wind-borne seeds and human traffic, there were well over one hundred. Among those who took a close interest in this fascinating horticultural phenomenon was Eliot Hodgkin.

During his early career Hodgkin painted murals, in which he often incorporated flowers and architectural motifs. In 1937 he began to work on a smaller scale in tempera. At the outbreak of the Second World War he entered the Ministry of Information (a withered left arm excluded him from military service). It was during breaks from his duties as an air-raid warden in the City that Hodgkin painted his exquisite series of 'bomb-site' flower paintings.

Lousley counted a dozen flower species in *St Paul's and St Mary Aldermary from St Swithin's Churchyard*, encouraged to grow there by the richer soil of the City churchyards. He noted: 'Here are shown the flower head of the Leek, the bare stem of the Hogweed and the leaves of the Tufted Vetch (all left), with the Broad-leaved Dock (left centre and extreme right), the grass Yorkshire Fog (right centre), Scentless Mayweed and leaves of Common Clover (right foreground); as well as such wind-dispersed plants as Canadian Fleabane (left), Common Sowthistle (left and right), Dandelion (centre) and Coltsfoot, with one plant of Viscid Groundsel (extreme left foreground).' The Haberdashers' Hall, he observed, displays yellow Oxford ragwort and rosebay, in bud at the right of centre.[30] MP

♣46

C. Eliot Hodgkin (1905–1987)

St Paul's and St Mary Aldermary from
St Swithin's Churchyard 1945
Tempera on panel, 50 x 36
Private Collection

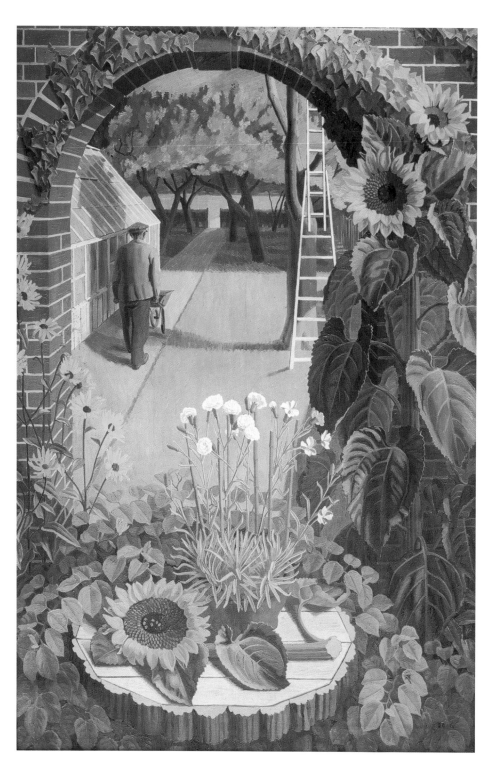

⁂47

Charles Mahoney (1903–1968)
The Garden 1950
Oil on canvas, 182.9 x 121.9
Paul Liss Fine Art Ltd, London

In Charles Mahoney's *The Garden* the vegetation typically provides the focus of attention: sunflowers (a particular favourite of the artist), yellow rudbeckia and a pot of garden pinks (dianthus). Through the brick arch, a Kentish fruit-picker's ladder rests against a tree trunk, while to the left the nurseryman quietly goes about his business. *The Garden* was Mahoney's contribution to *Sixty Paintings for '51*, an exhibition of contemporary British art organised for the Festival of Britain in 1951. Aside from Mahoney, the sixty artists included Lucian Freud, William Gillies, Ivon Hitchens, John Maxwell and Carel Weight, all of whom feature in the present exhibition.[31] As in many of Mahoney's works, the garden appears here as a source of hope and regeneration.

Charles (baptised Cyril) Mahoney developed an interest in large-scale mural and theatre design at the Royal College of Art during the 1920s, when he was commissioned, with Edward Bawden and Eric Ravilious, to paint a series of murals for London's Morley College (destroyed during the Second World War). In 1932 Mahoney, by now teaching at the RCA, began work on a mural scheme at Brockley School, alongside his students Evelyn Dunbar, Mildred Eldridge and Violet Martin. It was in these works that he was able to fully express his fondness for garden imagery. In the mid-1930s Mahoney embarked on a series of paintings and drawings of Adam and Eve in the Garden of Eden, inspired by his close relationship with Dunbar. The garden also provided the inspiration for his murals of the life of the Virgin, painted between 1942 and 1952, in the Lady Chapel at Campion Hall, Oxford.[32] MP

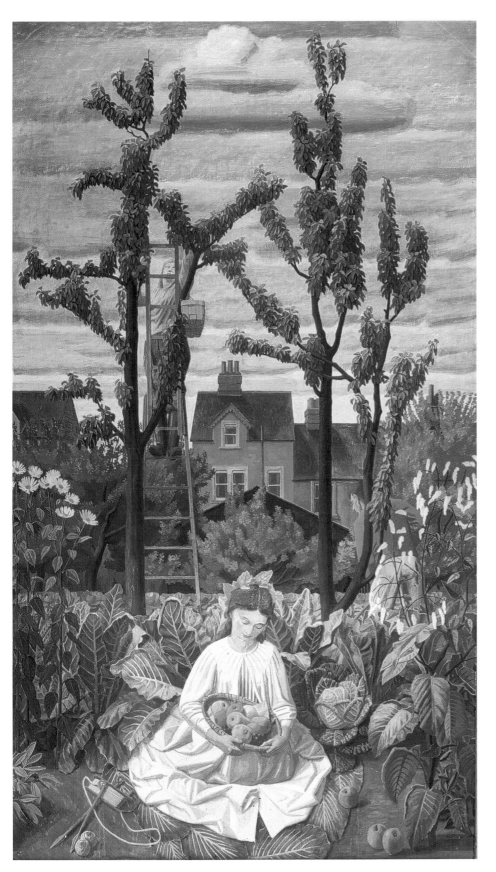

🌿48

Charles Mahoney (1903–1968)

*Autumn c.*1951
Oil on board 215.5 x 124
Elizabeth Bulkeley, the Artist's Daughter

Autumn shares the same ethos as *The Garden* (cat.47), although here it is expressed in the form of an allegory. As Mahoney's daughter has observed, the figures recall those found in his earlier mural works. 'The sitting figure reflects the theme of the Muses from the mural at Morley College and the fruit-picker on her ladder is reminiscent of the figures of angels in the murals at Campion Hall, Oxford. The figure of Autumn was modelled by Mahoney's wife, Dorothy. She sits in the Kentish garden like a Muse of Abundance, her acolytes behind her. She cradles her basket of fruit like a child that she has brought forth, contemplating it in the manner of an early Italian Renaissance Madonna.'[33] The plants in the picture were based on Mahoney's garden in Wrotham, while the red-brick Victorian house in the background and the shed were modelled on buildings visible from nearby Borough Green station, where Mahoney caught the train to London. MP

49

Barbara Hepworth (1903–1975)
Corymb 1959
Bronze, 29.2 x 35.6 x 24.1
Private Collection

This is one of an edition of nine identical bronze casts made by Barbara Hepworth, another of which is displayed in the artist's sculpture garden in St Ives, Cornwall. *Corymb*, the title chosen by Hepworth, is a botanical term, referring to a flat-topped or convex flower cluster, where flower stems of different lengths rise from the same stalk – such as *Spiraea ulmaria* (meadowsweet), *Achillea millefolium* (yarrow) or *Sambucus nigra* (common elder). Since Hepworth's sculpture does not resemble this formation it would appear that she wanted to evoke the general idea of inflorescence rather than emulate a particular type of flower.[34] She may also have been attracted to the poetic resonance of the word itself, which derives from the Latin *corymbus*, meaning a flower or fruit cluster, such as can be found in the crown worn by the god Bacchus.

Even before she moved to Trewyn Studio in St Ives in 1949, Hepworth had enjoyed setting her sculptures in a horticultural context, placing them among potted plants. In the mid-1950s she turned her full attention to the garden in St Ives, planting and redesigning the layout. From this time the symbiosis between Hepworth's sculpture and the natural world became increasingly apparent. *Corymb*, which at St Ives nestles among foliage and flowers, its surface covered with a patina of verdigris, exemplifies this harmonious relationship.[35] MP

50

Carel Weight (1908–1997)
The Silence 1965
Oil on panel, 91.4 x 121
Royal Academy of Arts, London

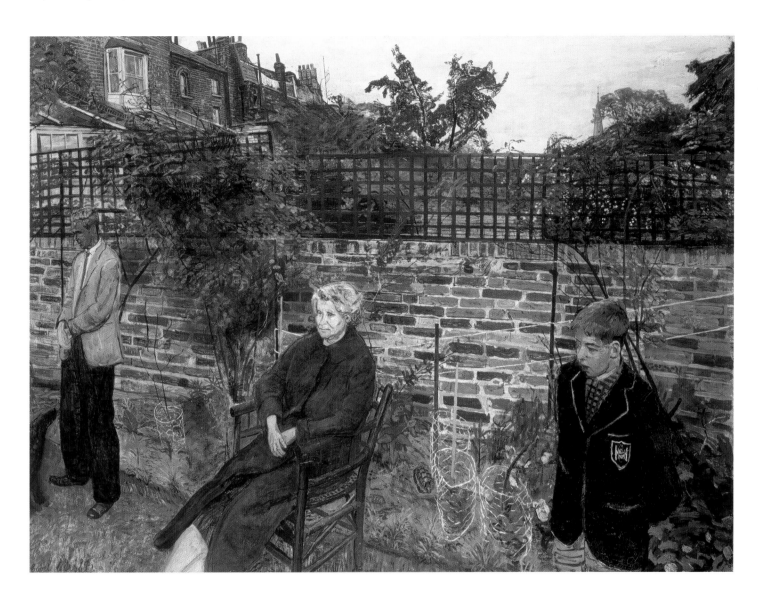

The subject of this picture is the two-minute silence, nowadays observed at 11 am on the second Sunday of November, Remembrance Sunday, to remember the dead of the two world wars and later conflicts. As Carel Weight observed: 'It's always seemed eerie to me – the two minutes' imposed silence on Remembrance Day. And especially so if it's broken by a dog in the distance somewhere, bewildered by it all … The three in this little family are observing the silence, each one locked away in a world of his or her own.'[36]

Carel Weight was born in Paddington, London, and grew up in straitened circumstances in nearby Fulham and Chelsea. His earliest memories were shaped by an unsettled home life, his imagination fuelled by the imagery of Blake, Hogarth, Cruikshank, the Pre-Raphaelites and Edvard Munch. In adulthood Weight used his immediate environment, the suburban London garden, as the setting for a number of his narrative pictures. Here he wove together childhood memories and private fantasies, at times mournful, contemplative, erotic, and macabre. As he commented: 'This is one of many pictures in the setting of my garden in Battersea, which seems to be an unending source of inspiration. I have imagined murders, rapes, surprises and all sorts of wonders there …'[37] MP

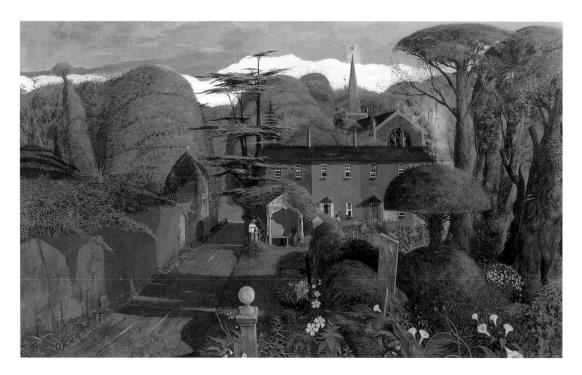

♣51

John Shelley (born 1938)
Annunciation 1968
Oil on board, 95.9 x 156.8
Tate. Purchased by the Trustees of the Chantrey Bequest 1969

The title of John Shelley's enigmatic painting relates to the figure of the man leaning against his bicycle and the young woman seated in the nearby arbour; their meeting is likened by the artist to that of the angel Gabriel and the Virgin Mary.[38] Indeed, the association between the figures and their biblical counterparts is underlined by their appearance: the woman is dressed in blue (the traditional colour of the Virgin's robe) and the man in 'angelic' white. His bicycle confirms his role as messenger. The setting, too, is carefully calculated to suggest the allegorical nature of the work, with the proximity of the parish church and a shaded arbour, which recalls Italian Renaissance representations of the Annunciation.

The detailed depiction of objects within the picture – the row of artisans' cottages, the ornate gazebo, the kitchen gardens and the medieval church – appears to suggest a specific location. Shelley, however, affirms that the work is deliberately eclectic, inspired by images taken from a variety of sources, both real and imagined. At the same time the setting is reminiscent of rural Surrey, where Shelley lives and works. (The west end of the church, for example, is loosely modelled upon All Saints, Carshalton.)

Among the artists to have inspired Shelley is Samuel Palmer, the date '1825' inscribed on a flagstone in the left foreground of the picture being a subtle homage to that artist. Another important influence is Stanley Spencer, who, Shelley states, had a profound impact when he was training at Wimbledon Art School in the 1950s. He recalls meeting Spencer in Cookham at that time: 'we were on a student trip, and we all descended upon him as he was painting in the church-yard. He was very nice and offered me a Spangle'. MP

♣52

David Inshaw (born 1943)
The Badminton Game 1972–3
Oil on canvas, 152.4 x 183.5
Tate. Presented by the Friends of the Tate Gallery 1980

Inshaw's painting was inspired by his appreciation of the landscape around Devizes, Wiltshire, where he had settled in 1971. 'Everything in the picture,' he explained, 'is taken from near my house in Devizes and rearranged in its right place. I changed everything I used in the picture in order to increase the mystery and wonder I felt around me in this magic place.'[39] Drawn to the area by the ancient earthworks at Stonehenge and Avebury, Inshaw was also captivated by more recent human interventions, including the 'warm red brick of the Georgian houses, against the early morning spring skies', which provided the inspiration for the present picture.[40] By now Inshaw had also developed a fascination with topiary, which became a leitmotif of his art at that time.

Inshaw, whose grandfather had been a professional gardener, developed an interest in horticulture during his early twenties, notably during a visit to Paris in 1964, where he spent six months drawing in the celebrated Jardin des Plantes. His other passions, also reflected in the present picture, were English literature, games and women. As Inshaw recalls, he was 'very much in love' with the two girls who feature in *The Badminton Game*. In this context, the iconographic significance of *The Combat of Love and Chastity* by Gherardo di Giovanni del Fora (National Gallery, London), which Inshaw sites as a major influence on his picture, becomes apparent.

The original title of Inshaw's painting was 'Remembering mine the loss is, not the blame', a line taken from Thomas Hardy's poem 'She, To Him':

Remembering mine the loss is, not the blame,
That Sportsman Time but rears his brood to kill,
Knowing me in my soul the very same —
Once who would die to spare you touch of ill! —
Will you not grant to old affection's claim
The hand of friendship down Life's sunless hill?

In the poem a young girl foresees that her beauty will fade, yet hopes that in time her lover will become her friend. Inshaw, who was particularly drawn to the love poetry of Hardy, aspired in *The Badminton Game* to make a poetic statement about his own emotional state. 'I wanted to pin down a moment, make it go on living, I wanted to be particular and yet general. I wanted to be excessive and yet modest. I wanted the picture to contain all my feelings and thoughts, happy thoughts as well as sad, full of waking dreams and erotic fantasies. I wanted the painting to be of this world and of the world of daydreams.'[41] MP

❦53

Ivor Abrahams (born 1935)
Shrub Group 1975
Metal cut-out with decal transfer, 120 x 140 x 25
Courtesy of the artist

Abrahams became interested in the garden as a subject for his art in the late 1960s, when he produced his first series of garden prints, 'Garden Emblems'. During the next ten years he explored the subject through further print series, often based on illustrations drawn from gardening books and magazines. At the same time he made a number of ambitious garden sculptures, reliefs and three-dimensional works, which he invested with an emblematic and, at times, illusionistic quality.

In 1984 Abrahams exhibited *Shrub Group* at the Yorkshire Sculpture Park, in the grounds of Bretton Hall.[42] Abrahams explains: 'During the Seventies, a lot of my print and drawing work utilised a cut-out or profiling method. This followed my interest in nineteenth-century silhouettes and the advertising method for "point of sale" cut-out figures on retail displays … In a department store, approaching a cut-out figure offering some product, from a distance in a crowd, it could easily be mistaken for the real thing. I thought the "point of sale" technique used by advertising could be applied to my cut-out shrub, creating an illusionary element when placed in a natural setting to paraphrase nature.'[43]

For *Shrub Group*, Abrahams had a printer make an enlargement of a small photographic image he had found in a gardening magazine. From this enlarged image he cut out a profile, separating the image from its background, and introduced some steps into the foreground. Detail, and then colour, were added to the black and white original. After proofing, the result was printed on large-scale transfer paper, and the resulting cut-out shape was manufactured in mild steel. Finally, the transfer was applied to the metal and protective coats of varnish were applied.[44] MP

❦54

Hubert Dalwood (1924–1976)
Bonsai Garden II 1975
Bronze, pebbles and plant, 9 x 62 x 55
Gimpel Fils, London

Hubert Dalwood confirmed his fascination with the garden in 1971 when he proposed a book on landscape and garden design, which was to include, among other things, eighteenth-century English gardens and Japanese rock gardens. The following year he was awarded a two-month scholarship to visit Japan. There he was entranced by the Shinto and Zen gardens, notably the celebrated gardens at the Roan-ji Temple in Kyoto. In 1973 he wrote of the Japanese garden: 'With the simplest of means, raked sand and stones, it expresses not only formal ideas of great refinement but uses formal arrangements to suggest both parallels with the real world, a microcosmic landscape, with metaphysical ideas, like the conflict of order and disorder.'[45] The following year Dalwood made the first of a series of four small bonsai gardens. The gardens, which were sculpted initially in clay, were, like the present one, intended to be cast in bronze and could, if desired, contain a living bonsai specimen. In this way Dalwood sought a union between the ancient 'art' of bonsai and his own art, with its ongoing preoccupation with notions of scale and the metaphysical.

In bonsai, the miniature tree specimen is rigorously trained so that only its most essential features are retained, while its health and longevity are maintained. First appearing in China over a thousand years ago, bonsai spread to Japan in the late twelfth century with Zen Buddhism. From this time it became popular among the country's social and intellectual elite. The art of bonsai was also interwoven with certain aesthetic and philosophical principles, relating to the three essential virtues of truth, goodness and beauty, or *shin-zen-bi*.

The four bonsai gardens were among Dalwood's final works and formed just one aspect of his fascination with landscape and the environment. Indeed, in the months leading up to his premature death at the age of fifty-two, Dalwood had hoped to extend his practice beyond sculpture, to landscape garden design. MP

❦55

John Pearce (born 1942)
Clement's Garden 1986
Oil on board, 150 x 91
Private Collection, courtesy Francis Kyle Gallery, London

The customary view of the private suburban garden is from the house or artist's studio. In *Clement's Garden*, however, Pearce has tucked himself away among the far reaches of undergrowth, looking back towards the house, glimpsed through the branches of a spreading chestnut tree. This unusual vantage point, together with the overgrown and neglected gardenscape, lends the work an air of secrecy, as though the house and garden are being observed unawares.

Pearce began making pictures of gardens during the early 1960s, when he was awarded the Sketch Club Prize for a painting of his own back garden in Crouch End, north London. Clement's garden (which belonged to a friend Pearce had known since his school days) is also a north London garden, situated in Whitehall Park, a tree-lined street of high, brick terraced houses, sloping downhill. The garden rises steeply from the back of the house, the end being level with the roof.

The painting, like all Pearce's garden pictures, was made entirely from direct observation over a period of months: the chestnut trees were budding when the painting was begun, eventually developing into an important focal point. Typically, Pearce erected a transparent awning over his easel, allowing him to continue uninterrupted by rain, and to take advantage of what he refers to as 'the peculiar clarity of rainy light'. Pearce was also drawn to the untended state of Clement's garden, which he perceived as a virtual wildlife reserve. 'For me,' he notes, 'it affords an interesting community of wild and cultivated plants, seclusion and privacy in the open air, and, caught between the overgrown, almost wooded slopes of the garden and the house, an often indirect or diffused daylight which is intriguing as well as practical to work in.'[46] MP

56

Mat Collishaw (born 1966)
Who Killed Cock Robin? 1997
Iris print, 107.5 x 81
Courtesy the artist and Modern Art, London

Mat Collishaw works in a variety of media but has a long-standing fascination with film and photography. His eerie and inventive images frequently interweave references from art history with ideas and imagery from literature and popular myth. Scenes such as that depicted in *Who Killed Cock Robin?*, transporting the viewer into a dark, enchanted setting, are evocative of Victorian fairy painting. In this verdant enclosure young children gather mournfully around a dead robin. The bird is strangely out of proportion, far larger than the weeping children, and dominates the scene. This suggests they are imaginary characters, although the shift in scale also hints at a world seen through the eyes of a child.

In 1995 Collishaw had made a series of manipulated colour photographs of 'fairies', depicting himself as a 'poacher' trying to catch them as they darted over the surface of Clapton Pond in east London. This series of works, like the subsequent *Who Killed Cock Robin?*, captures a sense of nostalgia for our early life – its mysteries and adventures. The title of the piece reinforces such ideas, taken as it is from an old nursery rhyme, its traditional verses summoning up the private fantasy world of childhood.

Many such light verses concealed much darker meanings, however. It has been suggested that the story of Cock Robin may refer to the death of King William II, also known as William Rufus ('Cock Robin'), who was killed with an arrow while hunting, allegedly on the orders of his younger brother, who assumed the throne. Likewise, the beauty of Collishaw's imagery is never innocent, but dependent on techniques of mediation and manipulation that hint at more ambiguous meanings. MH

Who killed Cock Robin?
I, said the sparrow,
With my bow and arrow,
I killed Cock Robin.

...

All the birds of the air
fell a-sighing and a-sobbing,
when they heard the bell toll
for poor Cock Robin. 47

🍂57

Sarah Jones (born 1959)
*The Garden
(Mulberry Lodge) VI* 1997
Photograph on paper
on aluminium, 150 x 150
Tate. Purchased 1999

The photographs of Sarah Jones shift between the genres of portraiture, still life and landscape, exploring how people interact with and relate to different environments. In 1997 Jones began three series of works, *The Dining Room*, *The Sitting Room* and *The Garden*. As the titles suggest, each suite of images features a quintessentially English domestic setting. Jones worked with three teenage girls, near neighbours and close friends, photographing them repeatedly in closely related compositions. The resulting photographs shift between the confines of tightly ordered, middle-class interiors and a place where nature is as closely, but never completely, controlled: the garden.

Despite her use of real people and real locations, what remains most powerful in Jones's photographs is the sense of artifice. Using evocative lighting, she portrays the girls like actors on a stage, frozen in awkward poses with inscrutable,

enigmatic expressions. Although a narrative is implied it remains ambiguous and this creates a sense of uncertainty and suspense. *The Garden (Mulberry Lodge) VI* could be read as an allegory, with Jones exploring the nature of adolescence and teenage repression within the context of contemporary suburban life. The girls inhabit a space between childhood and maturity, between the boundlessness of youthful imagination and the structures of parental authority. As Jennifer Higgie has observed, 'Myriad ways of representing nature have emerged as one of Jones's most potent indicators of confusion and dislocation. Adolescents – intensely aware of the loaded potential of the psychological gesture – are often adrift in a kind of emotional Diaspora. At best sheltered and nurtured in their parents' homes, they are nonetheless often uncomfortable in them, restless and full of secrets which reveal themselves in their aggressive yet supplicating posturing.'[48] MH

58

Lucian Freud (born 1922)
Garden from the Window 2002
Oil on canvas, 71.1 x 60.6
Acquavella Contemporary Art Inc., New York
LONDON ONLY

Here Freud focuses intensely on the dying blossoms of
a buddleia, the so-called 'Butterfly Bush' that has become
such an ubiquitous feature of the British garden, as well
as a tenacious inhabitant of railway embankments, waste
ground and derelict buildings.

In the summer of 1997 Freud painted a large picture of the
same buddleia that grows in the garden of his house in
Notting Hill Gate. He explained that he wanted to 'take on
the garden' because previously he had either brought plant
species into his studio or had painted them outside from a
distance. 'I was,' he stated, 'very conscious of where I was
leading the eye. Where I wanted the eye to go but not to
rest; that is, the eye shouldn't settle anywhere ... I realised
that I could sustain the drama that I wanted in the picture
by – as I nearly always do – giving all the information that
I can.'[49]

Freud, who was born in Berlin, moved to England in 1932,
later enrolling at the East Anglian School of Drawing and
Painting in Dedham, Essex, run by Cedric Morris. Morris's
own art was inspired by his passion for the garden, which
in turn influenced his students, as for example in Freud's
Still Life with Cactus and Flower Pots, which he painted
there.[50] While the human figure has increasingly formed
the prime focus of his art, Freud has retained a fascination
with plants, flowers and vegetation, which appear promi-
nently in his portraits, as well as being studied intensively
in their own right. Throughout his career Freud has painted
plants in the confines of the studio. In the late 1970s he
filled his home with houseplants, noting how he wanted
'a real biological feeling of things growing and fading
and leaves coming up and others dying'.[51] More recently,
as the present work indicates, he has begun to look to
his garden for inspiration. MP

Fragments and Inscriptions

A Garden contemplation suits,
And may instruction yield,
Sweeter than all the flow'rs and fruits
With which the spot is filled.'[1]

*J*ohn Newton's hymn of 1779 suggests that the garden should provoke meditation upon the Garden of Eden and the causes and consequences of Adam's Fall. It is indicative of an approach to the garden that locates it as a symbolic space, an embodiment of ideas. It is a reminder that such spaces have seldom been simply places for relaxation and cultivation. Long before the advent of the cottage garden the intellectual garden existed as a complex matrix of poetic and philosophic meaning. In fifteenth- and sixteenth-century Britain the use of the garden as a symbol of human and earthly transience was popular in poetry, literature and philosophical discourse, as well as in religious thinking. Consequently gardens, inspired by the examples described in classical texts, were envisioned as spaces for contemplation; most usually of mortality. Such gardens were decorated with symbols such as sundials, funerary urns and fragments of antique statuary, symbols which remain equally potent today.

This section therefore includes art works which address an emblematic and inscriptive tradition. Such gardens stand opposed to the more visual, sensual, floricultural tradition and are rooted in the past and in place, infused with the *genius loci*. Their archetype is the woodland grove. An ancient form, groves of whatever era have an antiquarian aura. Overarched by trees, studded with stone monuments, inscriptions or fragments of monuments, the grove is a site of meditative reverie, poetic and elegiac. Yet, like all Arcadian images, it is shadowed by decay and death. Perhaps the most iconic, and influential, treatment of this theme in art is Nicolas Poussin's *The Shepherds of Arcady c.*1650–5 (Louvre, Paris). The painting depicts a group of shepherds who have discovered a tomb on which is inscribed 'Et in Arcadia Ego', a phrase found in Virgil's fifth eclogue, which translates literally as 'Even in Arcadia, there am I'; thus is signalled the presence of death in even this idealised location. The inscription absorbs the figures in the contemplation of mortality and human vanity.[2]

The contemporary artist whose work best encapsulates the Arcadian theme is perhaps Ian Hamilton Finlay. Finlay's garden, Little Sparta, at Stonypath, in the Scottish Lowlands, consciously emulates the classical garden. It contains works intended to provoke metaphysical questioning, memorials, reminders of mortality, plaques, temples, columns. It recalls the classical ideal, but also revives the neo-classical republican tradition of eighteenth-century Britain and France. It is overtly political; emblems of warfare are a leitmotif in Finlay's work. In contrast, and at the opposite geographical extreme to Finlay's Scottish garden, a different kind of Arcadia is found in Derek Jarman's extraordinary garden on the Kent coast at Dungeness, won from a harsh environment and shadowed by a nuclear power station, represented here by Howard Sooley's photographs (cat.71a–d).

Photography has proven a potent tool for making images that are about time and time passing. In very different ways ideas of mortality and transience are central to work by Gerry Badger and David Spero. Badger's images recall the artificial ruins of the eighteenth century yet depict real places (cats.62–3).

His photographs show the eventual fate of every garden, of every human endeavour; they are subject to irresistible forces of entropy and decay. In the end everything falls apart. As Thomas Whately wrote in 1770: 'At the sight of a ruin, reflections on change, the decay, and the desolation before us, naturally occur; and they introduce a long succession of others, all tinctured with that melancholy which these have inspired ...'[3] Spero's *Garden* series (cat.72a–e) features a garden that recalls the classical, Arcadian ideal of the retreat; a quiet, enclosed space in which one might sit and think. Yet the changes of the seasons, writ so large across the series, are uncontrollable. And with each successive owner the garden is subtly transformed; the evidence of previous owners' activities, their influence, is slowly obliterated.

A memorial or monument encourages thoughts of the brief passage of human life, yet also invites consideration of the achievements of those memorialised; and perhaps such thoughts may encourage personal aspirations. In Ivor Abrahams's *Funerary Urn* (cat.66), taken from his series *Monuments* 1978, the memorial is anonymous. The theme is also found, albeit in very different form, in Sir William Nicholson's painting of *Miss Jekyll's Gardening Boots* (cat.59) and Edwin Smith's photograph of *Vita Sackville-West's Boots, Sissinghurst, Kent* (cat.61c); oblique portraits and memorials to two hugely influential gardeners. Jekyll was, of course, alive when Nicholson painted her boots — these well-worn personal artefacts suggesting an emblematic portraiture — yet with time the painting has acquired a kind of memorial status. Howard Sooley's images of Derek Jarman's garden perhaps function in the same way. Here, despite Jarman's absence, his presence, and his life and achievements, are powerfully implied by the rugged and idiosyncratic sculptural forms of the garden, which stand in for its creator and encapsulate the essence of the surrounding landscape.

The intellectual garden takes many forms. Paul Nash, like many artists, recognised the peculiar *otherness* of gardens, a characteristic he described as 'poetical' and which he found the camera particularly suited to recording. His photographs are fragmentary images; they hint at something happening beyond the visible world, and reveal unexpected transformations (cat.60a–e). This is another Arcadia, but it is also 'haunted'. Like Nash, Richard Wentworth subjects his materials to extraordinary mutations (cats.69–70). An important precedent for such thinking is another classical text, Ovid's *Metamorphoses*, the archetypical transformative narrative.

By the mid-nineteenth century the emphasis within gardens had shifted towards plants and planting. Nonetheless the classical tradition has survived. Gardens are still created, if not for the promotion of pleasurable melancholy and metaphysical questioning, then as retreats and places of meditative quiet. As a contrast to the gardens of Finlay and Jarman we can see the survival of the classical tradition in contemporary suburbia in photographs by John RJ Taylor and Martin Parr. The garden in Taylor's *North London* (cat.67) still represents a retreat, but the statues (co-opted as planters and bird baths) that decorate the front gardens in Parr's images of the suburbs around the North Circular ring road in London are perhaps more to do with questions of style and status than with the encouragement of philosophical thought (cat.73a–b). —*Ben Tufnell*

59

William Nicholson (1872–1949)
Miss Jekyll's Gardening Boots 1920
Oil on plywood, 32.4 x 40
Tate. Presented by Lady Emily Lutyens 1944

In 1920 William Nicholson, one of the foremost British portrait painters of the early twentieth century, was commissioned by Sir Edwin Lutyens to paint Gertrude Jekyll's portrait. He later wrote to Lady Jekyll, Gertrude's sister-in-law: 'It was a great event for me to meet Gertrude Jekyll, and I remember thinking her exactly the person I should like to paint. It wasn't an easy job, however, because she thought herself unpaintable … I didn't entirely waste the daylight, as I painted her Army boots and gave the result to N. (Lutyens).'[1] Nicholson evidently had some problems with the sitting (Jekyll wrote: 'all I had to do was sit, which I did after a good show of resistance as I think ugly people had better not be painted')[2] and so used the time he had while he waited for Jekyll to make this study of the boots that she used for gardening. In the event, the painting of the boots perhaps does more to sum up her character and achievements than the fine, but unremarkable, portrait, now in the National Portrait Gallery, London.

Gertrude Jekyll (1843–1932) studied at Kensington School of Art and hoped to become an artist before deteriorating eyesight forced her to abandon painting, allowing her to devote herself fully to gardening and garden design. She was hugely influential as a designer, bringing a painterly engagement with colour to her planting schemes, and writing a number of important and popular books, including *Colour in the Flower Garden* (1908). She wrote: 'The duty we owe to our gardens and to our own bettering in our gardens is to use plants that they shall form beautiful pictures.'[3] Jekyll often worked in collaboration with Sir Edwin Lutyens, designing gardens for the houses that he built.

Nicholson perhaps had in mind Van Gogh's paintings of boots (*Boots with Laces, Paris* 1885, Van Gogh Museum, Amsterdam, and *A Pair of Boots* 1887, Baltimore Museum of Art) and his other studies in which inanimate objects and personal effects are made to stand in for a character, such as *Van Gogh's Chair* 1888 (National Gallery, London). Nicholson had the previous year painted another portrait of boots, *Miss Simpson's Boots* 1919 (Private Collection). Jekyll's boots themselves are now in Godalming Museum, where there is a considerable collection of Jekyll memorabilia. BT

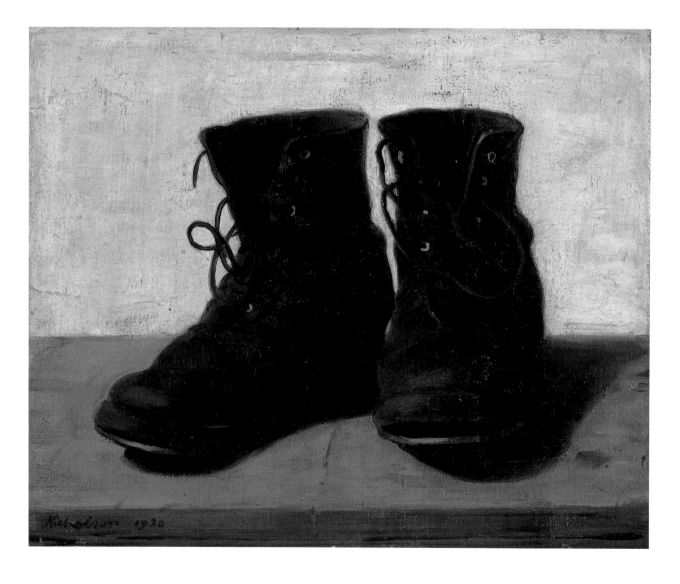

⊚ 60a–e

Paul Nash (1889–1946)
a *The Grotto at 3 Eldon Grove NW3* 1936–9
b *Border Plants and the Sword of a Swordfish* 1936–9
c *Stone Form in Arcadia (Stone Eagle, Springfield)* c.1940–1
d *Box Garden, Beckley Park, Oxfordshire* c.1940–1
e *The Haunted Garden* c.1940–1
Photographs, each 23.5 x 39.3, except 60c 39.3 x 23.5
Tate Archive

Paul Nash's principal artistic theme was landscape, but his concern was not topographical. Rather, he was preoccupied with the *genius loci*, the way place can function as a matrix for a range of unnoticed or 'unseen' possibilities. Nash outlined what he was looking for in 1938:

The landscapes I have in mind are not part of the unseen world in a psychic sense, nor are they part of the Unconscious. They belong to the world that lies, visibly, about us. They are unseen merely because they are not perceived; only in that way can they be regarded as 'invisible'.

All these things under consideration here – stones, bones, empty fields, demolished houses, and back gardens – all these have their trivial feature, as it were their blind *side; but, also, they have another character, and this is neither moral nor sentimental nor literary, but rather something strange and – for want of a better word, which may not exist – poetical.*[4]

a *The Grotto at 3 Eldon Grove NW3* 1936–9

b *Border Plants and the Sword of a Swordfish* 1936–9

In his photography Nash concentrated on landscapes and images of what he called object-personages – curious or evocatively shaped found wood and stones – often in carefully composed groups; but he also took a large number of photographs of gardens, including his own garden at Eldon Grove in Hampstead and formal gardens at Gregynog in Wales and at Beckley Park. In the images of his own garden it can be seen how Nash used it as a kind of laboratory for the poetic; he was fascinated by the contrasting shapes of plants, the often anthropomorphic forms of leaves, stems and buds, the textures of decay. Plants and inanimate objects are placed in surprising or unnerving juxta-positions; as in *Border Plants and the Sword of a Swordfish*. In his photographs of more formal gardens he seeks out the viewpoint that renders the setting strange in some way; the garden at Beckley Park seems to consist of a series of geometric forms rendered in spongy foliage, and nothing else. He is fascinated by the way that ivy and other creeping plants slowly overwhelm walls and statues, as can be seen in *The Haunted Garden* and *Stone Form in Arcadia*, which come from a series of photographs of the statuary in Edward Burra's garden at Springfield.

Nash was a central figure in the development of British Modernism. He made his name as an Official War Artist during the First World War but in the following decades he was a leading advocate for the introduction of contemporary developments in art – in particular abstraction and Surrealism – into England. In 1933 he was a founding member of Unit One (with Henry Moore, Barbara Hepworth, Ben Nicholson and others) and in 1936 he was on the Committee of the International Surrealist Exhibition in London. Nash was also important as a writer, contributing articles and reviews to a range of publications. Although best known for his paintings and prints, he was also an accomplished and distinctive photographer. He used photography as a means to develop a visual resource, and to refresh his painting practice. As Andrew Causey has written: 'Nash was not technically minded, nor curious about the technical side of photography. He regarded his camera as the tool of his imagination. His work as a photographer complemented his research as a painter.'[5] Nash was particularly interested in what he characterised as 'the peculiar power of the camera to discover formal beauty which ordinarily is hidden from the human eye'.[6]

Towards the end of his life, when he was increasingly unable to paint in the landscape owing to ill health, Nash's photographs came to occupy a more central role in his working process. Many were subsequently used as the basis for paintings. Cat.60e was the basis for *The Haunted Garden* 1941 (Ashmolean Museum, Oxford) and cat.60d for *Box Garden* 1943 (Private Collection). BT

c *Stone Form in Arcadia (Stone Eagle, Springfield)* c.1940–1

d *Box Garden, Beckley Park, Oxfordshire* c.1940–1

e *The Haunted Garden* c.1940–1

61a–e

Edwin Smith (1912–1971)

a *Nymph of the Grot, Stourhead, Wiltshire* 1956
b *Sphinx at Bodnant* 1962
c *Vita Sackville-West's Boots, Sissinghurst, Kent* 1962
d *Garden Seat, Rousham, Oxfordshire* 1966
e *Essex, Saffron Walden* 1970
Photographs, each 41.7 x 30.5, except 61b 30.5 x 41.7
RIBA Library Photographs Collection, London

Edwin Smith took photographs for more than thirty books on a range of subjects, including *English Parish Churches* (1952), *English Cottages and Farmhouses* (1954), *The English Garden* (1964) and *English Cottage Gardens* (1970). His speciality was architectural photography but he also took a large number of images of gardens; the combination of architecture and landscape in the garden obviously appealed to his sensibility. He worked with an old-fashioned half-plate bellows camera made in 1904, using available light, often making very long exposures, to produce intense images with great tonal subtlety. His gardens are typically empty, still spaces; as such his images convey an extraordinary sense of timelessness. The forms of the garden, the spaces and objects within, are all set out with clarity, and the images have a quiet and meditative quality. Unlike Nash, Smith does not seek out the surreal in the garden, but like Nash he delighted in finding the surprising angle, the revealing view, as can be seen in *Sphinx at Bodnant* and *Garden Seat, Rousham, Oxfordshire*. He loved the strangeness of formal gardens, the jumbled contrasts of cottage gardens and sub-urban courtyards. In Smith's work the camera records the infinite variations in texture found in gardens: lawns, trees, paving stones, borders; the rich play of light and shadow.

Vita Sackville-West's Boots, Sissinghurst, Kent and *Garden Seat, Rousham, Oxfordshire* are both, in different ways, striking images of time passing, and by implication reminders of mortality. In the second, the nettles that push through the slats of the garden bench are reminders of the transience of human endeavour. Likewise, a pair of boots can become a kind of memorial to the person who wore them, somehow invested with character through contact. They can also act as a substitute for a living presence, as William Nicholson's 'portrait' of Gertrude Jekyll's boots demonstrates (cat.59).

Smith described himself as 'an architect by training, a painter by inclination and a photographer by necessity'.[7] Having trained as an architect (but being forced to abandon the course before he completed it, owing to financial difficulties) he took up photography in 1935. In the late 1930s he met Paul Nash, who encouraged him and arranged for him to use the darkroom at the London premises of the publisher Lund Humphries. Nash also introduced Smith to the editor of *Vogue*, which led to the beginning of his professional career as a photographer. Smith was much influenced by the French photographer Eugène Atget, who regarded his own photographs as 'simply documents', and Smith's work has a simplicity which recalls Atget. Nonetheless Smith was an extremely sophisticated artist and his ideas about the potential of photography echo Nash's (see cat.60a–e). He said that with photography 'much that was before visually incomprehensible has become, in the presence of the camera, significant'.[8] BT

b *Sphinx at Bodnant* 1962

a *Nymph of the Grot, Stourhead, Wiltshire* 1956

c *Vita Sackville-West's Boots, Sissinghurst, Kent* 1962

e *Essex, Saffron Walden* 1970

d *Garden Seat, Rousham, Oxfordshire* 1966

62

Gerry Badger (born 1946)
*Derelict Garden, Primrose Hill c.*1977
Photograph, 54.3 x 74.9
Victoria & Albert Museum, London

63

*The Hall, Wormingford c.*1982
Photograph, 47 x 57
Victoria & Albert Museum, London

Images of entropy, decay and disintegration run through Gerry Badger's work. His photographs depict abject, neglected spaces; gardens that have disintegrated through lack of care. *The Hall, Wormingford* depicts the bottom of a domestic garden, yet one in which order has begun to break down; the fence is collapsing (along with the furniture stacked against it) and the border between this garden and its even more dilapidated neighbour is becoming blurred. Badger's images display the eventual fate of every garden and as such they fulfil a role familiar from literature and visual art – the garden as metaphor for mortality – that of the *vanitas*. Yet in some of Badger's images there is also the distinct possibility that the destruction has not been wrought by time, but through human agency; *Derelict Garden, Primrose Hill* shows a garden that looks as if it has been hit by a bomb, although neglect (and possibly vandalism) is the more likely cause.

Badger grew up in London in the years following the Second World War and in fact recalls playing on bomb sites as a child; he remembers them as places with the same kind of unconsidered beauty that he now sees in the ruined sites that he photographs. He is drawn to the sculptural qualities of the locations that he uses. He is also interested in archaeology – and archaeological photography – and likens the images of ruins, and what he describes as the 'accidental sculptures' within them, to 'finds'.[9] In this sense he shares Paul Nash's aesthetic of the 'unseen' (see cat.60a–e).

Badger works primarily as an architect, although he is also active as a photographer, critic and teacher. With John Benton-Harris he curated the important exhibition *Through the Looking Glass: Photographic Art in Great Britain 1945–1989* at the Barbican Art Gallery, London, in 1989. Having exhibited widely in the 1970s, he spent a period living abroad in the 1980s and exhibited less. Since then he has continued to take photographs, but has become better known as a writer about photography. His books include *Eugène Atget* (London 2001), *Chris Killip* (London 2001) and *Collecting Photography* (London 2003). BT

Ian Hamilton Finlay (born 1925)
Sundial: A Small Interruption in the Light 1977
Slate with metal gnomon and brick plinth,
sculpture 62 x 53.3 x 53.3; plinth 40.3 x 53.3 x 53.3
Arts Council Collection, Hayward Gallery, London

Sundials became popular as ornaments for gardens in the sixteenth and seventeenth centuries, when they were not only used as timepieces but also regarded as symbols of transience. Commonly this association would be enhanced by an inscription on the dial. The dial at Mannington Hall, Shropshire, dated 1595, is inscribed: 'These shades do fleet | From day to day: | And so this life | Passeth awaie.' While the sundial as an instrument for telling the time was superseded by mechanical clocks in the seventeenth century, it has endured as a garden ornament, doubtless because of its powerful symbolism.

The texts on Finlay's sundials typically refer not only to their practical function, and evoke a sense of human mortality, but also provoke metaphysical questioning. Thus his dial at the Royal Botanic Gardens, Edinburgh, *Sundial: Umbra Solis Non Aeris* ('The shadow of the Sun and not of the Bronze'), questions the nature of what it is that we are looking at. Of *Sundial: A Small Interruption in the Light* Finlay has said that the inscription 'refers to the gnomon and the shadow; by habit we think of the shadow as something added to the dial whereas it is (of course) the absence of the light – something missing rather than something added. The function of the shadow is that of pointing the hour (telling the time); the shadow is therefore synonymous with time, which may be regarded as a small interruption in eternity, itself often represented by tradition as a kind of infinity of light …'[10]

Finlay has made a number of sundials and some are sited in public spaces, including *Sundial: Sea/Land* 1972 at the University of Kent, Canterbury, and *Sundial: Dividing the Light I Disclose the Hour* 1979 at the British Embassy, Bonn. The text on cat.64 has also been used on a circular dial at the University of Liège, Belgium.

Finlay briefly attended Glasgow School of Art before making his reputation as a poet. His practice has gradually developed from poetry to the creation of prints and objects incorporating texts. As a sculptor he has worked collaboratively in a wide range of materials, from stone to neon lighting. With the acquisition of an abandoned small farm at Stonypath in 1966 he began to create a garden within which text works and objects would integrate with and react to landscape and environment (see pp.234–5). Finlay does not regard the distinction between 'poet' and 'visual artist' as having any real relevance to his work. He is 'a poet who wants to build lochs and make a garden … these things seem to me to be natural extensions of my poetry'.[11] He has also said: 'I think all of these things are to do with composing. What you compose with is neither here nor there, you compose with words, or you compose with stone plants and trees, or you compose with events; the sheriff's officer, or whatever. It is all a matter of composing and "order".'[12] BT

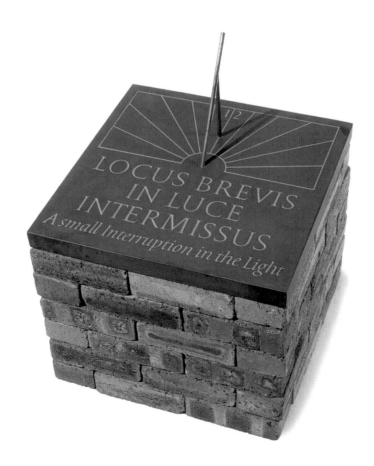

@65

Ian Hamilton Finlay (born 1925)
Nature Over Again After Poussin 1979–80
Eleven black and white photographs, each in halves
mounted separately on perspex; plinths; recorded flute music;
each photograph 49.5 x 29.2, overall dimensions variable
Scottish National Gallery of Modern Art, Edinburgh

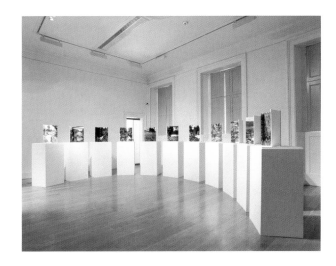

The title of this work inverts Cézanne's celebrated ambition to 'paint Poussin over again after Nature'. Poussin is one of eleven masters of European landscape art, from Altdorfer to Watteau, whose signature and style is used to create eleven photographs of nature made over in terms of art. They depict Ian Hamilton's Finlay's garden, Little Sparta, itself a work of art in the Pentland Hills south of Edinburgh. The chain of collaboration is longer than is usual: Ian and Sue Finlay set up the scenes, Nicholas Sloan cut the signatures in the stonework, Dave Paterson made and mounted the photographs and Wilma Patterson composed the music (played by David Nicholson). It was first exhibited at the Collins Exhibition Hall, University of Strathclyde, in 1980, a contentious period when Finlay was in dispute with art and government officials in Scotland over the status of his work, and British scholars were launching investigations into landscape art as a cultural terrain. At the time Finlay stated that a main point the work raised was the 'status of the garden in our society':

In the prevailing view, the garden should echo the house – from which it follows that the council house tenant is obliged to 'know its situation in life', and to play the role of the 'obedient citizen', it has been limited and secularized. The exercise of discovering eleven old master landscapes within our own garden ... is in that sense a polemical demonstration of Possibility.[13]

In his catalogue essay Stephen Bann stated that 'the purpose – and the predicament' is 'to draw the visitor into the perspectives of a shared cultural inheritance':

Its format is the individual enclosure or 'corner', established by a series of photographic scenes. The visitor will stop in front of each one, his field of vision defined by the envelopment of the photographic image. As he observes, and meditates, his mind will play upon a series of associations engendered by the image: its relation, secured by the inscribed signature, to the work of a particular painter; its relation, through that painter, to a 'type' of landscape securely established within our culture; finally its relation, through the instrumentality of Ian Hamilton Finlay and his 'school' of craftsmen, to a certain polemical placing of landscape within the cultural debate of the present day.[14]

Pictorial allusions are precise, both direct and oblique. Dürer's monogram is cut in a plaque hanging on a tree modelled on one in the artist's engraving *Adam and Eve* 1504, the leafy but empty Eden recalling the figures expelled from the garden. The music book in the 'Fragonard' image echoes that in Fragonard's *Music Lesson c.*1769 (Louvre, Paris); the pages show a score based on the letters JULIE, a reference to the intimate garden which the heroine of Rousseau's *La Nouvelle Héloïse* created within a larger garden (as there is a Julie garden within Little Sparta). The score is *Julie's Theme*, flute music played as part of the presentation of this work, an interlude in the sequence of images, and one with pastoral echoes of the folded hill pastures around Little Sparta, 'the fluted land'.[15] SD

⟲66

Ivor Abrahams (born 1935)
Funerary Urn 1978
Screenprint, varnish and embossing on paper, 68.5 x 45.5
Tate. Presented by Evelyne Abrahams, the artist's wife 1986

Ivor Abrahams is known primarily as a sculptor but has also
produced a considerable body of graphic work. His prints
of the late 1960s and 1970s were distinguished not only
by their engagement with the garden as subject but also
by their use of innovative techniques such as flocking;
Funerary Urn features embossing. While for many of the
prints Abrahams used, as source material, images culled
from popular magazines such as *Amateur Gardening* and
Popular Gardening, the finished images typically consist
of a combination of photographic and hand-drawn imagery.
They show a sculptural preoccupation with space – forms,
masses, voids, openings – but are also characterised by
an unnerving or uncanny atmosphere. None of Abrahams's
gardens is peopled; they are empty spaces.

Funerary Urn comes from the series *Monuments* (1978).
Made at a turning point in Abrahams's life, when he was
moving away from the garden theme with which he
made his name, the series is dark in mood, the imagery
melancholy and ominous. The classical funerary urn,
originally designed to hold ashes, is also a potent symbol
of death. Sculptures of funerary urns became popular in
England as garden ornaments in the sixteenth century,
when gardens were often envisaged as metaphors for
the transience of life. The other prints in the series are
The Sphinx 1978 and *Wounded Warrior* 1978, which have
equally potent symbolic significance. The monuments
of the title might be sited in either private gardens or public
spaces; they also recall gardens of remembrance.

Abrahams has said of his work: 'The garden image was a
ready-made. It did not require distortion – it only required
permutation. The garden iconography was like an elaborate,
endless chess game that never stopped. It seemed that
this was an area common to everyone and this I liked –
I thought important. It was popular and available to everyone
– easily understood.'[16] BT

67

John RJ Taylor (born 1958)
North London 1982
Photograph, 47 x 57
Victoria & Albert Museum, London

68

Back garden patio with precast ornaments 1983–7
Photograph, 47 x 57
Victoria & Albert Museum, London

In John RJ Taylor's images the ordinary contemporary suburban garden contains subtle echoes of the traditional grove or garden of contemplation. It still represents a place of retreat, a place in which to rest or to read, as the figures in the foreground of *North London* demonstrate. Whereas traditionally the contemplative space of the garden was enhanced by antique statuary or fragments of architecture, in the modern suburban garden this role is fulfilled by pre-cast ornaments. The putti supporting a bird bath in the manner of a caryatid references a historical genealogy, but the rabbits and wheelbarrow seem to indicate a more modern sentimentality, perhaps influenced by the enduring popularity of Beatrix Potter's children's stories.

North London won John RJ Taylor a prize in the South Bank Photography Show Competition while he was still a student at the Royal College of Art. The photograph depicts the garden of his sister's house in Enfield. *Back garden patio with precast ornaments* is one of a series of images of the interior and garden of the same home made between 1983 and 1987. Both images were published in the seminal book *Ideal Home: a detached look at modern living*.[17] Taylor has said that these images are part of a larger body of work featuring 'North London suburbia and the edge of the green belt'.[18] In each image Taylor focuses on a single part of the house or garden, a room, cupboard, group of furniture, the patio or garden shed. The photographs are unpeopled – the emphasis is on things, places – except for an occasional appearance by the family dog. *North London*, which was made before the main series, is the exception. No value judgments are proposed; the photographs are a record of a time and a place, a way of living. Mark Haworth-Booth has described Taylor's project as 'cataloguing the uncatalogued'.[19] BT

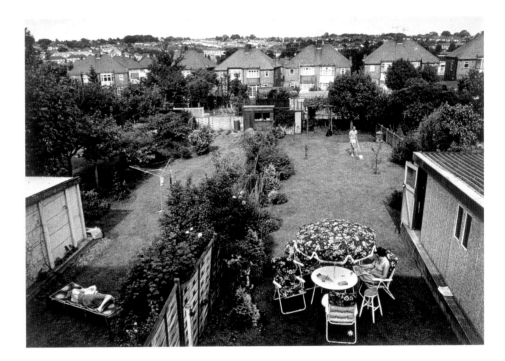

69

Richard Wentworth (born 1947)
Guide 1984–8
Rubber and concrete, 42 x 33 x 12
Arts Council Collection, Hayward Gallery, London

Guide consists of a child's rubber wellington boot set in concrete within a larger adult wellington boot. The work contains a number of possible readings: that the adult is a guide for the child (or perhaps vice versa) or that the child is contained within the adult. We might also think of the footprints that perhaps guide us through a snowy or muddy landscape. Also implied are more disturbing notions of containment; the 'concrete boots' of urban criminal legend. In a reversal typical of Wentworth's work, what at first appears a simple conceit reveals a wide range of potential meanings. The wellington boot is a fundamental part of any gardener's kit, and the association with gardens and gardening is one that the viewer may make, but Wentworth himself is non-prescriptive about the way that his works can be interpreted, as evidenced by his titles. Many, including *Guide,* are allusive, often revealing hidden layers of meaning or implication; others are simply descriptive, or at least appear to be.

Wentworth works with everyday materials. Chairs, ladders, buckets and the like are transformed in his work, taking on new meanings and presenting new possibilities of use through witty, comical, unnerving or disturbing combinations. Many of Wentworth's works are in essence 'assisted ready-mades' and he has said: 'I live in a ready-made landscape and I want to put it to work.'[20] The wellington boot, a banal, practical object whose form is defined by its function, is typical of the kind of object that Wentworth characteristically employs in his work. BT

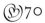70

Richard Wentworth (born 1947)
Piece of Fence 1990
Thirteen garden tools and wire, 181.6 x 228.6 x 15.2
Private Collection

At first glance *Piece of Fence* appears to be simply a row of gardening tools. Yet on closer inspection it becomes clear that it is precisely what the title says it is, a piece of fence. A hoe, a rake, a spade and other tools are bound together by wire to form a barrier. These functional objects have been rendered dysfunctional – they can no longer be used for the purpose for which they were made. They have acquired a new role through Wentworth's intervention, yet as a barrier they are fairly useless too. Wentworth has created a bizarre object which typifies his way of inverting the meaning or function of everyday objects.

Wentworth studied at Hornsey College of Art, London, from 1965, worked with Henry Moore in 1967 and studied at the Royal College of Art, London, from 1968 to 1970. He came to prominence in the late 1970s, along with Tony Cragg, Richard Deacon and Bill Woodrow, as one of the artists associated with the 'New British Sculpture', using everyday materials, wit and humour to make rich and engaging work. Wentworth was also an influential teacher at Goldsmiths College, London, between 1971 and 1987. BT

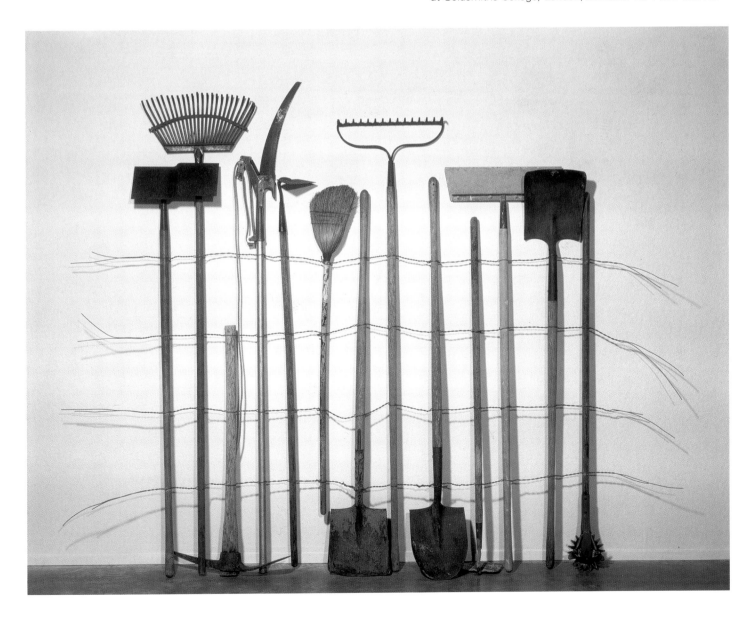

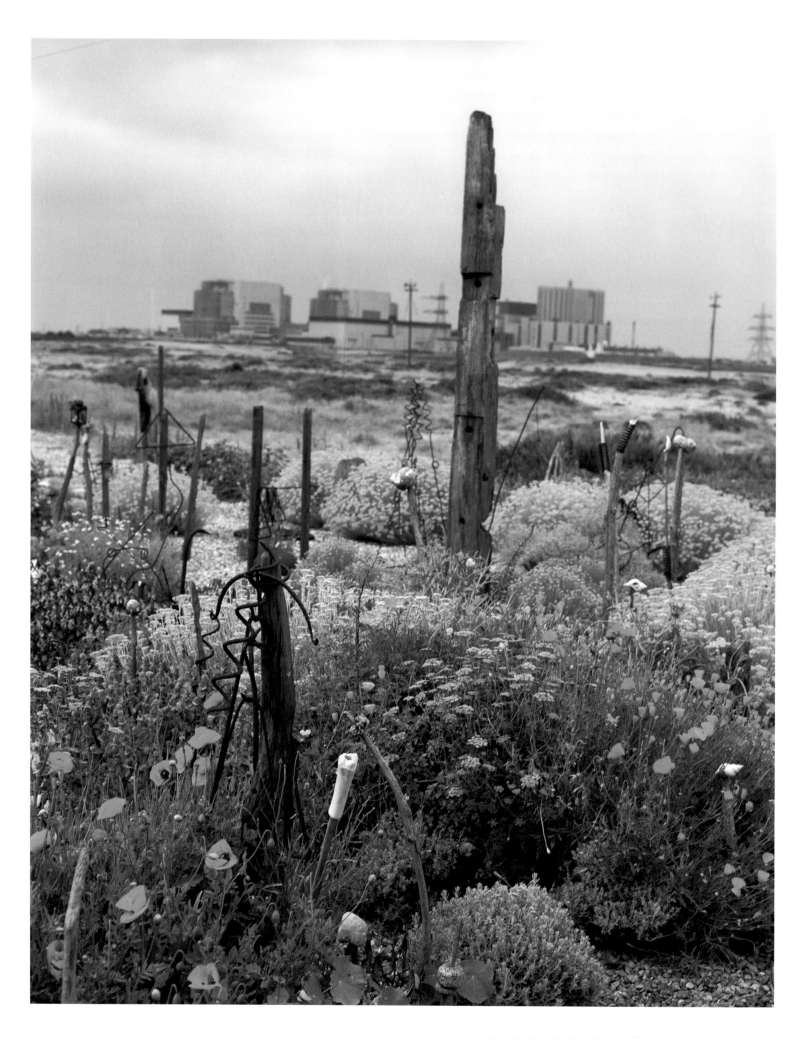

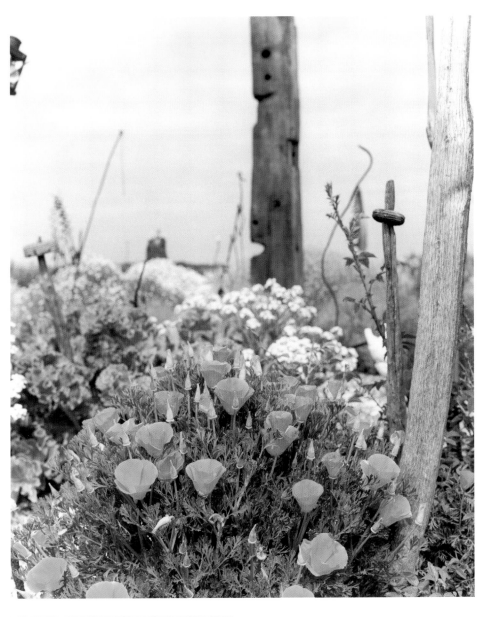

71a–d

Howard Sooley (born 1963)

*Derek Jarman's Garden at Dungeness c.*1990
Four photographs, each 50.8 x 61
Courtesy the artist

Howard Sooley met Derek Jarman in 1991 when he was commissioned to take stills for Jarman's *Edward II.* Their common interest in plants resulted in Sooley's close involvement in the 'second phase' of Jarman's garden at Dungeness (see pp.236–7). Armed with a plantsman's knowledge of local nurseries and garden centres, Sooley chauffeured Jarman on plant-buying expeditions, and worked closely with him on developing the garden around Prospect Cottage. He also began to photograph it intensively.

Many of the photographs, like those shown here, concentrate on Jarman's garden sculpture, composed of driftwood and found objects such as 'dragon-toothed' flints, old tools, rusting chains and pieces of corkscrewed anti-tank fencing, which he used as climbing frames for plants. For Jarman, who cherished old garden implements, the integration of man-made objects with plants and flowers was more than a decorative scheme; rather it was an affirmation of gardening as an art form, where practical considerations are constantly weighted against the desire to make an aesthetic and philosophical statement. At a time of great personal turmoil and increasing illness Jarman's garden was, as he stated, 'a therapy and a pharmacopoeia'; the plants and flowers cultivated not merely for their beauty but their power to heal and soothe.[21]

In 1995, the year after his death, Jarman's final book, *Derek Jarman's Garden*, was published, with over 150 photographs by Sooley. The photographs were far more than illustrations to Jarman's text. It has been observed, 'Sooley's photographic record of Jarman's final years is in fact incomparable: a visual equivalent of the journal Sooley's subject was himself so religiously keeping.'[22] In the book Jarman recalled his own experience of Sooley at work: 'Howard Sooley is like a giraffe, a giraffe that has stared a long time at a photo of Virginia Woolf; he possesses the calm and sweetness of that miraculous beast. When he takes a photo he stands like a T that has lost half an arm; he smiles, clicks, mutters little words of encouragement – more to himself or to the garden ...'[23] MP

c *Sophie's Garden, May 2000*

72a—e

David Spero (born 1963)
From *Garden* 1998–2003
a *Madeleine's Garden, June 1998*
b *Madeleine's Garden, February 1999*
c *Sophie's Garden, May 2000*
d *Sophie's Garden, October 2001*
e *Charlotte's Garden, September 2003*
C-type photographic prints, each 61 x 50.8 (image 46.9 x 36.8)
Courtesy the artist

The *Garden* series is an ongoing sequence of images
(there are nine to date) of the garden below David Spero's
flat in north London, taken with a large-format camera over
a period of five years. During this period the garden has
had three owners: Madeleine, Sophie and Charlotte. Spero
is fascinated not only with the passing of time in the garden
– the way the fullness of summer shades into the spareness
of winter – but also with the very different ways in which
the owners have used the garden. The changing garden
thus becomes not only a marker of the seasons but also
a reflection of different personalities; a matrix of varying
degrees of engagement, presence and absence. We can
see that for one owner, it is 'something to be tamed every
other year, not a space with which to express herself',
while another's attitude towards the garden is perhaps
'romantic'.[24] At times the garden is almost wild; at others
it is highly ordered. Nonetheless, despite this interest in
characterisation, as in almost all Spero's work the photo-
graphs are unpeopled (except for the fleeting presence
of a cat, caught investigating the remains of a barbecue;
or the fugitive presence of Sophie's gardener). Spero has
spoken of the fact that the removal of the actual human
presence makes the signs of that person's passing more
important, more telling.

Spero is in this context a passive observer (although he
has spoken of how he 'shares' the garden with its actual
owners, despite not being able to physically enter it). From
his vantage point the structure of the garden is revealed
in a way that is not visible to someone actually in it; the
garden, with its oval patch of lawn, becomes a kind of
stage. As time is condensed in the sequence of images
changes are rendered more visible, the contrasts between
the seasons almost shocking – as too is the tendency for
order to break down, for artifice to give way to nature.

David Spero graduated from the Royal College of Art,
London, in 1993. Since then, working in series, he has
created a body of work characterised by a quiet intensity,
'a gentle magic'.[25] Engaging with expansive, spiritual
themes, often focusing on the subtle means by which
we negotiate private and public spaces, Spero has affirmed
that his art is about 'how people relate to the world around
them'. Working in series, he has said, is like gardening,
in that it is about 'subtly nurturing things'; allowing ideas
to develop and emerge in stages over time. BT

a *Madeleine's Garden, June 1998*

b *Madeleine's Garden, February 1999*

d *Sophie's Garden, October 2001*

e *Charlotte's Garden, September 2003*

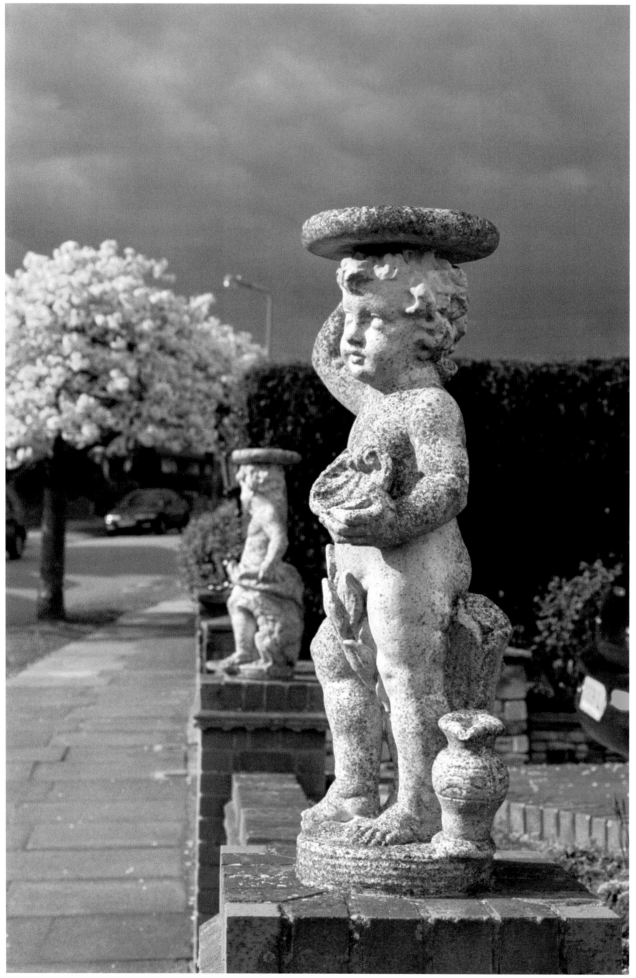

73a

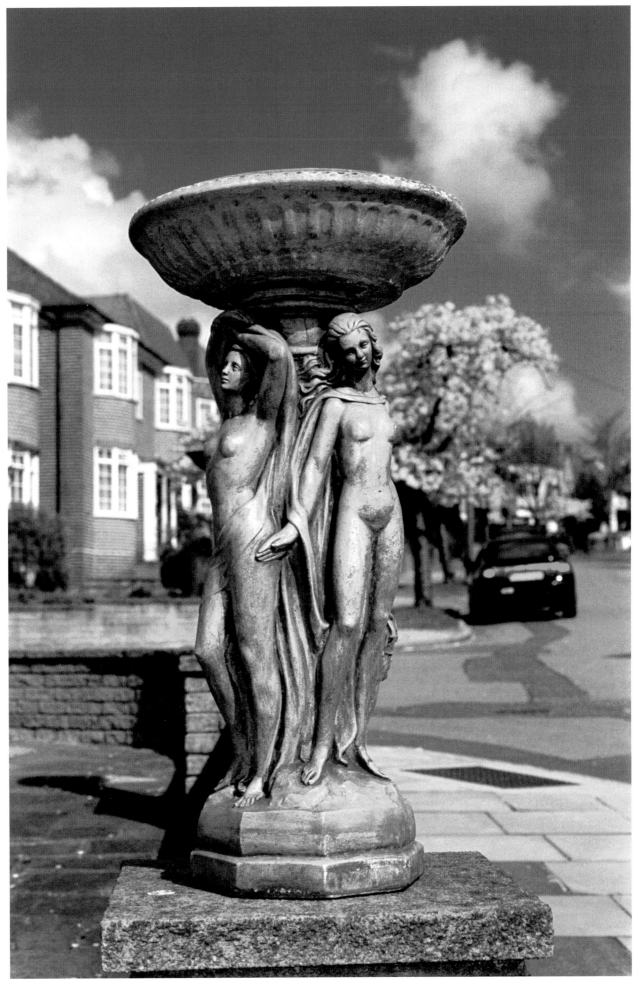

73b

73a–b

Martin Parr (born 1952)
From *North Circular* 2001
a *Fairholme Gardens, N3, London*
b *Fairholme Gardens, N3, London*
Photographs, each 121.9 x 79.1
Courtesy the artist

These two photographs are part of series taken while Parr was artist in residence at the magazine *The Big Issue* in 2001. During his commission he travelled on and around the North Circular road in north London, recording the streets and buildings and the people he met there. A selection of the images were subsequently published in the magazine. These particular images depict contemporary 'antique' garden ornaments, used to enhance the appearance of the stereotypical suburban front garden, and were taken in an affluent area near Finchley. The critic Geoff Nicholson has commented that in Parr's photographs 'everything looks fake'.[26] In these images the disjunction between the pre-cast sculptures, which recall grand formal gardens, and the pavements and terraced houses, throws such 'fakeness' into sharp relief. Parr photographs suburban and urban life in all its complex, banal, quotidian detail. It is a place in which the appearance of things is hugely revealing in terms of social status and aspiration. 'Fakeness', an indicator of artificiality, is a quality exaggerated in Parr's work by his use of saturated colour.

It is worth noting, however, that the antique statues and ornaments found in historical gardens – and emulated here – were themselves copies and casts, albeit often sophisticated in construction and made from fine materials. These north London gardens therefore represent a continuing tradition, yet one which is undermined by the incongruity of the locations chosen by Parr.

Parr became interested in photography at an early age and was encouraged by his grandfather, who was a keen amateur. He studied photography at Manchester Polytechnic, working as a staff photographer at Butlins in Filey during his holidays. His early works were black and white images documenting communities such as those at Hebden Bridge in West Yorkshire and Leitrim, Ireland. Parr began using colour in the early 1980s and made his name with two groundbreaking series, *The Last Resort* 1986, depicting holidaymakers at New Brighton, and *The Cost of Living* 1989, satirising the conspicuous consumption of the Thatcher years.

Parr has described his *modus operandi* as 'highly subjective documentary photography'.[27] However, it is the precise degree of subjectivity in his work – the question of whether he sympathises with or despises his subjects – that has made his work contentious. Parr himself recognises the paradox at the heart of his approach. He has said: 'If I look at my relationship towards England, for example, I both love it and hate it at the same time. I can't express it in words as well as I can express it in pictures. It's always based on a contradiction, on a juxtaposition, on an ambiguity.'[28] BT

74

Ivan and Heather Morison (born 1974 and 1973)
Garden 114 2001–3
Twelve printed cards, each 13.5 x 13.5
Private collection

Wood Pigeon, Magpie, Song Thrush,
Robin, Nuthatch, Lesser Black-backed Gull,
Tawny Owl, Blackbird, Treecreeper,
Blue Tit, Great Spotted Woodpecker, Jay.

Birds in Ivan Morison's garden, autumn 2001

Ivan Morison is astounded by the excellent
progress of the plants in his greenhouse.
His Long Green Stripped marrows are developing
well, as are his Ornamental gourds and Atlantic
Giant pumpkins. His Enorma and Lady Di runner
beans have grown quickly and his Earthwalker
and Velvet Queen sunflowers are nearly touching
the ceiling. Ivan is happy with the slow, but steady,
growth of his Green globe artichokes and is
encouraging his Cantaloupe melons,
whose progress is far behind the others.

Last week Ivan Morison spread one tonne
of horse manure over his garden.

Garden 114, Westbourne Road Leisure Gardens, Edgbaston, Birmingham
To make an appointment telephone 07939 076 376

Garden 114, Westbourne Road Leisure Gardens, Edgbaston, Birmingham
To make an appointment telephone 07939 076 379

Garden 114, Westbourne Road Leisure Gardens, Edgbaston, Birmingham
To make an appointment telephone 07939 076 376

Heather and Ivan Morison describe their work as involving 'allotment gardening, floristry, fruit and vegetable vending, dendrology and forestry, ice fishing, bird watching and travelling'.[29]

From 2001 to 2003 their work was centred on Garden 114, an allotment in Edgbaston, Birmingham, which Ivan Morison initially took in order to house his scale model of Derek Jarman's Prospect Cottage.

We first took the garden on a snowy day in February 2001. It is the plot at the very furthest corner of the Westbourne Road Leisure Gardens, and had been left unattended and closed for eight years. We had to tunnel in through the trees and bushes that had grown almost completely to the centre of the garden. We spent the first months clearing the undergrowth. What was revealed (and the reason why the Leisure Gardens chairman had been reticent about renting the garden) was a remarkably intact original Victorian Garden, with its original layout including paths and edging tiles. The original fruit trees were all there, the topiary bushes (now grown huge), gooseberry patch, and roses (grown right up to the top branches of the apple trees).[30]

In the garden 'the act of learning, gardening and the garden itself all constitute the (art)work'. In addition there is a documentary aspect to the Morisons' practice. They have produced film and sound works, drawings and photographs, documenting the changes in the garden and various projects that have taken place there, and the garden has also been open to the public.

An important part of the documentation and dissemination of the garden and the artistic activities connected to it is a series of printed texts, produced as simple cards, mailed out to selected recipients (typically using the mailing lists of galleries or organisations with whom the Morisons are collaborating). These cards detail the successes and failures of the various plants and vegetables growing in the garden, and offer observations on the flora and fauna of the garden. Some of the texts consist of lists (of flowers, birds seen in the garden, colours noted in the garden), others record gardening activities ('Today Ivan Morison planted six hundred and sixty four bulbs in his garden') and some report on incidents (such as the disappearance of a 'prize winning Elvis Presley scarecrow' from the garden). In the texts 'Ivan Morison' becomes a kind of comical character; bemused by the frequent disappointments the garden brings him, as well as unexpected successes. Cumulatively the texts create a narrative which blurs the line between objective observation and subjective storytelling; a disjointed but compelling account of success and failure familiar to any gardener.

'We have always approached the act of gardening 114 as performative, and the character of Ivan Morison the gardener began when we took on the garden. The gardening knowledge of Ivan Morison at the beginning was almost zero, all he had was enthusiasm and a naive wonder of what was happening there, and as time has gone on that knowledge has increased, slightly.'[31] BT

Coloured Grounds

*P*ainting and gardening both involve working with colour, and this shared concern has resulted in a series of exchanges between the two practices. The garden has sometimes been thought of as a living picture, while in turn painters have sought to capture the ephemeral harmonies that could be created with flowers. But if painting were once invoked as a model for gardeners, the flower garden would soon come to be conceived as a work of art in its own right, and then it would be open to doubt whether the transient, fragile spectacle it presented could ever be adequately matched by the fixed colour relations of painting. Later, mid-twentieth century artists would take the motif of the garden as a point of departure for experiments in colour and pictorial space, emphasising the autonomy of painting rather than its descriptive capacity. The association of garden colour with ideas of mutability and impermanence has persisted, however, as is clearly apparent from some of the most recent work in this section.

The section begins with the influence of painting, exemplified by Gertrude Jekyll's copy of a work by Turner (cat.76); it is followed by images of the planting schemes she went on to devise for her garden at Munstead Wood (cat.77a–d), in which she put her ideas on colour progression into practice. But while it was possible for Jekyll to make a faithful account of Turner, her own colour compositions were ephemeral in their very nature. She was a constant advocate of pictorial values in the garden and encouraged chosen artists, such as Helen Allingham, to make pictures of her celebrated summer border (cat.78). For her own record of what she had achieved, however, Jekyll preferred to rely on written description, black and white photography and diagrammatic outlines. The complex, changing chromatic effects she created would have presented a formidable, and perhaps insuperable, challenge to the conventional means of pictorial representation.

The modern flower garden was nevertheless perceived as a suitable subject for artistic treatment, and a school of garden painters, including Alfred Parsons, George Samuel Elgood, Beatrice Parsons and Margaret Waterfield (cats.80–6), emerged during the last decade of the nineteenth century. Some of these artists were also gardeners, and experimented with colour groupings in their own gardens before recording them in pictures. Such work lent itself to illustration, and served more than one purpose, offering escapist images or aspirational fantasies for jaded urban viewers, but also disseminating knowledge and ideas for garden design. After 1914 the lavish and labour-intensive gardens of the Edwardian period could no longer be maintained under new economic and social conditions, and garden pictures also gradually went out of fashion. The paintings may have outlasted the gardens they depicted, but the reputations of the artists proved in many cases to be no more durable than the gardens themselves.

John Singer Sargent's *Carnation, Lily, Lily, Rose* (cat.75) is, in many ways, the exception among garden paintings: its combination of sweetness, modernity and ambition was admired in its day, and ensured a lasting celebrity. It was painted in the Cotswold village of Broadway, but it is not primarily a response to the kind of English garden that appealed so much to his contemporaries. Although carnations, lilies and roses are present in the picture, Sargent's garden is more like a stage set, with imported (and, as the season progressed, artificial) flowers. His real interest lay in capturing the quality of light at a particular hour, and he treated the garden as a temporary outdoor studio where a fleeting effect of evening light could be analysed. In this respect Sargent was subscribing to the

modern method of working out of doors and to the values of naturalism, but the effect of changing light on colour continued to interest painters long after the flower garden itself had lost its validity as a subject.

Later artists would move beyond Sargent's dusk to paint their garden under winter moonlight, as in the example of William Gillies (cat.92), or as in the case of John Maxwell (cat.91), creating a day-for-night effect in the flood of artificial light from a window. Adrian Berg's painting (cat.93) also seems to suggest both day and night, combining the colours of blossom with the glow of fluorescent street lighting.

If colour has periodically emerged as an intense focus of interest for gardeners and painters, such phases have rarely coincided, and the exploration of colour as a linking theme needs to take into account these patterns of discontinuity, as well as to contemplate some unpredictable juxtapositions. Gertrude Jekyll spoke of taking many years to work out certain problems of colour in her own garden, but it was only much later that colour came to occupy a comparably central place in the agenda of painting. When Patrick Heron (cats.89–90) began to think in terms of an art in which colour was the main vehicle of expression he turned to the motif of the garden to help formulate his idea. (It is pure coincidence that the notable garden he had acquired at Zennor, Cornwall, overlooked a property that had once belonged to Jekyll, though she had never established a garden there.) Heron was careful to explain that he was not taking the garden as a subject for painting in any literal sense: the theme had suggested an autonomous realm of colour, shape and light, one that came close to the borders of abstraction.

Towards the end of the twentieth century, Gary Hume is another painter who has resorted to the garden as a subject. In contrast to Heron's, the surfaces of his paintings are glossy and uninflected, their appearance decorative and inscrutable. But the imagery and mood of his work might suggest some further, and less expected, comparisons: the title *Four Feet in the Garden* (cat.95), for example, could be a laconic alternative to Sargent's *Carnation, Lily, Lily, Rose*, and the connections do not end with this whimsical possibility. Sargent's painting has a dreamy, *tableau vivant* character, and is filled with symbols of transience: the flowers, candles, tapers, dusk, girlhood, the garden itself. In Hume's painting the enigmatic scenario may be disclosed only in fragments, but it has something of the tapestry-like aspect of the Sargent, as well as the heightened sweetness and underlying melancholy.

The 'coloured grounds' of the section title are literally encapsulated in the floor piece by Anya Gallaccio, a work that alludes to both painting and gardens. The title *Red on Green* (cat.94) evokes the colour-field abstraction of the modernist era, while the 10,000 roses constitute an indoor garden, vivid and extravagant at first, with the romantic symbolism of roses undercut by the reference to the industrial scale of modern production methods and the year-round availability of the flowers in defiance of the season. The piece forms an initially bright foreground across which other paintings might be viewed, but the colour relationships are inherently unstable and the processes of decay are at work from the moment the installation begins. A painting might seem more permanent than a garden, but an element of uncertainty has been introduced, and the analogy implied here between petals and pigments focuses our attention on the fragile nature of the expressive materials of both gardening and art.
—*Nicholas Alfrey*

✳75

John Singer Sargent (1856–1925)
Carnation, Lily, Lily, Rose 1885–6
Oil on canvas, 174 x 153.7
Tate. Presented by the Trustees of the Chantrey Bequest 1887

The setting of this painting is a garden in the village of
Broadway, in the Cotswolds, and the models are daughters
of the American illustrator Frank Barnard, Polly and Dolly,
aged eleven and seven when the painting was begun.
Sargent worked on it for about twelve weeks from August
to November 1885, resuming it the following September
for a further four or five weeks, still in the same village
though in a different garden. The title, while describing the
flowers in the painting, is taken from a line in a popular
song. The painting was very favourably received when it
was exhibited at the Royal Academy in 1887, and its
popularity has been enduring.[1]

The charms of Broadway had been discovered by the
American painters and illustrators Edwin Austin Abbey and
Frank Millet, who had rented Farnham House in the village
in 1885 and invited Sargent to come. They were joined
by Henry James, Edmund Gosse, Alfred Parsons, the
Shakespearian actress Mary Anderson and others, a group
that brought together overlapping interests in painting,
literature, music and gardening. Sargent had moved to
England the previous year from Paris, where he had direct
contact with Impressionist painting. His ambitious 'garden
picture' certainly drew on that experience, but was also
a response to his new context and friendships.

Sargent adhered to a rigorous method of open-air painting,
setting up his elaborate machinery – easel, canvas, models,
flowers – each day, but working for only a few minutes at
dusk in order to capture exactly the right light. This methodical
pursuit of appearance paradoxically led him to resort to ever
greater artifice: he wrote to his sister that 'there are hardly
any flowers and I have to scour the cottage gardens and
transplant and make shift', and he complained to Robert
Louis Stevenson that, having hit on his subject too late in
the season, 'my garden is a morass, my rose trees black
weeds with flowers tied on from a friend's hat and ulsters
protruding from under my children's white pinafores'. A
photograph shows him at work on the picture in a stony
yard apparently painting a lily growing in a pot, and he
seems to have drastically reduced the width of his original
canvas to make it nearer square in format, so that there was
less garden to paint and more emphasis on the figures.

For the second season of work, in 1886, the Millets had
moved to Russell House, but Sargent made preparations
to have a new garden set up in readiness, sending Millet's
wife a batch of Aurelian lily bulbs ('I am to put 20 in pots
and force them for his big picture'), having a flower bed cut
and ransacking the neighbourhood for appropriate flowers;
on one occasion he instructed the proprietor of a nursery
garden at Willersey to dig up half an acre of roses in full
bloom and send them along to Broadway immediately. The
experienced painter-gardener Alfred Parsons may have had
a hand in all this, but it is clear that the English garden in this
case is not so much the subject of Sargent's painting as a
contrivance designed to meet the needs of the picture. NA

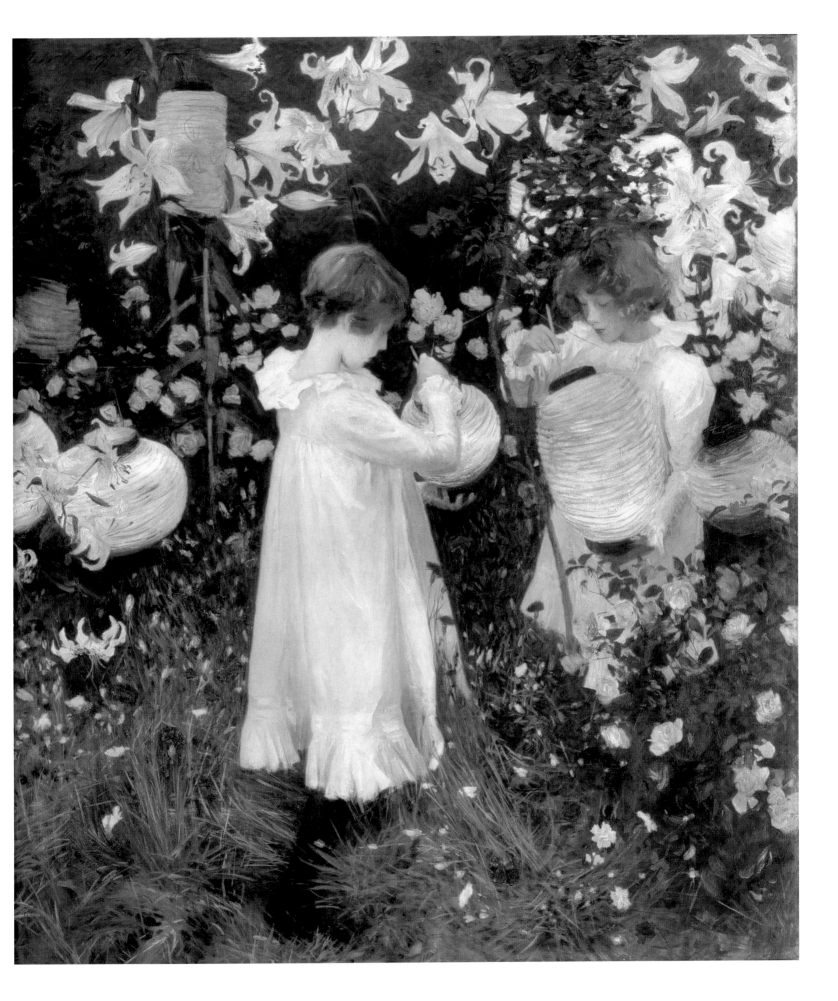

✳76

Gertrude Jekyll (1843–1932)
'The Sun of Venice Going to Sea',
*after J.M.W. Turner c.*1870
Oil on canvas, 59 x 89
Godalming Museum

What might an image of Venice have to do with the art of
the garden? It has been suggested that the ultimate outcome
of Gertrude Jekyll's practice as a copyist is to be found in
the complex harmonies demonstrated in her borders, and
that her ideas on colour progression are grounded in her
knowledge of Turner. It would be misguided, however, to
imply that the borders at Munstead Wood might be seen as
a floral tribute to the artist. Jekyll's receptiveness to painting,
analytical approach to colour and emphasis on pictorial effect
are a vital part of her aesthetic, but she always worked
back to first principles to consider every aspect of site,
materials and conditions. Her borders might be intended
to be experienced as pictures, but no painting could ever
be a template for a garden.

Gertrude Jekyll made a number of copies of paintings by
other artists in the decade after finishing her studies at the
Kensington Schools of Art in 1863, and her biographers have
made a special point of her interest in Turner's work. *The
Sun of Venice Going to Sea* had been exhibited by Turner in
1843: Jekyll's copy is almost identical in size to the original.
Her nephew Francis Jekyll, who had access to her diaries,
notes that in 1870 'many days were spent at the National
Gallery, copying Dutch and Italian masterpieces, or the great
Venetian scenes of Turner', though he mentions her copying
Turner at the National in previous years as well.[2] There is no
mention in the Gallery's records of any copy of *The Sun of
Venice* before 1877, when nine were made, but it is unlikely
that Jekyll would have made her copy as late as this. 1870
was the last year in which she exhibited her work as an
artist, though she continued to take an interest in painting,
stimulated by her association with Barbara Leigh Smith
Bodichon and Hercules Brabazon Brabazon. Other late
paintings by Turner copied by Jekyll include *The Fighting
'Temeraire'* 1838 (National Gallery, London), *Ancient Rome;
Agrippina Landing with the Ashes of Germanicus* 1839 (Tate)
and *St Benedetto, Looking towards Fusina* 1843 (Tate).[3]

Venice came into Jekyll's life indirectly when, in 1870, her
elder sister Caroline and her husband Frederick Eden went
to live permanently in the city. Later the couple were to
establish a celebrated garden on the Giudecca; Gertrude
is said to have advised on its layout and planting, and it
became known, inevitably, as the Garden of Eden.[4] NA

✳77a–d

Attributed to Herbert Cowley (1885–1967)
a *Iris and Lupin Border, Munstead Wood* c.1911
b *The Grey Garden, Munstead Wood* c.1911
c *The Red Section of the Main Flower Border, Munstead Wood* c.1912
d *The Michaelmas Daisy Border, Munstead Wood* c.1912

Prints taken from original autochromes, print size 20.1 x 25.2
Country Life Picture Library

A series of ten autochromes in the archives of *Country Life* magazine, taken at different times of year, record aspects of the colour sequences at Munstead Wood and provide a valuable complement to the watercolours by Helen Allingham. Jekyll's books were illustrated by her own monochrome photographs, and it was at one time assumed that the autochromes must also be by her, but all the evidence suggests that they are the work of Herbert Cowley, the gardening editor for Country Life publications. This image of the iris and lupin border was used as a frontispiece for *Gardens for Small Country Houses* by Jekyll and Lawrence Weaver, published in 1912. Jekyll had reservations about the process, commenting that 'colour photography from Nature has not yet reached such a degree of precision and accuracy as can do justice to a careful scheme of colour groupings'.[5]

The autochrome process was invented by the Lumière brothers and first made public in 1907. It involved spreading starch grains across a glass plate: the grains were dyed green, violet and orange, evenly mixed and coated with a panchromatic emulsion. They were developed as black and white film, then treated chemically to produce a coloured positive. Exposure times were very slow, and so the process was better adapted to landscape subjects than to figures, and even then needed bright and windless days. Despite Jekyll's strictures, the autochrome might be thought especially well suited to the representation of flower gardens.[6]

a Iris and Lupin Border, Munstead Wood
This autochrome records the appearance of the iris and lupin border in June, with the 'Munstead white' strain of lupin set off by contrast with the yew hedge. The building beyond is The Loft, a traditional Sussex barn Jekyll had acquired and re-erected on the site, possibly under the supervision of Lutyens.

b The Grey Garden, Munstead Wood
This garden was described by Jekyll in the chapter on 'Gardens of Special Colouring' in *Colour in the Flower Garden* (1908):

The Grey garden is so called because most of its plants have grey foliage, and all the carpeting and bordering plants are grey or whitish. The flowers are white, lilac, purple and pink. It is a garden mostly for August, because August is the time when the greater number of suitable plants are in bloom; but a grey garden could also be made for September, or even October, because of the number of Michaelmas Daisies that can be brought into use.

The Grey garden at Munstead Wood was laid out in the area of the kitchen and nursery garden, adjacent to the iris and lupin borders and, like them, overlooked by the windows of The Loft. The beds in this part of the grounds were used by Jekyll for her experiments in colour and for trying out new planting combinations. She had a particular fondness for her grey-based scheme, though she emphasised the idea of 'restricted' rather than single-colour gardens. She thought that 'people will sometimes spoil some garden project for the sake of a word', whereas in her own practice she made judicious use of complementary colours to produce an enhanced purity of effect.[7]

c The Red Section of the Main Flower Border, Munstead Wood
This autochrome shows the spectacular central section of Jekyll's great two-hundred-foot-long border, where a carefully selected combination of geraniums, salvias, cannas and dahlias create a massed effect of scarlets and reds, backed by a purple-leafed claret vine trained up the wall behind. Some commentators on Jekyll have referred to this section as a 'sunset' passage, and linked it explicitly with her studies of Turner's *The Fighting 'Temeraire'*, seeing the fiery set-piece heart of her border as the equivalent of the heated colouring at the core of the painting.[8] On either side of the red section the colour progression moved through oranges and yellows of gradually diminishing strength, sinking down to blues and greys at each end. No colour photograph or other visual record exists to show the full effect of this carefully orchestrated colour sequence, and indeed the sheer scale of the border would make any single picture of it impossible to frame.

d The Michaelmas Daisy Border, Munstead Wood
The Michaelmas daisy borders at Munstead Wood, with their drifts of blue, white and purple, were another celebrated instance of Jekyll's concern to bring a succession of parts of the garden into their own at different times of year. She had established two separate Michaelmas daisy borders: the one shown in this autochrome was situated beyond the kitchen garden area, in the north-western angle of the site, and flowered in September. The other, which was painted by Helen Allingham and Samuel George Elgood, was closer to the house and flowered in October to provide almost the last colour of the year. The earlier border was designed to be chromatically more complicated, with pink and yellow flowers amid those tending towards a cooler, bluish hue, all set off by an edging of grey foliage. In writing of these autumn borders, Jekyll alluded to the 'painting of a picture' with living plants, but remarked that, unlike the painter, the gardener cannot see the colours on the palette at the time the work is done.[9] NA

77a *Iris and Lupin Border, Munstead Wood* c.1911

77b *The Grey Garden, Munstead Wood* c.1911

77c *The Red Section of the Main Flower Border, Munstead Wood c.*1912

77d *The Michaelmas Daisy Border, Munstead Wood c.*1912

Helen Allingham (1848–1926)

Gertrude Jekyll's Garden, Munstead Wood c.1900
Pencil and watercolour on paper, 53.3 x 44.5
Penelope Hobhouse

This watercolour shows part of the main hardy flower border established in the early 1890s by Gertrude Jekyll in her garden at Munstead Wood. Helen Allingham had worked as a professional illustrator under her maiden name Paterson, and established a career as a watercolourist after her marriage to the poet William Allingham in 1874. She was introduced to Jekyll through their mutual friend Barbara Bodichon, and after her husband's death in 1889 Allingham and Jekyll became close. They had a common interest in cottage architecture; the cottages of Surrey had become Allingham's main theme in the 1880s, while in the same period Jekyll was researching the vernacular idiom of Sussex in preparation for the design of her own house.

Allingham made several watercolours of the border at Munstead Wood. One was illustrated in her 1903 publication book *Happy England*, and a close variant of it is in the collection of Godalming Museum, while another was exhibited at the Fine Art Society in 1901. These three compositions all had as their focal point the break in the border where a path led through an arch in the sandstone wall to the Spring Garden beyond. The present watercolour also shows part of the north-east section of the border, with hollyhocks, red hot pokers, yuccas, pinks, marigolds and dahlias in flower, and a blue note of a geranium contrasting with the warmer colours. As Penelope Hobhouse has pointed out, however, it would be misleading to take this picture as documentary evidence of how the border was actually planted.[10] Jekyll's own descriptions of her planting scheme do not accord fully with the colour combinations that appear in Allingham's compositions, and the painter may have added some variations of her own to the garden artist's 'living picture'. NA

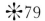✳79

Helen Allingham (1848–1926)
*The Kitchen Garden at Farringford c.*1890s
Watercolour on paper, 37.5 x 28.6
Private Collection

Farringford was Alfred Tennyson's retreat on the Isle of Wight. Allingham had been introduced to the poet through her husband; she first went to Farringford in 1890, and continued to visit the house and paint there after Tennyson's death in 1892. The kitchen garden had been one of the poet's favourite haunts, and one of Allingham's paintings of it was included in the section on 'Tennyson's Homes' in her book *Happy England* (1903), illustrated by seventy-five drawings selected from her life's work. Three further paintings of the kitchen garden, including this watercolour, were reproduced in *The Homes of Tennyson* two years later.[11]

According to Allingham's own commentary on this watercolour, it was painted in mid-May: 'the elms are in brightest green, the roses and lilies are in bud – the apple blossom is beginning to go over, but the lilacs, hyacinths, pink peony, pansies and sweet-scented stocks are in perfection'.[12] Tennyson's poetry had been associated with the imagery of English flowers, and his lines were often invoked by garden writers, particularly those protesting against high-Victorian formality. Taken out of context, Allingham's watercolour might easily be seen as one of the cottage garden subjects for which she was renowned, but this only goes to demonstrate how ambiguous in social, economic and aesthetic terms the ideal of the cottage garden was in practice, and how easily mythologised it was as a category. NA

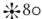80

Alfred Parsons (1847–1920)
Warley Place: Daffodils and Pergola date unknown
Watercolour on paper, 38.1 x 49.5
Private Collection

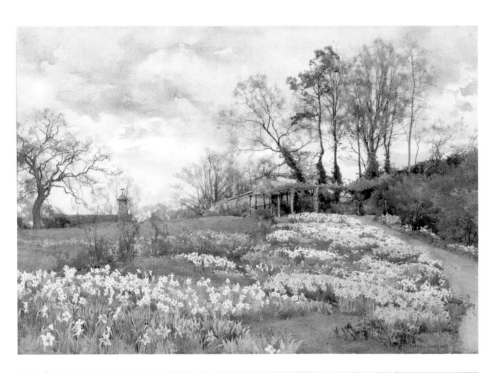

81

Warley Place: Lilies 1898
Watercolour on paper, 35.6 x 54.6
Private Collection

The gardens at Warley Place, Essex, were largely the creation of Ellen Willmott, who was described by Gertrude Jekyll in 1897 as 'the greatest living woman gardener'. Her father had acquired the property in 1876, but even before she inherited a fortune from her wealthy godmother and eventually the estate itself, she had made gardening the central passion of her life. Her sister Rose was her initial collaborator, and after her marriage to Robert Berkeley established a remarkable garden at Spetchley Park; Ellen would go on to acquire two other gardens in France and Italy and to gain a serious reputation for her experiments with plant hybridisation and her botanical scholarship.[13]

Alfred Parsons is perhaps still best known for the illustrations he produced for Ellen Willmott's major published work, *The Genus Rosa* (1910–14), but the less strictly botanical aspect of his work is brought out in the series of watercolours she commissioned from him of Warley Place. These offer a striking embodiment of the idea of the wild garden in practice. It was Parsons's illustrations to the 1881 edition of William Robinson's *The Wild Garden* that had helped gardeners envisage the potential of naturalising plants among shrubberies and woodland, and particularly the informal planting of bulbs. Ellen Willmott was especially well known for her expertise in daffodils: she was a member of the Narcissus Committee of the Royal Horticultural Society and experimented extensively with new strains at Warley. Parsons's evocation of the great drifts she had established in the vicinity of the pergola thus represents the perfect conjunction of their respective skills and experience.

In his study of lilies, Parsons has resolved the difficult technical problem of combining a meticulous study of the flower heads with a deep field of vision, this time looking out across the farms and wooded hills beyond Warley. The large boulder at the left and the sense of the ground dropping steeply away suggest that this scene is in the vicinity of the gorge Willmott had had excavated by the firm of James Backhouse of York, creating a deep rock and alpine garden as a protective environment for imported plants. NA

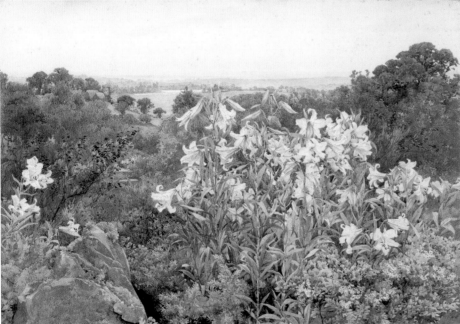

Alfred Parsons (1847–1920)
Orange Lilies, Broadway 1911
Oil on canvas, 92 x 66
Royal Academy of Arts, London

This painting was submitted by Parsons as his Diploma picture after his election as a full Academician in 1911, and was shown at the Royal Academy exhibition the following year. Parsons had been a key figure in the Broadway circle in the mid-1880s, and maintained his connections with the village. Henry James called him 'the best of men as well as the best of landscape painters and gardeners', while Jane Brown has referred to him as 'the doyen of Cotswold gardening'.[14] Parsons was already closely involved in garden illustration and journalism before his arrival in Broadway, and it was here that he made his first experiments in garden design. He went on to have a house, Luggers Hill, built for him in the village by the architect Andrew Prentice in 1911, and established a garden around it.[15] *Orange Lilies, Broadway* is dated 1911, when his own garden was not yet established, and the painting almost certainly shows the garden of Russell House, the home of his friend Frank Millet, which Parsons had also helped to create. The main compositional ingredients, a grassy avenue flanked by flower borders leading to a secluded nook, are already present in an earlier painting of a Broadway garden engraved for William Robinson's journal *The Garden* in April 1893 (fig.27).

Parsons was a prolific painter in both oil and watercolour, and exhibited widely at a range of institutions from the early 1870s. His career as a professional artist continued after he had diversified into the field of garden design around 1895. He was a painter of landscape rather than a specialist in gardens, and his *When Nature Painted all Things Gay*, an orchard subject, was purchased for the Chantrey Bequest in 1887, the year that Sargent's *Carnation, Lily, Lily, Rose* was also acquired for the Bequest. Parsons's resistance to new tendencies in painting secured him praise in his time but not the attention of later generations. NA

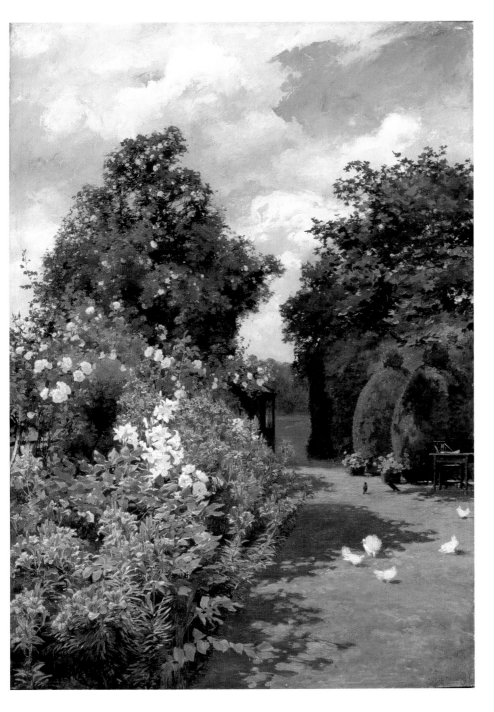

Alfred Parsons (1847–1920)
The Artist's Garden at Luggers Hill, Broadway after 1912
Watercolour, 45.7 x 61
Private Collection

This watercolour shows the garden Parsons had laid out for himself at Luggers Hill in the last years of his life. The view is towards the south-eastern angle of the garden, with the first houses of the village visible above the boundary wall and Broadway Tower prominent on the hill above. The motif of the curving flagstone path leading the eye to the hillside beyond is one that he had already deployed at nearby Court Farm, though the site at Luggers Hill is flatter and the escarpment further back. The evidence of this watercolour suggests that Parsons treated this part of the garden with surprising informality, although an aerial photograph of the site, taken probably some time during the 1940s, shows an arrangement of formal parterres in this area, and these have been restored by the present owners. The summer house built against the garden wall has not survived.

The tulips and fruit blossom are in flower, the latter a reminder that Broadway lies on the edge of the Vale of Evesham, celebrated for its orchards and at its pictorial best in spring. The blossom motif might also indicate Parsons's interest in Japan: he had been there in 1892 and published a book on his experiences, including his observations on Japanese gardening.[16] The influence of his trip was reported to be evident in the garden of neighbouring Russell House: 'to his visit to Japan some years ago is due the fine collection of Tree Paeonies that have waxed great and strong in this fine soil and rear their numerous and immense blooms six or seven feet into the air'.[17] On the whole, though, Parsons seems to have been faithful in his practice to a traditional English idiom, and the main features at Luggers Hill were clipped yews, stone walls and flower borders. NA

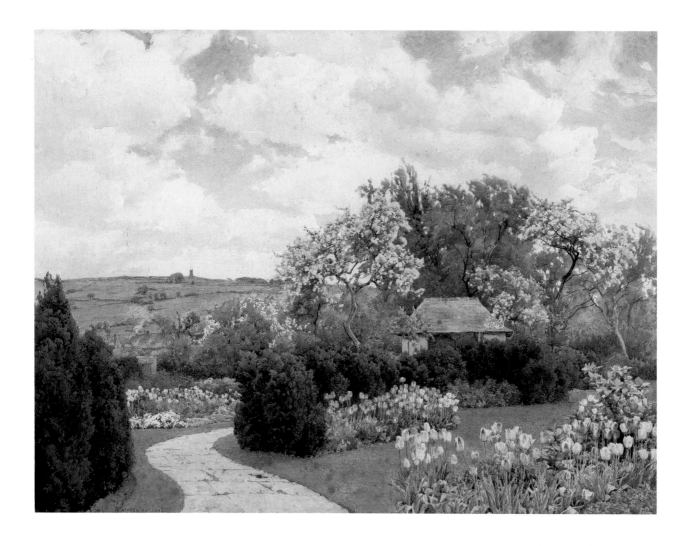

84

Margaret Waterfield (1860–1950)
Oriental Poppy and Lupin, Nackington,
*Canterbury c.*1904
Watercolour, 24.1 x 37.5
Private Collection, USA
LONDON ONLY

This watercolour shows the artist's own garden at Nackington, near Canterbury, Kent. It was reproduced as one of the illustrations in *Garden Colour*, published in 1905, and shows white lupins mixed with two varieties of Oriental poppy: 'it makes a most brilliant effect, but alas one very quickly over'.[18] Margaret Waterfield is certainly the least known of the artists who came to specialise in garden subjects in the late Victorian and Edwardian periods, but she had a distinctive manner of painting and *Garden Colour* was a notable volume; it anticipated Gertrude Jekyll's *Colour in the Flower Garden* (1908) in many respects, particularly in its emphasis on the artistic massing of colour and the idea of composing pictures in flowers. In contrast to Jekyll's publication, however, Waterfield's took the form of a de luxe gift book, and her watercolour illustrations were reproduced in colour, the better to help amateurs unable to interpret the word pictures of other writers on the subject. A high proportion of her examples were taken from Nackington, but she also illustrated planting schemes from William Robinson's Gravetye Manor, and it is clear that Robinson was one of her main sources of inspiration.

Robinson's principles of wild gardening are evident in *Oriental Poppy and Lupin*: the exotic poppies have been naturalised, growing with informal abandon so that it seems more of a hedgerow scene than a cultivated garden. But the artless look in practice required careful tending, as Jekyll and others had pointed out. Waterfield's style has been described as 'impressionistic', though this should not be taken to imply that a French model is being consciously followed. The brushwork has a breadth and virtuosity that contrasts with that of some of the more cautious technicians of the garden school, and the tonal unity given by the dark background foliage here is also a characteristic of her best work. NA

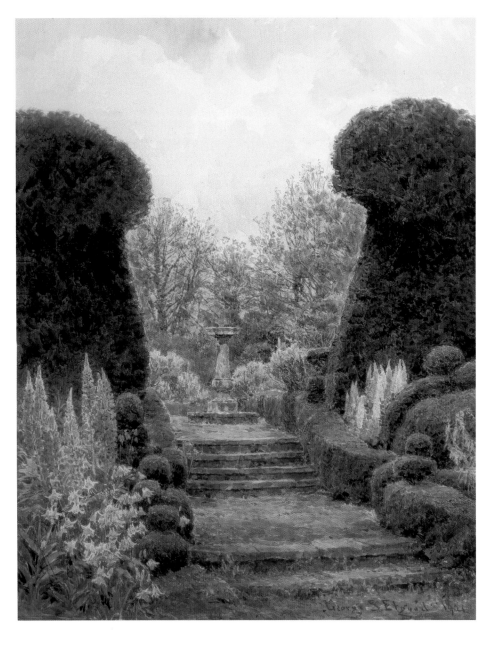

✳85

George Samuel Elgood (1851–1943)
The Sun Dial, Knockwood exh.1923
Watercolour on paper, 33.5 x 26.5
Maidstone Museum and Bentlif Art Gallery

This watercolour shows the artist's own garden at
Knockwood, near Tenterden, Kent. Elgood had established
a reputation as the leading exponent in watercolour of the
garden subject through a series of solo exhibitions at the
Fine Art Society between 1891 and 1914. His work was
also well known through the medium of book illustration,
most notably *Some English Gardens*, a selection of his
garden pictures with commentaries by Gertrude Jekyll,
published in 1904.[19]

Among the gardens illustrated and discussed in *Some
English Gardens* was the first garden Elgood had established
for himself at Ramscliffe, Markfield, on the southern slopes
of Charnwood Forest in Leicestershire. Jekyll developed
one of her key ideas in her description: 'a flower border
makes many a picture in the hands of a garden artist.
His knowledge of the plants, their colours, seasons, habits,
and stature, enables him to use them as he uses the colours
on his palette'.[20] She regarded Elgood as a master of the
principles of pictorial gardening, but he was fortunate
enough to be able to make a career out of making garden
pictures in a literal sense too.

In 1908 Elgood purchased a half-timbered fourteenth-century
cottage at Knockwood and began to transform its neglected
plot into a second garden. He was an admirer of the old-
fashioned style in gardens, and this watercolour shows how
he sought to emulate, on a modest scale, the formal aspect
of gardens such as that of Levens Hall, Cumbria, which he
had painted in 1892. Delphiniums in the foreground and fruit
trees in blossom beyond are set off against the bold shapes
of clipped yews, box hedges and stepped paths. By 1921,
the probable date of this watercolour, the golden age of
garden painting and illustration was already over. NA

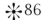86

Beatrice Parsons (1870–1955)
August Flowers, The Pleasaunce, Overstrand,
Norfolk date unknown
Watercolour on paper, 35.5 x 45.7
Private Collection

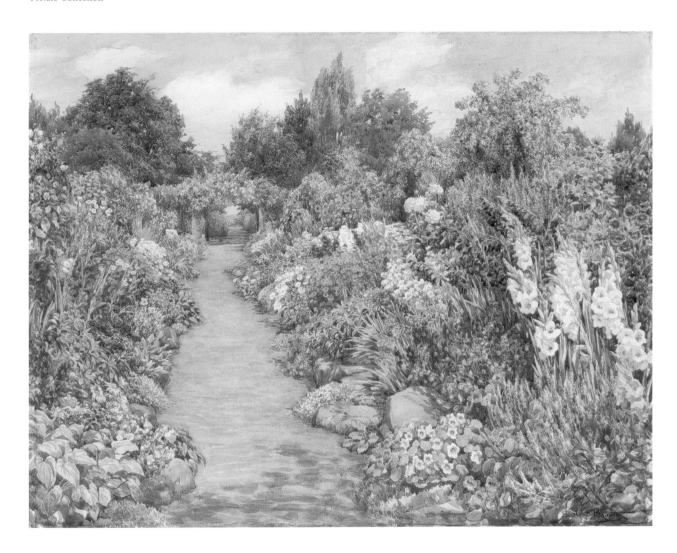

The gardens at The Pleasaunce, Overstrand, were designed by Edwin Lutyens in 1897–9 for Cyril Flower, who had been created Lord Battersea in 1892, and his wife, Constance. It was a cliff-edge garden of many varied spaces and was described in its maturity as 'one of the distinctive gardens of modern England'.[21] The planting schemes were devised by the Batterseas themselves, and although Gertrude Jekyll had no hand in the design, the double late summer borders depicted in this watercolour might be contrasted with the one she had established earlier that decade at Munstead Wood. A distinctive feature of the beds at The Pleasaunce is the use of large stones to create an irregular edge, merging the aspect of a rockery with that of a herbaceous border.

Beatrice Parsons (no relation to Alfred) emerged as a successful specialist in garden subjects with her first exhibition at the Dowdeswell Gallery in 1904. Lord Battersea died in 1907, so if, as has been suggested, this watercolour was commissioned by him it must be dated early in her career.[22] Her style, once formed, changed little over the years, however, and she continued to exhibit until the 1930s, preserving the opulent effects of the heyday of Edwardian gardening in her work. Compared with Allingham or Elgood, Parsons tends to emphasise the character of individual plants and her colouring is usually pitched in a higher key. Not surprisingly, her watercolours were later used by Suttons to illustrate their seed catalogues, as their bright colours seem to hold out a promise of remarkable chromatic displays, perhaps more of an ideal than a likely outcome. NA

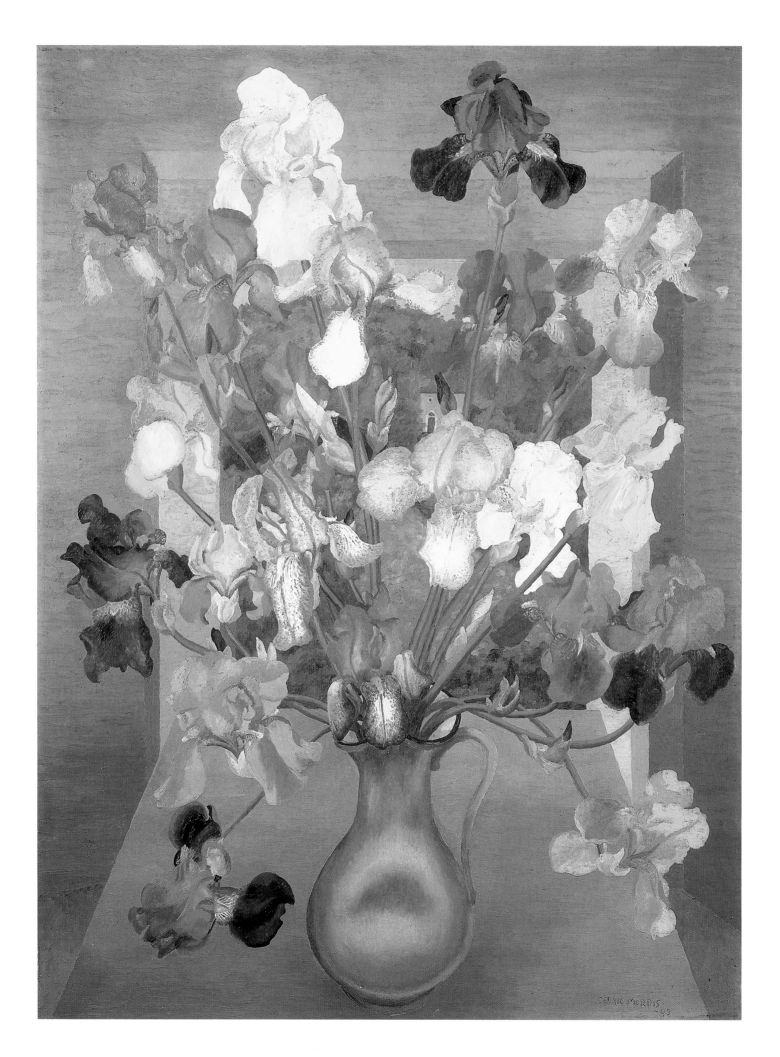

✳87

Cedric Morris (1889–1982)
Iris Seedlings 1943
Oil on canvas, 122 x 91.7
Tate. Purchased 1981

Iris Seedlings was painted at Benton End in Suffolk,
where Cedric Morris had a renowned garden (see pp.226–7)
and where he and his partner, Arthur Lett Haines, ran the
East Anglian School of Painting and Drawing. It is one of
Morris's largest and finest flower paintings, a bravura
display of design, colour harmonies, sensitivity to texture
and complex spatial organisation. This last quality is all the
more extraordinary as, reportedly, Morris usually painted
straight on to the canvas with no preliminary drawing,
working his way down from the top-left corner to the
bottom right, as if he were unrolling an image that had
already been painted.

Morris was fascinated by the qualities of 'grimness, ruth-
lessness, lust and arrogance' that he saw in flowers, and
his paintings of them are characterised not only by their
rich and vibrant colours, but also by a sensuality that is
sometimes almost aggressive or predatory and sometimes
shades into an overt eroticism.[23]

The painting depicts white, pink, blue, yellow and purple irises
– bred and grown by Morris – in a Chinese jug. The artist
stated in 1981 that the flowers are shown in front of one of
his own landscape paintings.[24] However, the various planes
behind the flowers seem to suggest a space opened into
the wall, rather than something leaning against it or hanging
on it. It seems more likely that Morris positioned the flowers
and jug on a table in front of an open door or window so
that he could paint them against the Suffolk countryside
– a motif he used in other flower paintings, such as *Floreat*
1933 (Cyfartha Castle Museum, Merthyr Tydfil) and *Heralding*
1959 (Private Collection). It is possible that the image is
deliberately ambiguous, so as to create a tension between
nature and representation, and interior and exterior; a
strategy used by a number of Morris's contemporaries,
including Ben Nicholson and Frances Hodgkins.

Morris had begun to breed irises in 1934, and with the
move to Benton End in 1940 this became an increasingly
important part of his activities. The 1943 season was
particularly successful and the painting may have been
made in celebration of that fact. In 1949 Morris received
the Foster Memorial Plaque, the highest award given
by the British Iris Society. BT

✳88

Ivon Hitchens (1893–1979)
Garden Cove 1952–3
Oil on canvas, 44 x 108
Arts Council Collection, Hayward Gallery, London

The most vivid account of Hitchens's West Sussex retreat
is still that given by Patrick Heron in his monograph on the
artist, published in 1955 (the same year that Heron acquired
his own garden at Eagles Nest in Cornwall):

*Bombed out of Hampstead during the early raids of the war, Hitchens
retired to a caravan he had lately purchased for £20 and driven into a
thicket on Lavington Common composed of rhododendron and silver birch,
with oaks above and bracken below. Here, with more turpentine than
water, he remained ... And there today, in this setting of dense undergrowth
... his one storey house spreads itself, and is all but invisible from a distance
of ten yards. In autumn the faces of sunflowers and dahlias, planted under
the giant bracken ferns which sweep against the walls of the house, emerge
at an unusual height above them and glow through the windows.*[25]

Hitchens had purchased six acres of woodland on Lavington
Common, just south of Petworth, in 1939, and had already
established a studio there before making it his permanent
home. He had a house, Greenleaves, built for him on a
piecemeal basis: it was single-storey and flat-roofed, except
for an attic above the studio. Parts of it can be seen on
either flank of this painting, as if in a 180-degree pan across
the field of vision, the undergrowth pressing in closely.
Hitchens created four small ponds on his land and gradually
extended his holdings to twenty-six acres, including an old
orchard. He made no clear distinction between the garden
and the immediate surroundings, but together they provided
him with a lifetime's subject matter.[26] NA

89

Patrick Heron (1920–1999)
Azalea Garden: May 1956 1956
Oil on canvas, 152.4 x 127.6
Tate. Purchased 1980

✳90

Patrick Heron (1920–1999)
Autumn Garden: 1956 1956
Oil on canvas, 182.9 x 91.5
Estate of Patrick Heron

The garden at Eagles Nest was established from the 1920s by William Arnold-Forster, Slade-trained painter and author of *Shrubs for Milder Counties* (1948). The situation was challenging: an exposed position on granite moorland, west of St Ives on the Zennor road and overlooking the sea about a mile distant. The climate, though, is temperate, and the construction of a series of walls and windbreaks, strung between huge boulders and at various levels on the slope, enabled azaleas, camellias and other shrubs, both tolerant and exotic, to flourish in the protected pockets. As a child Heron had stayed for several months at the house with his family, and when in 1955 the opportunity to buy the property came up, he felt that he was returning to 'a childhood magic garden'.[27]

This rediscovered garden inspired an important series of paintings the artist began to make in the spring of 1956. Looking back years later, he said: 'although I was conscious of painting the most abstract paintings that anyone was painting, I didn't call them abstract, I called them Garden paintings'.[28] The relationship between subject matter and pictorial reality had emerged as a sensitive issue, and Heron was anxious to avoid any suggestion of descriptiveness in his approach, or the idea that a recognisable motif had been gradually stylised and simplified in the process of painting, emphasising instead the search for pictorial equivalents to the sensation of space. But the garden theme is clearly more than a pretext, a way of making abstraction acceptable. The vivid proximity of his garden enabled him to rethink his compositional terms, and to break away from the cubist-derived armatures that had underpinned his paintings until now. The new paintings are structured as all-over fields of overlapping colour patches.

In *Azalea Garden* the elongated colour accents seem to take the form of a penetrable screen, a device strongly reminiscent of the French *tachiste* painter Pierre Soulages, whose work Heron admired.[29] In *Autumn Garden* the colour notes are less sustained but chromatically more complex, with the paint allowed to run down freely in a series of thin vertical flows. These pictorial elements would be radically simplified in the more demanding and controversial stripe paintings produced the following year.

Heron made a second series entitled 'garden paintings' in the 1980s. These later works do not convey the same sense of flowers and foliage seen at close range in brilliant light; rather, they deploy a compositional vocabulary of linked enclosures and compartments. Heron had spoken of his interest in the relationship of his garden as a whole to the contours and rhythms of the surrounding landscape, but it was only when he had the opportunity to fly over the site in a helicopter that he recognised forms similar to the ones in his paintings laid out in the landscape below him. His later paintings were the fruit of long acquaintance with his own place.[30] NA

*91

John Maxwell (1905–1962)
Night Flowers 1959
Oil on canvas, 91.4 x 61
Tate. Purchased 1959

Maxwell described this painting as one of four on the theme of flowers, butterflies and moths inspired by the flowering of a bush of *Rosa moyesii* in his garden at Dalbeattie, Kirkcudbrightshire.[31] It is a night scene, with the flowers illuminated in the light from a window while moths flutter against the pane, their scale hugely exaggerated and their colouring intensified, so that they take on the appearance of exotic specimens or tropical fish in an aquarium. Such magical transformations are characteristic of Maxwell, and his approach to the theme of the garden at night is in striking contrast to that taken by William Gillies (cat.92). The two artists had been closely associated since the late 1920s: both valued their garden retreats, but whereas Gillies always adhered more closely to the appearance of things, Maxwell's paintings are full of dream imagery and private symbols.

After inheriting Millbrooke, his parents' house in Dalbeattie where he had grown up, Maxwell retired from his teaching post in Edinburgh in 1946 to live there permanently. He was a keen gardener, and garden motifs are threaded throughout his work. He had designed murals for the Garden Club at the Empire Exhibition in Glasgow in 1938, and his contribution to the Festival of Britain exhibition *Sixty Paintings for '51* was entitled *The Trellis*, a fantastical variation perhaps on the rose trellis he had recently erected in his garden at Millbrooke.[32] NA

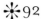

William Gillies (1898–1973)
Garden, Temple, Winter Moon 1961
Oil on canvas, 96.5 x 121.9
Paisley Museum and Art Gallery

This painting shows the garden of Gillies's cottage in the village of Temple, situated above the steep banks of the River South Esk some fifteen miles south-west of Edinburgh, where he had lived since 1939 with his mother and sister. It is one of a number of paintings he made in the early 1960s on the theme of his garden seen in winter or early spring, sometimes framed by the windows of his studio. It was a difficult time for the artist: when this picture was painted, his mother was aged ninety-eight, his sister had died the previous year and his recent appointment as Principal of Edinburgh College of Art, where he had taught for thirty-five years, was severely limiting the time he was able to devote to painting.

The view is along the back of the cottage (in fact three cottages which had been connected inside), looking uphill towards the gate into a little side lane between two outhouses. Part of the flat-roofed, grey-rendered extension Gillies had added to the rear of his property can be seen at the left, transformed into an elegant grid. Accounts of the artist's life at Temple have tended to emphasise its unsophisticated, unassuming character, but his painting has a distinctively modern European frame of reference. The greys of the night sky are fitted over the subtly discontinuous mesh of skeletal branches in a way that recalls the practice of Cézanne, while the doors, gates and roofs are made into a geometric arrangement of brightly coloured panels. The garden remains as it was in Gillies's day, but the three doors and gates are now all painted black; perhaps they always were, since their heightened local colour is not readily explained here by the angle of the moonlight. NA

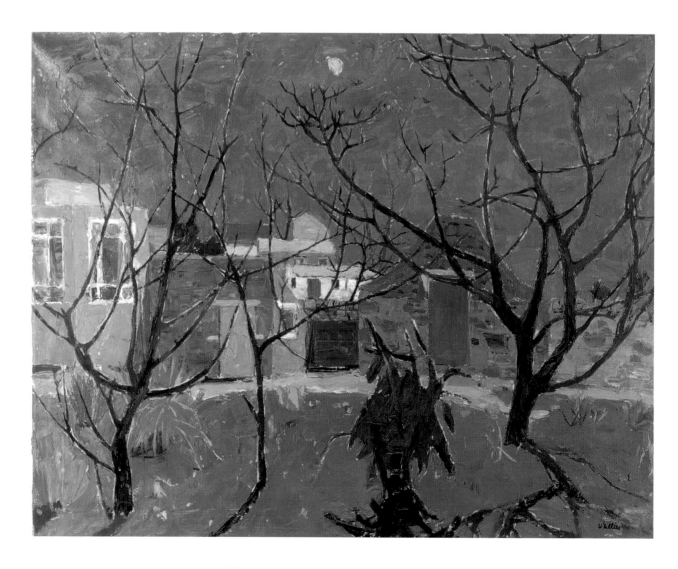

✳93

Adrian Berg (born 1929)

Gloucester Gate, Regent's Park 1982
Oil on canvas, 177.5 x 177.4
Tate. Presented by the Trustees of the Chantrey
Bequest 1984

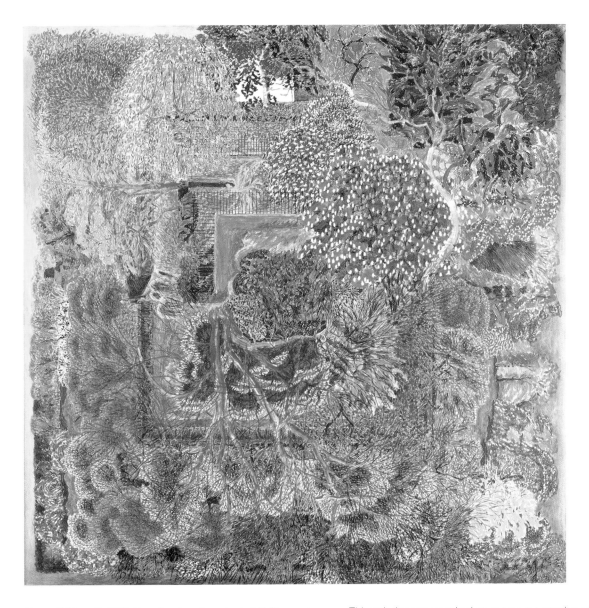

From 1961 until 1985 Berg lived and worked at 8 Gloucester Gate, Regent's Park, London, in a flat in one of Nash's terraces leased from the Crown Estate, and the view across the park became a compulsive subject for him. He had been making paintings of it at least since the mid-1960s, although his relationship with the place extended even further back: in an interview he recalled that his family had once lived in Ormonde Terrace, adjacent to the park, and went on to speak of how it had informed all his childhood subjects, and of coming back 'to live in this corner of the park'.[33] He continued to live overlooking the park until he left London in 1988, though he had also begun to add other park and garden subjects to his repertoire.

This painting was worked on over a succession of days in May and June 1982. Berg was acutely conscious of the rapidly changing phases of the foliage and his paintings tended to take on a diary or calendar-like aspect. He was also concerned with multiple images: earlier paintings had been divided up into compartments, suggestive of unfolding or fractured narratives, and later he began to organise his paintings in strips, each one the record of a different phase, month or point of view. He then began to experiment with a square format in which multiple views could be fitted seamlessly together, as in the present example. The 180-degree arc he could survey from his studio window has been shaped and edited in order to accommodate it to the square canvas; the resulting composition combines elements of the Persian carpet, the scroll and the panorama. The painting can be viewed in four different orientations, but the one displayed here is that preferred by the artist. NA

✳94

Anya Gallaccio (born 1963)
Red on Green 1992
10,000 fragrant English tea roses, heads laid
on a bed of thorns, approximately 300 x 400
James Hyman Fine Art, London

It is characteristic of Anya Gallaccio to work with natural
materials – plants, flowers or fruit, sugar, salt or ice
– and she exploits the often unpredictable nature of the
results. Her sculptures and installations invariably evolve
in unexpected ways, engaging with different senses at the
same time.

Gallaccio has created a number of installations using flowers
– gerberas, sunflowers, narcissi and roses – working with
vast quantities and vivid colours to make installations that
are visually and physically arresting. She is well aware of
the rich symbolism of flowers, especially roses, and uses
them to explore age-old themes in new and surprising ways.
One piece, recently remade in the Turner Prize exhibition
at Tate Britain, involved 1,300 fresh gerbera stems cut at the
beginning of the show and pressed to a wall behind panes
of glass. The viewer was able to see the flowers progres-
sively droop and rot. For *Red on Green* 10,000 cut red roses
are arranged in a neat rectangle on the floor of the gallery.

In all of Gallaccio's installations there is a powerful tension
between the fragile nature of the material used and its
highly formal presentation. Parallels can be drawn with the
clean geometry of Minimalist sculpture, and *Red on Green*
both reprises and rebuffs Carl Andre's slate floor pieces,
mimicking his crisp, formal language but using soft and
mutable material. The title of the work is a reference to
the American abstract painter Mark Rothko, whose pictorial
compositions were often structured as rectangular fields of
colour floating over one another (such as *Black on Maroon*
1959, Tate). Unlike with a painting, however, Gallaccio's
roses are subject to change: they will wither and dry, even
though – significantly – they retain some of their colour.
She prompts us to consider not only our own mortality but
also our romantic notions of nature. Roses are industrially
farmed and mass-produced all year round, and by presenting
them in such a staggering quantity she reminds us of this
fact. MH

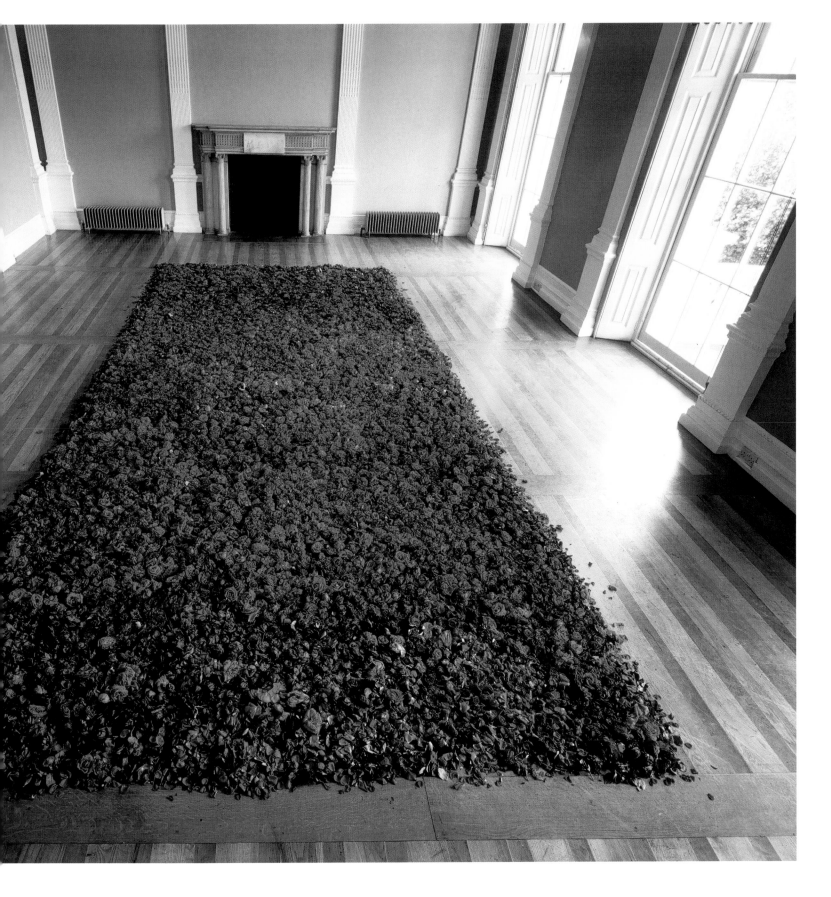

Gary Hume (born 1962)
Four Feet in the Garden 1995
Gloss paint on aluminium panel, 221 x 170
Arts Council Collection, Hayward Gallery, London

The title of this painting seems at first to be at odds with
the content: there are *eight* feet in the garden, four male
and four female. Perhaps we are looking at mirrored forms,
or a folded-out image in which everything is doubled. The
close-up, fragmented nature of the imagery compounds
the difficulty, and the relationship between the figures, in
the psychological as well as physical sense, is teasingly
ambiguous. For all its near-heraldic simplicity of form there
is nothing clear-cut about this painting, and the approach –
decorative, oblique and inscrutable – is entirely characteristic
of the artist.

Hume often begins with a photographic source, tracing
an image on to an acetate sheet and projecting it on to
the panel, but the process ensures that the original context
can no longer be accessed and uncertainty creeps in. The
motif of naked feet in a garden might suggest a state of
innocence, the Garden of Eden even, or evoke a golden
age, or perhaps an altogether less elevated erotic scenario.
At the same time the 'garden' reads as a black spill, a
phantasmal shape coming between the figures as much
as the ground on which they stand. The row of bright-green
blades of grass along the bottom edge adds a further note
of comedy and discomfort. NA

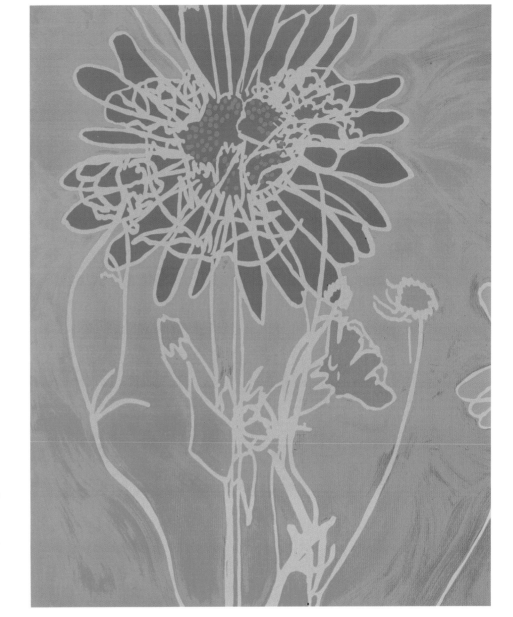

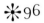96

Gary Hume (born 1962)
What Time is It? 2001
Gloss paint on aluminium panel, 150 x 120
Mr and Mrs Kennaway

Like many of Hume's recent paintings, this is made up by overlaying several drawings to create a complex interlacing effect. The linear elements in Hume's paintings are often extended across the entire surface in open webs or ripples, but in this case there appears to be a clear relationship between figure and field: the flower head emblazoned on an orange ground has an opulent, almost art nouveau quality. The colour is all in the ground and not the flower, however, and there are other reversals at play in the work. The 'drawing' reveals the reflective aluminium surface of the panel in such a way that relationships within the piece alter with every move the spectator makes, so that the design is sometimes bound by a silver trace and in other places momentarily lost to view.

Leaf, flower and petal forms have been a frequent motif in Hume's work, present in the form of exaggerated floral backgrounds or as a substitute for the human figure. He began to make a loose series of 'Garden Paintings' in 1996, claiming that he resorted to painting his garden whenever he could not think of anything else to make. It is an imaginary garden, however, populated by invented creatures, and sometimes appearing from an unexpected angle: from the point of view of an insect, for example, or of a bird flying overhead. But Hume has also spoken of letting the colour of a chosen petal determine the harmonic basis of a painting as a way of getting away from habitual combinations of the palette. NA

Representing and Intervening

his obsession with surface is everything. It's as if all our values of indoor space have escaped into the outdoors. We are sophisticated enough to distinguish public from private, and the weather still tells us which is in and which is out, but we are very busy blurring these things. It's worth reminding ourselves that it was us who named 'nature'. It didn't name itself.[1]

At the close of the twentieth century the artist Richard Wentworth described the English landscape as 'intensely gardened'[2] – heavily cultivated, controlled and contrived. Many contemporary artists share his concerns. They acknowledge that the garden has an ambiguous status. They use it to explore the wonders of the natural world but equally to question man's continuing desire to bend nature to human will. This is complicated by the fact that artists, like gardeners, recognise and relish the potential for creativity within this space. Thus the contemporary garden is a site of contradiction and uncertainty: part conflict, part co-operation; a garden of unearthly delights and earthly imperfections.

The dichotomy between nature and culture has been a topic of art for centuries. In the latter part of the twentieth century many artists expressed their anxiety about the modern industrial world by abandoning the confines of the museum and going to work in the wider landscape. From the late 1960s, throughout Europe and the USA, they embraced the ephemeral, focusing their attention on ideas, processes and materials over and above a finished art object. In Britain artists such as Richard Long and Hamish Fulton sought a very personal interaction with nature and made walks in the landscape, which they then documented through words, maps and photographs. They wanted to connect everyday experience with the natural world and escape the city.

This tradition of conceptual art practice both anticipates and diverges from the methods of Ivan and Heather Morison. The Morisons also seek a direct engagement with nature, but they would argue that the most effective means for doing so, in the reality of the urban and suburban landscape, is through gardening. They use gardening as an art form, and their garden in Birmingham as a studio or stage on which to 'perform' creative acts. While cultivating the garden, Morison has also cultivated a fictive alter ego – 'Ivan Morison, the amateur gardener' – and he informs people of his horticultural exploits by post. His elegant missives echo the telegrams and postcards sent out by the Japanese conceptual artist On Kawara reassuring us of his existence – 'I am still alive', 'I woke up' – imbued in equal measure with humour and pathos. They are also comparable to the evocative texts of Hamish Fulton, whose walking journeys are distilled into succinct, poetic phrases allowing a wider audience an imaginative engagement with his experience. Although Morison reports real events, the authenticity of his activities is not so important for him. By disseminating the daily trials of the gardener by mail-outs and on a website[3] he develops a space in the imagination, offering a 'virtual leisure garden that everyone can share'.[4]

Morison's enterprise highlights how easy it is to become accustomed to experiencing nature at one remove, and that contemporary understanding of the natural world is largely filtered through mass media such as magazines and newspapers, television and the internet. Whether or not this is Morison's primary motive, a recurrent theme in contemporary art and the garden is man's increasing detachment and distance from nature. Popular gardening programmes, with their accompanying websites and magazines, have cultivated a new breed of gardener who is more wishful than actual, people who speculate and contemplate but never get their hands dirty. It is the idea of the garden rather than its reality that inspires many city-dwellers. The fact that the BBC's *Gardener's World* website enables subscribers to build a 'virtual' garden in two

dimensions, plotting an imagined space, selecting and arranging various shrubs and accessories, is further evidence of this. The parallels that were drawn between pictorial composition and garden design in the nineteenth century now seem to have found an equivalent in the relationship between such virtual resources and living gardens. An analogy could even be drawn between virtual garden making and the methods of many contemporary painters.

Few painters work from direct observation, preferring a nature that is filtered through the imagination and the media. George Shaw, who has documented his father's garden for many years, prefers to work from photographs and uses the traditional and popular medium of watercolour to evoke a nostalgic ideal. Gary Hume's 'garden paintings' address nature but again present an idealised

version of it. His motifs are elegantly emblematic, derived from sources such as tapestries and books of pressed flowers. Their surface beauty is enhanced by the qualities of the household gloss paint he uses. Their smooth contours and bold colours create an impression of nature but stand firmly outside of it. Fellow painter Paul Morrison's imagery is as precise and poignant, generated from reference books, cartoons or art history. Radically simplified and devoid of colour and detail, Morrison's plants and paraphernalia — a dandelion, a fir tree, a wooden fence — are rendered in striking but simplified silhouettes so that they resemble stencils or pictograms. Morrison's view of nature is mediated by culture and convention and his organising hand creates another form of virtual garden where natural objects become signs, arranged and ordered in varying constellations. Morrison creates an idealised depiction in two dimensions in much the same way as Marc Quinn has done in three dimensions, with *Garden* 2000 (*fig.48*).

fig.48
Marc Quinn (born 1964)
Garden 2000
Installation, 320 x 1270 x 543
Fondazione Prada, Milan

fig.49
The Eden Project,
St Austell, Cornwall

Using real plants as his raw material, Quinn constructed a vast, refrigerated and enclosed environment in which to display varieties of exotic flowers, frozen in silicone and suspended in a kind of perpetual summer. Quinn's fanciful desire to transport us into an exotic other world, a picturesque paradise, might seem less ambitious when compared with another enclosed garden that came into being contemporaneously. The Eden Project, in Cornwall, was heralded as 'a global garden for the twenty-first century', housing replications of all the world's major ecosystems within a vast covered area (*fig.49*). Made from recyclable material and lit by solar energy, its domes shelter and nurture a multitude of exotic plant life and primitive animal life. In contrast to the serious ecological research that underpins the Eden Project, Quinn's *Garden* was driven by whim and desire. Quinn chose the most elaborate and colourful specimens, preferring flowers that were instantly recognisable (lilies, sunflowers, tulips and roses). This work could be read as an ironic commentary on the impossibility of creating an earthly paradise (the refrigerated tank does, after all, need constant supplies of electricity to sustain it) and as a warning against man's frivolous interventions in natural processes.

Quinn's work is a quest for the prolongation of life and beauty by any means, and his search has significant historic forebears, not least in the endeavours of early physicians, apothecaries and botanists such as Dr Frederick Ruysch (1638–1731).

Ruysch was a renowned anatomist and the director of Amsterdam's botanical garden, who also developed his own museum for the display of natural wonders. Ruysch's embalmed body parts were valued as tools for medical research as much as works of art, and his interest in anatomy and botany involved him in the intricacies of collection, classification, preservation and display.[5] Contemporary artists such as Quinn and Jacques Nimki mirror these practices, albeit in their own idiosyncratic ways. Nimki calls all of his artworks 'florilegium', which literally means a gathering of flowers. He explores and excavates the urban hinterland, styling himself a modern-day plant explorer, sketching the weeds and wild flowers that he finds, recording the locations and attributes of each one on a database of his own devising. Back in the studio, these sketches become the basis for large-scale drawings and collaged paintings offering a richly layered, visual anthology of plants from a given area.

The fact that Nimki has used weeds as the basis for his art-making activities subverts the traditional assumptions about beauty and value that Quinn's *Garden* upholds. Nimki creates fictional garden compositions, aestheticising the unwanted and overlooked elements of the urban world. Although his plants are more humble than Quinn's gorgeous blooms, both artists are preoccupied by issues of preservation and presentation. Moreover, the way Nimki uses weeds, including dried, pressed flowers, in his compositions, suggests the weed can function as a kind of 'ready-made', a found object taken from its everyday context and given new significance in fresh surroundings. This scenario is not far removed from Quinn's use of exotic plants, plucked from glossy sales catalogues and artfully arranged for the viewer. Another parallel can be drawn with Anya Gallaccio's work with flowers and plants. It is characteristic of Gallaccio to employ natural, mutable materials in her practice and she has used cut flowers many times to create spectacular sculptural installations that slowly wilt, rot or wither over time. Like Quinn, Gallaccio selects the kinds of flowers that are popular and immediately identifiable – roses, sunflowers, gerberas – and she acknowledges that such specimens can function effectively as 'a pop ready-made or found object' because they are 'mass-produced all year round as disposable commodities'.[6] An awareness of this might not necessarily detract from the enjoyment of her work, but it can trigger unease in the viewer.

Nimki's elevation of the common weed is particularly timely. In summer 2003 English Nature reported that certain kinds of weed are now on the brink of extinction, and issued a field guide to 100 specific arable types that are apparently dying out, blaming intensive farming, the use of herbicides and the loss of hedgerows. Nimki recognises that weeds are 'part of our heritage – part of our culture'[7], and the fact that the dandelion, the quintessential weed, has become a recurrent feature in Paul Morrison's paintings demonstrates their iconic status. Weeds might be taken as a sign of neglect or a threat to the established order when found in the garden, but they are also symbolic of nature's stubborn persistence.

Susan Hiller demonstrates man's troubled relationship with weeds by articulating the means by which they might be suppressed. Her carillon *What Every Gardener Knows* (cat.109) is based on codes devised by the geneticist Gregor Mendel (1822–1884), the result of his experiments on the plants in his own garden. The composition celebrates the variety of genetic patterning and Mendel's achievement. It is a cheerful tune; but there is a divergence between form and content, and the hidden implications are more chilling: 'When Mendel made plant breeding a science, gardeners were enabled to produce internally consistent plant populations; this meant they could do more than merely eliminate weeds, they could also seek out weed-like traits existing within garden species, and attempt to eliminate them as well.'[8] Hiller subtly but succinctly sums up our predicament: that man's desire

to master nature might undermine it. Her garden gently sings 'Kill the weeds', and the implied link to eugenics – the selective prevention or encouragement of births for social, racial or political ends – illustrates how natural processes can be wilfully manipulated. When today's artists take up the subject of cultivating nature, their work is often an exploration and critique of how nature has been interfered with. Two recent treatments of the orchid – one of the most intensively farmed flowers today – illustrate this point. Cerith Wynn Evans raised several shop-bought orchids on his own urine in order to create 'a variety of Frankenstein flowers and symbolic alter egos' (*Future Anterior* 1998–2000).[9] Later Marc Quinn took a hybrid orchid and recreated it on a vast scale, as a two-dimensional steel sculpture rendered in lurid colours (cat.104).

Quinn's *Garden* is clearly a reference to the biblical Eden, the blissful state of nature described in the Old Testament. However, the Garden was lost to man once Adam and Eve were expelled, and so the idea of the garden carries connotations of corruption and lost innocence. Artists today are conscious of its ambiguous status, as Anya Gallaccio's use of the highly symbolic apple tree (*blessed* 1999), laden with slowly rotting fruit, suggests. Indeed the description of the garden as an idyll or safe haven is now continually called into question, and often it is depicted as a place of danger, temptation and intrigue. Mat Collishaw prefers to explore the dark underworld evoked by garden spaces, populating his gardens with vagrants and vermin. Equally, Sarah Jones fixes on the overgrown corners of urban gardens by night. Eerie and portentous, her locations foster contradictory emotions: they are seductive but also slightly sinister. Such work reflects how, as towns and cities encroach on the natural world, nature still fights back. There will always be these in-between spaces that are not built on or regulated. Collishaw and Jones recognise how the nocturnal garden or park has become associated with illicit encounters, transgression and danger in the city. The theorist Michel Foucault called these unsettling, ambiguous social spaces, 'heterotopias'[10]: sites that have an aura of mystery about them. Heterotopia is Greek for 'place of otherness' and originally came from the study of anatomy, where it refers to 'parts of the body that are either out of place, missing, extra, or alien'. There is a sense of being 'out-of-place' in the gardens of Collishaw and Jones, and David Rayson's backyards harbour the same air of uncertainty and anxiety. They are either neurotically tidy or overgrown and abandoned. Rayson reflects on the impossibility of man's desire to live in harmony with nature. In his urban scenes, night is always encroaching on day, and rain clouds are never far away. His impressions of the suburbia that surrounds him reveal how the built environment tries to keep nature at bay, and the recent introduction of bright, synthetic colours into his compositions only serves to heighten the artifice and exaggerate a sense of alienation.

Today the accelerating development of land has worrying implications, and its threat to the natural landscape has become another important theme for art. In recent decades artists throughout Europe and the USA have articulated the need to mediate between the ecologist and the industrialist. Many have begun to combine ecological and social issues with horticultural ones and to offer solutions to endangered ecosystems, devising models, plans and systems and inserting their work into the logic of our everyday world. Helen Mayer Harrison and Newton Harrison, for example, transported a 400-year-old meadow to the roof of a German museum (*Future Garden – the Endangered Meadows of Europe* 1996). Mark Dion created a garden of rare and near-extinct fruit trees in Lancashire (*Tasting Garden* 1998). Blurring the boundaries between art and science, Janice Kerbel has followed in this line of socially and ecologically engaged art by creating a series of small garden utopias for the built environment.

Dr Nathaniel Ward (1791–1868) had already devised a way of protecting plants from polluted air and preserving them against poor climatic conditions when he invented the Wardian case in the 1830s. He thus laid the foundations of a national passion for cultivating rare plants under glass, and his glass boxes became a fashionable home accessory for middle-class Victorians. Kerbel has now devised her own interior gardens, and one specifically for a Victorian terraced house. Observing how increasing numbers of people spend most of their time indoors, she devised these *Home Climate Gardens* (cat.110a–b). They are small-scale interior gardens, beautiful but practical, and adapted for various indoor habitats. Kerbel meticulously researched which species of plants could live together, where and how, as indicated in her intricate and intriguing plans. But she implies that the climatic conditions of the built environment are now better suited for the needs of many plants than those of their indigenous environments. Her project highlights the implications of global warming and urbanisation, and as one critic recently wrote: 'All artists who now work with plants deal with the unstated postmodern metaphor: the tainted garden.'[11]

Nils Norman shares some of Kerbel's concerns and aspirations, as expressed through his models and plans, many of which propose alternative ecosystems for towns and cities. His way of fusing art, architecture, urban planning and environmental activism is now gaining currency and his *Gerrard Winstanley Radical Gardening Space Reclamation Mobile Field Center and Weather Station Prototype* 1999 encapsulates his ambitions (see cat.101). This work carries a dual message of self-education and self-sufficiency, containing a library that brings together a heterogeneous mix of books on urbanism and ecological design, eco-activism and radical gardening. Norman's plans always highlight the potential of experimental gardening and permaculture for creating a better, sustainable world. His *Geocruiser* 2001–2 extended these ideas, housing a more expansive education resource in a converted coach, at the back of which various plants, vegetables and herbs flourished. Norman's other plans, such as his recent *Proposed Redevelopment of the Oval, Hackney E2 London* 2003, aim to integrate beauty and use, work and leisure, country and town. That a great many of Norman's proposals are fictional need not disappoint. He does not expect most of his models or plans to be realised, but instead relies on the power of suggestion: 'Norman highlights a distinctive mode of utopian thinking: to invent a fiction that throws the shortcomings of reality into sharp relief.'[12] The same is true of Kerbel's enterprise, which is coloured more by a sense of expectation than actuality.

In recent times, then, the garden has been depicted as a speculative space. As with the projects of Kerbel and Norman, much is open to conjecture. While acknowledging the shared anxieties over genetic breakthroughs, global warming and urban development, artists are still drawn to the idea of the garden and able to find beauty there. Susan Hiller's carillon is a pleasing melody, and there is no denying the rich, visual impact of Anya Gallaccio's installations, Sarah Jones's photographs or Jacques Nimki's weed 'florilegiums'. Gallaccio has talked of the garden as a 'palimpsest ... letting the past show through and seeing what happens in the future'.[13] Recent aesthetic endeavours are mindful of this future: Gallaccio ensures that her materials are given fresh life beyond each installation — dried roses become pot pourri, rotten fruit produces saplings or schnapps; while Nimki cultivates weeds, makes weed wine and disseminates his knowledge through education workshops and seminars. For many artists, ideals about the garden have been tempered but not quashed, and even if the garden is virtual, the yearning for it is most definitely real. —*Mary Horlock*

 97a–d

Richard Wentworth (born 1947)
From the series *Occasional Geometries*
a *Gloucestershire, England* 1997
b *Tottenham Court Road, London* 1998
c *King's Cross, London* 2002
d *Islington, London* 2002

Photographs, each 25.4 x 30
Courtesy the artist and the Lisson Gallery, London

Since the mid-1970s Richard Wentworth has used photog-
raphy to record the incidental details of the everyday
world, focusing on the absurd or unexpected as well as
the overlooked. Although he rarely photographs people,
his world is very human. He is attracted to objects and
incidents that reveal man's pragmatic, sometimes whimsical,
and often curious interaction with the landscape. The artist
has said: 'Display is an essential aspect of urban life. We
are surrounded by display, every shop window is a theatri-
cal space, with things arranged in it for effect. Parked cars
are on display. In the over-developed landscape that we
all inhabit it's hard not to attribute some intention to
everything that we survey.'[1] Thus Wentworth draws our
attention to a recycling bin, unsuccessfully camouflaged
with a stylised, leafy design, or to patches of lawn dug
up and folded neatly like a domestic carpet. 'Wentworth's
vision – refined and thoroughly democratised – makes
us aware of all the stuff we not only fail to notice but
actually edit out in the hurried course of our daily lives.'[2]
The title of this series of photographs is suitably ambiguous.
Occasional Geometries evokes the impromptu and
spontaneous quality of the subject-matter, but equally
points to the presence of an underlying order, structure
or symmetry. MH

98

Graham Fagen (born 1966)
Lawn 1999
Fujicolor crystal archive print mounted
on aluminium with printed text on paper,
print 76.2 x 101.6, text 29.7 x 21
Courtesy of the artist/Doggerfisher Gallery,
Edinburgh/Matt's Gallery, London

Lawn forms part of *The Plant Series*, a body of work
executed by Graham Fagen in 1999. This is a series of nine
sumptuous, close-up colour images of individual plants
and flowers, among them a rose, an orchid, a thistle,
a lily and a shamrock, as well as a lawn. Each image
is paired with a short text that uses the first person
to invoke fragments of associative material. Placed
alongside the photograph, these texts operate like the
interpretative captions that are often found in museums.
The nature of the texts varies, ranging from seemingly
specific recollections to more general and historic
references. For example, the text that accompanies the
image of the thistle refers back to a tale from Scottish
folklore. This recounts how one night an English soldier
had brushed against a thistle, and his shrieks of pain had
caused his battalion's assault on a Scottish castle to fail.

The text relating to *Lawn*, however, is more personal. Here
someone remembers how they first tried to understand the
class system and their place within it: 'When I was younger
I can remember seeing a comedy sketch on TV about working
class, middle class and upper class. A few years on, I read in
a newspaper an article about class, again it outlined the three
types. I thought hard about my own situation. Being working
class was not considered. I'm not sure why. These were
poor people you felt sorry for, tramps and dirty people. We
had a nice house in a new council scheme with an upstairs
and a back and front garden, so we couldn't be in the middle
of the class categories. So, I thought, we must be in the only
category that was left, upper class.' Owning a front and back
garden was the key to some certainty of social and econom-
ic status. Fagen acknowledges that the work stems from his
own experience: 'My family moved from a Glasgow tene-
ment to this brand new housing scheme – all new and excit-
ing, with a back and front door and an upstairs that no-one
had used or lived in before. Back was for fruit and veg. with
the front more formal with, of course, a lawn.'[3]

Working with a variety of media, Fagen has often used
language to explore the complex networks of personal
and cultural influences that shape identity. Plants and
flowers are recurrent motifs in his art, as he exploits their
ability to suggest various meanings: social, emotional,
personal and national. Fagen calls them 'associative
symbols of experience'. MH

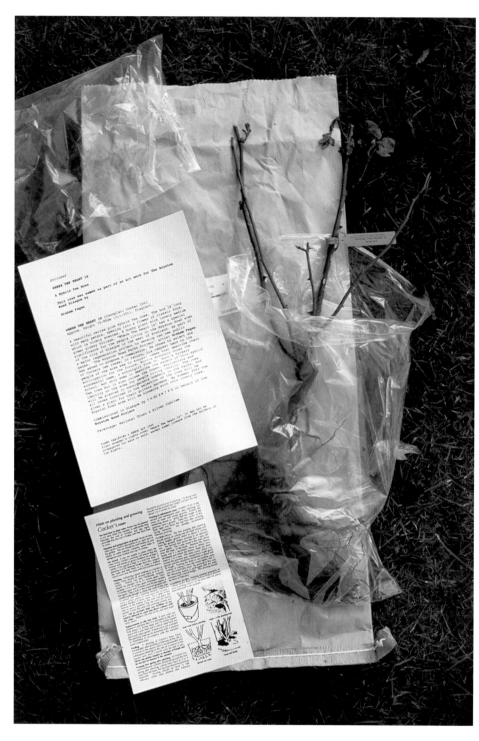

 99

Graham Fagen (born 1966)
Where the Heart is 2001
Hybrid tea rose, dimensions variable
Courtesy the artist, purchased from Cocker's Nursery, Aberdeen

Where the Heart is has a particular significance for the people living in the Royston Road area of Glasgow. Graham Fagen was invited to propose a public artwork as part of a regeneration initiative to develop two new parks (one in Roystonhill and the other in Provanmill, in 2001 and 2002 respectively). As one aspect of the commission, he selected a hybrid tea rose (then only known by its seedling code number, JC30518/A) that had been developed by Cocker's Nursery in Aberdeen, and he purchased the rights to it. Partly influenced by the Scottish poet Robert Burns (1759–1896) and the symbolic significance he gave to this particular flower,[4] Fagen then asked the people from the Royston Road area to suggest a name for the rose: something that might make it specific to them and that could also describe their hopes for the future. A local schoolgirl, Nicole McDonald, suggested the winning name: *Where the Heart is.* The name has connotations of belonging, as in the phrase 'home is where the heart is'.

As the sales catalogue for *Cocker's Award Winning Roses* explains:

Not only does it describe the warmth of this Hybrid Tea rose but it also raises the hopes, aspiration and identity of the area for people living locally. The rose will be planted in considerable numbers in the Parks, and all those involved in the selection of the rose will be given a plant for their private gardens. By summer 2003 the Royston Road area will be blooming with this lovely rose.[5]

The rose is now commercially available, and has been planted in the flower beds at the front of Tate Britain. MH

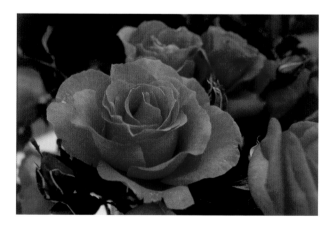

 100

Graham Fagen (born 1966)
Where the Heart is 2002
Bronze, 50 x 50 x 50
Courtesy of the artist/Doggerfisher Gallery, Edinburgh/Matt's
Gallery, London

Graham Fagen's hybrid tea rose *Where the Heart is* has
now been planted throughout the Royston Road area of
Glasgow. Fagen had offered the rose as a kind of emblem
or mascot for the community, and his decision to use it
in a public art project encouraged him to consider its
potential as a permanent piece of sculpture. He cultivated
six rose bushes in his own garden and decided to make
casts from them to create his own version of a rose bush
in bronze. His choice of material was significant since
bronze was, he felt, 'a traditional, acceptable, "understood
without question" medium for sculpture'.[6] The fragile
nature of the plants made it impossible for Fagen to cast a
rose bush in its entirety, and so he cast individual branches
which were then welded together, creating three slightly
different versions. The resulting sculpture is realistic and
recognisable as both a rose bush and a work of art. The
strength and weight of the bronze vies with the fragility
and frailty of the subject matter depicted, but the bronze
is disguised, painted to resemble the 'real' rose on which
it was based. As the writer Jeremy Millar pointed out:
'in contrast to the living form of the plants themselves
it might appear unnatural, although we would be wise to
remember that this was a plant that was bred, licensed
and then bought, which is hardly a natural engagement'.[7]
MH

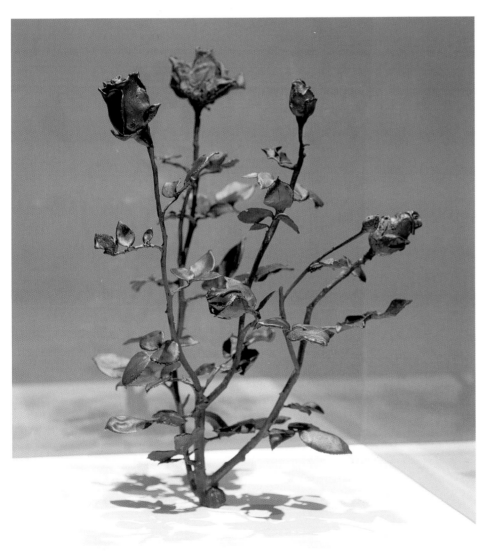

 101

Nils Norman (born 1966)
The Gerrard Winstanley Radical Gardening Space
Reclamation Mobile Field Center and Weather Station
(European Chapter) 2000
Bicycle with trailer, library, weather station,
solar-powered photocopier, 211 x 220 x 74
Private Collection, Germany

Nils Norman's art takes the form of plans, models,
proposals and projects all aimed at improving the quality
of city life by redesigning the urban landscape. His witty
and imaginative ideas are intended to provoke discourse
and encourage a more positive way of thinking about
the environment.

For Norman, the dissemination of information is crucial
and *The Gerrard Winstanley Radical Gardening Space*
Reclamation Mobile Field Center and Weather Station
(European Chapter) is a perfect system for sharing
knowledge and ideas. It features a compact bicycle and
trailer with a library, weather station and solar-powered
photocopier. The library offers books on urban planning,
experimental gardening and other ecological issues and
the public are invited to photocopy any topics of interest,
ranging from organic gardening to historic utopian models.
The title refers to Gerrard Winstanley, one of the most
important figures in the English Revolution of 1649, a noted
writer and radical and leader of the Diggers movement.
The Diggers fiercely denounced the private ownership
of land and saw the land as 'a common treasury for all',
and set about squatting on common land to provide homes
for the homeless. Winstanley believed that if all resources
were held in common and all men were permitted to
develop them freely, then the resulting wealth would
naturally become communalised. Norman clearly shares
some of Winstanley's aspirations, and a great many of
his plans propose radical renovations of public space and
oppose the privatisation of urban areas.

Norman's environmentally engaged practice follows in
a tradition established by American artists such as Robert
Smithson and Gordon Matta-Clark, and, significantly, he
lived in New York City for eight years. But Norman also
has affinities with a growing group of European artists
who work with and transform the urban landscape, such
as the artist collective Atelier van Lieshout. MH

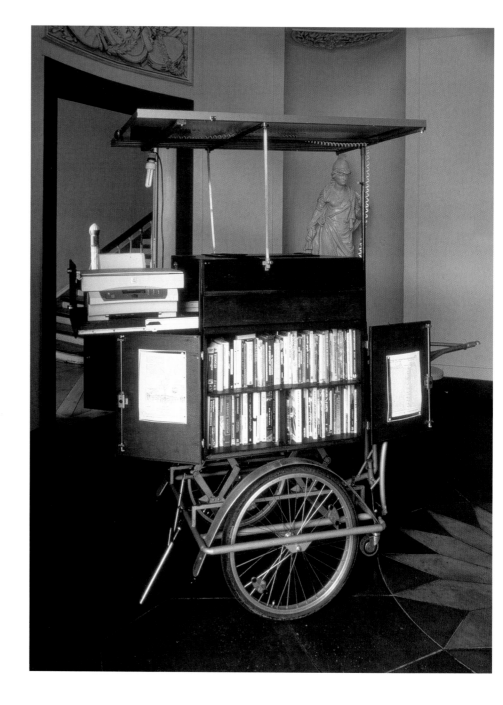

 102

Marc Quinn (born 1964)
75 Species 2000
Pencil, watercolour and collage on paper, 154.2 x 220 x 5
Courtesy the artist and Jay Jopling/White Cube, London

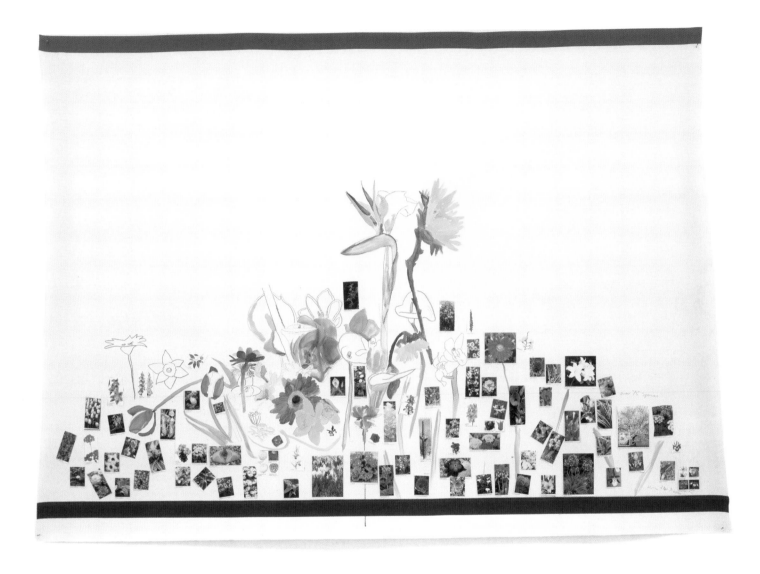

Much of Marc Quinn's oeuvre addresses the ever-changing physical states of the body and explores issues that refer to nature, science and mortality. One of his most ambitious projects was realised at the Prada Foundation in Milan in 2000, where he created a frozen flower garden sealed in a vast steel refrigeration tank. This was a garden of plants and flowers from all over the world which, despite differing seasonal rhythms, could live together, forever, immersed in a basin of silicone at -20°C. His *Garden* 2000 (fig.48) evoked the perfection of the Garden of Eden, a place of eternal beauty, although the artifice involved in its creation was more than apparent. As one critic wrote: 'an order is imposed on nature … frozen in an immobile existence, cured of her physical metamorphosis by technology. It is a *simulacrum* that is a paralysis of life's movement, yet at the same time it is art in action, for it succeeds in condensing the natural beauty of flowers and plants in order to create a tableau forever vivant.'8

75 Species is a working drawing for *Garden* and maps out the flowers the artist wished to include. They were selected on the basis of their aesthetic impact, and many – the lilies, sunflowers, roses and orchids – were chosen because of their rich, symbolic associations from literature and history. Their exotic and evocative names (many of which are included in *75 Species* alongside their images) also make an impressive roll call: *Dianthus (Dad's Favourite)*, *Rosa 'Ingrid Bergman'*, *Tulip 'Queen of the Night'*, *Magnolia Kobus*, *Delphinium 'Blue Nile'*. The way they are represented here, cut-outs taken from nursery catalogues and seed packets, in glorious full-colour close-up, reinforces the idea that their arrangement was completely idealised. The very title *75 Species* gives some idea of the ambition of Quinn's project. MH

 103

Marc Quinn (born 1964)
Italian Landscape (Z) 2000
Permanent pigment on canvas, 53 x 79.5
Courtesy the artist and Jay Jopling/
White Cube, London

One of the most striking features of Quinn's frozen garden
entitled *Garden* was the vivid and gaudy colours of the
flowers (fig.48). They were so bright and so perfect it was
hard to think of them as 'real'. The series of photographs
that he took of the installation in Milan captures this
powerfully. Quinn used a pigment printing process,
which, because it does not fade in the way that
photographic dye does, extends the life of the image
considerably. This process thus ran in parallel with that
of the freezing process of the larger project. MH

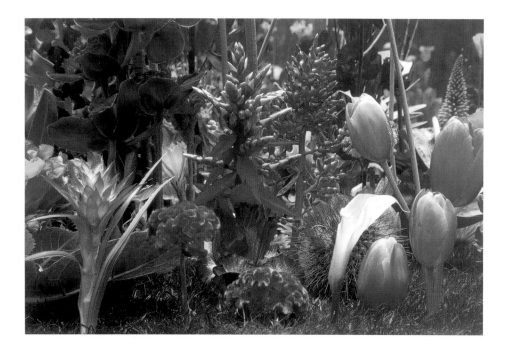

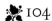 104

Marc Quinn (born 1964)
The Overwhelming World of Desire
(Paphiopedilum Winston Churchill Hybrid) 2002
Pigment on steel, 8 metres high
Courtesy Sculpture at Goodwood and Jay Jopling/
White Cube, London

Quinn's giant steel orchid, *The Overwhelming World of
Desire (Paphiopedilum Winston Churchill Hybrid)*, evolved
from the work he had started making in 2000, his frozen
flower garden at the Prada Foundation in Milan. The orchid
depicted, *Paphiopedilum Winston Churchill*, is based on
a species that originated in the eastern Himalayas, but is
a hybrid created at an orchid nursery in Crowborough,
East Sussex. Artificial hybridisation is very common in
orchids and over the past 150 years 12,000 artificial hybrids
have been registered with the Royal Horticultural Society.
Quinn sees *Paphiopedilum Winston Churchill* as a pure
product of human desire: 'Its natural habitat is the plant
nursery or the mind of the person who created it. With
all the contemporary issue surrounding DNA and genetic
therapies it's interesting to remember that in pure
Darwinian terms anything that we create is natural
because our desire is as much part of the natural world
as that of a bird or bee.'[9]

The vast scale of the sculpture means that we are reduced
to the size of insects in front of it, but because it is
two dimensional and has no volume as such, it almost
disappears when viewed sideways-on. Thus, it operates
rather like a mirage or hallucination. It is a 'photographic
sculpture' and its method of fabrication was complex.
The image was silk-screened on to a polyester base using
specially manufactured screen inks made with long-life
mineral pigments. This was then bonded to steel and
embedded in UV-resistant resin coating with an anti-graffiti
finish. The work is thus more sturdy and resistant than
most monuments, and able to withstand the elements and
the test of time – in complete contrast to the fragile flower
on which it is based. MH

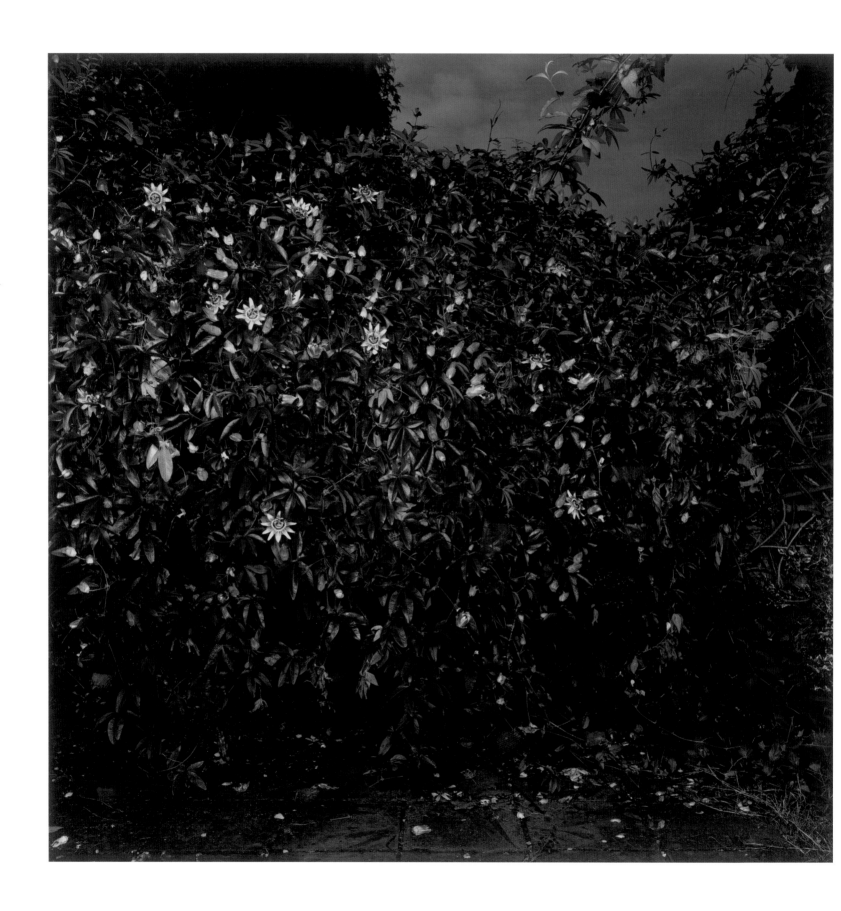

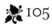 105

Sarah Jones (born 1959)
The Fence (Passion Flower) II 2002
C-type print mounted on aluminium, 150 x 150
Courtesy of the artist and Maureen Paley/Interim Art, London

In her recent works Sarah Jones has photographed
adolescents and adults in the back garden of a terraced
house in south-east London. *The Fence (Passion Flower) II*
was initially conceived as a diptych, and Jones used the
passion flower as the background for a portrait before then
focusing on it as a still life.

The passion flower has taken hold of the fence and all
but covered it, and Jones is drawn to this aspect of nature,
portraying it as an unruly, imperfect and uncontrollable
force. She used both real and artificial lighting to create the
impression of a strange, twilight time, and the play of light
also brings out the rich detail of the foliage and flowers.

The scale and format of Jones's print accommodate the
viewer's proportions and give the work a strong theatrical
presence. Her compositions often refer to the formal
devices traditionally associated with painting; this series
of works was partly inspired by the portraits of the Italian
Renaissance painter Pisanello, who often set his figures
against intensely detailed depictions of nature. MH

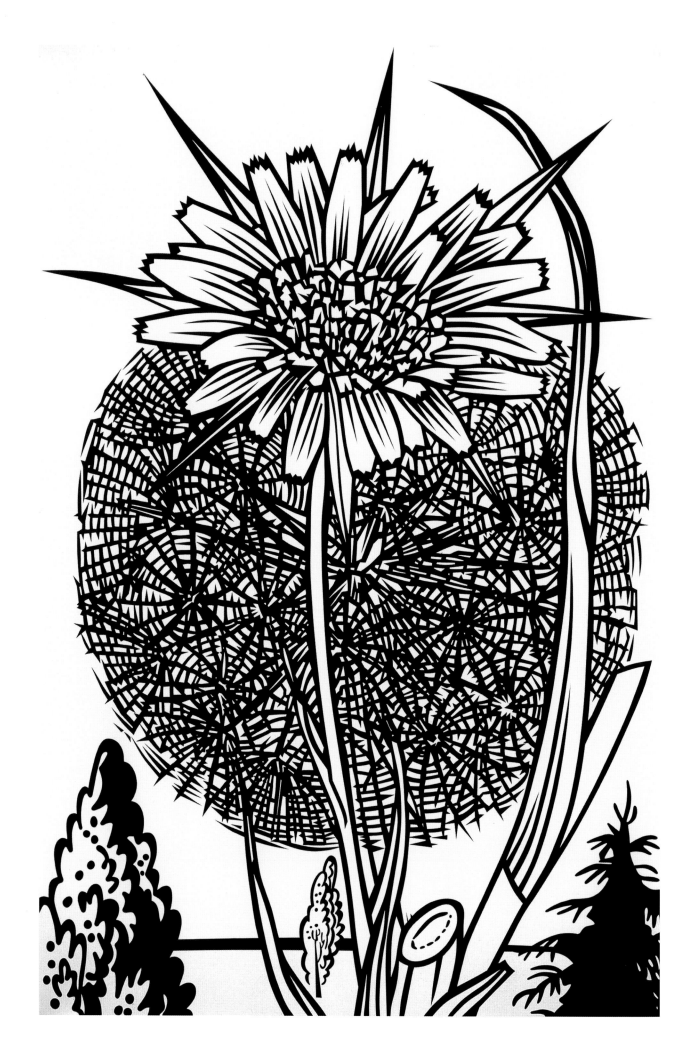

107

Paul Morrison (born 1966)
Garden 2003
Acrylic on canvas, 54 x 44.5
Private Collection
LONDON ONLY

Paul Morrison's paintings convey meaning by an economy of means, a sensibility echoed in the simple, one-word titles that he gives them. *Garden* shows a tree stump illuminated by moonlight. The moon is full; a perfect circle of white acrylic contrasting with the pure black paint surrounding it. This circular motif is subtly mirrored in the round of the tree stump, which offers up more detail with its irregular surfaces and accompanying weeds, Thus, the two images both complement and contrast with each other. MH

106

Paul Morrison (born 1966)
Sepal 2002
Acrylic on canvas, 274 x 183
Courtesy aspreyjacques, London

Paul Morrison's monochrome paintings render natural forms as silhouetted signs or pictograms. He distils his imagery from a variety of representational sources, ranging from art history (the woodcuts of Albrecht Dürer, the drawings and designs of William Morris) to botanical and scientific illustrations, commercial art and Pop art. The specific sources are unimportant, only that Morrison finds them within an environment common to us all. Morrison leaves in enough detail to make each of his images recognisable, but eliminates anything that appears too particular. In this way he creates what he has called 'cognitive landscapes', an array of signs and symbols that we can 'read' and interpret easily. His paintings are a meditation on the complex play between nature and artifice, between reality and representation, and as the critic Mark Godfrey points out, these works are not 'representations of natural scenes, or even of imagined scenes, but representations of the representations of "landscape" (itself already a construct).'[10]

Morrison's artful juxtapositions are intensified by discontinuities of scale and distorted perspective. *Sepal* all but overwhelms us with its giant cartoon-like dandelion motif, set against what appears to be the gossamer ball of seeds from the same flower. The dandelion is a favourite symbol for this artist; its serrated leaves and dense flower head make it easily identifiable, and it has gradually taken on iconic status in his repertoire, appearing in many of his recent large-scale compositions, which he paints directly on to gallery walls. Morrison splices flower, tree and field motifs to create impossible and impressive hybrid panoramas. His images, invariably painted in two coats of black acrylic paint on a white ground, are computer-scanned, manipulated on screen and projected on to the canvas or wall. The finish is elegant, pristine and pin-sharp, eliminating any evidence of the artist's own hand. MH

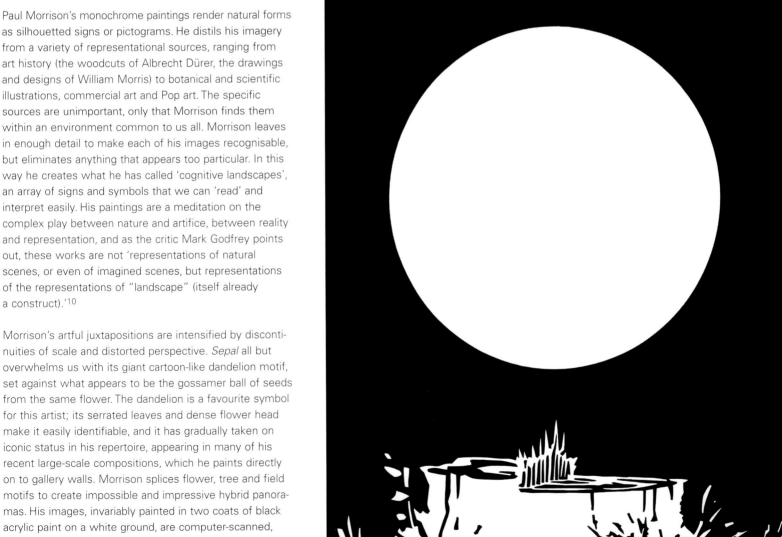

 108

Dee Ferris (born 1973)
Hallelujah 2003
Oil on canvas, 183 x 152.5
Courtesy Corvi-Mora, London

Dee Ferris has painted a series of works inspired by the idea of the garden as an ambiguous space, exotic but unavailable. Framed by leafy foliage and diffused in a dazzling, quasi-spiritual light, her garden enclosures offer up an Arcadian idyll. Ferris is interested in the idea of the rococo garden and draws inspiration from paintings of that period, mixing in imagery taken from suitably flamboyant magazine advertisements ranging from the 1970s to the present day. Her palette is composed from light, confectionery-like colours that highlight the sense of dreamy unreality.

The title *Hallelujah* gives the painting religious connotations, although it was in fact inspired by slightly more ambiguous lyrics of a song written by Leonard Cohen and performed by Jeff Buckley: 'It's not a cry that you hear at night | It's not somebody who's seen the light | It's a cold and it's a broken Hallelujah.'

One critic has written: 'Revelling in their camp special effects Ferris's paintings nevertheless manage the curious feat of denying the viewer access to these seductive scenes, through the saccharine overdose of her palette and an oppressive luminosity that hides more than it reveals.'[11] Ferris foregrounds the contrived and constructed aspect of the garden, and creates a view which is both compelling and perplexing. There is a constant tension between content and form, abstraction and figuration. MH

 109

Susan Hiller (born 1943)
What Every Gardener Knows 2003
CD, modified CD player, timer,
dimensions variable
Courtesy the artist

What Every Gardener Knows[12] is a carillon in the form
of an electronic melody derived from the codes of Gregor
Mendel, who, in the nineteenth century, defined the
basics of genetic theory by experimenting on the plants
in his garden.

Hiller writes: 'Transposing Mendel's system into sound was
feasible because his work proposes a series of elements
in binary combinations that combine and recombine in
further binaries, which I have expressed as basic chords.
Every garden is an attempt to create a perfectly controlled,
predictable plant population bred according to Mendel's
laws of inherited characteristics … When Mendel made
plant breeding a science, gardeners were enabled to
produce internally-consistent plant populations; this meant
they could do more than merely eliminate weeds, they
could also seek out weed-like (e.g. undesirable) traits
existing within garden species and attempt to eliminate
them as well … My garden carillon, "What every gardener
knows", plays the system controlling the distribution of
inherited characteristics discovered by Mendel. It is a
code that celebrates patterns of sameness and difference,
dominants and recessives, in a more profound and
complicated way than at first may be appreciated, since
it accounts for the transmission of invisible characteristics
and the possibility of combining and recombining traits
in complex and surprising ways.'[13]

Hiller's carillon is a celebration of Mendel's dedication
and the diversity of genetic patterning, the music acting
as a counterweight to the more ominous implications
of eugenics.

Susan Hiller was born in the USA but has lived and worked
in London since the early 1970s. She initially trained as
an anthropologist before she began to make art, and has
become known for an innovative practice in a wide range
of media, from drawing to video. The common denominator
in all her works is their starting point in a cultural artefact,
and her varied projects collectively have been described
as investigations into the unconscious of culture. MH

 110a–b

Janice Kerbel (born 1969)
From *Home Climate Gardens* 2003
a *Council Flat*
b *Victorian Terrace*
Ink on paper, each 100 x 70
Courtesy the artist, commissioned by
Tyndall Centre for Climate Change Research
and Norwich Art Gallery

First exhibited at Norwich Art Gallery, Janice Kerbel's series of *Home Climate Gardens* proposes perfectly adapted site-specific interior gardens for the modern urban environment. Kerbel consciously chose archetypal and commonplace environments as the sites for each *Garden* and then varied them in design and scale accordingly. The two drawings shown here are proposals for a garden with a council flat and a Victorian terrace house (based on the artist's own house in north London). Kerbel thoroughly researched the range of plants that might thrive in the different architectural and climatic conditions offered by each site, illustrating her possible ideals in scientific detail. However, she does not expect any of her plans to be followed through: 'what you see in her work, despite its appearance of scientific rigour, is more tinged with expectation than actuality'.[14] Presented as drawings and computer-generated plans, *Home Climate Gardens* uses the language of architectural and landscape design but also references the tradition of landscape painting, Modernist Abstraction and Minimalist sculpture.

Kerbel initially studied cultural anthropology and much of her work is research-led, engaging various disciplines and technologies, and it often takes the form of a plan or study. Her interest in nature was first articulated in *The Bird Island Project* 2000–3, a web-, sound-, text- and print-based project that explored and developed the idea of an earthly paradise. MH

 III

Ivan and Heather Morison (born 1974 and 1973)
Audio recordings from Global Survey 2003
CD, CD player and speakers
Courtesy the artists, supported by Vivid
through the hothaus programme

In 2003 Heather and Ivan Morison began their *Global Survey*, an international research project that took the form of a modern-day expedition in which they set out to discover and document 'the lives of everyday folk'. The artists have been travelling around the globe for over a year, guided by the individuals they meet along the way. It is these people who form the focus of the expedition: their occupations and hobbies, their stories and experiences (fig.50). The Morisons make recordings of their subjects talking about their passions so as to gain greater insight into their lives. The edited recordings are then shared locally and globally, by radio broadcasts and on the internet,[15] and a selection has been made especially for this exhibition.

These recordings highlight the fact that one of the principal ways the Morisons interact with people is through nature and indeed though the garden. One particularly evocative recording included here was made when the Morisons were in Helsinki and met Marina Pimenoff. She was planning to show them her garden but delayed because spring was late. Finally she relented and they recorded her giving them a tour of the garden. There were no signs of life above ground but Marina was able to describe every plant, how she acquired it, its location and what it would hopefully look like when the fine weather eventually arrived. As a result we can imagine the garden as if it were in full bloom.

The art of Ivan and Heather Morison has expanded beyond gardening and its related activities of floristry and fruit and vegetable selling into the more specialist realms of dendrology and forestry, ice fishing and birdwatching. The title of their project, *Global Survey*, is deliberately grandiose, and the artists acknowledge that they have set themselves an impossible task and have no final destination in sight, but their wit and enthusiasm has already enabled them to travel across vast areas of the world. MH

fig.50
Inga-Lill Kihlberg, *Inga-Lill's Grandmother's Large Dahlia Tuber, Gällinge, Sweden* 2003

 112

Jacques Nimki (born 1959)
Florilegium 2003
Acrylic, laminate and pressed flowers, 194 x 142
Courtesy the approach, London

The main focus of Jacques Nimki's artistic activities is
the collection and documentation of weeds and wild
flowers. These plants form the material for his intricate
and minutely detailed compositions. Nimki builds up
each image very gradually and the resulting composition
contains hundreds of life-size depictions of weeds and
wild flowers. He uses water-based paints to add colour,
and incorporates pressed weeds and flowers, laminating
them on to the surface to add an extra layer of texture.
Each of Nimki's drawings or paintings represents his
attempts to document a given area over a particular
timescale, to make 'a carefully constructed record of what
is regarded as worthless and insignificant … and imbue
them with a sense of exclusivity and beauty'.[16]

All of Nimki's works share the same title, 'florilegium',
which derives from the Latin *florilegus*, meaning flower
gathering. Nimki locates his work in a precise historic
precedent, drawing inspiration from seventeenth-century
flower books of the same name. Flower gardens evolved
as a consequence of the plant explosion of the late
sixteenth century, which brought an influx of colourful,
exotic plants into Europe. The collecting and growing
of new blooms became increasingly fashionable, with
gardens perceived as the signifiers of status, wealth
and learning. 'Florilegia' were albums commissioned by
wealthy property owners in which artists recorded all
the flora and fauna contained in their gardens. Inevitably,
many of these albums were more elaborate and fanciful
than the gardens they depicted, artfully enhanced to
flatter the patron. Nimki concurs: 'The picturing of plants
in the form of a Florilegium has no scientific purpose,
no intent to analyse, classify or otherwise explore its
subject, no text, and no argument, it was primarily a
statement of possession, of ownership.'[17] He adapts
this idiosyncratic practice to his own ends, working in the
urban landscape and using the most common of plants.
In this way he is able to apply his own system of values
to the natural world. MH

 113

David Rayson (born 1966)
Night Garden 2003
Ink on paper, 102 x 72
Courtesy the artist and Maureen Paley/
Interim art, London

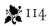 114

All day Wednesday, Thursday and today 2003
Ink on paper, 102 x 72
Courtesy the artist and Maureen Paley/
Interim art, London

Having become known for his highly detailed paintings of modern suburbia, David Rayson recently began to concentrate exclusively on drawing. His work is now defined in graphic outlines, worked out with characteristic precision, but more striking and spartan than before.

Rayson dissects the suburban environment, examining its private and its public face and drawing out the tensions and uncertainties between these two realms. He tries to understand and articulate how man relates to the modern world and he has become increasingly fascinated by the small details that give some sense of human narrative in the built environment. He often focuses on the least attractive features – litter, cigarette butts, weeds in the garden – and through these details he reveals a troubling underside to provincial suburbia. Rayson's images reverberate with an acute anxiety about the outside world, as he has said: 'I'm realising now that it's not about getting back to the estate I grew up on, or inventing another place

to go to, or even about going anywhere. In fact I need never leave the house again.'[18] *All day Wednesday, Thursday and today* seems to evoke precisely this sentiment. The garden is viewed through heavy net curtains, with cigarette butts artfully balanced on the window sill – a poor substitute for the ornaments or plants that could prettify the derelict garden outside. In *Night Garden* a child's bicycle has been abandoned in an equally neglected backyard.

These harsh images are enlivened by bright, synthetic colours: psychedelic pinks, greens and purples. Rayson compared this striking introduction of colour to 'turning up the volume'[19] – it strengthens the artificiality and ambiguity of each scene. It becomes impossible to distinguish night from day, winter from summer. This reinforces the sense that Rayson's images are expressive of a mental state and not a record of reality. MH

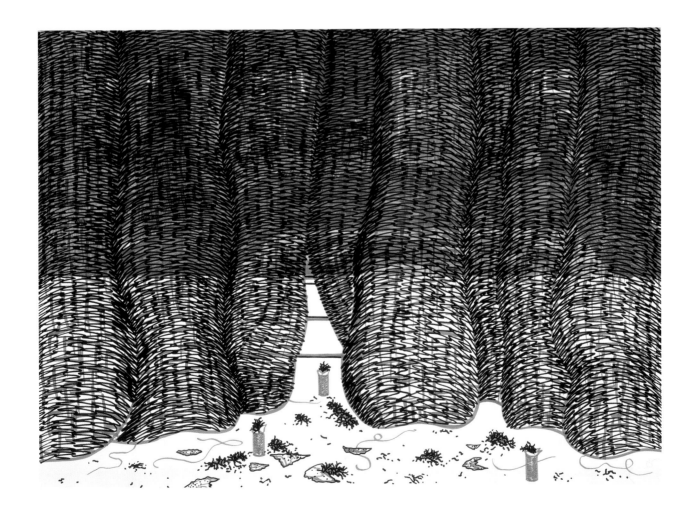

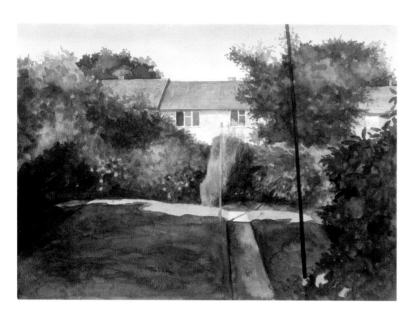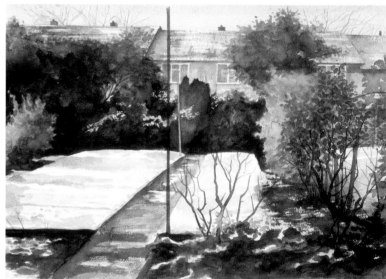

🌹 115a–d

George Shaw (born 1966)
a *The Back Garden II (Summer)* 2003
b *The Back Garden IV (Winter)* 2003
c *The Back Window* 2003
d *Dad's Roses* 2003
Watercolour, each 29.5 x 42, except 115d 22 x 30.2
Courtesy the artist and Wilkinson Gallery, London

All of George Shaw's paintings are based on the areas around where he lived as a child, and over many years and through the changing seasons he has made watercolours documenting the garden of his family home. As his father has channelled all his energies into creating and cultivating this garden, so Shaw has recorded the result, producing an ongoing series of evocative watercolours loaded with atmosphere. Although the garden is beautifully maintained, it is always depicted empty. Shaw recalls: 'the way my father talked about it … it was like a holy place, we never played in it as kids, it was a place we looked at from inside the house'.[20] The artist communicates this same sense of reverence in the paintings.

Shaw chose to use watercolour for these works because it evokes a mood of romantic nostalgia which so suits the subject matter, as demonstrated by the delicate treatment of *Dad's Roses*. The medium also triggers associations with the activities of the amateur painter or part-time artist, or indeed the old-fashioned pursuits of the English country gentleman. Shaw relishes these allusions and his paintings can be understood as a representation of every-man's suburban garden and a nostalgic and idealistic image of past times. As with the artist's intense landscape paintings in enamel, these images are about what has been forgotten as much as what is now remembered. MH

Artists' Gardens

James Tissot

Alfred Parsons

Edward Atkinson Hornel

Charles Mahoney

Cedric Morris

Ivon Hitchens

Barbara Hepworth

Patrick Heron

Ian Hamilton Finlay

Derek Jarman

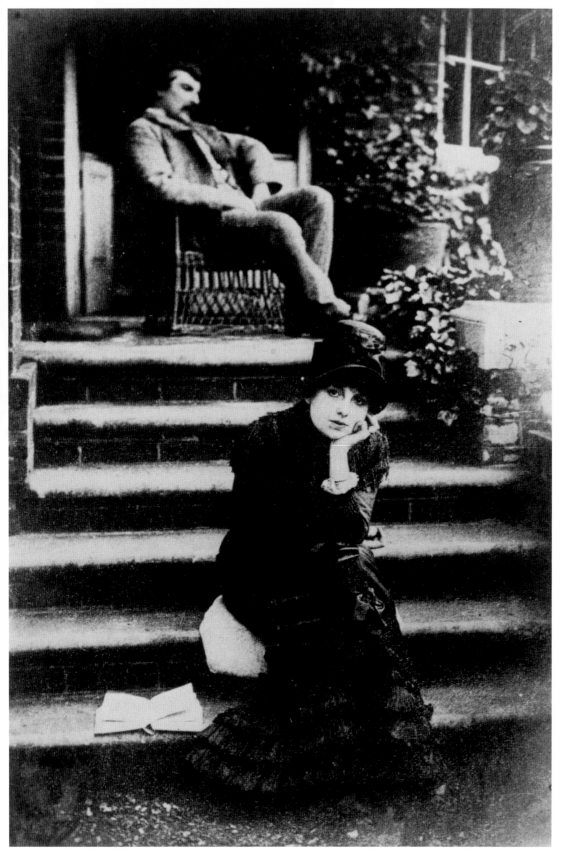

Photograph of Kathleen Newton sitting on the steps at Grove End Road *c.*1876–82

The French artist James Tissot trained in Paris during the 1850s, becoming a successful society portraitist and painter of modern life. In 1871, in the wake of the Franco-Prussian War, he moved to London, where, through a network of well-placed patrons, he quickly established himself as an artist and man about town. In the spring of 1873 he moved into a detached villa at 17 Grove End Road, St John's Wood, north-west London. Immediately he set about a series of improvements to the property, adding a large studio-cum-salon and a spacious conservatory filled with potted palms. Beyond the studio was a short terrace with steps down to an elaborate garden: the setting for some of his most celebrated paintings, as well as the focal point of a domestic life that culminated in personal tragedy and public notoriety.

The principal feature of Tissot's garden was a large ornamental fishpond, around which ranged a colonnade, composed of a cast-iron entablature resting upon semi-transparent ionic columns wrought from flat strips of iron. The inspiration for the colonnade apparently derived from a similar structure in Paris's Parc Monceau, which had opened to the public in the early 1860s. As Tissot's various paintings attest, his own garden con-tained a number of mature trees, chestnut and willow, as well as spacious lawns and well-tended flower beds; the whole being maintained by a live-in gardener, Willingham, who resided with his wife in a custom-built lodge at the end of the garden. From the garden's creation, the care Tissot lavished on it was notable, the French writer Edmond de Goncourt summoning up a vision of visitors entertained with champagne on ice while 'all day long, one can see a footman in silk stockings brushing and shining the shrubbery leaves'.[1]

James Tissot (1836–1902)

GROVE END ROAD, ST JOHN'S WOOD, LONDON

By the 1870s St John's Wood, which fifty years earlier had been a rural retreat, was a fully-fledged suburb of London, and a noted artists' enclave. It was also looked upon disapprovingly as a somewhat louche neighbourhood, prominent among whose denizens were, according to one contemporary, 'divorced wives, not married to anyone in particular, mysterious widows whose husbands have never been seen, married women whose better halves were engaged in the City'.[2] With its comfortable detached villas and spacious private gardens, St John's Wood offered an opportunity for domestic bliss and transgression in equal measure, an image which Tissot's garden pictures did little to discourage.

These paintings invariably portrayed intimate, informal activities: promenading, picnicking, couples courting and quarrelling, or the figure of a woman lazing in a hammock on a summer afternoon. Critics, though they admired Tissot's polished technique, considered his subject matter to be vulgar. As the *Athenaeum* observed in 1879: 'ladies in hammocks, showing a very unnecessary amount of petticoat and stocking, and remarkable for little save a sort of luxurious indolence and insolence, are hardly fit subjects for such elaborate painting'.[3] The risqué nature of such works was underlined by Tissot's frequent use of his mistress, Kathleen Newton, and her illegitimate children as his models, as his garden pictures took on an increasingly autobiographical aspect.

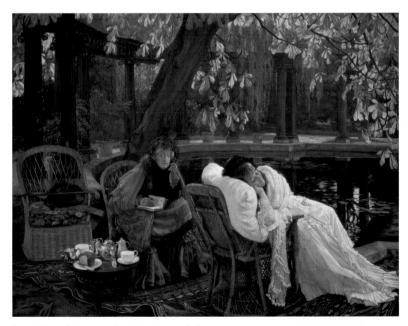

James Tissot (1836–1902), *A Convalescent* c.1876
Oil on canvas, 76.7 x 99.2
Sheffield Galleries and Museums Trust

Tissot had met Newton around 1875, and she moved in with him the following year. He protected her true identity and she was known simply as 'La mystérieuse'. Nonetheless, Newton's prominent presence in pictures Tissot exhibited at the Grosvenor Gallery, including *The Hammock* and *A Quiet Afternoon*, both of 1879, kept her very much in the public eye and did much to confirm the artist's reputation as a fundamentally immoral individual. *Punch* magazine went so far as to rename *The Hammock* 'The Web':

Will you walk into my Garden?
Said the Spider to the Fly.
'Tis the prettiest little garden
That ever you did spy.
The grass a sly dog plays on;
A Hammock I have got;
Neat ankles you shall gaze on,
Talk – à propos de bottes.
Elle est bien botte alors. *Is it so?* '*Tis so.*[4]

The rumours surrounding Tissot's mistress persisted into the twentieth century, it being even suggested that she had become a virtual prisoner in his house and eventually committed suicide by flinging herself from a window. The truth was more prosaic. Kathleen Newton died from tuberculosis at 17 Grove End Road on 9 November 1882, and was buried at Kensal Green cemetery. At once Tissot abandoned his house and garden and returned to Paris. A visitor recalled: 'In the studio there were still his paints, his brushes, and several untouched canvases. In the garden the old gardener was burning the mattress from the bed of the mysterious lady.'[5] MP

Treillage Colonnade, Grove End Road, *Country Life* 1912

The Garden House, Russell House, Broadway 1911

Alfred Parsons (1847–1920)

LUGGERS HILL, BROADWAY, WORCESTERSHIRE

The garden Alfred Parsons established at Luggers Hill towards the very end of his career marked the culmination of years of experience as a garden designer, and a long association with the village of Broadway both as an artist and garden-maker. Luggers Hill, a large house in the idiom of the Cotswold vernacular revival, had been designed for him by the architect Andrew Prentice in 1911.[1] It is situated on gently rising ground at the western edge of the village, and one of the attractions of the site for Parsons must have been its proximity to Russell House, the home of his close friend the American artist Frank Millet. He had probably stayed with the Millets before establishing a permanent base of his own in Broadway. Tragically, before Luggers Hill was completed, Millet fell victim to the *Titanic* disaster in 1912.

The first garden Parsons was involved with at Broadway was that of Russell House itself. Frank and Lily Millet, the historical genre painter Edwin Austin Abbey and Parsons first occupied the property in the summer of 1886, but when John Singer Sargent completed the painting of *Carnation, Lily, Lily, Rose* (cat.75) there late that season, the 'garden' was a hastily contrived affair. Later, however, Mrs Millet became an expert gardener in her own right and specialised in raising and hybridising carnations. The gardens at Russell House had originally been laid out in the late eighteenth century, and included a gothick turret and gazebo. Frank Millet had been able to purchase the meadows at the back of the property to make a link to another building he had acquired, the fourteenth-century Abbots Grange, which he had restored for use as a studio.

An article in *Country Life* in January 1911 described the Millets' two properties and their connecting gardens, and made it clear how much Parsons had been involved in the process of garden-making: 'she [Mrs Millet] has been helped by Mr Alfred Parsons, who is never happier in his pictures than when the subject is some corner or effect in these gardens'.[2] This article enables us to identify the subject of the 'Broadway garden' that figures so frequently in his work. One of the photographs illustrating the article shows a semicircular garden house with a conical slate roof above a curving loggia; Parsons would make an almost exact replica of this structure at Luggers Hill.

At Court Farm, an old farmhouse at the upper end of the village, Parsons created an entirely new garden for the retired American actress Mary Anderson, who was to become the leading light of Broadway after moving there with her husband, Antonio de Navarro, in the mid-1890s. She described the making of the garden in the second volume of her memoirs: looking out from the old house to where the garden should be 'there was nothing but a riot of rough, nettle-grown, uneven ground, some old outhouses, barns, and rows of pigstyes; no paths – disorder and ugliness everywhere. I knew nothing of gardening and felt bewildered. Fortunately for us, our old friend Alfred Parsons R.A. was living in Broadway at the time, and his hobby and recreation was the planning and planting of gardens.'[3] In fact by this date Parsons had already embarked on a second career as a professional garden designer, so that his intervention was more than a hobby. Anderson describes how he had hundreds of cartloads of earth removed, laid out paths and planted yew hedges and a rose garden.

Subsequently the de Navarros acquired the adjacent Bell Farm, another picturesque old building, which had been admired by William Morris; they linked the two dwellings, and Parsons incorporated the new garden into the one he had already designed. He transformed a stagnant pond on the upper level into a swimming pool, constructed a rose pergola and laid out coppices and orchards as well as formal rows of lime trees. This garden has remained largely intact and offers a clear demonstration of Parsons's scenic approach: the eye is lead from formal, old-fashioned parterres and clipped yews near the house, appropriate to its period, to an open prospect of the hillside beyond. He employed these principles again at Luggers Hill.

As at Court Farm, the garden at Luggers Hill 'consists of a larger garden and several smaller ones'.[4] To the west, the pleasure gardens were enclosed by a wall of castellated yew, and a nut walk once led to the orchard beyond. To the east of the site was a walled kitchen garden, with the semicircular garden house mentioned above at its outer angle. In the centre of the vista as viewed from the house a gently curving rose pergola was constructed close to the perimeter wall. With the exception of a single surviving watercolour (cat.83), the appearance of the garden in Parsons's day is not documented visually, and certain sections of it may have been treated more formally in later years. But the clarity, scale and breadth of his conception are still apparent: Parsons brought a landscape painter's eye to his garden plan, setting out a structured foreground to frame the wider prospect of Broadway Hill and Tower.

The outlying parts of the land were subsequently sold off, and the garden began to lose its shape. Over the past ten years, however, the two acres of pleasure garden have been sympathetically restored by the present owners, working on the basis of old aerial photographs, surviving traces on the ground and the evidence of Parsons's other extant gardens. NA

Aerial photograph of Luggers Hill, Broadway

Hornel in the garden at Broughton House *c.*1925

Edward Atkinson Hornel
(1864 – 1933)

BROUGHTON HOUSE, KIRKCUDBRIGHT,
DUMFRIES AND GALLOWAY

The garden of Broughton House at Kirkcudbright was established by Hornel between 1901 and 1933. This part of Galloway has a mild climate for its latitude, owing to the Gulf Stream, and the combination of the scenic beauty of the region and its associations with Celtic culture has sometimes led to comparisons with Cornwall. Broughton House is an imposing building of the mid-eighteenth century with distinguished local connections, situated in the High Street just along from the house where Hornel grew up, and near his own first house and studio. His ability to purchase the property was an obvious sign of his arrival as an artist, and over the next few years he began to realise ambitious plans for a gallery, garden and library on the site. Hornel had established an international reputation, but was still intensely local in his allegiances; his acquisition of the property coincided with an increasing withdrawal from his artist contemporaries, and he was becoming isolated in his practice as a painter.

The gardens behind the house slope down to the banks of the River Dee, and in 1910 Hornel extended them by acquiring the adjoining property and adding the garden to his own. His mother's house also had an extensive garden running down to the river, but whereas that had been strictly functional — she kept fowls in it, and several 'four-footed beasts' — his new garden was for display and the formation of a varied collection of plants.[1] In this respect his gardening can be seen as analogous to his other endeavours, the collecting of porcelain, pewter, bronzes and books. The latter became a particular passion in his later years, and he built up an important library dealing with aspects of the region's history and associations. This library related to one of the dominant themes in his work, the mythology and folklore of Galloway, but he also invested considerable time and resources in his garden projects. He was elected a Fellow of the Botanical Society of Edinburgh in 1927.

The garden is arranged as a series of compartments of different character, connected by narrow paths and with frequent sculptural or architectural incidents: ornamental gate piers, stone troughs, sundials, a summer house on a rotating base, a wisteria tunnel, a rose arch. He laid out part of the garden in the Japanese style, or at least in that free and romanticised version of the Japanese garden that had become fashionable in the Edwardian period, with ponds, a rock garden and stepping stones. This was doubtless an allusion to his own experience of Japan; he had visited the country in 1893–4, and the paintings on Japanese themes he exhibited just after his return had perhaps marked the high point of his achievement as a formal innovator.

Hornel's painting after about 1910 is usually considered somewhat repetitive and formulaic, though he continued to enjoy commercial success. His garden, however, was a work of art in its own right, and remained a main focus of his creative energies throughout the second part of his career.

There is an enigmatic allusion to Hornel in a piece by Ian Hamilton Finlay in his garden at Little Sparta (see pp.234–5). Set into the waters of the Temple Pool is a plinth with a bronze plaque inscribed as follows: 'An oil painting by HORNEL dated 1918 entitled THE BIRDS NEST measuring 14" x 19" has been made available for sale through the Demarco Gallery. The painting shows two small girls with bird's nests in the foreground with blossom and two swans in the background beside a stream.'[2] This is hardly an unequivocal homage by one modern Scottish artist-gardener to another: instead, the casting of an ephemeral sales announcement in bronze, and the explicit reference to a minor, late painting by Hornel, are suggestive of an uneasy relationship between nostalgia and commerce. Both works have a sylvan setting, but there is an implied disjuncture between them, and Hornel's sentimental version of the pastoral is in marked contrast with Finlay's sceptical, questioning position.

In 1919 Hornel established a trust to which he could leave his house, its contents and the garden 'for the benefit of the people of the Stewartry and visitors thereto'. After his death in 1933 his sister, Elizabeth, with whom he had shared the house, continued to live there until she died in 1950. The National Trust for Scotland took over responsibility for the management of Broughton House and its garden in 1994.[3] NA

Edward and Elizabeth in the garden at Broughton House c.1925

The garden and studio at Oak Cottage

Charles Mahoney (1903–1968), *Evening, Oak Cottage* 1938–9
Oil on canvas, 46 x 61. Private Collection

Charles Mahoney (1903–1968)
OAK COTTAGE, WROTHAM, KENT

Charles Mahoney in the garden of Oak Cottage *c*.1960

Charles Mahoney's garden, in the village of Wrotham, north-west Kent, was the wellspring and inspiration of his art from the late 1930s until his death in 1968. Oak Cottage is a pretty half-timbered hall house dating from the late sixteenth century, situated in a narrow lane, between a row of almshouses and what was then the village butcher's shop. Mahoney had initially purchased Oak Cottage with his brother as a home for their widowed mother and himself. After the Second World War he returned from evacuation with the Royal College of Art in the Lake District, bringing his wife and young daughter to settle at Oak Cottage. He was at last able to transform the back garden into his own 'back garden of Eden'.[1]

Born in Lambeth, the son of a mechanical engineer, Mahoney spent his childhood and youth in south London, before gaining a scholarship to the RCA in 1922. There he developed an interest in mural painting and theatre design. Six years later he returned to the college as a member of the teaching staff and was subsequently put in charge of a major mural scheme at Brockley County School in south London. While working there he developed a close friendship with a very talented senior student, Evelyn Dunbar, who shared his passion for gardening. Dunbar came from a family of keen gardeners and it was in her parents' extensive garden at Strood, Kent, that she and Mahoney experimented with their various horticultural schemes. In 1937, the year that Mahoney purchased Oak Cottage, they published their innovative book on garden plants, *Gardeners' Choice*. The plants described, including *Geranium armenum* and gold- and silver-laced polyanthus, can be found in many gardens today, but were little known then. By now armed with considerable horticultural expertise, Mahoney set about creating his own garden at Wrotham.[2]

The garden was situated on a long, sheltered strip of land behind Oak Cottage (cat.17). Among its advantages were the rich, dark soil, manured for generations by waste from the adjacent slaughter-house, and the south-facing limestone wall which separated Mahoney's land from the almshouses. Against this wall he cultivated a variety of delicate plants as well as grapes, plums and pears. The planting scheme that he adopted was radical for its time, and quite at odds with the irregular cottage garden designs then still in vogue through the pervasive influence of William Robinson and Gertrude Jekyll. In common with other artist-gardeners in his circle – John Nash and Edward Bawden – Mahoney divided his garden into rectangular beds, edged with box, lavender or low-growing plants such as mossy saxifrage or creeping campanula.

He made a lawn some distance from the house where the ground levelled, and beyond it he built his studio, screened by a bed of old roses and by some of his favourite giant herbaceous plants. Despite the garden's modest size, at the farther end fruit trees were combined with such statuesque plants as giant hogweed, plume poppies, giant scabious and ten-foot-tall orange inulas, all of which became the subjects for innumerable vivid drawings and paintings. In the centre of them stood Mahoney's studio, an unassuming white-boarded building, constructed after the war from munition packing cases.

Mahoney was a gifted draughtsman, and loved to draw and paint directly from the plants in his garden. These same flowers also featured prominently in his murals for the Lady Chapel at Campion Hall, Oxford, and in his large subject pictures (cats.47–8). In later years, as his health declined, Mahoney was to spend an increasing amount of time in his garden, studying plants or absorbed in the extensive library of horticultural and art books contained in his garden studio. Among the imaginative subjects he worked on in the early 1960s were studies for *Adam and Eve*, *Bathsheba*, and *The Muses*, an unfinished decorative panel depicting a young artist attended by the Muses in the Garden of Eden. MP

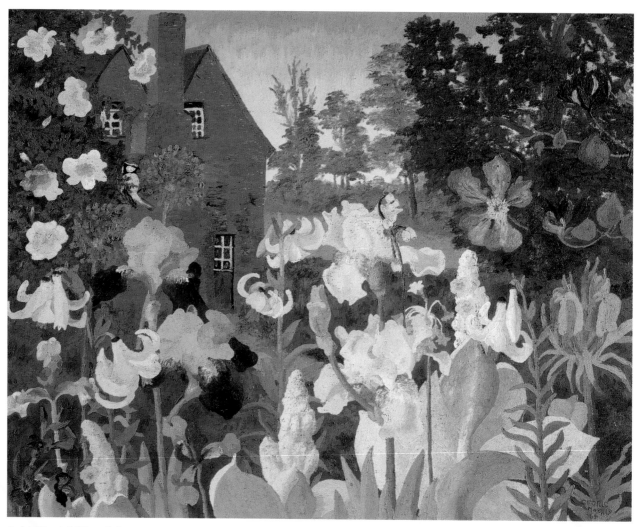

Cedric Morris (1889–1982)
Benton Blue Tit 1965
Oil on canvas, 72 x 64
Private Collection

Cedric Morris (1889–1982)

BENTON END, HADLEIGH, SUFFOLK

In early 1929 Cedric Morris, with his partner Arthur Lett Haines (1894–1978), took the lease on Pound Farm, outside Higham, Suffolk. At this time Morris was enjoying national and international success yet was disillusioned with the art world.[1] In Suffolk he continued to paint but was also able to embark on the creation of two extraordinary gardens. These, at The Pound and later at Benton End, were at the centre of the influential creative environments that Morris and Haines created around themselves.

The Pound was a big, long, old house with a large garden. Joan Warburton remembered that 'its garden was a paradise ... you approached it down a tunnel of trees to come out into sunlight. A large black marble torso by John Skeaping graced the forecourt, by a

wall was a small greenhouse where Cedric grew cacti and geraniums. Set in the Suffolk pink plaster ... were abstract heads and faces by Lett. At the back of the house ... lay the garden that ran down a slope to a pond. In the middle of this stood a smaller torso by John Skeaping, and beyond was a marvellous view of the Stour valley. The garden was a series of low hedged beds and Cedric's studio, the old wash house, was beside the house in the garden.'[2] Morris had been inspired by Monet's garden at Giverny to make a garden that could be used by young painters and this ambition was realised in 1937 when he and Haines opened the East Anglian School of Painting and Drawing. This was located in the village but the students made frequent visits to the garden in order to paint.

The EASPD embraced radical *cours libre* (literally, 'free course') principles, unique in England at this time, in which the emphasis was on the creation of the right conditions for the individual student to develop.[3] Students included Lucian Freud, Maggi Hambling, Glyn Morgan and Esther Grainger, and the very different character of their work reveals that the EASPD successfully fostered individuality rather than a house style. It was an immediate success but, a year after it opened, the school's premises in the village burnt down. By the end of 1939 Morris and Lett had bought Benton End, on the edge of nearby Hadleigh; a large sixteenth-century house overlooking the River Brett, with enough room to accommodate seven or eight students and gardens of about three and a half acres. This was to be home to Morris's most famous garden.

At both The Pound and Benton End Morris developed a plantsman's garden; the emphasis was on species plants and unusual specimens brought back from plant-hunting expeditions to the Mediterranean and North Africa. Masses of vegetation were cut through with wide paths, punctuated by trees and sculptures. Beth Chatto, who memorably described Morris as a 'dirty hands gardener', has written of Benton End: 'It was not a conventionally designed garden … Dotted here and there were pillars of old fashioned roses and several huge clumps of sword-leafed *Yucca gloriosa*. The rest was a bewildering, mind-stretching, eye-widening canvas of colours, textures, shapes, created primarily with bulbous and herbaceous plants. Later I came to realise it was probably the finest collection of such plants in the country.'[4]

The garden also contained fruit trees, and beds filled with tulips, narcissi, fritillaries, alliums and hellebores; also vegetable beds. All the beds were initially edged with box hedges (see cat.21), giving the garden a rather formal aspect, but these were eventually removed. At each garden the main focus of attention was the spectacular iris beds. Morris was widely known as a breeder of irises and in the late 1940s and early 1950s, when the garden at Benton End was in its prime, it held over a thousand new iris seedlings every year.

The notion of *cours libre* teaching allied to an environment that was conducive to creative work was fully realised at Benton End. Here the garden became an extension of the studio and the classroom. Glyn Morgan has observed: 'The Pound had been … a private home with a school as a separate entity. Now, for the first time, Cedric and Lett, the School and the garden were all on the same premises. Perhaps this helps to account for the extraordinary intensity of the Benton End experience … in this house where painting was not just a pleasant holiday task but a way of life, an enclosed world was hidden in an enchanted garden'.[5]

The gardens were not only important for Morris as gardener and artist but were also central to the success of the EASPD. They provided the students with a wealth of subject matter, as well as food for the table, and introduced a different dimension to the social mix. The many and frequent visitors included Francis Bacon and Duncan Grant, artist-gardeners such as John Nash and John Aldridge, and gardeners, notably Beth Chatto and Constance Spry. House and garden together formed a kind of hothouse for artistic creativity and inspired gardening.

Benton End ceased to function as a school in the 1960s, although many students continued to return each year. Lett died in 1978; Morris remained there until his death in 1982 at the age of ninety-two. Today many of his plants can be purchased from specialist nurseries. His irises have the prefix 'Benton' and there are narcissi, poppies and fennels, among others, that bear his name. BT

The Garden at Benton End *c*.1950

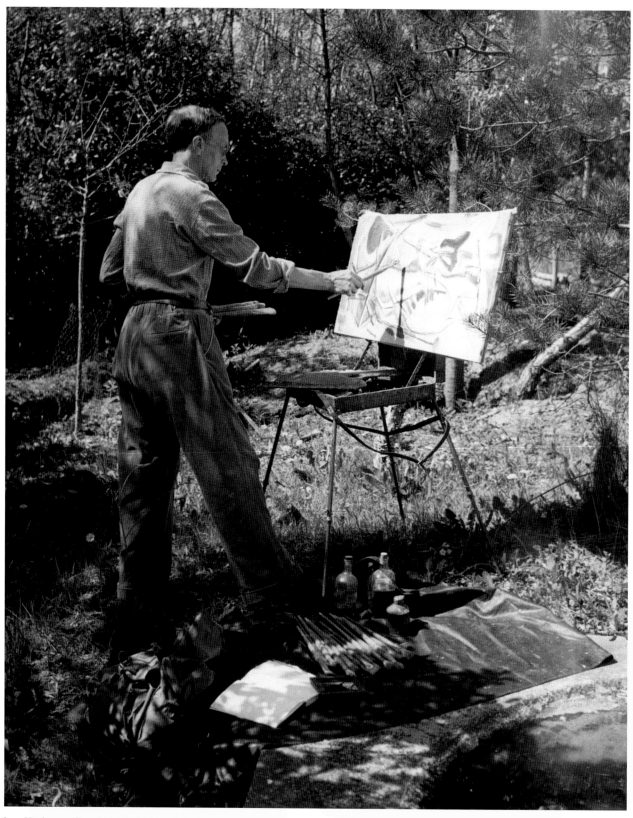

Ivon Hitchens at Greenleaves in the late 1940s

Ivon Hitchens (1893–1979)

GREENLEAVES, NEAR LAVINGTON COMMON, WEST SUSSEX

Ivon Hitchens's arrival at Greenleaves was memorably described by Patrick Heron in his 1955 monograph on the painter. 'Bombed out of Hampstead during the early raids of the war, Hitchens retired to a caravan he had lately purchased for £20 and driven into a thicket on Lavington Common composed of rhododendron and silver birch, with oaks above and bracken below. Here, with more turpentine than water, he remained, with his wife and infant son for company, to paint the war out.'[1]

Hitchens had in fact been staying at Barnett's Farm, near Lavington Common, Sussex, when he heard about the imminent sale of six acres of woodland there. After he had purchased the land and a gypsy caravan, birch and bracken were cleared to make space and the caravan was towed there by two carthorses. At first it was a hard life with, initially, no running water and no electricity. Over the years more of the woodland was cleared and a studio was built, which was then gradually added to, room by room, until it became a house. Hitchens built a courtyard garden and planted sunflowers, poppies and dahlias in the sandy soil around the house, but the majority of the property was left 'magnificently uncultivated'. Heron wrote that the house was 'all but invisible from a distance of ten yards'.[2] There were some flower beds, and some patches of lawn close to the house — the garden spaces were seemingly quite haphazard and developed in a very organic way — but beyond that was woodland, thick with rhododendron, birch, oaks, larches and chestnuts, cut through with broad paths that needed to be cleared every year. Over time Hitchens extended the property, primarily in order to retain privacy and prevent unwelcome development. Ivon's son, John Hitchens, himself an artist, continues to use Greenleaves as a studio.

It is difficult to characterise Hitchens's activity at Greenleaves as the creation of a 'garden' in the conventional sense. Indeed, his gardening there rather took the form of woodland management. He was able to see, in the woods all round him, innumerable subjects for his paintings, and he wished essentially to keep it this way.

Perhaps Hitchens's most significant addition to Greenleaves was the construction of a series of ponds. The earlier, smaller ponds can be seen in *Boathouse, Early Morning* 1956 (Fitzwilliam Museum, Cambridge) The two largest ponds were constructed at a later stage and were invaluable when Hitchens was older and less able to travel as far afield in search of motifs. They can be seen in *Lake: Evening Light* 1969 (Private Collection), standing in for larger expanses of water, reflecting wider vistas. Hitchens's fascination with the quality of reflected light, and his construction of the ponds to use as motifs in his paintings, has been likened by a number of critics to Monet's continual re-engagement with his water garden at Giverny.

Hitchens's close friend Peter Khoroche has argued that the move to Greenleaves had a decisive effect on his painting and the development and direction of his work. 'He was now able to put into practice his preference for, as a true son of Cézanne, painting directly from nature, in the open air — "going humbly to nature to 'see' what later I would try to paint," as he put it. It would be no exaggeration to say that the remaining forty years of his life were largely dedicated to the exploration of his immediate surroundings in all weathers, all seasons, and every nuance of changing light.'[3]

The move out of London and into the woods revitalised Hitchens's work. His paintings of the 1940s show great energy and formal inventiveness; his colours have a new boldness; the spaces of the paintings are more fluid and open. He was renewed by the daily contact with nature that he found at Greenleaves. He painted outdoors every day, in all kinds of weather, continuing this practice well into his eighties. His work thus represents a direct engagement with, and abstraction from, the motif.

Unlike contemporaries such as Paul Nash and Graham Sutherland, Hitchens was not concerned to convey the 'spirit of place': the spiritual presence or poetic essence of particular landscapes. Instead, drawing on the work and ideas of Cézanne, he investigated the properties of landscape in terms of form, space and depth. However, many commentators have found a pronounced poetic dimension to his work. Many of his woodland images are redolent of damp, gloom and a particularly English melancholy; associations enhanced by titles such as *Shrouded Water* 1948 or *Dark Pool* 1960. Nonetheless they are relieved by intense passages of almost Mediterranean colour evoking the brightness of sunlight, or sky reflected in water. The luminosity in many of Hitchens's paintings of Greenleaves may derive from the fact that the woods there are not uniformly dense and dark, but, being made up largely of silver birch, often open and light. The contrasts between dark rhododendron below and light-filled birch above are a distinctive characteristic of many of his works made there. BT

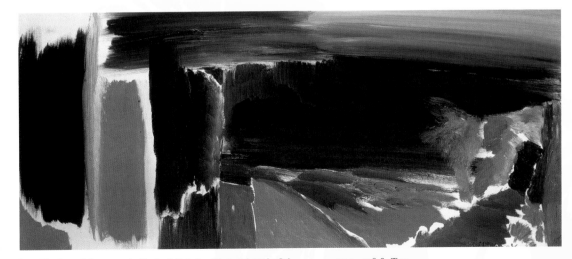

Ivon Hitchens (1893–1979), *Woodland, Vertical and Horizontal* 1958. Oil on canvas, 51.4 x 116.8. Tate

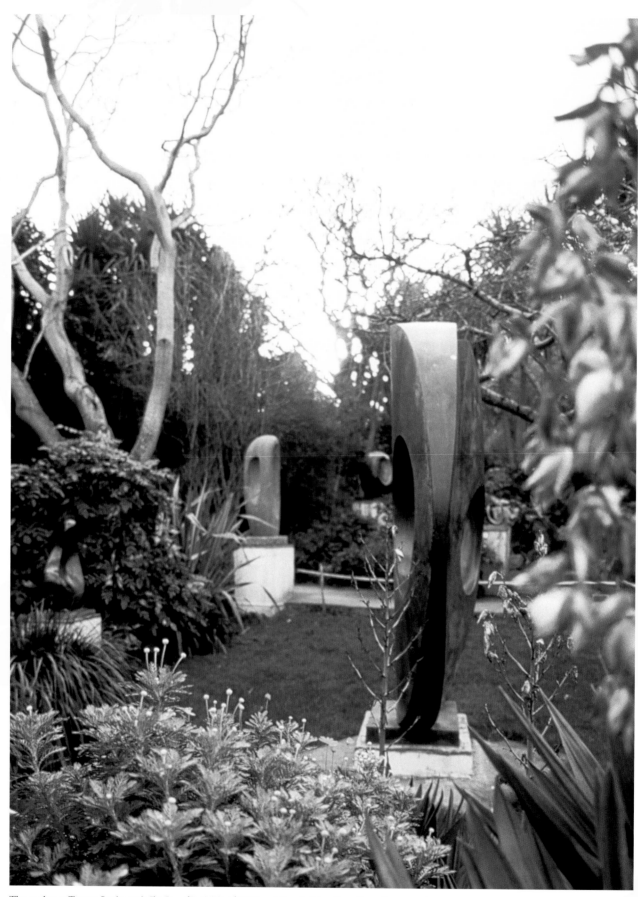

The garden at Trewyn Studio with *Two Forms (Divided Circle)* 1968 and *Stone Sculpture (Fugue II)* 1956

Barbara Hepworth (1903–1975)

TREWYN STUDIO, ST IVES, CORNWALL

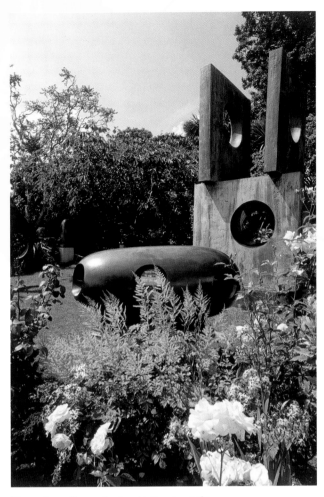

The garden at Trewyn Studio with *River Form* 1965
and *Four Square (Walk Through)* 1966

The garden is small and gently sloping. When Hepworth moved there it contained overgrown rose beds, lawns and a number of mature trees, including copper beech, holly, pear and elm. Pressure of work meant that Hepworth did little to the garden, using it mainly as a space in which to work on large-scale sculptures such as *Contrapuntal Forms* 1950–1 (Harlow Arts Trust). In 1956 she began to give serious thought to redesigning the garden: the purchase of an additional strip of land from John Milne, her neighbour, enabled her to do that.

Hepworth had learnt the rudiments of gardening during the war, when she worked at Adrian Stokes's market garden, and also grew vegetables in her and Ben Nicholson's garden in Carbis Bay. She also knew Will Arnold-Forster, who had established the extraordinary garden at Eagles Nest (see pp.232–3), and she had read his book *Shrubs for the Milder Counties* (London 1948; revised edition, Penzance 2000), an indispensable primer for gardening in this particular environment. Now, working with her friend the composer Priaulx Rainier, and with practical help from her studio assistants, she began an extensive reworking of the garden, cutting out new beds, making pathways and adding many new plants, including Chinese fan palm, magnolia, hibiscus, fuchsia, bay tree, New Zealand satin flower, honeysuckle, and water hawthorn beside the pond.

At this point the garden became important as a setting for her own sculptures, a continually evolving exhibition of work in bronze and stone, carefully positioned among the trees and shrubs. Later, in 1965 and 1973, extra strips of land were added to the garden, enabling her to display larger-scale works such as the multi-part *Conversation with Magic Stones* 1973 (Tate).

In 1939 Barbara Hepworth moved to Cornwall with Ben Nicholson and their three children. They lived in Carbis Bay, near St Ives, but constraints on space meant that by the late 1940s Hepworth was looking for a separate studio in which to work. In 1948, with financial help from friends, she bought Trewyn Studio, initially to use as a studio space, and by 1950, with the breakdown of her relationship with Nicholson, she began to live there. It remained her home and studio until her death in 1975.

Trewyn Studio is in the centre of St Ives. It is a simple, two-storey building with a small garden surrounded by high walls which confer a remarkable degree of privacy. While the rooftops of the town and the tower of the nearby church are visible from the studio, the garden itself retains an extraordinary sense of enclosure; a private and meditative space removed from the busy town which surrounds it. Initially Hepworth used the garden primarily as a work space, but over the ensuing decades, as she reworked the garden, adding to it, it became important as a place in which she could display her work, and as an integral part of the intellectual positioning of her sculpture.

While the garden was important as a place in which visitors could view her work, it was, crucially, also a space in which Hepworth herself could look at, and think about, her own work. Within the garden one is aware not only of the sculptures themselves, but of views through and past works and correspondences between the forms and surfaces of the sculptures and the garden's organic forms and textures. The garden did not directly influence her sculptures; its real importance perhaps lies in the way that it allowed such visual connections to be established. It has been suggested that in this way the garden performed an important role in the intellectual positioning of Hepworth's work. It was the venue in which many visiting curators, writers and collectors would first see her work. It was also an important element in the development of her public image from the 1950s onwards, disseminated through photography of her work, pictured in the garden, and images of the artist at work on sculptures in the garden. As such the garden 'helped to secure the association of her apparently abstract works with the natural world'.[1]

In her will Hepworth invited her executors to consider 'the practicability of establishing a permanent exhibition of some of my works in the Trewyn Studio and its garden'. She envisaged 'small sculptures, carvings and drawings ... On the first floor ... my working studio being shown as closely as possible as it has been during my lifetime, ... and a few large works ... in the garden.'[2] The studio and garden opened to the public in 1976. BT

Photographs by Patrick Heron of the garden at Eagles Nest

Patrick Heron (1920–1999)

Eagles Nest, Zennor, Cornwall

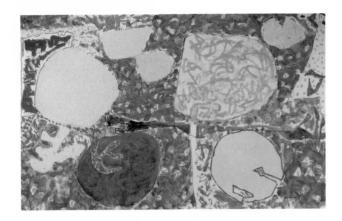

Patrick Heron (1920–1999)
Big Purple Garden Painting:
July 1983–June 1984 1983–4
Oil on canvas, 208 x 335
Private Collection

Eagles Nest sits on the edge of the moor above Zennor, 600 feet above the sea. To the north the view is of the Atlantic, far below, and to the south lie rough moors. The house was Patrick Heron's home from 1956 until his death in 1999 and the garden there was central to his work as an artist.

The politician Will Arnold-Foster bought Eagles Nest in 1921 and began to create a garden there. He grew a series of windbreaks (escallonias and senecios) around the house and set out a garden of exotic flowering trees and shrubs (including azaleas, camellias and rhododendrons) amid pine trees and huge granite boulders. Arnold-Forster, an expert gardener, later wrote *Shrubs for the Milder Counties* (London 1948; revised edition, Penzance 2000). In it he described Eagles Nest as 'what must surely be the windiest garden in Britain'.[1]

Patrick Heron's family moved to Cornwall in 1925. They lived variously at Newlyn, Leland and St Ives until 1929, but in the winter of 1927–8, while the Arnold-Forsters were away, they spent five months at Eagles Nest, hoping it would help Patrick's asthma. The garden was in its infancy at this point, but it still made a strong impression; Heron described it later as 'a childhood magic garden'.[2] In 1929 the Herons left Cornwall for Welwyn Garden City, but Patrick was to visit the area again on holiday in 1938 and 1943. In 1944 he went to live in St Ives, as a conscientious objector, to work at the Leach pottery. Eventually, in 1955, he was able to buy Eagles Nest from Arnold-Forster's son and moved there with his family in the following spring. It had an immediate effect on his painting.

In 1955 the brushstrokes in his still lifes and interiors had become increasingly autonomous — their abstract qualities increasingly pronounced — and in the winter of that year he made a series of small abstract paintings constructed from complex layered surfaces marked with vertical *tachiste* brushstrokes. With the move to Eagles Nest and the stimulus of the garden, the scale of his work increased and colour became increasingly vibrant and dominant. The brushstrokes began to articulate space within the painting but also served to restate the fact of the painted surface. Heron's paintings of 1956, including *Camellia Garden: March 1956* (Private Collection), *Garden (Mist): 1956* (Estate of Patrick Heron), *Azalea Garden: May 1956* (cat.89) and *Autumn Garden: 1956* (cat.90), represented a breakthrough. They paved the way for his pioneering stripe paintings, begun early the following year.

Heron's paintings do not depict Eagles Nest but are an analogy for the experience of the garden; the flickering light, ambiguous spatial organisation of leaves, branches and flowers, solid forms and air. Yet, while they are abstract, the colours and complex spaces they generate do recall the visual sensations one might experience in the garden. Heron recognised that there was a connection and made it explicit by calling them 'Garden' paintings. This led to some confusion when the paintings were shown at the Redfern Gallery in London later that year, critics

such as John Berger making comparisons with Monet's depictions of his garden at Giverny. Heron himself was always clear that the connections between the paintings and the garden were implicit rather than depictive. He later said that the paintings 'tied in very obviously with this absolute bombardment of spotted colour which was happening outside'[3] but also stressed that: 'I have not, since I came to live here forty odd years ago, gone in this garden with a pencil and a pad and done a drawing ... The motive was excitement with things seen — with a landscape. But I never actually drew this garden direct!'[4]

The garden at Eagles Nest was once more to be of crucial importance to Heron at a later stage in his career. By the end of the 1970s he had reached an impasse in his work and in 1979 he faced a personal crisis when his wife Delia died. For some time he made little or no work, but when he began to paint again the garden provided inspiration and suggested a consequent reinvigoration of his painting practice. Heron's paintings of the 1980s are loose, highly coloured, calligraphic; in them he draws his motifs in colour against a white ground, giving the impression that the images have been flooded with bright light. In paintings such as *Big Purple Garden Painting: July 1983 – June 1984* 1983–4 (the first of the garden paintings of the 1980s; Private Collection), *Pale Garden Painting: July – August 1984* 1984 (Private Collection) and *White Garden Painting: May 25 – June 12 1985* 1985 (Estate of Patrick Heron) recognisable shapes — flowers, rocks, leaves, pathways — emerge fleetingly from paint that has been scribbled, brushed, drawn, dabbed and scrubbed. Like the earlier 'Garden' paintings these images provoke a sense of recognition without actually describing a specific place.

Mel Gooding has written of Heron's relationship with Eagles Nest: 'In shaping and re-shaping the house and its unique garden, he has been shaped by it; in occupying it, it has come to occupy him; it has become the ground of his creative being, the very centre of his vision and imagining.'[5] BT

Ian Hamilton Finlay at Little Sparta 2001

Ian Hamilton Finlay (born 1925)
Little Sparta, Dunsyre, Lothian

Set high on the slopes of the Pentland Hills, twenty-five miles south-west of Edinburgh, Little Sparta is both a celebrated garden and the major art work of its creator Ian Hamilton Finlay. Finlay and his wife, Sue, acquired the fourteen-acre property, an abandoned farm called Stonypath, through Sue Finlay's family, the local landowners. When they moved there in 1966, it consisted of a stone croft and some derelict outbuildings with little between the rolling moorland pastures save a stunted ash tree and tattie patch. The Finlays first set about cultivating a sheltered plot adjacent to the house and then moved farther out, damming streams, digging ponds, moving boulders, laying paths and planting a variety of trees and flowers. Stonypath took shape as a landscape garden, with temples, statues, grottoes and glades and a series of artefacts, many inscribed – urns, columns, monoliths, temples, statues, headstones.

Since then Little Sparta has been extended and elaborated, as a series of spaces, seven gardens of various kinds, an allotment and, the most recent addition, an area of 'English Parkland'. Little Sparta is a work in progress, a landscape in itself and a nursery of ideas for projects elsewhere, including commissions for private and public gardens throughout Europe. This has involved a growing network of collaborators, on the ground and in exhibition and publication, including stonemasons, gardeners, sculptors, calligraphers, ceramicists, printmakers, gardeners, photographers, artists and academics.[1]

Eclogue Drystone Wall, Little Sparta

Finlay's transformations of Stonypath farm extended his work as a concrete poet. He had already arranged words on walls and columns, in poems which intersected wider worlds, of land and sea, before inscribing the terrain as an emblematic landscape. This took Finlay back to a classical tradition of landscape gardening, notably that of the eighteenth-century poets and penmen William Shenstone and Alexander Pope. (He suggests echoes of childhood memories, visiting the grounds of the neo-classical Hopetoun House near Edinburgh, where his grandfather, uncle and aunt spent their working lives.) The classical aesthetic elevated the garden as an arena of aesthetic and moral virtue, a place of virtuous retirement from the world and its corruptions, but also a vantage point for launching moral criticism. As Finlay put it in one of his *Unconnected Sentences on Gardening*, 'Certain gardens are described as retreats when they are really attacks.'

The locus of Finlay's classical imagery varies, from pre-Socratic epigrams to the slogans of the French Revolution, and is focused on issues of power and conflict, in nature and culture, in arresting images of death and terror, as well as love and vitality; it is an arena Finlay saw as obscured in the modern culture, and horticulture, of liberal humanism. 'Classical gardens deal in grave generalisations, modern gardens in fussy particulars.' In 1978 Finlay embarked on a 'Five Year Hellenisation Plan'. This involved renaming Stonypath Little Sparta, in homage to the ancient Greek state which confronted the power of Athens. The new name framed Finlay's disputes with representatives from Edinburgh, 'the Athens of the North', home of the Scottish Arts Council, over his withdrawal from an exhibition in the city, and the Strathclyde Regional Authority, over levying a rate on the former byre Finlay converted to a Temple of Apollo. The confrontation was scripted by Finlay and supporters as a series of staged 'battles' around 1983 known as the Little Spartan War; the first battle is commemorated by a memorial at the entrance gate.

Little Sparta is not an austerely ideological or programmatic landscape, but eclectic and enchanting, springing a succession of surprises, as much puckish as pugnacious. Features set in train series of associations, at different registers, mixing the arcane with the homely, the epic with the everyday. A bridge inscribed 'CLAUDI', a facsimile of the signature of the classical landscape painter Claude Lorrain, is cast in pink-painted concrete, around which are planted stands of rhubarb, the word of choice for babbling actors feigning conversation, but also the first food crop Finlay planted at Little Sparta.[2] A notice inscribed 'KAILYARD' set into a wicker gate of the allotment alludes both to the traditional Scottish cottage garden and the genre of sentimental literature to which it gave its name. Some installations are discreet, half-hidden in foliage, and even monumental installations placed on the garden periphery, facing the windswept sheep pastures, are never heavy-handed. 'Art,' Finlay has remarked, 'is a small adjustment.' Little Sparta's cultural landscape is richly horticultural as well as literary or painterly, sensuous as well as cerebral, subject to changing moods of weather and visitor.

As it reaches its full extension, Little Sparta stands in a more accommodating cultural environment. It is now widely recognised as a landmark garden of international stature, and despite, or perhaps because of, past quarrelsome relations with the Scottish cultural establishment, is esteemed as part of a distinctive, independently minded, national tradition of art. Some of Little Sparta's features even bear a resemblance, superficial it must be said, to current fashions of designer-gardening, post-modern architectural classicism and environmental art. Little Sparta is in the care of the Little Sparta Trust, which plans to enhance an informed appreciation of the garden, raise funds to purchase the freehold, conserve its rich array of existing features and complete those already planned. It seeks to achieve this without compromising Ian Hamilton Finlay's distinctive, challenging vision. SD

Claudi Bridge, Little Sparta

Photograph by Howard Sooley of Derek Jarman at Prospect Cottage

Derek Jarman (1942–1994)

PROSPECT COTTAGE, DUNGENESS, KENT

Prospect Cottage, a modest fisherman's dwelling of around 1900, stands upon a huge bank of shingle on the Kent coast, in the shadow of a nuclear reactor. Here the 'prospect' is punctuated by pylons and overhead cables, the pebble beach strewn with ramshackle huts and rusting machine parts; a most unlikely setting for an English country garden. Yet it was here in the late 1980s that Derek Jarman created a garden of immense beauty, shaped by the physical environment and conditioned by his own artistic and personal circumstances.

Jarman had been drawn to Dungeness since the 1970s, enraptured by its desolate character. In 1986 he used it as the setting for his film *The Last of England*, an allegory based on the social and sexual inequalities generated, as he saw, by Thatcherism. Later that year Jarman was diagnosed as HIV-positive. From this moment he devoted his public life to the cause of gay rights. Within a year or so his private life was to be increasingly absorbed by a desire to create a garden of his own at Prospect Cottage, which he purchased in May 1987 with money bequeathed to him by his father. He then also visited his father's home and took repossession of the garden tools he had used as a child, cleaning and oiling them with loving care.

While Jarman had shown early promise as a gardener, and had won gardening prizes at school, his subsequent horticultural efforts had been largely confined to window boxes and an unrealised design for his sister's garden. Given his relative inexperience, and the inhospitable conditions, Jarman initially had little hope of creating a garden at Dungeness. Yet through persistence, an intuitive knowledge of plants and the help of friends — notably the photographer and plantsman Howard Sooley — he succeeded.

The structure of Jarman's garden was established through assiduous beachcombing, as flints and coloured stones were garnered from the shingle to form large, circular beds and standing stones, or 'dragon's teeth'. Jarman also collected discarded fishing tackle, shells, broken garden tools, driftwood and pieces of twisted metal that had been part of Second World War sea defences. Such objects served as plant supports and garden sculptures. The front garden, facing the sea, was laid out in formal beds. The back garden was more experimental, as befitting an essentially private space; although at Prospect Cottage there are no fences or walls.

From the outset Jarman made the most of local plants, the abundant blue-grey sea kale, which he used as central features in formal circular beds, the purple sea pea, yellow gorse and broom, blackthorn blossom and viper's bugloss with its showy spikes of blue flowers.[1] Yellow flowering helichrysum, the curry plant, formed the 'backbone of the garden', while santolina and lavender were planted in formal circles. Jarman also introduced local wild flowers: toadflax, foxglove, horned poppy, red and white valerian, rose, pinks, carnations and thrift. Intent that his should be a 'working' garden, he created a vegetable patch with peas, purple rocket and spinach, as well as a herb garden and a beehive. In June 1990 the eminent gardeners Christopher Lloyd and Beth Chatto accidentally stumbled across Jarman's garden

Photograph by Howard Sooley of garden sculpture at Prospect Cottage

while picnicking. Lloyd instantly recognised its innovative qualities, while Jarman was in turn to make several trips to Lloyd's nursery garden at Great Dixter, East Sussex.

Although suffering from AIDS, Jarman continued to work in the garden, as well as on his art and his film projects. In 1989 his film *War Requiem* featured both the house and the garden, and the following year the latter was the focal point of *The Garden*, 'a parable about the cruel and unnecessary perversion of innocence', where it figured as both 'Eden and Gethsemane'.[2] In 1991 Jarman published *Modern Nature*, a journal he composed at Prospect Cottage. The narrative, which deals frankly with formative aspects of his childhood and adult life, is filtered through his everyday experience of the garden and the philosophy that underpinned it: 'The gardener digs in another time, without past or future, beginning or end. A time that does not cleave the day with rush hours, lunch breaks, the last bus home. As you walk in the garden you pass into this time — the moment of entering can never be remembered. Around you the landscape lies transfigured. Here is the Amen beyond the prayer.'[3]

In May 1993 Jarman, physically frail but still hard at work, took a final holiday to Monet's garden at Giverny. The following January, on his fifty-second birthday and by now almost blind, he made a farewell visit to his own garden. He died three weeks later and was buried in the churchyard of St Clement, Old Romney, under the shade of a favourite yew tree. MP

Thresholds and Prospects
INTRODUCTION

1. Stephen Daniels, 'Goodly prospects', in Nicholas Alfrey and Stephen Daniels, *Mapping the Landscape: Essays on Art and Cartography*, exh. cat., University of Nottingham 1990, pp.9–12; Julius Bryant, *Finest Prospects: Three Historic Houses: A Study in London Topography*, exh. cat., The Iveagh Bequest, Kenwood, London 1986.

2. George Carter, Patrick Goode and Kedrun Laurie, *Humphry Repton: Landscape Gardener 1752–1818*, Norwich 1983, pp.92–3; Todd Longstaffe-Gowan, *The London Town Garden 1740–1840*, New Haven and London 2001, pp.67–9.

3. Ian Jeffrey, *British Landscape 1920–1950*, London 1984, pp.8–9; Malcolm Andrews, *Landscape and Western Art*, Oxford 1999, pp.107–28.

CATALOGUE ENTRIES

1. Stephen Daniels, 'Revisioning Britain: Mapping and Landscape Painting 1750–1830', in Katharine Baetjer (ed.), *Glorious Nature! British Landscape Painting 1750–1850*, New York 1993, pp.61–72.

2. Stephen Daniels, 'Love and death across an English garden: Constable's paintings of his family's flower and kitchen gardens', *The Huntington Library Quarterly*, vol.55, no.3, 1992, pp.433–58.

3. See Susan Morris, 'Family and friends, a network of lady pupils and patrons', in Greg Smith, *Thomas Girtin: The Art of Watercolour*, London 2002, pp.257–8.

4. Reproduced, with an account of the Gordons' patronage of Turner, in Ian Warrell, *Turner on the Loire*, exh. cat., Tate Gallery, London 1997, pp.181–3. James Hamilton has discovered that a shell fountain was a feature of the terrace at The Orchard, and argues that this is alluded to by Turner in the larger-than-life sea shell he places in the foreground. Turner has evidently relocated the fountain and increased its scale in his version of the scene. See James Hamilton, *Turner, the Late Seascapes*, New Haven and London 2003, pp.4–7.

5. See Alexander Robertson, *Atkinson Grimshaw*, London 1998, to which this entry is indebted.

6. Millais produced a version (now lost) five years later, based on the abandoned gardens of the house he leased in Perthshire. See Anne Helmreich, 'Poetry in Nature: Millais's pure landscapes', in Debra N. Mancoff, *John Everett Millais: Beyond the Pre-Raphaelite Brotherhood*, New Haven and London 2001, pp.149–80.

7. Pauline Fletcher, *Gardens and Grim Ravines: The Language of Landscape in Victorian Poetry*, Princeton 1983, pp.42–71.

8. Ian Gale, *Arthur Melville*, Edinburgh, 1996, pp.4–6; Roger Billcliffe, *The Glasgow Boys: The Glasgow School of Painting 1875–1895*, London 1985, pp.25–6, 112–14; Tom Normand, 'A realist view of a Victorian childhood: re-reading James Guthrie's *A Hind's Daughter*', *Scotlands*, vol.4, no.2, 1997, pp.41–53.

9. The compiler is grateful to Tom Normand for sharing his insights into this painting.

10. Bill Smith, *The Life and Work of Edward Atkinson Hornel*, Edinburgh 1997, p.30.

11. Information from James Allen, librarian of Broughton House, Kirkcudbright.

12. Quoted in Smith 1997, p.34.

13. Kathleen Adler, *Pissarro in London*, exh. cat., National Gallery, London 2003, pp.16–21.

14. Wendy Baron, *The Camden Town Group*, London 1979, pp.188–94; Wendy Baron, *Perfect Moderns*, Aldershot 2000, pp.118–19.

15. 'Frederick Spencer Gore', *Blast*, no.1, 20 June 1914, p.150.

16. Frederick Gore and Richard Upstone, *Spencer Gore in Richmond*, exh. cat., Museum of Richmond 1996.

17. David Peters Corbett, 'The geography of *Blast*: landscape, modernity and English painting, 1914–1930', in David Peters Corbett, Ysanne Holt and Fiona Russell, *The Geographies of Englishness: Landscape and the National Past, 1880–1940*, New Haven and London 2002, pp.115–40; Ysanne Holt, 'An ideal modernity', ibid., pp.91–113.

18. 'Frederick Spencer Gore', *Blast*, no.1, 20 June 1914, p.150.

19. Frederick Gore and Richard Shone (eds.), *Spencer Frederick Gore 1878–1914*, exh. cat., Anthony d'Offay, London 1983, unpaginated.

20. Arnold Bennett, *Hilda Lessways*, London 1911, pp.241–2; *Clayhanger*, London 1954, pp.438–9.

21. Mervyn Miller and A. Stuart Gray, *Hampstead Garden Suburb*, Chichester 1992, p.77.

22. *Garden City to Camden Town: The Art of William Ratcliffe*, exh. cat., Letchworth Museum and Art Gallery 2003.

23. Evelyn Dunbar, typescript, 7 May 1956, Tate Archive.

24. The author is grateful to Dr Gill Clarke, who provided much of the information for this entry, based upon her forthcoming book, *Evelyn Dunbar: A Portrait*.

25. John Rothenstein, *Studio*, 1936, p.149.

26. Janet Barnes, *The Decorative Paintings of Harry E. Allen, 1894–1958*, exh. cat., Graves Art Gallery, Sheffield 1986, pp.38–40.

27. Harry Allen, 'Decorative Landscape Painting', *The Artist*, November 1942, p.57.

28. Timothy Hyman and Patrick Wright (eds.), *Stanley Spencer*, exh. cat., Tate Britain 2001, p.140.

29. Ian Jeffrey, *British Landscape 1920–1950*, London 1984.

30. Duncan Robinson, *Stanley Spencer*, Oxford 1990, p.80.

31. John Rothenstein, *Charles Mahoney. A Tribute on the Occasion of a Memorial Exhibition*, London 1975, p.9.

32. Roger Billcliffe, *James McIntosh Patrick*, London 1987.

33. Ron Thompson, *Easel in the Field: The Life of McIntosh Patrick*, Dundee 2000, pp.84–5.

34. Denys Forrest, *St James's Square: People, Houses, Happenings*, London 1986, p.145; Mireille Galinou (ed.), *London's Pride: The Glorious History of the Capital's Gardens*, exh. cat., Museum of London 1990, pp.190–2.

35. Galinou 1990, pp.191–2.

36. John Nelson Tarn, *Five Per Cent Philanthropy: An Account of Housing in Urban Areas between 1840 and 1914*, Cambridge 1973, pp.131–42.

37. A.C. Locke, *Harry Bush ROI 1883–1957 and Noel Laura Nisbet RI 1887–1956*, typescript, Imperial War Museum, July 1992, p.4.

38. Stephen Daniels, *Fields of Vision: Landscape Imagery and National Identity in England and the United States*, Cambridge 1992, p.32.

39. Prudence Bliss, introduction to *Douglas Percy Bliss: A Retrospective Exhibition*, exh. cat., The Hatton Gallery, Newcastle upon Tyne 1981.

40. The artist in conversation with Richard Morphet, Tate, 3 April 1982.

41. Robert Bartram, 'The Enclosure of Nature in Stanley Spencer's *Hoe Garden Nursery*', *Ecumene*, vol.6, no.3, 1999, pp.341–59.

42. Ibid., pp.343–4.

43. David Rayson in conversation with the author, 12 December 2003.

44. Quoted in 'Modern Painters: David Rayson Interview', www.ngca.co.uk/modernpaint/david-rayson, accessed 6 November 2003.

45. David Rayson, *somewhere else is here*, exh. cat., Kettle's Yard, Cambridge 2003; *Garden* reproduced on p.5.

46. Brown's painting is discussed in Stephen Daniels's essay 'Suburban Prospects' in this catalogue (see p.26).

47. George Shaw in conversation with the author, 10 December 2003.

48. Michael Bracewell, 'The Sleep of Estates: An Introduction to the Art of George Shaw', in George Shaw, *What I did this Summer*, exh. cat., Ikon Gallery, Birmingham 2003, pp.5–12; quotation on p.8.

The Secret Garden
INTRODUCTION

1. Frances Hodgson Burnett, *The Secret Garden*, London 1911, reprinted 1994, p.89.

CATALOGUE ENTRIES

1. Raymond Lister (ed.), *The Letters of Samuel Palmer*, 2 vols., Oxford 1974, vol.1, pp.7–8, n.2 and vol.2, pp.1081–3.

2. See Graham Reynolds, *The Later Paintings and Drawings of John Constable*, 2 vols., New Haven and London 1984, vol.1, p.93, no.21.104 and vol.2, pl.307.

3. R.B. Beckett (ed.), *John Constable's Correspondence. Volume VI. The Fishers*, Suffolk Records Society XII, Ipswich 1968, p.71.

4. See Reynolds 1984, vol.1, p.93, no.21.103, *A garden with a shed at Hampstead*.

5. Patricia Allderidge, *The Late Richard Dadd 1817–1866*, exh. cat., Tate Gallery, London 1974, p.28.

6. Allderidge 1974, p.87, no.112 and p.149, no.252.

7. Robert Ross, '"April Love", A Note', *Burlington Magazine*, vol.28, February 1916, p.171.

8. Leslie Parris (ed.), *The Pre-Raphaelites*, exh. cat., Tate Gallery, London 1984, no.72, pp.137–8.

9. Sidney Colvin, *The Portfolio*, 1870, p.5, quoted in *The Tate Gallery 1980–82: Illustrated Catalogue of Acquisitions*, London 1984, p.33.

10. John George Marks, *Life and Letters of Frederick Walker, A.R.A.*, London 1896, pp.213–14. Marks notes that Walker was at Bisham from around early August until mid-September. *An Amateur* was with Agnew by early October.

11. See Claude Phillips, *Frederick Walker and his Works*, London 1897, p.55. It was exhibited in 1870 at the Old Watercolour Society with the title *An Amateur* and in 1891 at Burlington House.

12. Lindsay Stainton, *British Landscape Watercolours 1600–1860*, London 1985, p.80, no.194.

13. Nancy Rose Marshall and Malcolm Warner, *James Tissot. Victorian Life/Modern Love*, New Haven and London 1999, p.110.

14. *Dublin University Magazine*, vol.90, July 1877, pp.125–6, quoted in Ronald Alley, *Catalogue of the Tate Gallery's Collection of Modern Art other than Works by British Artists*, London 1981, p.723.

15 Peter Trippi, *J.W. Waterhouse*, London 2002, pp.195–7. See also Ray Desmond, *The History of the Royal Botanic Gardens at Kew*, London 1995, p.306.

16. See Penelope Hobhouse and Christopher Wood, *Painted Gardens: English Watercolours, 1850–1914*, London 1988, pp.112–16.

17. See Gertrude Jekyll and George Elgood, *Some English Gardens*, London 1904, pp.67–9.

18. See P.F. Springett, '"Westbury-in-Suffolk"? or the Lost Garden of Ashe High House', *Garden History*, vol.2, no.3, Summer 1974, pp.77–89; P.F. Springett, '"Detective Story", further inquiries into the Lost Garden at Campsea Ashe, Suffolk', *Garden History*, vol.3, no.3, Summer 1975, pp.62–75.

19. Hobhouse and Wood 1988, p.25.

20. Judy Taylor, Joyce Irene Whalley, Anne Stevenson Hobbs and Elizabeth M. Battrick, *Beatrix Potter 1866–1943. The Artist and her World*, London 1987, p.104.

21. See Jane Laing, *Cicely Mary Barker and her Art*, London 1995, pp.37–8.

22. Kenneth Pople, *Stanley Spencer. A Biography*, London 1991, p.71, note.

23. *Dictionary of Art* 1996 (sourced at www.groveart.com).

24. Richard Carline, *Stanley Spencer at War*, London 1978, p.37. Tate Archive 733.3.1.

25. See Alice Thomas, *The Art of Hilda Carline. Mrs Stanley Spencer*, exh. cat., The Iveagh Bequest, Kenwood 1999, p.31.

26. Jonathan Miles and Derek Shiel, *David Jones. The Maker Unmade*, Bridgend 1995, pp.246–8.

27. Peggy Angus, letter to Lord Croft, 8 March 1959, Tate.

28. Anna Pavord, 'Flowers untouched by human hand', *Independent*, 24 April 1993, p.43.

29. J. Edward Lousley, 'Wild Flowers in the City of London', *The Geographical Magazine*, February 1946, p.413.

30. Lousley 1946, p.414.

31. See *25 from '51, Paintings from the Festival of Britain 1951*, exh. cat., Sheffield City Art Galleries 1978.

32. Elizabeth Bulkeley, 'Charles Mahoney's Approach to Gardening', unpublished ms.

33. Ibid.

34. See Matthew Gale and Chris Stephens, *Barbara Hepworth, Works in the Tate Gallery Collections and the Barbara Hepworth Museum St Ives*, London 2001, p.192.

35. See Miranda Phillips and Chris Stephens, *Barbara Hepworth Sculpture Garden*, London 2002, pp.28–9.

36. R.V. Weight, *Carel Weight. A Haunted Imagination*, Newton Abbot 1994, p.83.

37. Mervyn Levy, *Carel Weight*, London 1986, p.19.

38. The information in this entry is based upon the author's recent conversations with the artist.

39. *The Tate Gallery 1980–82*, p.143.

40. David Inshaw states that the house is a conflation of two Georgian buildings, one in Evesham, the other in the market square in Devizes. Inshaw in conversation with the author, 9 October 2003.

41. *The Tate Gallery 1980–82*, p.143.

42. *Ivor Abrahams*, exh. cat., Yorkshire Sculpture Park 1984, p.43, no.13.

43. Email from Abrahams to the author, 20 October 2003.

44. *Ivor Abrahams. Environments, Sculpturen, Zeichnungen, Komplette Graphiken*, exh. cat., Kölnischer Kunstverein, Cologne 1973, p.67, repr.

45. Chris Stephens, *The Sculpture of Hubert Dalwood*, London 1999, p.70.

46. Letter from Pearce to the author, 1 December 2003.

47. From Mother Goose, 'Who Killed Cock Robin?', *The Oxford Book of Light Verse*, ed. W.H. Auden, Oxford 1938.

48. Jennifer Higgie, *Sarah Jones*, exh. leaflet, The Jerwood Space, London 1999, unpaginated.

49. 'Some New Paintings', exh. leaflet, Tate Gallery, London 1998, quoted in William Feaver, *Lucian Freud*, exh. cat., Tate Britain 2002, p.46.

50. Lawrence Gowing, *Lucian Freud*, London 1982, p.19, pl.3.

51. Feaver 2002, p.33.

Fragments and Inscriptions
INTRODUCTION

1. John Newton, 'The Garden', from *Olney Hymns*, vol.2, no.95, 1779.

2. The important English writer and gardener William Shenstone (1714–1763) included a grove dedicated to Virgil in his garden at Leaseowes, Halesowen.

3. Thomas Whately, 'Observations on Modern Gardening' (1770), quoted in David R. Coffin, *The English Garden: Meditation and Memorial*, Princeton 1994, p.28.

CATALOGUE ENTRIES

1. Quoted in Andrew Nicholson (ed.), *William Nicholson, Painter*, London 1996, p.187.

2. Gertrude Jekyll, letter to an unidentified correspondent, dated 22 February 1922, in Tate Catalogue File.

3. Quoted in H. Avray Tipping, 'Gertrude Jekyll: An Appreciation', *Country Life*, 17 December 1932, p.689.

4. Paul Nash, 'Unseen Landscapes', *Country Life*, 21 May 1938.

5. Andrew Causey, *Paul Nash's Photographs: Document and Image*, exh. cat., Tate Gallery, London 1973, p.11.

6. Paul Nash, 'Photography and Modern Art', *The Listener*, vol.8, 1932, pp.130–1.

7. *Edwin Smith Photographs 1935–71*, London 1984, p.5.

8. Edwin Smith, statement in *1935–36 Anthology of Modern Photography*, ed. Francis Bruyguiere, quoted ibid., p.8.

9. Gerry Badger in conversation with the author, 17 October 2003.

10. Quoted in David Brown, *A Mansion of Many Chambers: Beauty and other works*, exh. cat., Arts Council Touring Exhibition 1981–3.

11. Quoted in James Campbell, 'Avant Gardener', *Guardian*, 31 May 2003.

12. 'The Death of Piety: Ian Hamilton Finlay Interviewed by Nagy Rashwan', *Jacket* 15, December 2001.

13. Ian Hamilton Finlay, letter to David Brown, 18 September 1979, David Brown Archive, Folders 7 and 8, Scottish National Gallery of Modern Art, Edinburgh.

14. Stephen Bann, introduction to *Nature Over Again After Poussin: Some Discovered Landscapes*, exh. cat., Collins Exhibition Hall, University of Strathclyde 1980, p.7.

15. Jessie Sheeler, *Little Sparta: The Garden of Ian Hamilton Finlay*, London 2003, p.23.

16. 'Ivor Abrahams in Conversation with R.J. Rees', in *Ivor Abrahams. Environments, Skulpturen, Zeichnungen, Komplette Graphiken*, exh. cat., Kölnischer Kunstverein, Cologne 1973, pp.17–18.

17. John RJ Taylor, *Ideal Home: a detached look at modern living*, Manchester 1989.

18. Quoted ibid.

19. Mark Haworth-Booth, introduction to *Ideal Home: a detached look at modern living*, Manchester 1989.

20. Quoted in Catherine Marshall (ed.), *Breaking the Mould: British Art of the 1980s and 1990s: The Weltkunst Collection*, London and Dublin 1997, p.70.

21. Derek Jarman, *Derek Jarman's Garden*, London 1995, p.12.

22. Tony Peake, *Derek Jarman*, London 1999, p.473.

23. Jarman 1995, p.34.

24. David Spero in conversation with the author, October 2003.

25. Charlotte Cotton, *Then Things Went Quiet*, exh. cat., MW Projects, London 2003.

26. Geoff Nicholson, 'Objects of Derision', *Modern Painters*, Summer 2002, pp.86–91.

27. Quoted in Andrew Billen, 'The Eyes of Martin Parr', *Evening Standard*, 30 August 2000.

28. Quoted in Sheryl Garratt, 'Snap Happy', *Evening Standard*, 20 May 2003.

29. See www.morison.info.

30. Email to the author, 22 October 2003.

31. Ibid.

Coloured Grounds
CATALOGUE ENTRIES

1. For a full account of this painting, see Evan Charteris, *John Sargent*, London 1927, chapters 11 and 12; Richard Ormond, 'Carnation, Lily, Lily, Rose', in Warren Adelson, Stanley Olson and Richard Ormond, *Sargent at Broadway, The Impressionist Years*, New York and London 1986, pp.63–75 (the source for the quotations from letters in this entry); Elaine Kilmurray and Richard Ormond, *John Singer Sargent*, London 1998, pp.114–16.

2. Francis Jekyll, *Gertrude Jekyll: A Memoir*, London 1934, p.88. See also the calendar compiled by Michael Tooley in Michael Tooley and Primrose Arnander (eds.), *Gertrude Jekyll, Essays on the Life of a Working Amateur*, Witton-le-Wear 1995.

3. Information kindly supplied by Primrose Arnander.

4. Annabel Freyberg, 'Edward and Julia Jekyll and their family', in Tooley and Arnander 1995, pp.33–4; Frederick Eden, *A Garden in Venice*, London 1903 (reissued in facsimile by Frances Lincoln, London 2003).

5. Gertrude Jekyll, 'A border of irises and lupines',

The Garden, no.76, 1912, p.639, cited by Judith B. Tankard and Martin A. Wood in *Gertrude Jekyll at Munstead Wood: Writing, Horticulture, Photography, Homebuilding*, Stroud 1996, p.56.

6. On the autochrome process, see Ian Jeffrey, *Revisions, an Alternative History of Photography*, Bradford 1999, pp.77–81.

7. Gertrude Jekyll, *Colour in the Flower Garden*, London 1908, p.90.

8. For example, Martin Wood, 'Gertrude Jekyll's Munstead Wood', in Tooley and Arnander 1995, pp.102–3; Tankard and Wood 1996, pp.22–3. Both refer to T.H.D. Turner's introduction to the Antique Collector's Club edition of Jekyll's *Colour Schemes for the Flower Garden*, Woodbridge 1982, in which *The Fighting 'Temeraire'* is reproduced.

9. Gertrude Jekyll and George Samuel Elgood, *Some English Gardens*, London 1904, p.122, quoted in Tankard and Wood 1996, p.149.

10. Penelope Hobhouse and Christopher Wood, *Painted Gardens: English Watercolours, 1850–1914*, London 1995, p.177.

11. Arthur Paterson, *The Homes of Tennyson*, London 1905, p.44.

12. Ibid.

13. For a biography, see Audrey Le Lievre, *Miss Willmott of Warley Place*, London 1980.

14. Leon Edel (ed.), *Henry James, Letters*, IV, Cambridge, Massachusetts 1984, p.63; Jane Brown, *Eminent Gardeners, Some People of Influence and Their Gardens, 1884–1980*, London 1990, chapter 2, 'The Henry James Americans'.

15. Nicole Milette, 'Landscape Painter as Landscape Gardener: the Case of Alfred Parsons, RA', unpublished PhD dissertation, University of York 1997, pp.242–4.

16. Alfred Parsons, *Notes in Japan*, London 1896.

17. 'The Abbot's Grange and Russell House at Broadway, Worcestershire, the Residence of Mr. F.D. Millet', *Country Life*, 14 January 1911, p.61.

18. Margaret Waterfield, *Garden Colour*, with contributions by Eleanor Vere Boyle, Maria Teresa Earle, Rose G. Kingsley and Vicary Gibbs, London 1905, p.79. Waterfield's notes on every month from February to October add up to a commentary on the gardening season at Nackington, though she is less specific about details of the site than Jekyll was in her published accounts of Munstead Wood.

19. Jekyll and Elgood 1904.

20. Ibid., p.60. Elgood painted this garden on many occasions, though he gave the name in a perplexing variety of spellings: Ramscliffe, Raundscliffe, Raunscliffe. His biographer has suggested that he may have been anxious to protect his privacy by putting potential visitors off the scent: see Eve Eckstein, *George Samuel Elgood: His Life and Work 1851–1943*, London 1995.

21. Marie Luise Gothein, *A History of Garden Art* (1913), London 1928, quoted in David Ottewill, *The Edwardian Garden*, New Haven and London 1989, pp.70–1.

22. Hobhouse and Wood 1995, p.29.

23. Cedric Morris, 'Concerning Flower Painting', *Studio*, 1942, pp.121–32.

24. *The Tate Gallery 1980–82: Illustrated Catalogue of Acquisitions*, London 1984, p.178.

25. Patrick Heron, *Ivon Hitchens*, Harmondsworth 1955, p.11.

26. One critic has objected that 'one cannot call anything so magnificently uncultivated a garden', T.G. Rosenthal in Alan Bowness (ed.), *Ivon Hitchens*, London 1973, p.15.

27. Transcript of an interview with Patrick Heron, Tate Archive TAV 247AB, quoted in Andrew Wilson, *Patrick Heron, Early and Late Garden Paintings*, exh. cat., Tate St Ives 2001, p.8.

28. Interview with Martin Gayford in David Sylvester (ed.), *Patrick Heron*, exh. cat., Tate Gallery, London 1998, p.29. The fullest account of Heron's Garden Paintings is Wilson 2001.

29. When early paintings from the series were exhibited at the Redfern Gallery in June 1956 Heron referred to them as '*tachiste*' (from the term *tachisme*, derived from *tache*, meaning a mark, trace or patch).

30. Bill Laws, *Artists' Gardens*, London 1999, p.81.

31. Letter to Tate Gallery from the artist, 2 September 1960, Tate Archive.

32. The idea is suggested by Philip Long in *John Maxwell 1905–1962*, Edinburgh 1999, p.27. This entry is very much indebted to Long's account.

33. Interview with Silas Tomkyn Comberbache (a pseudonym for Berg) in *Adrian Berg, Paintings 1955–1980*, exh. cat., Rochdale Art Gallery 1980, p.12.

❀

Representing and Intervening
INTRODUCTION

1. Richard Wentworth, 'Motorised & Pasteurised', in *Arcadia Revisited – The Place of Landscape*, London 1997, p.89.

2. Ibid., p.92.

3. www.morison.info.

4. Emma Safe, 'Flower Power', *Art Monthly*, July–August 2002, pp.24–5.

5. See *Spectacular Bodies: The Art and Science of the Human Body from Leonardo to Now*, ed. Martin Kemp and Marina Wallace, exh. cat., Hayward Gallery, London 2000, pp.61–3.

6. Ralph Rugoff, 'Leap of Faith', in *Chasing Rainbows*, exh. cat., Tramway, Glasgow 1999, p.12–13.

7. Dr Phil Wilson, quoted by Paul Brown in 'Weeds We Can't Afford to Lose', *Guardian*, 8 July 2003.

8. Statement by Susan Hiller, published in *Genius loci – Kunst und Garten*, exh. cat., Kunstfreunde Lahr e.V. (Hg), Leipzig 2003, unpaginated.

9. Ralph Rugoff, *The Greenhouse Effect*, exh. cat., Serpentine Gallery, London 2000, p.34.

10. See Michel Foucault, 'Of Other Spaces', in *Documenta X*, exh. cat., Kassel 1997, p.265.

11. Kim Levin, 'Gaining Ground: A Retrospective View of Art in Nature and Nature as Art', in *Transplant: Living Vegetation in Contemporary Art*, Ostfildern (Ruit) 2000, p.16.

12. Jan Verwoert, 'Free Radical', *frieze*, October 2001, p.84.

13. Anya Gallaccio, quoted in *Chasing Rainbows*, exh. cat., Tramway, Glasgow 1999, p.60.

CATALOGUE ENTRIES

1. Richard Wentworth, prompted and transcribed by Robert Malbert, 'Thoughts on Paper', *Thinking Aloud*, exh. cat., Arts Council Touring Exhibition 1999, p.6.

2. Geoff Dyer, 'Les Mots et Les Choses', in *Richard Wentworth/Eugène Atget*, exh. cat., The Photographer's Gallery, London 2001, p.21.

3. Graham Fagen by email, 21 October 2003.

4. See Burns's famous poem 'A Red, Red Rose', written in 1794.

5. *Cocker's Award Winning Roses*, Autumn 2003/Spring 2004 sales catalogue, p.14.

6. Graham Fagen by email, 23 October 2003.

7. Jeremy Millar, 'Dub Rosa', in *Graham Fagen – Lovely is Lovely*, exh. cat., The Fruitmarket Gallery, Edinburgh 2002, p.15.

8. Germano Celant, *Marc Quinn*, exh. cat., Fondazione Prada, Milan 2000, p.13.

9. Marc Quinn interviewed by Tim Marlow in *Marc Quinn: The Overwhelming World of Desire (Paphiopedilum Winston Churchill Hybrid)*, exh. cat., Sculpture at Goodwood 2003, p.17.

10. Mark Godfrey, 'A Journey into the Landscape of Painting through the Painting of Landscape', in *Twisted, Urban, and Visionary Landscapes in Contemporary Painting*, exh. cat., Stedelijk van Abbemuseum, Eindhoven 2000, p.48.

11. J.J. Charlesworth, 'I Want! I Want!', *artmonthly*, no.270, October 2003, p.33.

12. Susan Hiller was awarded a DAAD fellowship in 2002–3 (German Academic Exchange) and was based in Berlin when she produced this work, a site-specific commission for a city park in Lahr.

13. Susan Hiller, artist's statement, May 2003, originally published in *Genius loci – Kunst und Garten*, exh. cat., Kunstfreunde Lahr e.V. (Hg), Leipzig 2003, unpaginated.

14. Jennifer Higgie, 'Get it while you can', *frieze*, no.77, September 2003, p.69.

15. http://www.globalsurvey.org/.

16. Jacques Nimki by email, 16 September 2003.

17. Ibid.

18. David Rayson by email, 4 November 2003.

19. David Rayson by email, 2 November 2003.

20. George Shaw in conversation with the author, 10 October 2003.

JAMES TISSOT: GROVE END ROAD

1. Krystyna Matyjaszkiewicz (ed.), *James Tissot*, exh. cat., Barbican Art Gallery, London 1984, p.14.
2. Quoted in Nancy Rose Marshall, 'Image or Identity: Kathleen Newton and the London Pictures of James Tissot', in Katharine Lochnan (ed.), *Seductive Surfaces. The Art of Tissot*, New Haven and London 1999, p.36.
3. 'The Grosvenor Gallery Exhibition', *Athenaeum*, 10 May 1879, p.607, quoted in Michael Wentworth, *James Tissot*, Oxford 1984, p.147.
4. Quoted in Wentworth 1984, p.147.
5. Edward Knoblock, 'The Whimsical "Seventies"', *Country Life*, 26 December 1936, p.679.

ALFRED PARSONS: LUGGERS HILL

1. Nicole Milette, 'Landscape Painter as Landscape Gardener: the Case of Alfred Parsons, RA', unpublished PhD dissertation, University of York 1997, pp.242–3.
2. 'The Abbot's Grange and Russell House, at Broadway, Worcestershire, the residence of Mr. F.D. Millet', *Country Life*, 14 January 1911, p.61. For an account of Millet at Broadway, see Marc Simpson, 'Windows on the Past: Edwin Austin Abbey and Francis Davis Millet in England', *American Art Journal*, vol.22, no.3, pp.64–89.
3. Mary Anderson de Navarro, *A Few More Memories*, London 1936, p.255.
4. Ibid, p.258.

EDWARD ATKINSON HORNEL: BROUGHTON HOUSE

1. Bill Smith, *Hornel, The Life and Work of Edward Atkinson Hornel*, Edinburgh 1997, p.14.
2. Reproduced and the inscription transcribed in Jessie Sheeler, *Little Sparta: The Garden of Ian Hamilton Finlay*, London 2003, p.III.
3. The National Trust for Scotland, *Broughton House and Garden*, text by Frances Scott and James Allan, Edinburgh 1999.

CHARLES MAHONEY: OAK COTTAGE

1. Bernard Dunstan, 'Colleague, Draughtsman and Friend', in *Charles Mahoney 1903–1968*, exh. cat., Fine Art Society, London 1999, p.22.
2. The information presented here on the planting of Mahoney's garden and the species contained therein is derived from 'Charles Mahoney's Approach to Gardening', an unpublished note by Mrs Elizabeth Bulkeley, the artist's daughter, which she has kindly communicated to the author.

CEDRIC MORRIS: BENTON END

1. Just one year earlier Frances Hodgkins had written 'Cedric is on the wings of an incomparable success – selling & selling ... ' Letter to Dorothy Selby, 24 May 1928, in Linda Gill (ed.), *The Letters of Frances Hodgkins*, Auckland 1993, p.407.
2. Joan Warburton, 'A Painter's Progress: Part of a Life 1920–87', unpublished ms, Tate Archive.

3. See Ben Tufnell, *Cedric Morris and Lett Haines: Teaching Art and Life*, exh. cat., Norwich Castle Museum 2002.
4. Beth Chatto, 'Sir Cedric Morris, Artist-Gardener', *Hortus*, no.1, 1987, p.15.
5. Glyn Morgan, introduction to *The Benton End Art Circle*, exh. cat., Bury St Edmunds Art Gallery 1986, unpaginated.

IVON HITCHENS: GREENLEAVES

1. Patrick Heron, *Ivon Hitchens*, London 1955, p.11.
2. Ibid.
3. Peter Khoroche, *Ivon Hitchens*, London 1990, p.48.

BARBARA HEPWORTH: TREWYN STUDIO

1. Chris Stephens, 'A Sort of Magic', in Miranda Phillips and Chris Stephens, *Barbara Hepworth Sculpture Garden*, London 2002, p.6.
2. Quoted in 'The Barbara Hepworth Museum St Ives', *Cornish Life*, vol.3, no.5, 1976.

PATRICK HERON: EAGLES NEST

1. Quoted in Mel Gooding, *Patrick Heron*, London 1994, p.115.
2. Quoted in Andrew Wilson, *Patrick Heron: Early and Late Garden Paintings*, exh. cat., Tate St Ives 2001, p.8.
3. Quoted in Vivien Knight, 'The Pursuit of Colour', in *Patrick Heron*, exh. cat., Barbican Art Gallery, London 1985, p.9.
4. Interview with Martin Gayford in David Sylvester (ed.), *Patrick Heron*, exh. cat., Tate Gallery, London 1998, p.44.
5. Gooding 1994, p.8.

IAN HAMILTON FINLAY: LITTLE SPARTA

1. This entry is based on the following sources: Yves Abrioux, *Ian Hamilton Finlay: A Visual Primer*, London 1985, 1992, pp.39–70; Alec Finlay (ed.), *Wood Notes Wild: Essays on the Poetry and Art of Ian Hamilton Finlay*, Edinburgh 1995; Robert Gillanders, *Little Sparta*, Edinburgh 1998; 'Arcadian Greens Rural', *New Arcadian Journal*, nos.53/54, 2002; Jessie Sheeler, *Little Sparta: The Garden of Ian Hamilton Finlay*, London 2003.
2. On a visit by the author in June 2003, Finlay was dismayed by the effects of a hailstorm which destroyed the crop.

DEREK JARMAN: PROSPECT COTTAGE

1. For detailed descriptions of the planting scheme at Prospect Cottage, see Derek Jarman, *Derek Jarman's Garden*, London 1995, passim; Christopher Lloyd, 'The Jarman Garden Experience', in Roger Wollen (ed.), *Derek Jarman: A Portrait*, London 1992, pp.147–52.
2. Tony Peake, *Derek Jarman*, London 1999, pp.459, 445.
3. Journal entry for 7 March 1989 in Derek Jarman, *Modern Nature. The Journals of Derek Jarman*, London 1991, p.30.

A

Abrahams, Ivor, *Ivor Abrahams. Environments, Skulpturen, Zeichnungen, Komplette Graphiken*, exh. cat., Kölnischer Kunstverein, Cologne 1973

Abrioux, Yves, *Ian Hamilton Finlay: A Visual Primer*, revised and expanded second edition, London 1992

Adelson, Warren, Stanley Olson and Richard Ormond, *Sargent at Broadway, The Impressionist Years*, New York and London 1986

Adler, Kathleen, *Pissarro in London*, exh. cat., National Gallery, London 2003

Alfrey, Nicholas, and Stephen Daniels, *Mapping the Landscape: Essays on Art and Cartography*, exh. cat., University of Nottingham 1990

Andrews, Malcolm, *Landscape and Western Art*, Oxford 1999

Arts Council, *The Glory of the Garden: The Development of the Arts in England: A Strategy for a Decade*, London 1984

Austin, Alfred, *The Garden That I Love*, London 1906

Austin, Alfred, *Lamia's Winter-quarters*, London 1907

B

Baetjer, Katharine (ed.), *Glorious Nature! British Landscape Painting 1750–1850*, New York 1993

Bennett, Sue, *Five Centuries of Women & Gardens*, London 2000

Berg, Adrian, *Adrian Berg, Paintings 1955–1980*, exh. cat., Rochdale Art Gallery 1980

Billcliffe, Roger, *James McIntosh Patrick*, London 1987

Billcliffe, Roger, *The Glasgow Boys. The Glasgow School of Painting 1875–1895*, London 1985

Bisgrove, Richard, *The English Garden*, London 1990

Bowles, E.A., *My Garden in Spring*, London 1914

Bowles, E.A., *My Garden in Summer*, London 1914

Bowles, E.A., *My Garden in Autumn and Winter*, London 1915

Bliss, Prudence, *Douglas Percy Bliss: A Retrospective Exhibition*, exh. cat., The Hatton Gallery, Newcastle upon Tyne 1981

Bossé, Laurence, Carolyn Christov-Bakargiev and Hans Ulrich Obrist , *La Ville, Le Jardin, La Mémoire*, exh. cat., French Academy in Rome – Villa Medici, Rome 2000

Bowness, Alan (ed.), *Ivon Hitchens*, London 1973

Bracewell, Michael, *England is Mine: Pop Life in Albion from Wilde to Goldie*, London and New York 1997

Brown, Jane, *Gardens of a Golden Afternoon*, London 1982

Brown, Jane, *Eminent Gardeners, Some People of Influence and Their Gardens, 1884–1980*, London 1990

Brown, Jane, *The Pursuit of Paradise: A Social History of Gardens and Gardening*, London 1999

Bryant, Julius, *Finest Prospects: Three Historic Houses: A Study in London Topography*, exh. cat., The Iveagh Bequest, Kenwood, London 1986

Bulkeley, Elizabeth, 'Charles Mahoney's Approach to Gardening', unpublished ms.

Burchardt, Jeremy, *The Allotment Movement in England, 1793–1873*, Woodbridge 2002

C

Calthrop, Dion Clayton, *The Charm of Gardens*, London 1910

Carter, George, Patrick Goode and Kedrun Laurie, *Humphry Repton: Landscape Gardener 1752–1818*, Norwich 1983

Causey, Andrew, *Paul Nash's Photographs: Document and Image*, exh. cat., Tate Gallery, London 1973

Celant, Germano, *Marc Quinn*, exh. cat., Fondazione Prada, Milan 2000

Charteris, Evan, *John Sargent*, London 1927

Clayton-Payne, Andrew, and Brent Elliott, *Victorian Flower Gardens*, London 1988

Coffin, David R., *The English Garden: Meditation and Memorial*, Princeton 1994

Cook, E.T., *Gardens of England*, London 1908

Corbett, David Peters, Ysanne Holt and Fiona Russell, *The Geographies of Englishness: Landscape and the National Past, 1880–1940*, New Haven and London 2002

Crouch, David, *The Art of Allotments. Culture and Cultivation*, Nottingham 2003

Crouch, David, and Colin Ward, *The Allotment. Its Landscape and Culture*, London 1988

D

Daniels, Stephen, *Humphry Repton: Landscape Gardening and the Geography of Georgian England*, New Haven and London 1999

Dewing, David, *Home and Garden. Paintings and Drawings of English, Middle-class, Urban Domestic Spaces 1675 to 1914*, exh. cat., Geffrye Museum, London 2003

Dunbar, Evelyn, and Cyril Mahoney, *Gardeners' Choice*, London 1937

E

Eckstein, Eve, *George Samuel Elgood: His Life and Work 1851–1943*, London 1995

Eden, Frederick, *A Garden in Venice*, London 1903 (reissued in facsimile London 2003)

Elliott, Brent, *Victorian Gardens*, London 1986

Elliott, Brent, *The Country House Garden*, London 1995

F

Fearnley-Whittingstall, Jane, *The Garden. An English Love Affair*, London 2002

Feaver, William, *Lucian Freud*, exh. cat., Tate Britain 2002

Finlay, Alec (ed.), *Wood Notes Wild. Essays on the Poetry and Art of Ian Hamilton Finlay*, Edinburgh 1995

Finlay, Ian Hamilton, *Nature Over Again After Poussin: Some Discovered Landscapes*, exh. cat., Collins Exhibition Hall, University of Strathclyde 1980

Fletcher, Pauline, *Gardens and Grim Ravines: The Language of Landscape in Victorian Poetry*, Princeton 1983

G

Gage, John, *Colour and Culture: Practice and Meaning from Antiquity to Abstraction*, London 1993

Gale, Ian, *Arthur Melville*, Edinburgh 1996

Gale, Matthew, and Chris Stephens, *Barbara Hepworth, Works in the Tate Gallery Collections and the Barbara Hepworth Museum St Ives*, London 2001

Galinou, Mireille (ed.), *London's Pride: The Glorious History of the Capital's Gardens*, exh. cat., Museum of London 1990

Gore, Frederick, and Richard Shone (eds.), *Spencer Frederick Gore 1878–1914*, exh. cat., Anthony d'Offay, London 1983

Gore, Frederick, and Robert Upstone, *Spencer Gore in Richmond*, exh. cat., Museum of Richmond 1996

Gowing, Lawrence, *Lucian Freud*, London 1982

H

Harris, John, *The Artist and the Country House*, London 1979

Harrison, Michael, *Bournville: Model Village to Garden Suburb*, Chichester 1999

Helmreich, Anne, *The English Garden and National Identity: The Competing Styles of Garden Design, 1870–1914*, Cambridge 2002

Heron, Patrick, *Ivon Hitchens*, Harmondsworth 1955

Hiller, Susan, in *Genius loci – Kunst und Garten*, exh. cat., Kunstfreunde Lahr e.V. (Hg), Leipzig 2003

Hobhouse, Penelope, and Christopher Wood, *Painted Gardens: English Watercolours, 1850–1914*, London 1988

Holme, Bryan, *The Enchanted Garden. Images of Delight*, London 1982

Huish, Marcus B., *Happy England, as Painted by Helen Allingham, R.W.S.*, London 1903

Hunt, John Dixon, and Peter Willis (eds.), *The Genius of the Place. The English Landscape Garden, 1620–1820*, London 1975

Hunt, John Dixon (ed.), *The Oxford Book of Garden Verse*, Oxford 1994

Hunt, John Dixon, *Garden and Grove. The Italian Renaissance Garden and the English Imagination 1600–1750*, London 1986

Hussey, Christopher, *The Picturesque. Studies in a Point of View*, London 1983

Hyams, Edward, *The English Garden*, London 1964

Hyams, Edward, *English Cottage Gardens*, London 1970

Hyman, Timothy, and Patrick Wright (eds.), *Stanley Spencer*, exh. cat., Tate Britain 2001

J

Jackson, Alan A., *Semi-Detached London: Suburban Development, Life and Transport, 1900–1939*, London 1973

Jarman, Derek, *Modern Nature*, London 1991

Jarman, Derek, *Chroma. A Book of Colour – June '93*, London 1994

Jarman, Derek, *Derek Jarman's Garden*, London 1995

Jeffrey, Ian, *British Landscape 1920–1950*, London 1984

Jekyll, Francis, *Gertrude Jekyll: A Memoir*, London 1934

Jekyll, Gertrude, and George Elgood, *Some English Gardens*, London 1904

Jekyll, Gertrude, *Colour in the Flower Garden*, London 1908

Jekyll, Gertrude, *A Gardener's Testament*, London 1937

Jekyll, Gertrude, *Colour Schemes for the Flower Garden*, preface by T.H.D. Turner, Woodbridge 1982

K

Khoroche, Peter, *Ivon Hitchens*, London 1990

Kilmurray, Elaine, and Richard Ormond, *John Singer Sargent*, London 1998

Knoepflmacher, U.C., and G.B. Tennyson (eds.), *Nature and the Victorian Imagination*, Berkeley 1977

L

Laing, Jane, *Cicely Mary Barker and her Art*, London 1995

Lambarde, William, *Perambulation of Kent* (1576), Bath 1970

Laws, Bill, *Artists' Gardens*, London 1999

Le Lievre, Audrey, *Miss Willmott of Warley Place*, London 1980

Levy, Meryn, *Carel Weight*, London 1986

Light, Alison, *Forever England: Femininity, Literature and Conservatism Between the Wars*, London 1991

Lincoln, E.F., *The Heritage of Kent*, London 1966

Long, Philip, *William Gillies. Watercolours of Scotland*, Edinburgh 1994

Long, Philip, *John Maxwell 1905–1962*, Edinburgh 1999

Longstaffe-Gowan, Todd, *The London Town Garden 1740–1840*, New Haven and London 2001

Loudon, J.C., *An Encyclopaedia of Gardening, Comprising the Theory and Practice of Horticulture, Floriculture, Arboriculture, and Landscape-gardening*, London 1822

Loudon, J.C., *The Suburban Gardener and Villa Companion*, London 1838

Loudon, J.C., 'Descriptive Notices of Select Suburban Residences: Fortis Green', *Gardener's Magazine*, vol.16, 1840

M

Macartney, Mervyn, *English Houses and Gardens in the Seventeenth and Eighteenth Centuries*, London 1908

Major, Joshua, *The Theory and Practice of Landscape Gardening*, London 1852

Marshall, Catherine (ed.), *Breaking the Mould: British Art of the 1980s and 1990s: The Weltkunst Collection*, London and Dublin 1997

Marshall, Nancy Rose, and Malcolm Warner, *James Tissot. Victorian Life/Modern Love*, New Haven and London 1999

Matless, David, *Landscape and Englishness*, London 1998

Meacham, Standish, *Regaining Paradise. Englishness and the Early Garden City Movement*, New Haven and London 1999

Merritt, Anna Lea, *An Artist's Garden*, London 1908

Miles, Jonathan, and Derek Shiel, *David Jones. The Maker Unmade*, Bridgend 1995

Milette, Nicole, 'Landscape Painter as Landscape Gardener: the Case of Alfred Parsons, RA', unpublished PhD dissertation, University of York 1997

Millar, Jeremy, 'Dub Rosa', in *Graham Fagen – Lovely is Lovely*, exh. cat., The Fruitmarket Gallery, Edinburgh 2002

Miller, Mervyn, and A. Stuart Gray, *Hampstead Garden Suburb*, Chichester 1992

N

Nash, John, *The Artist Plantsman*, London 1976

Nixon, Mima, *Royal Palaces and Gardens*, London 1916

O

Oliver, Paul, Ian David and Ian Bentley, *Dunroamin: The Suburban Semi and its Enemies*, London 1994

Ottewill, David, *The Edwardian Garden*, New Haven and London 1989

P

Parris, Leslie (ed.), *The Pre-Raphaelites*, exh. cat., Tate Gallery, London 1984

Parsons, Alfred, *Notes in Japan*, London 1896

Pater, Walter, *Miscellaneous Studies*, Oxford 1895

Paterson, Arthur, *The Homes of Tennyson*, London 1905

Peake, Tony, *Derek Jarman*, London 1999

Phillips, Claude, *Frederick Walker and his Works*, London 1897

Phillips, Miranda, and Chris Stephens, *Barbara Hepworth Sculpture Garden*, London 2002

Pevsner, Nikolaus, *The Englishness of English Art*, London 1956

Pople, Kenneth, *Stanley Spencer. A Biography*, London 1991

Purdom, C.B., *The Garden City: A Study in the Development of a Modern Town*, London 1913

Q

Quinn, Marc, *The Overwhelming World of Desire (Paphiopedilum Winston Churchill Hybrid)*, exh. booklet, Sculpture at Goodwood 2003

R

Rayson, David, *somewhere else is here*, with introductory essay by Amanda Sawyer, exh. cat., Kettle's Yard, Cambridge 2003

Repton, Humphry, *The Landscape Gardening and Landscape Architecture of the Late Humphry Repton ... a New Edition ... by J.C. Loudon*, London 1840

Reynolds, Gwynneth, and Diana Grace, *Benton End Remembered*, London 2002

Reynolds, Jan, *Birket Foster*, London 1984

Ridgway, Christopher, 'William Andrews Nesfield: Between Uvedale Price and Isambard Kingdom Brunel', *Journal of Garden History*, vol.13, 1993

Ridgway, Christopher (ed.), *William Andrews Nesfield: Victorian Landscape Architect*, York 1996

Robertson, Alexander, *Atkinson Grimshaw*, London 1998

Robinson, William, *The English Flower Garden*, London 1883

Robinson, William, *The English Flower Garden*, fourth edition, London 1895

Robinson, William, *Gravetye Manor, or Twenty Years Work round an Old Manor House*, London 1911

Rosenfeld, Jason M, 'New Languages of Nature in Victorian England: the Pre-Raphaelite Landscape, Natural History and Modern Architecture in the 1850s', unpublished PhD dissertation, New York University 1999

Rothenstein, John, *Charles Mahoney. A Tribute on the Occasion of a Memorial Exhibition*, London 1975

Rothenstein, John, *John Nash*, London 1983

Rugoff, Ralph, *The Greenhouse Effect*, exh. cat., Serpentine Gallery, London 2000

S

Sayer, Karen, *Country Cottages: A Cultural History*, Manchester 2000

Shaw, George, *What I did this Summer*, foreword by Katrina Brown and Jonathan Watkins, exh. cat., Ikon Gallery, Birmingham 2003

Sheeler, Jessie, *Little Sparta: The Garden of Ian Hamilton Finlay*, London 2003

Sidgwick, Mrs Alfred, *The Children's Book of Gardening*, London 1909

Silberrad, Una, *Dutch Flowers and Gardens*, London 1909

Simo, Melanie Louise, *Loudon and the Landscape. From Country Seat to Metropolis*, New Haven and London 1988

Silverstone, Roger (ed.), *Visions of Suburbia*, London and New York 1997

Smee, Alfred, *My Garden: Its Plan and Culture*, London 1872

Smith, Bill, *The Life and Work of Edward Atkinson Hornel*, Edinburgh 1997

Smith, Edwin, *Edwin Smith Photographs 1935–71*, London 1984

Smith, W. Gordon, *W.G. Gillies. A Very Still Life*, Edinburgh 1991

Soden, Joanna, and Victoria Keller, *William Gillies*, Edinburgh 1998

Sotheby's, *The Glory of the Garden*, exh. cat., London 1987

Stephens, Chris, *The Sculpture of Hubert Dalwood*, London 1999

Strong, Roy, *The Artist and the Garden*, New Haven and London 2000

Swinstead, G. Hillyard, *The Story of My Old-world Garden (dimensions 55 ft. x 45 ft.) and How I Made It in a London Suburb*, London 1910

Sylvester, David (ed.), *Patrick Heron*, exh. cat., Tate Gallery, London 1998

T

Tankard, Judith B., and Martin Wood, *Gertrude Jekyll at Munstead Wood: Writing, Horticulture, Photography, Homebuilding*, Stroud 1996

Taylor, John RJ, *Ideal Home: a detached look at modern living*, Manchester 1989

Taylor, Judy, Joyce Irene Whalley, Anne Stevenson Hobbs and Elizabeth M. Battrick, *Beatrix Potter 1866–1943. The Artist and her World*, London 1987

Thomas, Alice, *The Art of Hilda Carline. Mrs Stanley Spencer*, exh. cat., The Iveagh Bequest, Kenwood, London 1999

Thompson, Ron, *Easel in the Field: The Life of James McIntosh Patrick*, Dundee 2000

Tooley, M.J. (ed.), *William Andrews Nesfield, 1794–1881: Essays to Mark the Bicentenary of his Birth*, Durham 1994

Tooley, Michael, and Primrose Arnander (eds.), *Gertrude Jekyll, Essays on the Life of a Working Amateur*, Witton-le-Wear 1995

Traeger, Tessa, and Patrick Kinmonth, *A Gardener's Labyrinth. Portraits of People, Plants and Places*, exh. cat., National Portrait Gallery, London 2003

Tufnell, Ben, *Cedric Morris and Lett Haines. Teaching Art and Life*, exh. cat., Castle Museum, Norwich 2002

U

Uglow, Jenny, *A Little History of British Gardening*, London 2004

W

Waterfield, Margaret, *Garden Colour*, with contributions by Eleanor Vere Boyle, Maria Teresa Earle, Rose G. Kingsley and Vicary Gibbs, London 1905

Webster, Roger (ed.), *Expanding Suburbia: Reviewing Suburban Narratives*, New York 2000

Weight, R.V., *Carel Weight. A Haunted Imagination*, Newton Abbot 1994

Whitehand, J.W.R., and C.M.H. Carr, *Twentieth Century Suburbs: A Morphological Approach*, London 2001

Wilkinson, J. Gardner, *On Colour*, London 1858

Wilson, Andrew, *Patrick Heron, Early and Late Garden Paintings*, exh. cat., Tate St Ives 2001

THRESHOLDS AND PROSPECTS

1 John Constable (1776–1837)
Golding Constable's Flower Garden 1815
Oil on canvas, 33 x 50.8
Ipswich Borough Council, Museums and Galleries
LONDON ONLY

2 John Constable (1776–1837)
Golding Constable's Vegetable Garden 1815
Oil on canvas, 33 x 50.8
Ipswich Borough Council, Museums and Galleries
LONDON ONLY

3 Joseph Mallord William Turner (1775–1851)
View from the Terrace of a Villa at Niton, Isle of Wight, from Sketches by a Lady exh.1826
Oil on canvas, 45.5 x 61
Museum of Fine Arts, Boston

4 Atkinson Grimshaw (1836–1893)
Knostrop Hall, Early Morning 1870
Oil on canvas, 59.7 x 90.2
Private Collection

5 Arthur Melville (1855–1904)
A Cabbage Garden 1877
Oil on canvas, 45.1 x 30.5
Andrew McIntosh Patrick

6 William York MacGregor (1855–1923)
A Cottage Garden, Crail 1883
Oil on canvas, 40.5 x 63.5
Private Collection

7 Edward Atkinson Hornel (1864–1933)
In the Crofts, Kirkcudbright 1885
Oil on canvas, 40.6 x 61
Private Collection

8 Edward Atkinson Hornel (1864–1933)
In Mine Own Back Garden 1887
Oil on canvas, 40.6 x 30.5
Hunterian Art Gallery,
University of Glasgow

9 Camille Pissarro (1830–1903)
Bath Road, London 1897
Oil on canvas, 54 x 65
Ashmolean Museum, Oxford,
Pissarro Family Gift, 1951

10 Spencer Gore (1878–1914)
The Fig Tree 1912
Oil on canvas, 63.5 x 76.2
Tate. Bequeathed by J.W. Freshfields 1955

11 Spencer Gore (1878–1914)
From a Window in Cambrian Road, Richmond 1913
Oil on canvas, 56 x 68.5
Tate. Presented by subscribers 1920

12 Spencer Gore (1878–1914)
The West Pier, Brighton 1913
Oil on canvas, 63.5 x 76.2
Collection of the Mellon Financial Corporation,
Pittsburgh

13 William Ratcliffe (1870–1955)
Hampstead Garden Suburb from Willifield Way c.1914
Oil on canvas, 51 x 76.3
Tate. Lent by Hampstead Garden Suburb

14 Evelyn Dunbar (1906–1960)
Winter Garden c.1929–37
Oil on canvas, 30.5 x 91.4
Tate. Purchased 1940

15 Harry Epworth Allen (1894–1958)
Village Allotments 1937
Tempera on canvas board, 45.5 x 59.5
Private Collection

16 Stanley Spencer (1891–1955)
Cookham Rise 1938
Oil on canvas, 45.7 x 61
Art Gallery and Museum, Royal Pump Rooms,
Leamington Spa (Warwick District Council)

17 Charles Mahoney (1903–1968)
Wrotham Place from the Garden c.1938–9
Oil on canvas, 40.7 x 61
Tate. Presented by the Trustees of the Chantrey
Bequest 1993

18 James McIntosh Patrick (1907–1998)
A City Garden 1940
Oil on canvas, 71 x 91.4
McManus Galleries, Dundee City Council,
Leisure and Arts

19 Adrian Allinson (1890–1959)
*The A.F.S. (Auxiliary Fire Service)
Dig for Victory in St James's Square* c.1942
Oil on canvas, 55.5 x 120
City of Westminster Archives Centre

20 Charles Ginner (1878–1952)
Bethnal Green Allotment 1943
Oil on canvas, 55.9 x 76
Manchester Art Gallery

21 Cedric Morris (1889–1982)
Wartime Garden c.1944
Oil on canvas, 61 x 76.5
Estate of Cedric Morris

22 Harry Bush (1883–1957)
A Corner of Merton, 16 August, 1940
exh.1945
Oil on canvas, 94 x 127
Imperial War Museum, London

23 Douglas Percy Bliss (1900–1984)
Gunhills, Windley 1946–52
Oil on canvas, 76.2 x 101.6
Tate. Purchased 1981

24 Stanley Spencer (1891–1955)
The Hoe Garden Nursery 1955
Oil on canvas, 67.8 x 108.2
Plymouth City Museums and Art Gallery

25 David Rayson (born 1966)
Patio 1998
Acrylic on board, 77.5 x 111.8
Private Collection, New York

26 George Shaw (born 1966)
An English Autumn Afternoon 2003
Humbrol enamel on board, 77 x 101
Collection of Joel and Nancy Portnoy

THE SECRET GARDEN

27 John Constable (1776–1837)
View in a Garden at Hampstead, with a Red House beyond 1821
Oil on canvas, 35.5 x 30.5
Victoria & Albert Museum, London
MANCHESTER ONLY

28 Samuel Palmer (1805–1881)
In a Shoreham Garden c.1829
Watercolour and bodycolour, 27.9 x 22.2
Victoria & Albert Museum, London
LONDON ONLY

29 Thomas Churchyard (1798–1865)
The Garden Tent c.1850
Oil on oak, 18 x 16.4
Tate. Presented anonymously in memory of Sir
Terence Rattigan 1983

30 Richard Dadd (1817–1886)
Portrait of a Young Man 1853
Oil on canvas, 60.9 x 50.7
Tate. Bequeathed by Ian L. Phillips 1984,
and accessioned 1992

31 Arthur Hughes (1832–1915)
April Love 1855–6
Oil on canvas, 88.9 x 49.5
Tate. Purchased 1909

32 Albert Moore (1841–1893)
A Garden 1869
Oil on canvas, 174.5 x 88
Tate. Purchased with assistance from
the Friends of the Tate Gallery 1980

33 Fred Walker (1840–1875)
An Amateur 1870
Watercolour and bodycolour, 17.7 x 25.4
The British Museum, London

34 James Tissot (1836–1902)
Holyday c.1876
Oil on canvas 76.2 x 99.4
Tate. Purchased 1928

35 John William Waterhouse
(1849–1917)
Psyche Opening the Door into Cupid's Garden
1904
Oil on canvas, 106.7 x 68.5
Harris Museum and Art Gallery, Preston

36 Ernest Arthur Rowe (1862–1922)
Campsea Ashe, Suffolk c.1904–5
Watercolour, 41.9 x 53.3
Private Collection

37 Helen Beatrix Potter (1866–1943)
*'The Rabbits' Potting Shed': two rabbits busy
potting geraniums* 1891
Watercolour, 21 x 16.5
Victoria & Albert Museum, London

38a–b Helen Beatrix Potter
(1866–1943)
From *The Tale of Peter Rabbit* 1901
a *Peter Hiding in the Potting Shed*
b *Peter Sees the White Cat*
Watercolour, each 9.4 x 7.3
Frederick Warne Archive, London
LONDON ONLY

39 Cicely Mary Barker (1895–1973)
The Rose Fairy c.1925
Watercolour, 21 x 14.9
Frederick Warne Archive, London

40 Cicely Mary Barker (1895–1973)
The Geranium Fairy c.1944
Watercolour, 21 x 14.9
Frederick Warne Archive, London

41 Stanley Spencer (1891–1959)
Zacharias and Elizabeth 1913–14
Oil on canvas, 142.6 x 142.8
Tate. Purchased jointly with Sheffield Galleries &
Museums Trust with assistance from the National
Lottery through the Heritage Lottery Fund, the

National Art Collections Fund, the Friends of the
Tate Gallery, Howard and Roberta Ahmanson and
private benefactors 1999

42 Hilda Carline (1889–1950)
Melancholy in a Country Garden 1921
Oil on canvas, 59.8 x 64.4
Private Collection

43 David Jones (1895–1974)
The Garden Enclosed 1924
Oil on panel, 35.6 x 29.8
Tate. Presented by the Trustees of the Chantrey
Bequest 1975

44 Eric Ravilious (1903–1942)
The Greenhouse: Cyclamen and Tomatoes 1935
Watercolour and pencil on paper, 47 x 59.7
Tate. Presented by Sir Geoffrey and the Hon. Lady
Fry in memory of the artist 1943

45 C. Eliot Hodgkin (1905–1987)
The Haberdashers' Hall, 8 May 1945 1945
Tempera on panel, 29.2 x 36.8
Imperial War Museum, London

46 C. Eliot Hodgkin (1905–1987)
*St Paul's and St Mary Aldermary from
St Swithin's Churchyard* 1945
Tempera on panel, 50 x 36
Private Collection

47 Charles Mahoney (1903–1968)
The Garden 1950
Oil on canvas, 182.9 x 121.9
Paul Liss Fine Art Ltd, London

48 Charles Mahoney (1903–1968)
Autumn c.1951
Oil on board 215.5 x 124
Elizabeth Bulkeley, the Artist's Daughter

49 Barbara Hepworth (1903–1975)
Corymb 1959
Bronze, 29.2 x 35.6 x 24.1
Private Collection

50 Carel Weight (1908–1997)
The Silence 1965
Oil on panel, 91.4 x 121
Royal Academy of Arts, London

51 John Shelley (born 1938)
Annunciation 1968
Oil on board, 95.9 x 156.8
Tate. Purchased by the Trustees of the Chantrey
Bequest 1969

52 David Inshaw (born 1943)
The Badminton Game 1972–3
Oil on canvas, 152.4 x 183.5
Tate. Presented by the Friends of the Tate Gallery
1980

53 Ivor Abrahams (born 1935)
Shrub Group 1975
Metal cut-out with decal transfer, 120 x 140 x 25
Courtesy of the artist

54 Hubert Dalwood (1924–1976)
Bonsai Garden II 1975
Bronze, pebbles and plant, 9 x 62 x 55
Gimpel Fils, London

55 John Pearce (born 1942)
Clement's Garden 1986
Oil on board, 150 x 91
Private Collection, courtesy Francis Kyle Gallery,
London

56 Mat Collishaw (born 1966)
Who Killed Cock Robin? 1997
Iris print, 107.5 x 81
Courtesy the artist and Modern Art, London

57 Sarah Jones (born 1959)
The Garden (Mulberry Lodge) VI 1997
Photograph on paper on aluminium, 150 x 150
Tate. Purchased 1999

58 Lucian Freud (born 1922)
Garden from the Window 2002
Oil on canvas, 71.1 x 60.6
Acquavella Contemporary Art Inc., New York
LONDON ONLY

FRAGMENTS AND INSCRIPTIONS

59 William Nicholson (1872–1949)
Miss Jekyll's Gardening Boots 1920
Oil on plywood, 32.4 x 40
Tate. Presented by Lady Emily Lutyens 1944

60a–e Paul Nash (1889–1946)
a *The Grotto at 3 Eldon Grove NW3* 1936–9
b *Border Plants and the Sword of a Swordfish*
1936–9
c *Stone Form in Arcadia (Stone Eagle,
Springfield)* c.1940–1
d *Box Garden, Beckley Park, Oxfordshire*
c.1940–1
e *The Haunted Garden* c.1940–1
Photographs, each 23.5 x 39.3,
except 60c 39.3 x 23.5
Tate Archive

61a–e Edwin Smith (1912–1971)
a *Nymph of the Grot, Stourhead, Wiltshire* 1956
b *Sphinx at Bodnant* 1962
c *Vita Sackville-West's Boots,*
Sissinghurst, Kent 1962
d *Garden Seat, Rousham,*
Oxfordshire 1966
e *Essex, Saffron Walden* 1970
Photographs, each 41.7 x 30.5, except
61b 30.5 x 41.7
RIBA Library Photographs Collection, London

62 Gerry Badger (born 1946)
Derelict Garden, Primrose Hill c.1977
Photograph, 54.3 x 74.9
Victoria & Albert Museum, London

63 Gerry Badger (born 1946)
The Hall, Wormingford c.1982
Photograph, 47 x 57
Victoria & Albert Museum, London

64 Ian Hamilton Finlay (born 1925)
Sundial: A Small Interruption in the Light 1977
Slate with metal gnomon and brick plinth,
sculpture 62 x 53.3 x 53.3; plinth
40.3 x 53.3 x 53.3
Arts Council Collection, Hayward Gallery, London

65 Ian Hamilton Finlay (born 1925)
Nature Over Again After Poussin 1979–80
Eleven black and white photographs, each in
halves mounted separately on perspex; plinths;
recorded flute music; each photograph 49.5 x 29.2,
overall dimensions variable
Scottish National Gallery of Modern Art, Edinburgh

66 Ivor Abrahams (born 1935)
Funerary Urn 1978
Screenprint, varnish and embossing on paper,
68.5 x 45.5
Tate. Presented by Evelyne Abrahams, the artist's wife
1986

67 John RJ Taylor (born 1958)
North London 1982
Photograph, 47 x 57
Victoria & Albert Museum, London

68 John RJ Taylor (born 1958)
Back garden patio with precast ornaments
1983–7
Photograph, 47 x 57
Victoria & Albert Museum, London

69 Richard Wentworth (born 1947)
Guide 1984–8
Rubber and concrete, 42 x 33 x 12
Arts Council Collection, Hayward Gallery, London

70 Richard Wentworth (born 1947)
Piece of Fence 1990
Thirteen garden tools and wire, 181.6 x 228.6 x 15.2
Private Collection

71a–d Howard Sooley (born 1942)
Derek Jarman's Garden at Dungeness c.1990
Four photographs, each 50.8 x 61
Courtesy the artist

72a–e David Spero (born 1963)
From *Garden* 1998–2003
a *Madeleine's Garden, June 1998*
b *Madeleine's Garden, February 1999*
c *Sophie's Garden, May 2000*
d *Sophie's Garden, October 2001*
e *Charlotte's Garden, September 2003*
C-type photographic prints, each 61 x 50.8
(image 46.9 x 36.8)
Courtesy the artist

73a–b Martin Parr (born 1952)
From *North Circular* 2001
a *Fairholme Gardens, N3, London*
b *Fairholme Gardens, N3, London*
Photographs, each 121.9 x 79.1
Courtesy the artist

74 Ivan and Heather Morison (born
1974 and 1973)
Garden 114 2001–3
Twelve printed cards, each 13.5 x 13.5
Private collection

COLOURED GROUNDS

75 John Singer Sargent (1856–1925)
Carnation, Lily, Lily, Rose 1885–6
Oil on canvas, 174 x 153.7
Tate. Presented by the Trustees of the Chantrey
Bequest 1887

76 Gertrude Jekyll (1843–1932)
'The Sun of Venice Going to Sea',
after J.M.W. Turner c.1870
Oil on canvas, 59 x 89
Godalming Museum

77a–d Attributed to Herbert Cowley
(1885–1967)
a *Iris and Lupin Border, Munstead Wood* c.1911
b *The Grey Garden, Munstead Wood* c.1911
c *The Red Section of the Main Flower Border,*
Munstead Wood c.1912
d *The Michaelmas Daisy Border,*
Munstead Wood c.1912
Prints taken from original autochromes,
print size 20.1 x 25.2
Country Life Picture Library

78 Helen Allingham (1848–1926)
Gertrude Jekyll's Garden, Munstead Wood c.1900
Pencil and watercolour on paper, 53.3 x 44.5
Penelope Hobhouse

79 Helen Allingham (1848–1926)
The Kitchen Garden at Farringford c.1890s
Watercolour on paper, 37.5 x 28.6
Private Collection

80 Alfred Parsons (1847–1920)
Warley Place: Daffodils and Pergola
date unknown
Watercolour on paper, 38.1 x 49.5
Private Collection

81 Alfred Parsons (1847–1920)
Warley Place: Lilies 1898
Watercolour on paper, 35.6 x 54.6
Private Collection

82 Alfred Parsons (1847–1920)
Orange Lilies, Broadway 1911
Oil on canvas, 92 x 66
Royal Academy of Arts, London

83 Alfred Parsons (1847–1920)
The Artist's Garden at Luggers Hill,
Broadway after 1912
Watercolour, 45.7 x 61
Private Collection

84 Margaret Waterfield (1860–1950)
Oriental Poppy and Lupin, Nackington,
Canterbury c.1904
Watercolour, 24.1 x 37.5
Private Collection, USA
LONDON ONLY

85 George Samuel Elgood (1851–1943)
The Sun Dial, Knockwood exh.1923
Watercolour on paper, 33.5 x 26.5
Maidstone Museum and Bentlif Art Gallery

86 Beatrice Parsons (1870–1955)
August Flowers, The Pleasaunce, Overstrand,
Norfolk date unknown
Watercolour on paper, 35.5 x 45.7
Private Collection

87 Cedric Morris (1889–1982)
Iris Seedlings 1943
Oil on canvas, 122 x 91.7
Tate. Purchased 1981

88 Ivon Hitchens (1893–1979)
Garden Cove 1952–3
Oil on canvas, 44 x 108
Arts Council Collection, Hayward Gallery, London

89 Patrick Heron (1920–1999)
Azalea Garden: May 1956 1956
Oil on canvas, 152.4 x 127.6
Tate. Purchased 1980

90 Patrick Heron (1920–1999)
Autumn Garden: 1956 1956
Oil on canvas, 182.9 x 91.5
Estate of Patrick Heron

91 John Maxwell (1905–1962)
Night Flowers 1959
Oil on canvas, 91.4 x 61
Tate. Purchased 1959

92 William Gillies (1898–1973)
Garden, Temple, Winter Moon 1961
Oil on canvas, 96.5 x 121.9
Paisley Museum and Art Gallery

93 Adrian Berg (born 1929)
Gloucester Gate, Regent's Park 1982
Oil on canvas, 177.5 x 177.4
Tate. Presented by the Trustees of the Chantrey
Bequest 1984

94 Anya Gallaccio (born 1963)
Red on Green 1992
10,000 fragrant English tea roses, heads laid on a
bed of thorns, approximately 300 x 400
James Hyman Fine Art, London

95 Gary Hume (born 1962)
Four Feet in the Garden 1995
Gloss paint on aluminium panel, 221 x 170
Arts Council Collection, Hayward Gallery, London

96 Gary Hume (born 1962)
What Time is It? 2001
Gloss paint on aluminium panel, 150 x 120
Mr and Mrs Kennaway

REPRESENTING AND INTERVENING

97a–d Richard Wentworth (born 1947)
From the series *Occasional Geometries*
a *Gloucestershire, England* 1997
b *Tottenham Court Road, London* 1998
c *King's Cross, London* 2002
d *Islington, London* 2002
Photographs, each 25.4 x 30
Courtesy the artist and the Lisson Gallery, London

98 Graham Fagen (born 1966)
Lawn 1999
Fujicolor crystal archive print mounted
on aluminium with printed text on paper,
print 76.2 x 101.6, text 29.7 x 21
Courtesy of the artist/Doggerfisher Gallery,
Edinburgh/Matt's Gallery, London

99 Graham Fagen (born 1966)
Where the Heart is 2001
Hybrid tea rose, dimensions variable
Courtesy the artist, purchased from Cocker's
Nursery, Aberdeen

100 Graham Fagen (born 1966)
Where the Heart is 2002
Bronze, 50 x 50 x 50
Courtesy of the artist/Doggerfisher Gallery,
Edinburgh/Matt's Gallery, London

101 Nils Norman (born 1966)
*The Gerrard Winstanley Radical Gardening Space
Reclamation Mobile Field Center and Weather
Station (European Chapter)* 2000
Bicycle with trailer, library, weather station,
solar-powered photocopier, 211 x 220 x 74
Private Collection, Germany

102 Marc Quinn (born 1964)
75 Species 2000
Pencil, watercolour and collage on paper,
154.2 x 220 x 5
Courtesy the artist and Jay Jopling/White Cube,
London

103 Marc Quinn (born 1964)
Italian Landscape (Z) 2000
Permanent pigment on canvas, 53 x 79.5
Courtesy the artist and Jay Jopling/
White Cube, London

104 Marc Quinn (born 1964)
*The Overwhelming World of Desire
(Paphiopedilum Winston Churchill Hybrid)*
2002
Pigment on steel, 8 metres high
Courtesy Sculpture at Goodwood and Jay Jopling/
White Cube, London

105 Sarah Jones (born 1959)
The Fence (Passion Flower) II 2002
C-type print mounted on aluminium, 150 x 150
Courtesy of the artist and Maureen Paley/Interim
Art, London

106 Paul Morrison (born 1966)
Sepal 2002
Acrylic on canvas, 274 x 183
Courtesy aspreyjacques, London

107 Paul Morrison (born 1966)
Garden 2003
Acrylic on canvas, 54 x 44.5
Private Collection
LONDON ONLY

108 Dee Ferris (born 1973)
Hallelujah 2003
Oil on canvas, 183 x 152.5
Courtesy Corvi-Mora, London

109 Susan Hiller (born 1943)
What Every Gardener Knows 2003
CD, modified CD player, timer,
dimensions variable
Courtesy the artist

110a–b Janice Kerbel (born 1969)
From *Home Climate Gardens* 2003
a *Council Flat*
b *Victorian Terrace*
Ink on paper, each 100 x 70
Courtesy the artist, commissioned
by Tyndall Centre for Climate Change
Research and Norwich Art Gallery

111 Ivan and Heather Morison (born
1974 and 1973)
Audio recordings from Global Survey 2003
CD, CD player and speakers
Courtesy the artists, supported by Vivid
through the hothaus programme

112 Jacques Nimki (born 1959)
Florilegium 2003
Acrylic, laminate and pressed flowers, 194 x 142
Courtesy the approach, London

113 David Rayson (born 1966)
Night Garden 2003
Ink on paper, 102 x 72
Courtesy the artist and Maureen Paley/
Interim art, London

114 David Rayson (born 1966)
All day Wednesday, Thursday and today 2003
Ink on paper, 102 x 72
Courtesy the artist and Maureen Paley/
Interim art, London

115a–d George Shaw (born 1966)
a *The Back Garden II (Summer)* 2003
b *The Back Garden IV (Winter)* 2003
c *The Back Window* 2003
d *Dad's Roses* 2003
Watercolour, each 29.5 x 42, except 115d 22 x 30.2
Courtesy the artist and Wilkinson Gallery, London

CATALOGUE ILLUSTRATIONS

Photograph courtesy the artist/the artist's estate 53, 72, 99–101, 109–11
Courtesy aspreyjacques/Andy Keate 106, 107
Courtesy the approach 112
© Gerry Badger/V&A 62, 63
Photograph © Museum of Fine Arts, Boston 3
© The Bridgeman Art Library/Harris Museum and Art Gallery, Preston 35
© The Bridgeman Art Library/ Maidstone Museum of Art 85
Courtesy Corvi-Mora 108
Country Life Picture Library 77
McManus Galleries, Dundee City Council 18
Owen Edelsten 7
© The Scottish Gallery of Modern Art, Edinburgh/Antonia Reeve photography 65
Hunterian Art Gallery, University of Glasgow 8
Courtesy Gimpel Fils 54
Courtesy Godalming Museum 76
© Sculpture at Goodwood 104
Courtesy Richard Green Galleries, London 4
Ipswich Borough Council Museums and Galleries 1, 2
Courtesy Francis Kyle 55
Photograph courtesy the lender 46, 84
Courtesy Paul Liss Fine Art 47, 48
Arts Council Collection, Hayward Gallery, London/John Webb 64, 69, 88, 95
© The British Museum, London 33
Fine Art Society, London 5
Imperial War Museum, London 22, 45
© Royal Academy of Arts, London 2002/ John Hammond 50, 82
© Manchester Art Gallery 20
Paul Nash/Tate Photography 60
Courtesy Acquavella Contemporary Art, New York 58
© The Ashmolean Museum, Oxford 9
Courtesy Maureen Paley Interim Art 25, 58, 105, 113, 114
Paisley Musuems and Art Galleries, Renfrewshire Council 92
Martin Parr/Magnum Photos 73
Beth Phillips Art Transparencies 26
Courtesy Mellon Financial Corporation, Pittsburgh, PA 12
© City of Plymouth Museums and Art Gallery 24
RIBA Library Photographs Collection/ Edwin Smith 61
Courtesy Royal Pump Rooms, Royal Leamington Spa 16
© Howard Sooley 71
Tate 10, 11, 13, 14, 17, 23, 29–32, 34, 41, 43, 44, 51, 52, 59, 66, 75, 87, 89, 91, 93
Tate Photography/Marcus Leith and Andrew Dunkley 15, 36, 42, 78, 80, 81, 83
Tate Photography/David Lambert 49
Tate Photography/Rodney Tidnam 57, 74
© John RJ Taylor/V&A 67, 68
© V&A Images 27, 28
Courtesy Waddington Galleries 90
Reproduced by permission of Frederick Warne & Co 37–40
Westminster City Archives 19
Courtesy White Cube/Stephen White 96, 102, 103
Courtesy Wilkinson Gallery 115
Courtesy Christopher Wood 79, 86
Edward Woodman for Karsten Schubert 94

FIGURE ILLUSTRATIONS

Courtesy the artist's estate 28
© Birmingham Museums and Art Gallery 16
© The Bridgeman Art Library/Birmingham Museums and Art Gallery 11
© The Bridgeman Art Library/Christopher Wood Gallery 26
Fitzwilliam Museum, Cambridge 15
© The National Gallery of Scotland, Edinburgh 3
Courtesy Lindley Library 20, 21, 24, 25, 29–38
By permission of the British Library, London 12, 13, 22
The British Museum, London 2, 14
Reproduced courtesy the London Transport Museum 17
Tate 1, 6
Tate Photography/Rodney Tidnam 19
Courtesy Michael Tooley 23

ARTIST'S GARDENS ILLUSTRATIONS

All courtesy the artist/artist's estate, excluding:
© The Bridgeman Art Library/ Sheffield Galleries and Museums Trust p.219
Country Life Picture Library p.220
Tessa Traeger p.234
Andrew Lawson p.245
Howard Sooley pp.236–7

Ivor Abrahams
Acquavella Galleries, New York
aspreyjacques, London
Boston, Museum of Fine Arts
Elizabeth Bulkeley
Corvi-Mora, London
Country Life Picture Library
Doggerfisher Gallery, Edinburgh
Dundee, McManus Galleries, Dundee City Council,
 Leisure and Arts
Edinburgh, Scottish National Gallery of Modern Art
Estate of Patrick Heron
Estate of Cedric Morris
Frederick Warne & Co Ltd., London
Gimpel Fils, London
Glasgow, Hunterian Art Gallery, University of
 Glasgow
Godalming Museum
Goodwood Sculpture Park
Ipswich Borough Council, Museums and Galleries
Susan Hiller
Penelope Hobhouse
James Hyman Fine Art, London
Jay Jopling/White Cube
Mr and Mrs Kennaway
Janice Kerbel
Leamington Spa, Art Gallery and Museum, Royal
 Pump Rooms (Warwick District Council)
Lisson Gallery, London
Vicky and Kent Logan
London, Arts Council Collection, Hayward Gallery
London, British Museum
London, City of Westminster Archives Centre
London, Imperial War Museum
London, RIBA Archive
London, Royal Academy of Arts
London, Tate
London, Victoria and Albert Museum
Maidstone Museum and Bentlif Art Gallery
Manchester Art Gallery
Maureen Paley/Interim Art, London
Mellon Financial Corporation
Ivan and Heather Morison
Jacques Nimki
Oxford, Ashmolean Museum
Paisley Museum and Art Gallery
Martin Parr
Paul Liss Fine Art Ltd., London
Plymouth City Museums and Art Gallery
Joel and Nancy Portnoy
Preston, Harris Museum and Art Gallery
Private Collections
Private Collection, courtesy Christopher Wood
 Gallery, London
Private Collection, courtesy Francis Kyle Gallery,
 London
Sheffield Galleries and Museums Trust
Howard Sooley
David Spero
Wilkinson Gallery, London

Numbers in bold refer to
main entries.

A

Abbey, Edwin Austin 27, 221;
no.**75**
Abrahams, Ivor
Funerary Urn 133; no.**66**
'Garden Emblems' no.**53**
Monuments 133; no.**66**
Shrub Group no.**53**
The Sphinx no.**66**
Wounded Warrior no.**66**
Aesthetic Movement 52; no.**32**
Aldridge, John 18, 227
Allen, Harry Epworth
Village Allotments no.**15**
Allingham, Helen 14–15, 16,
20, 37, 44; no.**77**
The Charm of Gardens 44
The Cottage Homes of England 15
Cutting Cabbages 15; fig.4
*Gertrude Jekyll's Garden, Munstead
Wood* 158; no.**78**
Happy England 14, 44; no.**78**
The Homes of Tennyson 44; no.**79**
The Kitchen Garden at Farringford
no.**79**
Allingham, William 14;
nos.**39**, 78–9
Allinson, Adrian
*The A.F.S. Dig for Victory in
St James's Square* no.**19**
allotment movement 13–14, 16,
18, 20, 28, 50; nos.7, 9, 15,
17, 74
Dig for Victory campaign
18; nos.18–21
Alma-Tadema, Lawrence no.**35**
Altdorfer, Albrecht no.**65**
The Ancients no.**28**
Anderson, Mary 221; no.**75**
Andre, Carl no.**94**
Angus, Peggy no.**44**
Apuleius, Lucius
The Golden Ass no.**35**
Arcadian imagery 132–3
Argenville, Dezallier d'
Théorie et pratique du jardinage 40
Arley Hall, Cheshire 45
Arnold-Forster, William 231,
233; no.**90**
Shrubs for the Milder Counties
231, 233; no.**90**
artist/gardeners 31, 33–9,
44–5, 158–9, 229–37
Arts and Crafts Movement
27, 28, 29; nos.9, 22
Atelier van Lieshout no.**101**
Atget, Eugène nos.61, 63
Austin, Alfred
The Garden That I Love 44;
fig.35

B

Bacon, Francis 227
Badger, Gerry 132–3

Derelict Garden, Primrose Hill
no.**62**
The Hall, Wormingford no.**63**
Bailey, Henry 42
Bann, Stephen no.**65**
Barker, Cicely Mary
'Flower Fairy' books 94;
nos.**39–40**
Barnard, Frank no.**75**
Barnett, Henrietta no.**13**
Barrie, Sir James Matthew
Peter Pan no.**39**
Bartram, Bernard 25
Bartram, Robert no.**24**
Bastien-Lepage, Jules 15
Bateman, James no.**16**
Battersea, Cyril Flower, Lord
no.**86**
Bawden, Edward 17–18, 225;
nos.**44**, 47
Beckley Park, Oxfordshire
no.**60d**
Bede, the Venerable 51
Bedford Park 27; no.**9**
Bedwell Lodge, Hertfordshire
nos.**37–8**
Bennett, Arnold no.**12**
Benton End, Hadleigh 17,
226–7; nos.21, 58, 87
Berg, Adrian
Gloucester Gate, Regent's Park 159;
no.**93**
Berger, John 233
Betjeman, John 29
bird's-eye views 60–1
Bisham Abbey, Berkshire no.**33**
Blake, William nos.28, 50
Bliss, Douglas Percy no.**44**
Gunhills, Windley no.**23**
Bodichon, Barbara Leigh Smith
nos.76, 78
Bodnant no.**61b**
Bone, Muirhead no.**42**
bonsai no.**54**
Bowles, E.A. 46
Bowles, Thomas fig.29
Brabazon, Hercules Brabazon
35; no.**76**
Brighton no.**12**
Brighton Pavilion 42
Broadway circle 38, 158–9,
220–1; nos.75, 82–3
Brooke, E. Adveno
Gardens of England 43; fig.32
Broughton House,
Kirkcudbright 222–3
Brown, Capability 42, 49
Brown, Ford Madox
An English Autumn Afternoon 26;
fig.16; no.**26**
Work 26
Brown, Jane no.**82**
Browning, Robert 14
Buckley, Jeff no.**108**
Burchardt, Jeremy 13–14
Burnett, Frances Hodgson
The Secret Garden 94

Burns, Robert no.**99**
Burra, Edward no.**60**
Bush, Harry
*A Corner of Merton, 16 August,
1940* no.**22**
Spring Morning, Merton fig.47;
no.**22**

C

Calabrella, Baroness de
Evenings at Haddon Hall 43–4;
fig.34
Caldecott, Randolph no.**37**
Calvert, Edward no.**28**
Camden Town School 16, 17;
nos.**11–12**
Camden, William 51
Campsea Ashe, Suffolk no.**36**
Canetti, Elias
Crowds and Power 50, 51
Canterbury 53–5; fig.42
Carline, Hilda
Melancholy in a Country Garden
95; no.**42**
Carline, Richard no.**42**
Carline, Sydney no.**42**
Carlyle, Thomas 14
Cattermole, George 43–4
Causey, Andrew no.**60**
Cézanne, Paul 229; nos.65, 92
Chambers, Sir William 41
Chatto, Beth 17, 227, 237
Chevreul, Michel Eugène 35
Christian iconography 95, 132
Churchyard, Thomas
The Garden Tent 94; no.**29**
Claremont, Surrey 49
classical tradition 132–3, 235
Clumber Park,
Nottinghamshire 33
Cohen, Leonard no.**108**
Collins, Wilkie
Basil 27
Collishaw, Mat 191
Who Killed Cock Robin? 94;
no.**56**
colour-field abstraction 39, 159
colour in garden design 31–9,
41–2, 43–4
colour illustrations 41–2,
43–4, 46
lost cultivars 43
tinted gravels 33, 34
Colvin, Sidney no.**32**
Compton Wynyates,
Warwickshire no.**36**
conceptual art 188
Constable, John 44, 60, 61;
nos.13, 29
Golding Constable's Flower Garden
no.**1**
*Golding Constable's Vegetable
Garden* 61; no.**2**
*View in a Garden at Hampstead,
with a Red House beyond* 94;

no.**27**
Cook, E.T.
Gardens of England 44–5
Cookham 61; fig.8; nos.16, 41
Corot, Jean Baptiste Camille
34, 38
'Cottage Door' genre 13
cottage gardens 12–16, 20, 44,
50; nos.5–8, 79
cottages, ornamental 23
'Cottingley Fairies' no.**39**
council housing 28, 30; nos.16,
20
country gardens 12–20
Country Life 46, 221; nos.14, 77
Cousen, John
Evenings at Haddon Hall 43–4;
fig.34
Coward, Noël no.**19**
Cowley, Herbert no.**77**
Cowper, William
The Task 23, 28; no.**1**
Cox, David no.**3**
Cragg, Tony no.**70**
Cran, Marion
The Garden of Innocence 46
Crane, Walter no.**37**
Crome, John 34; no.**29**
Cruikshank, George no.**50**

D

Dadd, Richard
Portrait of a Young Man 95;
no.**30**
Dalwood, Hubert
Bonsai Garden II no.**54**
Deacon, Richard no.**70**
De la Motte, William
*Canterbury Cathedral: View from
the Bishop's Garden* 54; fig.42
Dickens, Charles
Dombey and Son 26
Dick, Stewart
The Cottage Homes of England 15
Diggers no.**101**
Dig for Victory campaign 18;
nos.18–21
Dion, Mark
Tasting Garden 191
Dodd, Phyllis no.**23**
Doyle, Sir Arthur Conan
The Coming of the Fairies no.**39**
Dunbar, Evelyn 18, 225; fig.7;
nos.**44**, 47
Gardeners' Choice 18, 225;
no.**14**
A Gardener's Diary no.**14**
Winter Garden no.**14**
Dürer, Albrecht nos.28, 65, 106

E

Eagles Nest, Zennor 231,
232–3; nos.89–90
East Anglian School of Painting
and Drawing 17, 226–7;
nos.58, 87

ecologically concerned art 191–2
Eden Project 189; fig.49
Eldridge, Mildred no.**47**
Elgood, George 37, 44, 45,
158; nos.36, 77
The Garden That I Love 44;
fig.35
Some English Gardens 45
The Sun Dial, Knockwood no.**85**
Eliot, T.S.
Four Quartets 53
Elliott, Brent 35
Elliott, Clarence 17, 49, 50
Elvaston Castle 45; fig.32
endangered species 190, 191–2
English gardens no.**1**
Eyles, George 33

F

Fagen, Graham
Lawn no.**98**
Plant Series no.**98**
Where the Heart is nos.**99–100**
Fairchild
City Gardener 41
fairies, vogue for 94;
nos.**39–40**
Faringford, Isle of Wight no.79
fencings 61
Fenton, Roger 43
Ferris, Dee
Hallelujah no.**108**
Festival of Britain (1951)
nos.47, 91
Field, George 35
Fielding, Copley 32
Finlay, Ian Hamilton 55, 132,
223, 234–5
Nature Over Again After Poussin
no.**65**
*Sundial: A Small Interruption
in the Light* no.**64**
*Sundial: Dividing the Light I
Disclose the Hour* no.**64**
Sundial: Sea/Land no.**64**
Sundial: Umbra Solis Non Aeris
no.**64**
*Unconnected Sentences on
Gardening* 235
works for St. George's,
Brandon Hill 55; fig.43
Finlay, Sue 234; no.**65**
Fisher, Mark 36
florilegia no.**112**
Florist's Guide 42
Florist's Journal 43
Fora, Gherardo di Giovanni del
The Combat of Love and Chastity
no.**52**
formal gardens 31, 33–4,
36, 40–1
Fortis Green, Muswell Hill 42;
fig.20
Foster, Myles Birket 14, 16, 44
A Cottage Garden 14; fig.2
Foucault, Michel 191
Fragonard, Jean Honoré no.**65**

Freud, Lucian 227; no.47
 Garden from the Window 94;
 no.**58**
 *Still Life with Cactus and Flower
 Pots* no.58
Fulton, Hamish 188
funerary urns no.66
Fyleman, Rose
 'The Fairies' no.39

G
Gage, John 35
Gainsborough, Thomas 13
Gallaccio, Anya 190, 192
 Red on Green 159; no.**94**
The Garden 37, 45, 46; no.82
Garden City Movement 28; no.13
garden-construction narratives
 46
Garden of Eden 95, 132
Gardeners' Chronicle 43, 46
Gardener's Magazine 42, 46; fig.20
Gardener's Magazine of Botany 42
gardening manuals 40
Garden of Love 95
genius loci 132; no.60
Gill, Eric no.43
Gillies, William 159; no.47
 Garden, Temple, Winter Moon
 nos.91, **92**
Gilman, Harold no.11
Gilpin, Revd William 13
Ginner, Charles 16; no.42
 Bethnal Green Allotment no.**20**
 *Flask Walk, Hampstead, on
 Coronation Day* no.20
Girtin, Thomas no.3
Glasgow Boys 15, 16; nos.6–8
Glasgow School 16; no.5
Godfrey, Mark no.106
Golders Green 27; fig.17
Goncourt, Edmond de 218
Gooding, Mel 233
Gordon, Lady no.3
Gore, Spencer 61
 The Fig Tree no.**10**
 *From a Window in Cambrian Road,
 Richmond* no.**11**
 The West Pier, Brighton 61; no.**12**
Gosse, Edmund no.75
Gostling, William
 Walk about Canterbury
 53–4; figs.40–1
Grainger, Esther 227
Grainger, Percy
 'Country Gardens' 12, 16
Grant, Duncan 227
Gravetye Manor, Sussex 34, 37,
 38; no.84
Great Bardfield 17–18; no.44
Greenaway, Kate no.39
Greenleaves, Lavington
 Common 228–9; no.88
Gregynog, Wales no.60
Grimshaw, Atkinson
 Knostrop Hall, Early Morning
 60–1; no.4

Grossmith, George and Weedon
 The Diary of a Nobody 27–8
Grosvenor Gallery no.34
Grove End Road, St John's
 Wood 218–19; no.34
Guild of St Joseph and St
 Dominic no.43
Guthrie, James 15–16
 A Hind's Daughter 15;
 fig.3; no.7

H
Haines, Lett 17, 226, 227;
 no.87
Hambling, Maggie 227
Hampstead 27–8, 46; nos.13,
 27, 42
Hampton, Anthony
 The Curious Gardener 17
Hampton Court no.36
Hardy, Thomas
 'She, To Him' no.52
Harrison, Helen Mayer and
 Newton
 *Future Garden – the Endangered
 Meadows of Europe* 191
Haworth-Booth, Mark
 no.68
Helmreich, Anne 14, 15
Henry, George no.7
 A Cottar's Garden no.7
Heptarchy 51–2
Hepworth, Barbara no.60
 Contrapuntal Forms 231
 Conversation with Magic Stones
 231
 Corymb no.**49**
Trewyn Studio, St Ives 230–1;
 no.49
herbaceous borders 36, 44, 46;
 nos.77–8
Heron, Patrick 159, 229,
 232–3; no.88
 Autumn Garden: 1956 233;
 no.**90**
 Azalea Garden: May 1956 233;
 no.**89**
 *Big Purple Garden Painting: July
 1983–June 1984* 233
 Camellia Garden: March 1956
 233
 Garden (Mist): 1956 233
 garden paintings 233;
 nos.89–90
 *Pale Garden Painting: July – August
 1984* 233
 Summer Painting: August 1956
 39; fig.28
 *White Garden Painting: May 25 –
 June 12 1985* 233
heterotopias 191
Hever Castle no.36
Hidcote 38, 44
Higgie, Jennifer no.57
Hiller, Susan
 What Every Gardener Knows
 190–1, 192; no.**109**

Hill, Thomas
 The Gardeners Labyrinth 40;
 fig.31
Hitchens, Ivon 228–9; no.47
 Boathouse, Early Morning 229
 Dark Pool 229
 Garden Cove no.**88**
 Lake: Evening Light 229
 Shrouded Water 229
 Woodland, Vertical and Horizontal
 229
Hitchens, John 229
Hobhouse, Penelope no.78
Hodgkin, C. Eliot
 *The Haberdashers' Hall, 8 May
 1945* no.**45**
 *St Paul's and St Mary Aldermay
 from St Swithin's Churchyard*
 no.**46**
Hodgkins, Frances no.87
Hogarth, William no.50
Hood, Dr William no.30
Hopetoun House, Edinburgh 235
Hornel, Edward Atkinson
 222–3
 In the Crofts, Kirkcudbright no.7
 In Mine Own Back Garden no.**8**
hortus conclusus 95; nos.31–2
Hughes, Arthur
 April Love 95; no.**31**
Hume, Gary
 Four Feet in the Garden 159;
 no.**95**
 What Time is It? no.**96**
Hunt, John Dixon 54
Hyams, Edward
 The English Garden 49–50

I
Illustrated London News 43, 49
illustration
 botanical 45
 children's books 94;
 nos.37–40
 garden 37, 40–7
Impressionism 38, 45
Ingram, J.H.
 North Midland Country
 (Batsford guide) no.23
Inshaw, David
 The Badminton Game 95; no.**52**
intellectual garden tradition
 132–3
Isle of Wight no.3
Italianate gardens 44

J
James, Henry 32; nos.75, 82
 'Gardens and Orchards' 37
 Guy Domville 38
James, John 40
Japanese gardens 37–8, 223;
 no.54
Jarman, Derek
 Prospect Cottage 20, 132,
 133, 236–7; fig.9;
 nos.71a–d, 74

Jekyll, Gertrude 16, 31, 34–6,
 37, 39, 158, 225; nos.36,
 59, 80, 86
 Colour in the Flower Garden 34,
 36; fig.24; nos.59, 77, 84
 colour system 35–6, 159;
 no.85
 copies after Turner 35, 158;
 fig.23; nos.**76**, 77
 Gardens for Small Country Houses
 no.77
 Munstead Wood 36, 158;
 figs.24–5; nos.76–8
 *Old West Surrey, Some Notes and
 Memories* 16
 photographs 35; fig.24
 Some English Gardens 45; no.85
 *Thomas, Portrait of a Favourite Cat
 in the Character of Puss in Boots* 35
Johnston, Lawrence 38
Jones, David
 The Garden Enclosed 95; no.**43**
Jones, Owen 35
Jones, Sarah 191, 192
 The Fence (Passion Flower) II
 no.**105**
 The Garden (Mulberry Lodge) VI
 94; no.**57**
Journal of Horticulture 43
journalism 37–8, 42–3

K
Kawara, On 188
Kent 51–2; nos.17, 28
Kerbel, Janice
 The Bird Island Project no.110
 Home Climate Gardens 191–2;
 no.**110a–b**
Khoroche, Peter 229
Kingsley, Charles no.39
Kip, Johannes and Knyff,
 Leonard
 Britannia Illustrata 41
Kipling, Rudyard
 'The Glory of the Garden' 52
 'Sussex' 52
 'They' 52–3
kitchen gardens nos.2,
 5–8, 21, 33, 79
 see also allotment movement;
 Dig for Victory campaign
Knockwood, Kent no.85
Knostrop Old Hall, Leeds no.4

L
Labourer's Friend Society (LFS)
 13
Lambarde, William
 Perambulation of Kent 51
Lamb, Henry no.42
Lancaster, Osbert
 *By-Pass Variegated from Pillar to
 Post* 29; fig.19
land art 188
landscape gardening 23–5,
 41–2, 49–50, 61

Langley, Batty 40, 41
 New Principles of Gardening 40;
 fig.29
Larkin, Philip
 The Prelude no.26
Lawrence
 Clergyman's Recreation 41
Lawson, William
 New Orchard and Garden 40
Leisure Hour 43
Lennon, John 30
Le Nôtre, André 40
LeRouge
 Cahiers 41
Leslie, George 34–5
Letchworth Garden City 28;
 nos.11, 13
Levens Hall, Cumbria no.85
Lewis, Wyndham nos.10–11
Leyden, Lucas van no.28
Lindley, John 27
Lingholm no.37
Linnell, John 25, 26; nos.13, 28
 Alpha Cottage 25; fig.15
Little Sparta, Dunsyre 132, 223,
 234–5; nos.64–5
Lloyd, Christopher 237
Lloyd, Robert
 The Cit's Country Box 23
London Group no.13
Long, Richard 188
Loudon, Jane 24
Loudon, John Claudius
 24–5, 42
 Encyclopaedia of Gardening 13
 Gardener's Magazine 42; fig.20
 *The Suburban Gardener and Villa
 Companion* 24–5, 42; fig.13
 *View from the Lawn Front of Fortis
 Green* 33; fig.20
 The Villa Gardener 42
Lousley, J. Edward nos.45–6
Luggers Hill, Broadway 220–1;
 nos.82–3
Lutyens, Edwin nos.13, 59, 86

M
Macartney, Mervyn 41
McCartney, Paul 30
MacGregor, William York no.8
 A Cottage Garden, Crail 16;
 no.6
 The Vegetable Stall fig.44; no.6
magazines, gardening 42–3, 46,
 49; fig.20
Mahoney, Charles 18, 224–5;
 nos.14, 44
 Adam and Eve 225
 Autumn 95; no.**48**
 Bathsheba 225
 Campion Hall murals 225;
 nos.47–8
 Evening, Oak Cottage 224
 The Garden no.**47**
 Gardeners' Choice 18, 225;
 no.14
 The Muses 225

Wrotham Place from the Garden 61; no.**17**
Major, Joshua 42
Martin, Violet no.**47**
Mason, George
 Essay on Design in Gardening 49
Matta-Clark, Gordon no.**101**
Maund, George 45
Maxwell, John 159; no.**47**
 Night Flowers no.**91**
 The Trellis no.91
Melville, Arthur 61
 A Cabbage Garden 16; no.**5**
Mendel, Gregor 190; no.**109**
Meredith, George
 Rhoda Fleming 52
Merritt, Anna Lea 45
 An Artist's Garden 45, 46; fig.36
 Love Locked Out 45
Michelet, Jules 51
Millais, Sir John Everett
 Ophelia 25–6
Millar, Jeremy no.**100**
Millet, Frank 221; nos.**75, 82**
Millet, Lily 221
Milton, John no.**28**
mingled flower gardens
 no.**I**
Modern Movement 29;
 nos.**19, 24**
Monet, Claude 38, 226,
 229, 237
Moon, Henry George
 36–7, 38, 45
Moore, Albert
 A Garden 95; no.**32**
Moore, Henry nos.**60, 70**
Morgan, Glyn 227
Morison, Heather and Ivan
 20, 188
 *Colours and Sounds in Ivan
 Morison's Garden* 20; fig.10
 Garden no.**74**
 Global Survey fig.50; no.**III**
Morris, Cedric 17, 226–7;
 no.**58**
 Benton Blue Tit 226
 Floreat no.**87**
 Heralding no.**87**
 Iris Seedlings no.**87**
 *Still Life of Garden Produce against
 an Old Chimney* 17; fig.5;
 no.**21**
 Wartime Garden 227; no.**21**
Morrison, Paul 189, 190
 Garden no.**107**
 Sepal no.**106**
Morris, William 52, 54, 221;
 no.**106**
mortality, symbols of 132–3;
 nos.**59, 61–4, 66**
Mulready, William 44
Munch, Edvard no.**50**
Munstead Wood, Surrey 36;
 figs.24–5 nos.**76–8**
Myddelton House, Enfield
 46

N
Nash, John 16–17, 225, 227;
 no.**42**
 The Artist Plantsman 16–17
 Wild Garden, Winter 17; fig.6
Nash, Paul 17, 229;
 nos.**42, 61, 63**
 The Box Garden no.60
 The Haunted Garden no.60
 photographs 133; no.**60a–e**
Nasmyth, Patrick
 Landscape 13; fig.1
Navarro, Antonio de 221
Neale, J.P.
 Jones' Views of Seats 41
neo-classicism 25, 132; fig.14
Nesfield, William Andrews
 31–4, 36, 37, 42
 designs for Royal
 Horticultural Society garden
 33; fig.21
 villa at Fortis Green 33;
 fig.20
New British Sculpture no.70
Newton, John 132
Newton, Kathleen 218, 219
Nicholson, Ben 231; nos.**60, 87**
Nicholson, David no.**65**
Nicholson, Geoff no.**73**
Nicholson, Sir William
 Miss Jekyll's Gardening Boots 133;
 nos.**59, 61**
 Miss Simpson's Boots no.59
Nimki, Jacques 190, 192
 Florilegium no.**112**
Nisbet, Hume no.**22**
Nisbet, Noel no.**22**
Noble, James Campbell no.**5**
Norman, Nils
 Geocruiser 192
 *Gerrard Winstanley Radical
 Gardening Space ...* 192; no.**101**
 *Proposed Redevelopment of the Oval,
 Hackney E2 London* 192
Norton, W.E. 37, 38
Nuneham, Oxfordshire 42
nursery rhymes no.**56**

O
Oak Cottage, Wrotham 18,
 224–5
Olivier, H.A. 36
O'Meara, Frank
 Towards Night and Winter no.**7**
Ovid
 Metamorphoses 133
Oxford 53

P
Palmer, Samuel nos.**13, 17, 51**
 In a Shoreham Garden 95; no.**28**
Parr, Martin 133
 The Cost of Living no.**73**
 The Last Resort no.73
 North Circular no.**73a–b**
Parsons, Alfred 31–2, 36–9,
 44, 158, 220–1; no.**75**

*The Artist's Garden at Luggers Hill,
Broadway* 221; no.**83**
 China Roses, Broadway fig.26
 A Garden at Broadway, England
 38; fig.27
 illustration work 37; no.**80**
 Notes in Japan 37
 Orange Lilies, Broadway no.**82**
 Warley Place: Daffodils and Pergola
 no.**80**
 Warley Place: Lilies no.**81**
 When Nature Painted all Things Gay
 no.82
Parsons, Beatrice 44, 45, 158
 *August Flowers, The Pleasaunce,
 Overstrand* no.**86**
 Gardens of England 44–5
Pater, Walter 53
Paterson, Dave no.**65**
Patrick, James McIntosh 61;
 no.16
 A City Garden 61; no.**18**
 Tay Bridge from My Studio Window
 fig.46; no.18
Patterson, Wilma no.**65**
Pavord, Anna no.**44**
Pearce, John
 Clement's Garden no.**55**
Peel, Sir Robert 13
Penshurst no.36
Pevsner, Nikolaus
 'The Englishness of English
 Art' 49, 50, 53–4
photography 43, 46, 132–3,
 189; nos.**4, 53, 56–7, 60–3,
 65–8, 71–4, 97–8**
 colour 46; no.**77a–d**
Pinwell, George no.**33**
Piper, John
 *The Castles on the Ground: The
 Anatomy of Suburbia* 29–30;
 fig.18
Pisanello, Antonio no.**105**
Pissarro, Camille
 Bath Road, London 61; no.**9**
 Stamford Brook, London fig.45;
 no.9
 The Train, Bedford Park no.9
Pissarro, Lucien no.**9**
The Pleasaunce, Overstrand
 no.86
Pope, Alexander 49, 235
Port Lympne, Kent 46
Potter, Helen Beatrix
 The Tale of Peter Rabbit 94;
 nos.**37–8**
Poussin, Nicolas no.**65**
 The Shepherds of Arcady 132
Prentice, Andrew 221; no.**82**
Pre-Raphaelites 44, 52;
 nos.**31, 39, 50**
Prospect Cottage, Dungeness
 20, 132, 133, 236–7; fig.9;
 nos.**71a–d, 74**
prospect views 60–1
Purdom, C.B.
 The Garden City 28

Q
Queen Anne Revival 27
Quinn, Marc
 Garden 189, 190, 191; fig.48;
 nos.**102–4**
 Italian Landscape no.**103**
 The Overwhelming World of Desire
 191; no.**104**
 75 Species no.**102**

R
Rackham, Arthur no.**39**
Rainier, Priaulx 231
Ramscliffe, Markfield no.**85**
Ratcliffe, S.K. no.**13**
Ratcliffe, William
 *Hampstead Garden Suburb from
 Willifield Way* no.**13**
Ravilious, Eric 18; no.**47**
 *The Greenhouse: Cyclamen and
 Tomatoes* no.**44**
Rayson, David 191
 *All day Wednesday, Thursday
 and today* no.**114**
 Garden 25
 Night Garden no.**113**
 Patio no.**25**
Realism 15–16
Red House 52, 54
Repton, Humphry 23–4
 *Designs for the Pavilion
 at Brighton* 42
 *Fragments on the Theory and Practice
 of Landscape Gardening*
 24, 42; figs.12, 33
 *Observations on ... Landscape
 Gardening* 42
 Red Books 42
 *Sketches and Hints on Landscape
 Gardening* 42
Richards, J.M.
 *The Castles on the Ground: The
 Anatomy of Suburbia* 29–30;
 fig.18
Richmond, George no.**28**
Robinson, Duncan no.**16**
Robinson, William 14, 16, 31,
 36–7, 225; no.**84**
 The English Flower Garden 34, 35
 The Garden 37, 45, 46; no.**82**
 Tree and Garden Book 34
 The Wild Garden 34, 37, 45;
 no.80
Rossetti, Christina no.**39**
Rossetti, Dante Gabriel 14
 Found 52
Rothenstein, Sir John 17;
 nos.**14, 17**
Rothenstein, Michael 18
Rothenstein, Sir William no.**14**
Rothko, Mark no.**94**
Rousham, Oxfordshire no.**61d**
Rousseau, Jean Jacques no.**65**
Rowe, Ernest Arthur 44, 45
 Campsea Ashe, Suffolk no.**36**
Ruskin, John 14, 25–6; no.**39**
 Modern Painters 32

Ruysch, Dr Frederick 189–90

S
Sackville-West, Vita no.**61c**
St John's Wood 218–19; no.**34**
Salvin, Anthony 32
Sandby, Paul
 *The Artist's Studio, 4 St
 George's Row, Bayswater* 25;
 fig.14
Sargent, John Singer
 Carnation, Lily, Lily, Rose 38,
 158–9, 221; nos.**75, 82**
sexual desire, depictions of 95
Shakespeare, William
 Richard II 50, 52
Sharp, Cecil 16
Shaw, George 60, 189
 Back Garden II (Summer)
 no.**115a**
 The Back Garden II (Winter)
 no.**115b**
 The Back Window no.**115c**
 Dad's Roses no.**115d**
 An English Autumn Afternoon
 no.**26**
 *Scenes from the Passion: The First
 Day of the Year* no.26
Shelley, John
 Annunciation 95; no.**51**
Shenstone, William 235
Shoreham no.**28**
Sissinghurst, Kent 54; no.**61c**
Skeaping, John 226
Sloan, Nicholas no.**65**
Slough 29
Smee, Alfred
 My Garden 45–6
Smith, Edwin
 English Cottage Gardens no.**61**
 English Cottages and Farmhouses
 no.61
 The English Garden no.61
 English Parish Churches no.61
 photographs 133; no.**61a–e**
 *Vita Sackville-West's Boots,
 Sissinghurst, Kent* 133; no.**61c**
Smithson, Robert no.**101**
Society of Bettering Conditions
 and Increasing the Comforts
 of the Poor 13
Sooley, Howard 132, 133,
 236–7; fig.9
 Derek Jarman's Garden at Dungeness
 no.**71a–d**
Soulages, Pierre no.**90**
Spencer, Stanley 61; nos.**17,
 42, 51**
 Cookham Rise no.**16**
 Goose Run, Cookham Rise
 18; fig.8
 The Hoe Garden Nursery no.**24**
 Zacharias and Elizabeth 95; no.**41**
Spero, David 132–3
 Garden no.**72a–e**
Spetchley Park no.**80**
Spry, Constance 227

Stevenson, Robert Louis no.75
Stokes, Adrian 231
Stourhead, Wiltshire 50; no.61a
Straub, Marian 18
suburban gardens 22–30;
 nos.4, 22, 67–8, 73, 113–14
suffragette movement no.35
sundials nos.64, 85
Surrealism no.60
survey style of landscape painting
 nos.16, 18
Sussex 52–3
Sutherland, Graham 229
Sutton's seed catalogues 45;
 no.86
Swinstead, George Hillyard
 The Story of My Old-world Garden …
 46; fig.38
Switzer, Stephen 40–1
 *Nobleman, Gentleman, and
 Gardener's Recreation* 41
 *Universal System of Water and
 Water-works* 40; fig.29

T
Tatham, Charles Heathcote 25
Taylor, John RJ 133
 *Back garden patio with precast
 ornaments* no.68
 North London 133; no.67
Taylor, Walter no.12
Tennyson, Alfred Lord 14, 26,
 44; nos.4, 79
 'The Miller's Daughter' no.31
Thorpe Report 20
Tissot, James 218–19; no.4
 A Convalescent 219
 The Hammock 219
 Holyday 95; no.34
 A Quiet Afternoon 219
topiary 44, 52–3; nos.23, 52,
 60d, 85
Trentham, Staffordshire 43
Trewyn Studio, St Ives 230–1;
 no.49
Turner, Joseph Mallord William
 34, 35, 44, 61, 158
 The Fighting 'Temeraire' nos.76–7
 The Sun of Venice Going to Sea no.76
 View on Clapham Common 35;
 fig.23
 *View from the Terrace of a Villa at
 Niton…* no.3

U
Unit One no.60
Unwin, Raymond no.13

V
Van Gogh, Vincent no.33
 Boots with Laces, Paris no.59
 A Pair of Boots no.59
 Van Gogh's Chair no.59
vegetable gardens 12,
 13–14, 15, 16
villas 23, 26, 29, 42; figs.13,
 20; no.4

Virgil
 Eclogues 55, 132
virtual gardening 188–9

W
Walker, Frederick 37, 44
 An Amateur nos.5, 33
Wallington, Surrey 45–6
Wanstead House fig.33
Warburton, Joan 226
Ward, Cyril
 Royal Gardens 45
Wardian case 192
Ward, Mrs Humphry
 Robert Elsmere 53
Warley Place, Essex nos.80–1
Waterfield, Margaret 158
 *Flower Grouping in English, Scotch
 and Irish Gardens* 45; fig.37
 Garden Colour 45; no.84
 *Oriental Poppy and Lupin,
 Nackington* no.84
Waterhouse, John William
 The Awakening of Adonis no.35
 Flora and the Zephyrs no.35
 *Psyche Opening the Door into Cupid's
 Garden* 95; no.35
Watteau, Jean Antoine no.65
Watts, William
 Seats of the Nobility and Gentry 41
Weaver, Lawrence
 Gardens for Small Country Houses
 no.77
Weber, Eugen
 'In Search of the Hexagon' 51
weeds *see* wild flowers and weeds
Weight, Carel no.47
 The Silence 94; no.50
Wentworth, Richard 133, 188
 Guide no.69
 Occasional Geometries no.97a–d
 Piece of Fence no.70
Whately, Thomas 133
 Observations on Modern Gardening
 41–2; fig.30
Wheatcroft, Harry 49; fig.39
Wilde, Oscar no.34
wild flowers and weeds 190, 191,
 192, 237; nos.45–6, 109, 112
wild garden aesthetic 14, 34;
 no.84
Wilkinson, J. Gardner 35
 On Colour 34; fig.22
Williams, William
 *Conversation Piece before a House in
 Monument Lane* fig.11
Willmott, Ellen no.80
 The Genus Rosa 37; no.80
Willmott, Rose no.80
 windows 61
Winstanley, Gerrard no.101
Witley Court, Worcestershire
 33–4
woodland grove as archetype
 132
Woodrow, Bill no.70
Woollett, William 41; fig.30

Wordsworth, William
 The Prelude no.26
World War II 18, 29; nos.18,
 22, 45–6
 Dig for Victory campaign
 18; nos.18–21
 War Artists Advisory
 Committee nos.19–20

Y
Yeats, W.B. 27
Young, Arthur 13

Tate relies on a large number of supporters – individuals, foundations, companies and public sector sources – to enable it to deliver its programme of activities, both on and off its gallery sites. This support is essential in order to acquire works of art for the Collection, run education, outreach and exhibition programmes, care for the Collection in storage and enable art to be displayed, both digitally and physically, inside and outside Tate. Your donation will make a real difference and enable others to enjoy Tate and its Collections both now and in the future. There are a variety of ways in which you can help support the Tate and also benefit as a UK or US taxpayer. Please contact us at:

The Development Office
Tate, Millbank
London SW1P 4RG
Tel: 020 7887 3937
Fax: 020 7887 8738

Tate American Fund
1285 Avenue of the Americas (35th fl)
New York, NY 10019
Tel: 001 212 713 8497
Fax: 001 212 713 8655

DONATIONS
Donations, of whatever size, from individuals, companies and trusts are welcome, either to support particular areas of interest, or to contribute to general running costs.

GIFTS OF SHARES
Since April 2000, we can accept gifts of quoted share and securities. These are not subject to capital gains tax. For higher rate taxpayers, a gift of shares saves income tax as well as capital gains tax. For further information please contact the Campaigns Section of the Development Office.

TATE ANNUAL FUND
A donation to the Annual Fund at Tate benefits a variety of projects throughout the organisation, from the development of new conservation techniques to education programmes for people of all ages.

GIFT AID
Through Gift Aid, you can provide significant additional revenue to Tate. Gift Aid applies to gifts of any size, whether regular or one-off, since we can claim back the tax on your charitable donation. Higher rate taxpayers are also able to claim additional personal tax relief. Contact us for further information and a Gift-Aid Declaration.

LEGACIES
A legacy to Tate may take the form of a residual share of an estate, a specific cash sum or item of property such as a work of art. Legacies to Tate are free of Inheritance Tax.

OFFERS IN LIEU OF TAX
Inheritance Tax can be satisfied by transferring to the Government a work of art of outstanding importance. In this case the rate of tax is reduced, and it can be made a condition of the offer that the work of art is allocated to Tate. Please contact us for details.

TATE AMERICAN FUND AND TATE AMERICAN PATRONS
The American Fund for the Tate Gallery was formed in 1986 to facilitate gifts of works of art, donations and bequests to Tate from United States residents. United States taxpayers who wish to support Tate on an annual basis can join the American Patrons of the Tate Gallery and enjoy membership benefits and events in the United States and United Kingdom (single membership $1000 and double $1500). Both organisations receive full tax exempt status from the IRS. Please contact the Tate American Fund for further details.

MEMBERSHIP PROGRAMMES
Tate Members enjoy unlimited free admission throughout the year to all exhibitions at Tate Britain, Tate Liverpool, Tate Modern and Tate St Ives, as well as a number of other benefits such as exclusive use of our Members' Rooms and a free annual subscription to Tate Magazine.

Whilst enjoying the exclusive privileges of membership, you are also helping secure Tate's position at the very heart of British and modern art. Your support actively contributes to new purchases of important art, ensuring that the Tate's Collection continues to be relevant and comprehensive, as well as funding projects in London, Liverpool and St Ives that increase access and understanding for everyone.

PATRONS
Tate Patrons are people who share a strong enthusiasm for art and are committed to giving significant financial support to Tate on an annual basis. The Patrons support the Tate Collection, helping Tate acquire works from across its broad collecting remit: historic British art, modern international art and contemporary art. Tate welcomes Patrons into the heart of its activities. The scheme provides a forum for Patrons to share their interest in art and to exchange knowledge and information in an enjoyable environment.

CORPORATE MEMBERSHIP
Corporate Membership at Tate Modern, Tate Liverpool and Tate Britain, and support for the Business Circle at Tate St Ives, offer companies opportunities for corporate entertaining and the chance for a wide variety of employee benefits. These include special private views, special access to paying exhibitions, out-of-hours visits and tours, invitations to VIP events and talks at members' offices.

CORPORATE INVESTMENT
Tate has developed a range of imaginative partnerships with the corporate sector, ranging from international interpretation and exhibition programmes to local outreach and staff development programmes. We are particularly known for high-profile business to business marketing initiatives and employee benefit packages. Please contact the Corporate Fundraising team for further details.

CHARITY DETAILS
The Tate Gallery is an exempt charity; the Museums & Galleries Act 1992 added the Tate Gallery to the list of exempt charities defined in the 1960 Charities Act. The Friends of the Tate Gallery is a registered charity (number 313021). Tate Foundation is a registered charity (number 1085314).

TATE BRITAIN DONORS TO THE CENTENARY DEVELOPMENT CAMPAIGN

FOUNDER
The Heritage Lottery Fund

FOUNDING BENEFACTORS
Sir Harry and Lady Djanogly
The Kresge Foundation
Sir Edwin and Lady Manton
Lord and Lady Sainsbury
of Preston Candover
The Wolfson Foundation

MAJOR DONORS
The Annenberg Foundation
Ron Beller and Jennifer Moses
Alex and Angela Bernstein
Ivor Braka
Lauren and Mark Booth
The Clore Duffield Foundation
Maurice and Janet Dwek
Bob and Kate Gavron
Sir Paul Getty KBE
Nicholas and Judith Goodison
Mr and Mrs Karpidas
Peter and Maria Kellner
Catherine and Pierre Lagrange
Ruth and Stuart Lipton
William A Palmer
John and Jill Ritblat
Barrie and Emmanuel Roman
Charlotte Stevenson
Tate Gallery Centenary Gala
The Trusthouse Charitable Foundation
David and Emma Verey
Clodagh and Leslie Waddington
Mr and Mrs Anthony Weldon
Sam Whitbread

DONORS
The Asprey Family Charitable Foundation
The Charlotte Bonham-Carter Charitable Trust
The CHK Charities Limited
Sadie Coles
Giles and Sonia Coode-Adams
Alan Cristea
Thomas Dane
The D'Oyly Carte Charitable Trust
The Dulverton Trust
Tate Friends
Alan Gibbs
Mr and Mrs Edward Gilhuly

Helyn and Ralph Goldenberg
Richard and Odile Grogan
Pehr and Christina Gyllenhammar
Jay Jopling
Howard and Lynda Karshan
Madeleine Kleinwort
Brian and Lesley Knox
Mr and Mrs Ulf G. Linden
Anders and Ulla Ljungh
Lloyds TSB Foundation for England and Wales
David and Pauline Mann-Vogelpoel
Nick and Annette Mason
Viviane and James Mayor
Anthony and Deidre Montague
Sir Peter and Lady Osborne
Maureen Paley
Mr Frederik Paulsen
The Pet Shop Boys
The P F Charitable Trust
The Polizzi Charitable Trust
Mrs Coral Samuel CBE
David and Sophie Shalit
Mr and Mrs Sven Skarendahl
Pauline Denyer-Smith and Paul Smith
Mr and Mrs Nicholas Stanley
The Jack Steinberg Charitable Trust
Carter and Mary Thacher
Mr and Mrs John Thornton
Dinah Verey
Gordon D. Watson
The Duke of Westminster OBE TD DL
Mr and Mrs Stephen Wilberding
Michael S. Wilson
and those donors who wish to remain anonymous

TATE COLLECTION

FOUNDERS
Sir Henry Tate
Sir Joseph Duveen
Lord Duveen
The Clore Duffield Foundation
Heritage Lottery Fund
National Art Collections Fund

FOUNDING BENEFACTORS
Sir Edwin and Lady Manton
The Kreitman Foundation
The American Fund for the Tate Gallery
The Nomura Securities Co Ltd

BENEFACTORS
Gilbert and Janet de Botton
The Deborah Loeb Brice Foundation
National Heritage Memorial Fund
Patrons of British Art
Patrons of New Art
Dr Mortimer and Theresa Sackler Foundation
Tate Members

MAJOR DONORS
Aviva plc
Edwin C Cohen
Lynn Forester de Rothschild
Noam and Geraldine Gottesman
Mr and Mrs Jonathan Green
The Leverhulme Trust

Hartley Neel
Richard Neel
New Opportunities Fund

DONORS
Abstract Select Limited
Howard and Roberta Ahmanson
Lord and Lady Attenborough
The Charlotte Bonham-Carter Charitable Trust
Mrs John Chandris
Ella Cisneros and Guido Alba-Marini
Sir Ronald and Lady Cohen
Mr and Mrs Zev Crystal
Danriss Property Corporation Plc
Mr and Mrs Guy Dellal
Brooke Hayward Duchin
GABO TRUST for Sculpture Conservation
The Gapper Charitable Trust
The Getty Grant Program
Miss Kira Gnedovskayan and Mr Jonathon Fairman
Mr and Mrs Fisher
Mimi Floback
Mr and Mrs G Frering
Glenn R. Fuhrman
Kathy Fuld
Liz Gerring and Kirk Radke
Mr and Mrs Zak Gertler
Judith and Richard Greer
Calouste Gulbenkian Foundation
Mrs Brigid Hanson
Susan Hayden
HSBC Artscard
Angeliki Intzides
Lord and Lady Jacobs
Ellen Kern
The Samuel H Kress Foundation
Leche Trust
Robert Lehman Foundation
Mr and Mrs Diamantis M Lernos
Maxine Leslau
William Louis-Dreyfus
Mr and Mrs Eskandar Maleki
Brett Miller
The Henry Moore Foundation
Mary Moore
Guy and Marion Naggar
Friends of the Newfoundland Dog and Members of the Newfoundland Dog Club of America
Peter and Eileen Norton, The Peter Norton Family Foundation
Mr and Mrs Maurice Ostro
Dominic Palfreyman
William Palmer
Mr and Mrs Stephen Peel
The Honorable Leon B and Mrs Cynthia Polsky
Karen and Eric Pulaski
The Radcliffe Trust
The Rayne Foundation
Julie and Don Reid
Mr and Mrs Philip Renaud
Mr Simon Robertson
Barrie and Emmanuel Roman
Lord and Lady Rothschild
Mrs Jean Sainsbury
Debra and Dennis Scholl
Amir Shariat
John A. Smith and Vicky Hughes

Mr and Mrs Ramez Sousou
The Foundation for Sports and the Arts
Stanley Foundation Limited
Kimberly and Tord Stallvik
Robert and Warly Tomei
Mr and Mrs A Alfred Taubman
Mr and Mrs Pyrros N Vardinoyannis
Andreas Waldburg
Poju and Anita Zabludowicz
and those donors who wish to remain anonymous

TATE COLLECTORS FORUM
Lord Attenborough Kt CBE
Colin Barrow
Ricki Gail Conway
Madeleine Kleinwort
Jonathan Marland
Keir McGuinness
Frederick Paulsen
Tineke Pugh
Virginia Robertson
Roland and Sophie Rudd
Andrew and Belinda Scott
Dennis and Charlotte Stevenson
Sir Mark Weinberg
and those donors who wish to remain anonymous

COLLECTION SPONSOR
Carillion plc
Paintings Conservation (1995–2000)

TATE BRITAIN DONORS

MAJOR DONORS
The Bowland Charitable Trust
Mr and Mrs James Brice
The Henry Luce Foundation
The Henry Moore Foundation
The Horace W Goldsmith Foundation
John Lyon's Charity

DONORS
Howard and Roberta Ahmanson
Blackwall Green (Jewellery & Fine Art)
Mr and Mrs Robert Bransten
The Calouste Gulbenkian Foundation
Ricki and Robert Conway
The Glass-House Trust
ICAP plc
ICI
The Stanley Thomas Johnson Foundation
Kiers Foundation
The Kirby Laing Foundation
London Arts
The Paul Mellon Centre for Studies in British Art
The Mercers' Company
David and Audrey Mirvish
The Peter Moores Foundation
Judith Rothschild Foundation
Keith and Kathy Sachs
The Wates Foundation
and those donors who wish to remain anonymous

TATE BRITAIN CORPORATE MEMBERS

Accenture
American Express
Aviva plc
Bank of Ireland UK
The Bank of New York
BNP Paribas
Clifford Chance
Deloitte
Drivers Jonas
EDF Energy
EMI
Ernst & Young
Freshfields Bruckhaus Deringer
GAM
GLG Partners
Lehman Brothers
Linklaters
Mayer, Brown, Rowe & Maw
Microsoft Limited
Nomura
Paragon Business Furniture
Pearson
Reckitt Benckiser
Simmons & Simmons
Standard Chartered
Tishman Speyer Properties
UBS

TATE BRITAIN SPONSORS

FOUNDING SPONSORS

BP PLC
Campaign for the creation of Tate Britain
(1999–2000)
BP Displays at Tate Britain (1990–2007)
Tate Britain Launch (2000)

BT
Tate Online (2001–2006)

CHANNEL 4
The Turner Prize (1991–2003)

ERNST & YOUNG
Picasso: Painter/Sculpture (1994)
Cézanne (1996)
Bonnard (1998)
Art of the Garden (2004)

BENEFACTOR SPONSORS

EGG PLC
Tate & Egg Live (2003)

GlaxoSmithKline plc
Turner on the Seine (1999)
William Blake (2000)
*American Sublime: Landscape Painting in the United States,
1820–1880* (2002)

PRUDENTIAL PLC
*The Age of Rossetti, Burne-Jones and Watts: Symbolism in
Britain 1860–1910* (1997)
The Art of Bloomsbury (1999)
Stanley Spencer (2001)

TATE & LYLE PLC
Tate Members (1991–2000)
Tate Britain Community Education (2001–2004)

MAJOR SPONSORS

BARCLAYS PLC
Turner and Venice (2003)

THE BRITISH LAND COMPANY PLC
Joseph Wright of Derby (1990)
Ben Nicholson (1993)
Gainsborough (2002)

THE DAILY TELEGRAPH
Media Partner for *American Sublime* (2002)
Media Partner for *Pre-Raphaelite Vision:
Truth to Nature* (2004)
Media Partner for *In-A-Gadda-Da-Vida* (2004)

THE GUARDIAN
Media Partner for *Intelligence* (2000)
Media Partner for *Wolfgang Tillmans if one thing matters,
everything matters* (2003)
Media Partner for *Bridget Riley* (2003)
Media Partner for *Tate & Egg Live Series* (2003)
Media Partner for *20 Years of the Turner Prize* (2003)

THE INDEPENDENT NEWSPAPERS
Media Partner for *William Blake* (2000)
Media Partner for *Stanley Spencer* (2001)
Media Partner for *Exposed: The Victorian Nude* (2001)

MORGAN STANLEY
Visual Paths: Teaching Literacy in the Gallery
(1999–2002)

TATE MEMBERS
Exposed: The Victorian Nude (2001)
Bridget Riley (2003)
A Century of Artists' Film in Britain (2003–2004)
In-A-Gadda-Da-Vida (2004)
Art Now: Nigel Cooke (2004)

UBS
Lucian Freud (2002)

VOLKSWAGEN
Days Like These: Tate Triennial of Contemporary Art (2003)

SPONSORS

B&Q
Michael Andrews (2001)

CLASSIC FM
Media Partner for *Thomas Girtin: The Art of Watercolour*
(2002)

THE DAILY MAIL
Media Partner for *Turner and Venice* (2003)

THE ECONOMIST
James Gilray: The Art of Caricature (2001)

HISCOX PLC
Tate Britain Members Room (1995–2001)

JOHN LYON'S CHARITY
Constable to Delacroix: British Art and the French Romantics
(2003)

THE TIMES
Media Partner for *Art and the 60s: This Was Tomorrow*
(2004)